ACKNOWLEDGMENTS

This publication could not have been realized
without the support, both financial and non-
material, of various people and institutions.
We extend our thanks for their valuable input
and knowledge as well as for their support
of this project to:

Jutta Motz
Stephanie Motz

We are especially grateful to
Doris de Buys-Roessingh (†), sister of the collector
and photographer Armin Haab, for her verbal
support and guidance.

Bernhard von Waldkirch, Joachim Sieber,
Kunsthaus Zürich
Marco Obrist, Kunsthaus Zug
Corinne Wegmüller, Department of Culture,
Canton of Zug
Peter Moerkerk, Digitization Center
Zentralbibliothek Zürich
Teresa Gruber, Katharina Rippstein, Rosa Schamal,
Fotostiftung Schweiz, Winterthur
Domingo Eduardo Ramos, Felicitas Rausch,
Daros Latinamerica AG, Zurich

For their financial support of this publication,
we would like to thank

ARJA Immobilien AG, Zug

This book is
dedicated to
Armin Haab

↖ Armin Haab in Paricutín, Michoacán, Mexico, 1949 (Self-portrait)

Mexican Graphic Art

Milena Oehy

THE AUTHOR

Milena Oehy (*1984 in Lucerne), lic. phil.,
studied medieval and modern art history,
general history, and East Asian art history at
the University of Zurich. Her final thesis
focused on pictorial quotations in caricatures
from the satirical magazine *Nebelspalter*.
Milena Oehy has been working as a free-
lance curator and art historian in Zurich. Her
research focuses on art from the nineteenth
and twentieth centuries and graphic art
from Europe and Mexico.
 She has worked for the Swiss Institute
for Art Research (SIK-ISEA), for SIKART from
2008 to 2010, and since 2012 researching
the work of Ferdinand Hodler. From 2010 to
2012 she worked in the Kunsthaus Zürich's
Department of Prints and Drawings and
curated the exhibition *Posada to Alÿs. Mexican
Art from 1900 to the Present.* She is a member
of the Cultural Commission of the City
of Frauenfeld and curatorial director of the
municipal gallery Baliere in Frauenfeld.

CONTENTS

As concise as the title of the present publication and exhibition at the Kunsthaus Zürich may sound, for most people it will stir an association with highly expressive, powerful folkloristic works rife with a revolutionary and socio-critical spirit: For more than a century, the figurative and expressive art of Mexico has made a significant contribution to the long history of art on paper.

The historical starting point for typical Mexican graphic art are the nineteenth-century social satires and skeleton depictions *(calaveras)* by internationally well-known graphic artists Manuel Manilla and José Guadalupe Posada. The arc stretches over Ignacio Aguirre, Alberto Beltrán, Fernando Castro Pacheco, Jean Charlot, Leopoldo Méndez, and Alfredo Zalce to "Los tres grandes" (The Big Three), Diego Rivera, José Clemente Orozco, and David Alfaro Siqueiros, who designed a great number of murals on political, nationalist, and social themes *(muralismo mexicano)* from the 1920s until the 1970s. Outstanding works emerged from the Taller de Gráfica Popular (TGP), the Workshop for Popular Graphic Art, a coalition of international artists based in Mexico, which was founded in 1937. The graphic artists who pooled their forces there created broadsides and posters for the common people. They promoted trade unions and national education as well as socialist themes. Their works show, on the one hand, Mexican everyday life, the customs and characteristics of the indigenous people, and on the other hand, the first approaches toward abstract art.

With this publication, we present an extraordinarily important collection of Mexican prints and remember a passionate collector. The photographer Armin Haab (1919–1991), born in the Canton of Zug, traveled to Mexico for the first time in 1948 and photographed the cultural monuments, people, and their customs. He returned to Mexico on further journeys in 1954, 1962, 1973, and 1977. Enthused by Mexican culture, he purchased original Mexican prints on his journeys, and until 1980 from diverse galleries in Mexico, from the Taller de Gráfica Popular, collectors, and from artists directly. This collection of Mexican prints, which until Haab's death in 1991 would grow to roughly 400 prints and portfolios, includes works by sixty-five artists—all created in letterpress, gravure, or surface printing—all in all, more than 1000 sheets. This collection, unrivaled in Europe, offers a good overview of

the development of figurative graphics through to the first abstract depictions in Mexico between 1847 and 1976. Haab donated his collection to the Kunsthaus Zürich in the late 1980s.

Now, Milena Oehy has extensively researched the Armin Haab Collection and presents it in this volume. We are obliged to her for her great commitment and meticulous, careful work. Thanks to her efforts, we can truly appreciate the passion of this unusual collector who made a valuable contribution to the Kunsthaus. Our sincere thanks also go to Jutta Motz and Armin Haab's daughter Stephanie Motz, who infected everyone with their enthusiasm, and who shared in the creation of this volume, designed by Lena Huber. Assisting Milena Oehy in both her research and organizational work were Mirjam Varadinis and Franziska Lentzsch from the Kunsthaus. Milena Oehy also curated a beautiful exhibition showcasing the highlights of Armin Haab's collection to accompany the publication of the book. I owe my sincere thanks to everyone involved: Mexican graphic art has found a home here at the Kunsthaus Zürich!

Christoph Becker

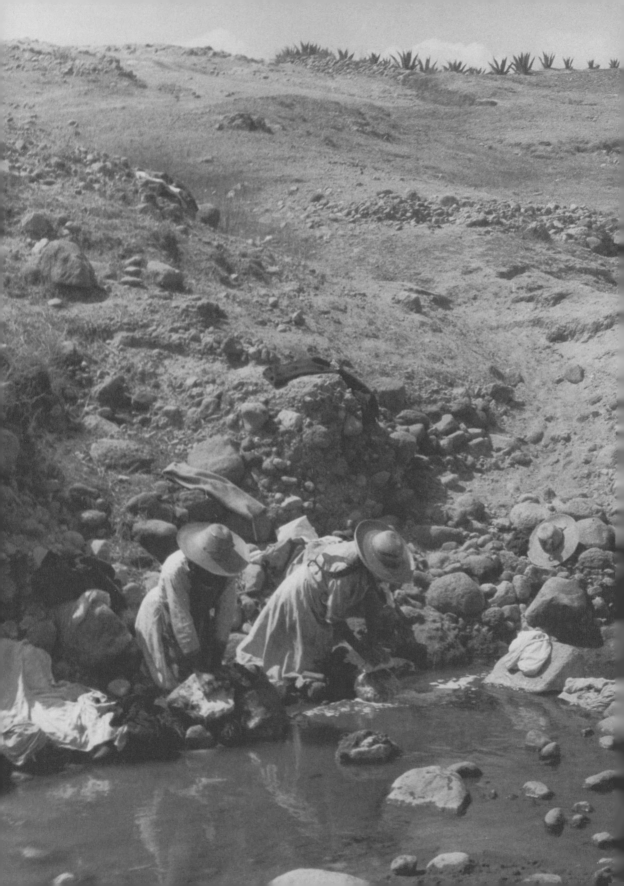

1949—Two Months and 12,000 Images

Armin Haab Sees Mexico

↖ Women washing clothes between Toluca, México, and Zitácuaro, Michoacán

↓ Boy with donkey near Tepoztlán, Morelos
→ Outlet of the Tecolutla River into the Golf near Papantla, Veracruz

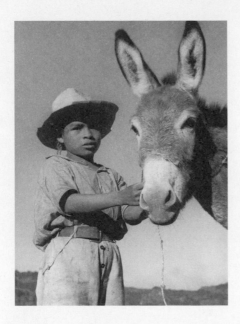

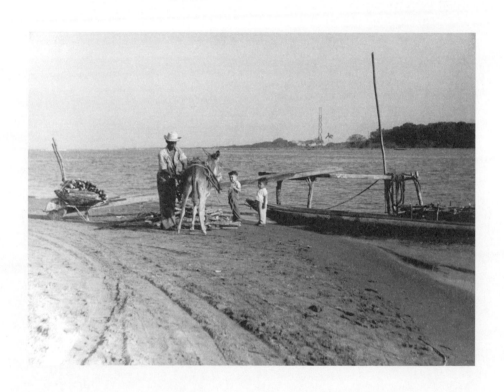

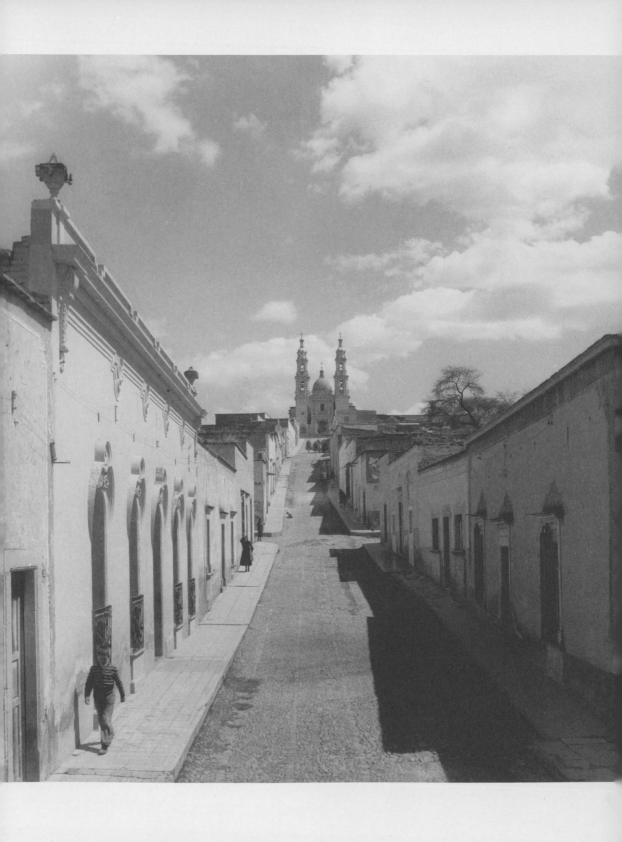

← Street in Irapuato, Guanajuato
↓ Young woman at the spinning wheel, San Cristóbal de las Casas, Chiapas

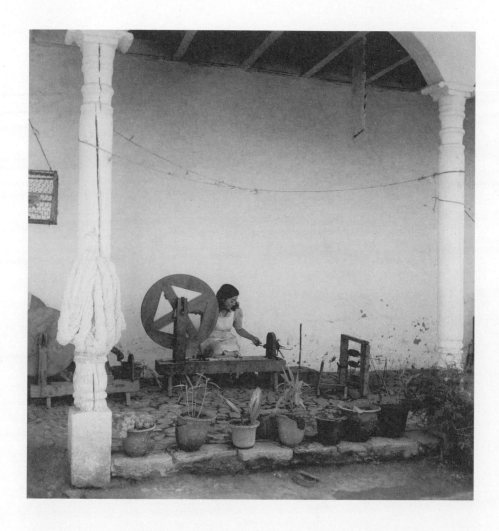

↓ Blessing of animals, Iglesia Santa Cruz Acatlán, Mexico City
→ View of the Iglesia Santa Prisca in Taxco, Guerrero

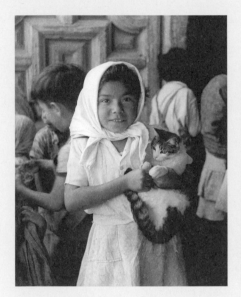
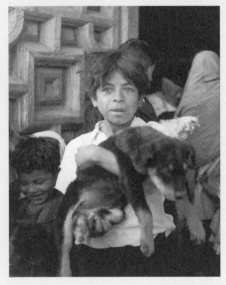

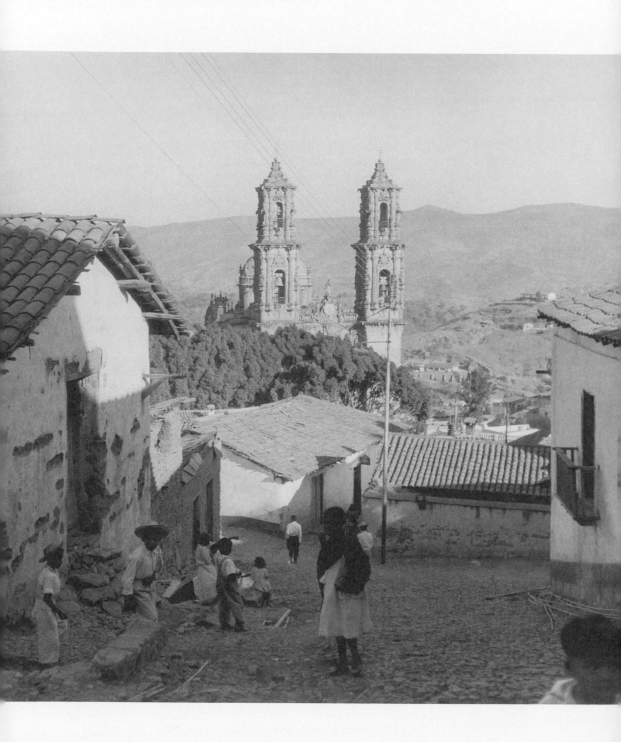

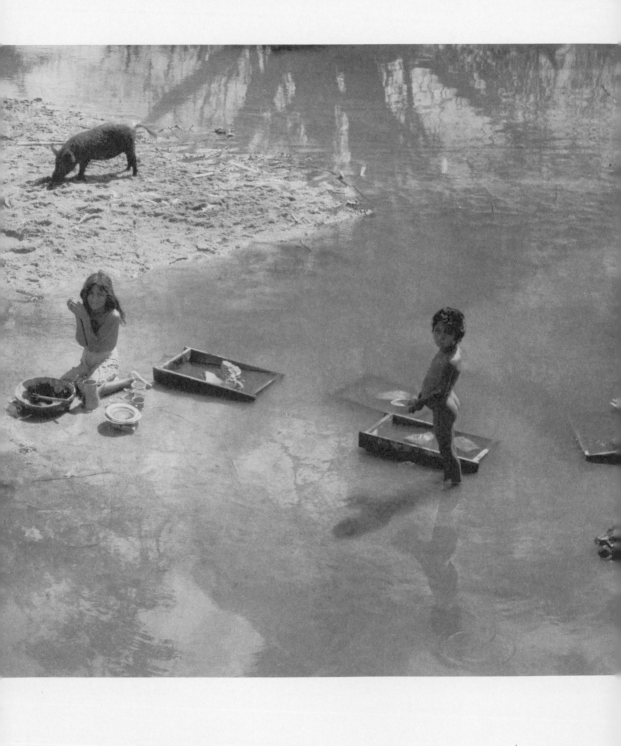

← Children by the river between Oaxaca de Juárez and Tehuantepec, Oaxaca
↓ Peasants building a dugout canoe, 1954

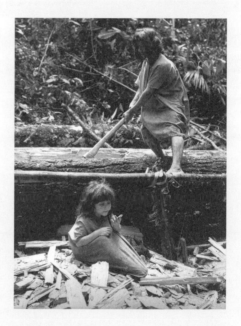

↓ Children playing, Fiesta María Candelaria, Tlacotalpan, Veracruz
→ Marketplace, Fiesta María Candelaria, Tlacotalpan, Veracruz

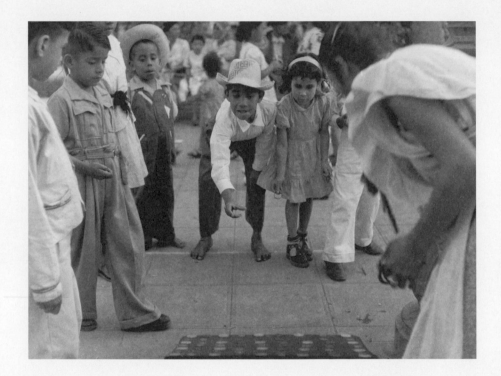

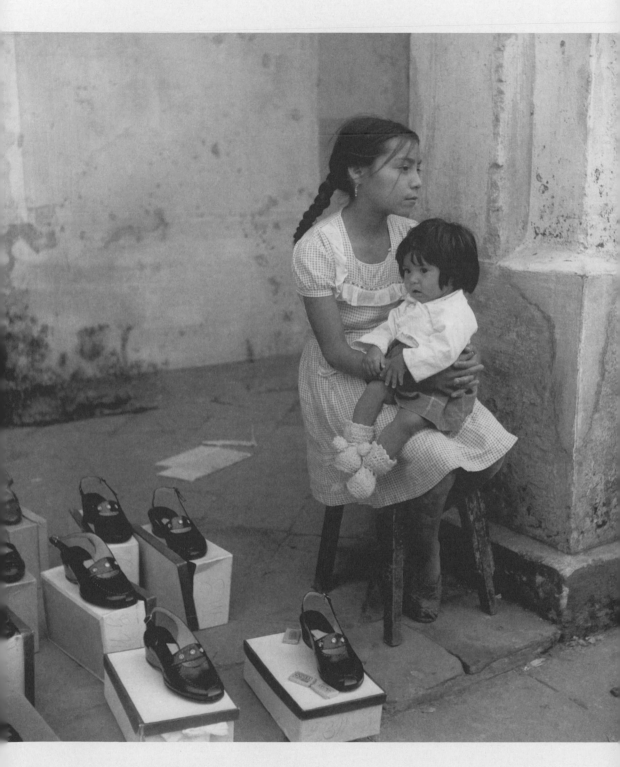

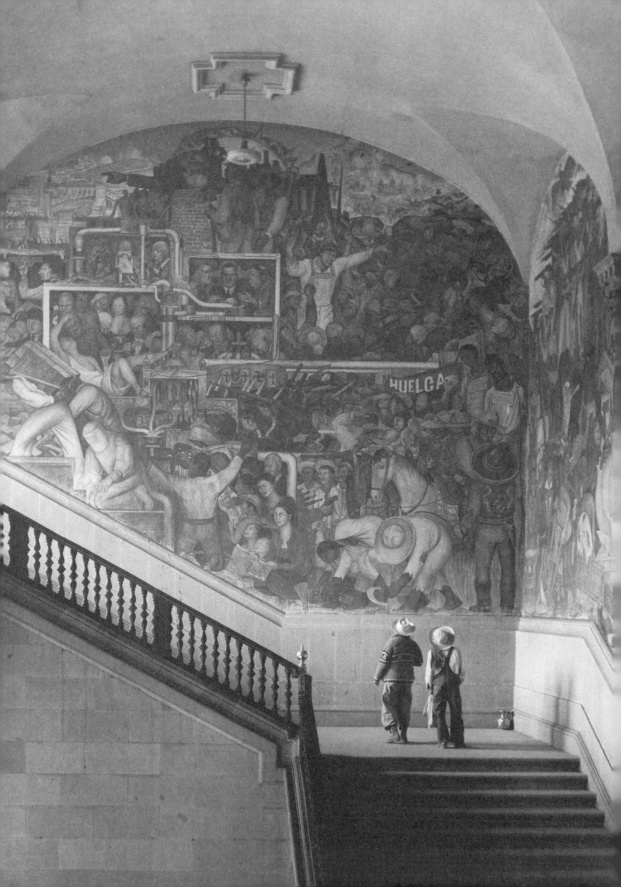

← Palacio Nacional, Mexico City
↓ Iglesia Santa María Tonantzintla, Puebla

↘ Yumuri Martha Paniagua, Fiesta María Candelaria, Tlacotalpan, Veracruz

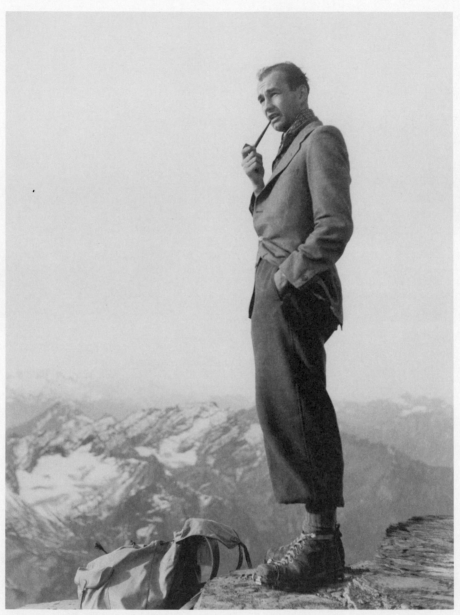

Armin Haab, Les Diablerets, 1942 (photo: Ernst K. Haab)

Biography

Armin Haab (1919–1991)

1919 Armin Haab, the third child of Ernst and Anna Haab-Wickart, is born on January 28. He attends secondary and trade school in Zug.[1]

1935 At the age of sixteen, Haab receives his first camera, a Rolleiflex, as a gift from his father. He sets up a darkroom in the cellar of his parents' home on Bahnhofstrasse in Baar (now the Gotthard shopping center), so that he can develop and enlarge his photos himself. The first self-portrait was most likely created in this cellar with the help of a self-timer.[2]

Haab completes a typography apprenticeship with Eberhard Kalt-Zehnder in Zug.

1941–1942 Haab concludes his active duty in the Swiss Army in 1941 and exhibits his photos for the first time, at the Casino in Zug. From 1941 to 1942 he attends the École de Photographie in Lausanne under the direction of Gertrude Fehr.

1943–1944 In 1943, Haab befriends the Austrian sculptor Fritz Wotruba, from whom Haab's father purchases a stone sculpture in 1944.[3]

Also in 1943, Haab goes to Zurich, where he attends the photo class under Hans Finsler and Alfred Willimann at the Kunstgewerbeschule (School of Arts and Crafts). Photo portraits arise of the writers Friedrich Dürrenmatt and Max Frisch and also of actors from Zurich's Schauspielhaus, among them, Therese Giehse.

Haab's teacher, Hans Finsler, during the photo class of the Kunstgewerbeschule, Zurich, 1943

Self-portrait of Armin Haab in his studio at his parents' house in Baar, 1945

When his older brother Ernst dies in an accident while hiking in the Berner Oberland in July 1943, Haab makes a career change in order to take over the family's grain mills. He earns a degree in business at the Minerva School in Zurich and returns to Baar. He has to stop his training as a photographer and instead begins an apprenticeship as a miller in the millwright firm of the Bühler brothers in Uzwil, SG. He begins work at the Neumühle in Baar under his father and his father's brother Johann Jakob in 1945, where he works until his father's death in 1960.[4]

Beginning in 1944 Haab takes hikes in Mendrisiotto, for example, from Bedretto to the Cristallina Pass or through the Valle Bavona to Bignasco. In doing so, he discovers his love of Ticino, which he will later call home.

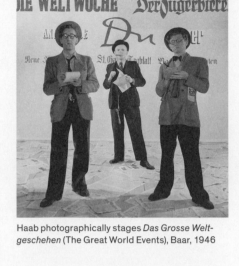

Haab photographically stages *Das Grosse Welt-geschehen* (The Great World Events), Baar, 1946

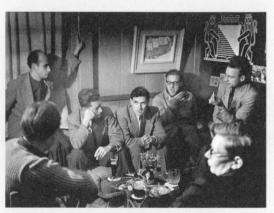

The members of the "Zentrale," Baar, ca. 1944

1938–1948 Haab maintains a close friendship with Geny Hotz from 1938 to 1948. The "Jeunesse dorée de Baar-les-Bains" meets regularly in Hotz's print studio, also called "Die Zentrale." The group includes, along with Hotz and Haab, also Christian Staub (photographer), Roberto Margotta (journalist), Werner Dossenbach (typographer and publisher), Max Huber (graphic designer), Hans "Johnny" Potthof (artist), Fritz Wotruba (sculptor), and Max "Busch" Schumacher (writer). Haab shoots photos in the Zentrale

on a regular basis from 1943 to 1947 to then publish a book with original photographs. Schumacher and Hotz are presented this chronicle of their times in 1948. Haab keeps a third copy for himself.[5]

1948–1949 Undertakes an eight-month journey through Scotland, Great Britain, the U.S., Mexico, and Spain. His summary of the professional aspects of the journey turns out to be rather sober: "Due to the extreme excess of wheat, the Americans were able to grind down the grain to only 40 percent rather than 68 percent, like we do. They bleach the brownish end product, which they call flour, snowy white and add great amounts of baking powder, – 'refining,' for which we would have been put behind bars on the basis of cautious war economy regulations."[6] He visits a total of twenty-eight mills in various federal states in the U.S. and Mexico. During his journey, he creates the photo series *New York, Harlem, Jazz* in New York.

1957–1961 Haab becomes a founding member of the Zuger Kunstgesellschaft and is active on the board until 1961.

1963 Becomes a member of the Kommission für die Förderung des kulturellen Lebens des Kantons Zug (Commission for the promotion of cultural life in the Canton of Zug).

1965–1975 Moves to Ticino, into his newly built house in Ascona. In 1975 he returns to the Canton of Zug and moves into an apartment in Oberwil. He begins to capture his home, the Canton and the City of Zug, in photos, an activity that becomes increasingly more difficult over the years due to the urban sprawl and architectural "lack of taste."

Between 1951 and 1990, Haab takes further journeys to the following countries, cities, and regions (in alphabetical order): the Aegean, Afghanistan, Antarctic, Argentina, Australia, Austria, Bali, Belgium, Benin (previously Dahomey), Bhutan, Black Sea, Bolivia, Borneo, Brazil, Burma, Cambodia, Cameroon, Canada, Caribbean, Chile (Easter Islands), Columbia, Crete, Croatia, Cyprus, Czechoslovakia (Prague), Denmark, Ecuador (Galapagos Islands), Egypt, Finland, France (New Caledonia, Tahiti), Germany, German Democratic Republic, Ghana, Great Britain, Guatemala, Haiti, Honduras, Hong Kong, India, Iceland, Israel, Italy, Japan, Java, Jordan, Kashmir, Kenya, Lebanon, Madeira, Malaysia, Mallorca, Malta, the Mediterranean, Morocco, Nepal, the Netherlands, Nigeria, Norway, Pakistan, Panama, Patagonia, Persia, Peru, Philippines, Puerto Rico, Russia, Singapore, South Africa, Spain, Sweden, Syria, Taiwan, Tanzania, Thailand, Tibet, Turkey, the U.S. (various states, including Alaska and Hawaii), Venezuela, Yemen, and Zimbabwe.[7] He consistently brings a rich yield of images home with him from these numerous journeys around the world.[8]

1989 Shortly before his death, Haab donates his extensive collection of Mexican prints to the Zürcher Kunstgesellschaft, thanks to mediation by Walter Binder, the head of the Stiftung für die Photographie in Zurich (today, Fotostiftung Schweiz, Winterthur).

1991 Armin Haab dies on March 4 in Oberwil, ZG. He donates a convolute of thirty-nine works of Classic Modernism to the Kunsthaus Zug.

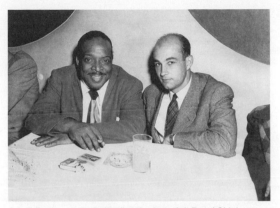

Count Basie and Armin Haab at the Jazz club Royal Chicken Roost on Broadway, New York, 1948 (unknown photographer)

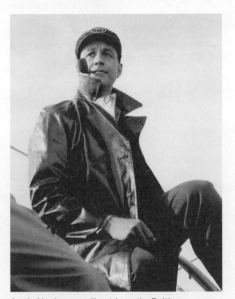

Armin Haab on a sailing trip on the Balticum near the Danish coast, 1966
(photo: Doris de Buys-Roessingh)

Photography

1951 The photo agency World Press Photo asks for the right to distribute Haab's photos: magazine publishers in Europe and the U.S. request Haab's images.

1952 Photos are subsequently published in two publications: *Das Buch vom Lande Zug* by Dr. Joseph Brunner and *U.S. Camera Annual*. Haab's photo *Sömmernde Pferde* is published alongside works by internationally renowned photographers, such as Ansel Adams, Henri Cartier-Bresson, Eliot Elisofon, Robert Frank, Philippe Halsman, Edward Steichen, or Edward Weston.

1957 Haab travels to Bhutan. He is invited due to mediation by his younger sister Doris de Buys-Roessingh, who had become acquainted with Kesang, the daughter of the Bhutanese Premier Dorji in a boarding school in London. Kesang is meanwhile married to the King of Bhutan. Regarding his journey from India to Bhutan, Haab writes: "On the Bhutanese side, a throng of bearers including interpreter, cook, and servants were waiting for the guest of state [...]."[9] Haab traveled in the west of the country for more than ten weeks. Back in Switzerland he publishes the Modern Times' first report about the Himalayan state illustrated with color photos.[10]

1961 Forty-eight color and sixty-four black-and-white photos are published in the volume *Bhutan. Fürstenstaat am Götterthron* by Sigbert Mohn.[11] Mohn on the photographs: "It would have been a crime not to have published the book." Many of the color photos were shown in museums as enlargements.

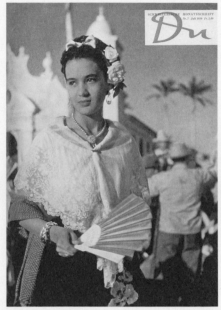

Du—Schweizerische Monatsschrift (Swiss monthly magazine), no. 7, July 1950

Mexico

1949 The publication *Mexican Heritage* by George Hoyningen-Huené inspires Haab's confrontation with Mexican culture.[12] From December 1949 he travels through Mexico for two months. He brings back 12,000 photographs from this journey that form the base for his photobook on Mexico (published 1956). He shows a selection of the photos to Arnold Kübler, publisher of the monthly magazine *Du*, who dedicates an edition to Mexico in 1950.[13]

In December Haab spends time in Mexico City and visits the Palacio de Bellas Artes, of which he later writes: "[...] where the country's print graphics is displayed almost completely and most spectacularly. The style of these linocuts and woodcuts, lithographs, etchings, and aquatints entered my blood stream like glucose. On a later day I asked in the office where they were from, and bought every print that I liked—for peanuts, compared to today's prices—and acquired entire portfolios and old books with original graphics. Yet when I looked for documentation for these artistic gems, there was practically nothing to be found."[14]

1954 Haab undertakes a second journey to Mexico, which leads him and Gertrude Duby-Blom to the rainforest of Chiapas. He photographs fervently, and after the two journeys has a considerable selection of his own photos, both color and black-and-white. What captivates him most are the Indian customs and people's everyday lives rather than the archaeological burial sites and ruins. On this second journey to Mexico he buys further works for his collection of Mexican prints, but also does so in Paris and Switzerland. He then puts together the biographies of the artists and their portraits as there is a lot of literature about Mexico as a country, but not much on its graphic arts. Haab writes, "I also have gotten together the information on the prints, to the extent that it was possible to determine. Remaining was the task of writing a commentary on each catalog illustration. This project stretched my abilities to their limits. I was lacking information that not even Mexican gallerists could provide, not to mention the artists themselves, whom it is a work of art in and of itself simply to find, especially since they diligently change their place of residence."[15] Haab's sister Doris recalls that even though Haab spoke Spanish, correspondence with the gallerists turned out to be difficult. These few written documents are no longer available. However, Haab wrote down the seller for every print that he bought, which provides us with a good picture of the Mexican print market of his day.[16]

1956 Publication of the book *Mexiko* with text and photos by Haab.[19] Reviewers justly criticize the poor quality of the colors.

1957 After the first publisher whom Haab approaches about a possible publication of his Mexican prints rejects his request, claiming that Posada's *calaveras* are too macabre, Arthur Niggli publishes the book.[17]

Armin Haab in the guest house, Wangdiphodrang, Bhutan, 1957 (photo: Ninon Vellis)

Haab's photobook *Bhutan. Fürstenstaat am Götterthron* is published in 1961

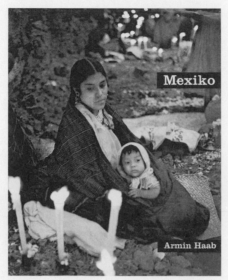

Haab's photobook *Mexiko* is published in 1956

The book *Mexikanische Graphik,* written and designed by Armin Haab, is published in 1957

It is the first German publication to provide a comprehensive overview of the diversity and peculiar pictorial language of Mexican prints. The book also includes an extensive appendix with more than thirty short biographies and portraits of the artists as well as illustrated commentaries on the images. All works presented in the book stem from the Armin Haab Collection, bringing together seminal works of Mexican graphics from the second half of the nineteenth century and first half of the twentieth century. Haab designs the publication himself and supplements the biographies with artists' portraits. The interest in Mexican culture is hardly significant at this time in Europe, and for some time, Mexico sinks into oblivion. Yet, the art historian Dorothea Christ reviews the publication in a radio broadcast: "This presents an exemplary method for how a book can make an unknown region accessible to us."[18]

1960 At the *Weltausstellung der Fotografie* (World Exhibition of Photography) in Lucerne, Karl Pawek exhibits Haab's Mexico photos.

1961 The color photos of Mexico are shown at the EPA und Loeb department stores in Bern. Loeb's head of advertising, Ernst Berger, chooses the motifs for this. The image that adorns the cover of Kusch's book about Mexico[20] is enlarged to four square meters and exhibited in a showcase window.

1962 Haab undertakes his third journey to Mexico, which once again leads him to Chiapas together with Gertrude Duby-Blom.

1967 Publication of the illustrated volume *Mexico,* edited by Hanns Reich.[21] Images by Haab and others are used, although the contributions cannot be attributed to the individual photographers.

1970 Dr. Michael Mathias Prechtl of the Albrecht Dürer Gesellschaft in Nuremberg addresses Haab: "Of all the books of prints, my favorite is your MEXIKANISCHE GRAPHIK."[22] A traveling exhibition is compiled, which begins in Nuremberg. There are mixed reviews in the press and appreciation is not evident in all cases.[23] For one year, the print graphics are on display at various exhibition sites, among others, at the Ibero-American Institutes in Bonn and Cologne. The *Frankfurter Allgemeine Zeitung* praises the exhibition in Cologne as a great event.

Also published in 1970 is *Die Kunst Mexikos* by Raquel Tibol, wherein entire paragraphs from Haab's foreword are quoted in the chapter on prints.[24] Haab's texts on Mexican prints become established as standard texts.

1973–1980 Further travels in 1973 and 1977 bring Haab to Mexico once again. As he writes, his "main concern in Mexico was not at all to collect prints, but rather, to photograph the country. [...] No country in the world has such a variety of beautiful, unique, and fascinating aspects as Mexico. And I wanted to capture such a country in pictures."[25]

Haab buys Mexican prints in the country itself until 1980 and purchases important prints in Europe and the U.S., which are meant to complete his collection and provide a valid overview of the development of figurative graphic prints in Mexico.

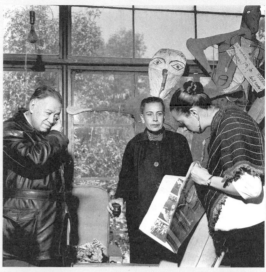

Visit to Diego Rivera's studio on the artist's birthday, 1954

Contacts to Mexican Artists

Haab purchased a majority of the prints directly from the individual artists, for example, from Raúl Anguiano and Mariana Yampolsky, or at the TGP, and thus personally met them on site. Photos from the Fotostiftung Schweiz provide evidence of his contacts to Ignacio Aguirre, Raúl Anguiano, Alberto Beltrán, Ángel Bracho, Elizabeth Catlett, Celia Calderón de la Barca, Arturo García Bustos, Andrea Gómez, Elena Huerta Múzquiz, Pablo O'Higgins, Fanny Rabel, and Diego Rivera, David Alfaro Siqueiros and Mariana Yampolsky (see portraits of the artists in the Appendix). A handwritten dedication to Haab by Roberto Berdecio in his 1972 book on Posada's Mexican prints is testimony that they were on friendly terms.[26]

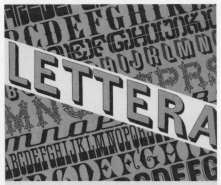

Armin Haab Walter Hættenschweiler
Lettera 2
A standard book of fine lettering
Nouveaux répertoire d'alphabets originaux
Standardbuch guter Gebrauchsschriften
Nueva serie de tipos y caracteres

Between 1954 and 1972, Armin Haab and Walter Haettenschweiler published the four legendary *Lettera* volumes with collections of fonts from around the world

Haab's first photobook on Zug, with his own annotations, is published in 1981

Typeface

Haab's interest in typefaces was stirred early on. He redesigned alphabets together with Alex Stocker and drafted his own fonts. He searched for industry fonts, font designers, and production artists at renowned foundries at home and abroad. From 1954, Armin Haab, Alex Stocker, and Walter Haettenschweiler published the font books *Lettera 1–4,* which served as templates for a number of media.[27] The four *Lettera* volumes quickly became standard works in publishing houses' production departments and can be found in libraries throughout the world.[28]

Publications

1968 Beginning in 1968, Haab calls himself a "Dilemma journalist" for the *Zuger Neujahrs-blätter,* from 1969 in cooperation with Prof. Dr. Johannes Brändle, where he publishes his essay "Totennacht auf Janitzio" (Night of the Dead on Janitzio) in 1968.[29] In addition to smaller publications that he had collaborated on, from the end of the 1960s he produces his own illustrated volumes on various themes.[30]

1970–1975 Without the otherwise necessary preparatory training, Haab works as a book-binder at the art book bindery Centro del bel Libro in Ascona under Josef Stemmle.
 After the fire that destroyed the second building of the Lucerne Railway Station in 1971, the city of Lucerne wants to remove the mural *Nord-Süd* by Maurice Barraud (1889–1954). Haab offers to have the work removed and re-stored at his own cost. A press campaign subsequently flares up, and in the end the SBB makes an offer to buy the mural. It is currently installed on the outside of the Lucerne Railway Station.

1975 Haab receives the Prix Bonet for a guest book that he had conceived and designed for his sister Doris.[31]

1976 Erich Kalt from Zug suggests that Haab designs a photobook, which is published in 1981.

1977 Haab's extensive article "Über die Lust, Bücher zu machen" is published in the *Zuger Neujahrsblatt.*

1981–1987 The book *Zug* is published in early October 1981 and sells 4,300 copies, leading to a second edition in 1982.[32]

In 1982 Erich Kalt suggests a second photobook. Haab already begins work on the publication in 1983, and it is published in 1987 as *Zug und seine Nachbarschaften.* Two-thirds of the copies are already pre-ordered by the time of its publication in autumn.[33]

1988 Walter Binder from the Stiftung für die Photographie (today's Fotostiftung Schweiz, Winterthur), at the time in the Kunsthaus Zürich, proposes an exhibition of Haab's photos at the Kunsthaus Zug.

1989–1990 The Kunsthaus Zug in cooperation with the Stiftung für die Photographie presents the exhibition *Armin Haab. Photographien,* with color and black-and-white photos, from November 5, 1989 to January 7, 1990. Walter Binder gives the laudatory speech.[34]

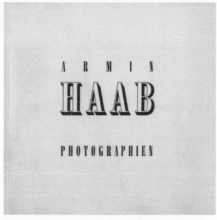

The catalog *Armin Haab. Photographien* is designed by Haab himself and accompanies the exhibition of the same title at Kunsthaus Zug, 1989

1] The information for Armin Haab's biography is mainly from Jutta Motz, Doris de Buys-Roessingh (†), and Beatrice Haab, from the archives of the Kunsthaus Zug, the documentation of the Fotostiftung Schweiz in Winterthur, the *Jahresberichte der Zuger Kunstgesellschaft,* the *Zuger Neujahrsblätter,* and from Haab 1977.

2] Walter Läubli, "Armin Haab. Ein Schweizer Photoamateur" / "Armin Haab. A Swiss photographer," in *Camera: Internationale Monatsschrift für Photographie und Film,* Ger./Eng./Fr. edition, vol. 30, no. 1, January 1951, pp. 2–25, fig. p. 2.

3] Fritz Wotruba, *Sitzender Knabe,* 1937, red grindstone, 145 × 48 × 36 cm, privately owned, Switzerland. See Otto Breicha, *Fritz Wotruba. Werkverzeichnis. Skulpturen, Reliefs, Bühnen- und Architekturmodelle,* ed. Jürg Janett, St. Gallen: Erker-Verlag, 2002, p. 155, cat. 79. Armin Haab states in 1972 that his father bought the sculpture called *Fischerknabe* in 1944 and dates it as from 1938/39. After the death of Ernst Haab in 1960, the sculpture was found in Armin Haab's house in Ascona. See Armin Haab, "Fritz Wotruba in Zug," in *Zuger Nachrichten,* no. 64, 31.5.1972, [pp. 21–22], with two illustrations of the sculpture; see Josef Brunner, "Der Bildhauer Fritz Wotruba," in *Zug. 1938–1945,* p. 51; "Dokumentation. Berichte," in *Zuger Neujahrsblatt 1975,* ed. Gemeinnützige Gesellschaft des Kantons Zug, Zug: Kalt-Zehnder, 1975, pp. 47–72.

4] Armin Haab, "Die Neumühle Baar," in *Zuger Neujahrsblatt 1961,* ed. Gemeinnützige Gesellschaft des Kantons Zug, Zug: Kalt-Zehnder, 1961, pp. 49–57.

5] *Zuger Nachrichten 1972* (see note 3), [p. 22].

6] Haab 1977, p. 39.

7] Documentation of the exhibition Zug 1989/90, archives of the Kunsthaus Zug.

8] Haab's photographic estate is at the Fotostiftung Schweiz, Winterthur, and comprises the negative archive, contact copies, and forty-three theme-based cassettes with prints (ca. 80,000 pieces) from the 1950s to the 1980s.

9] Haab 1977, p. 50.

10] Photos by Haab of Bhutan were subsequently published in Jolanda Tschudi, "Mittelalterliches Bhutan," in *Neue Zürcher Zeitung,* vol. 180, morning edition, no. 2810, weekend 38, page 5, 19.9.1959, pp. 17–18.

11] Ninon Vellis and Armin Haab, *Bhutan. Fürstenstaat am Götterthron,* Gütersloh: S. Mohn/Bertelsmann Verlag, 1961. The printing took place in the best gravure printing facility in Switzerland at the time, Imago Zürich, personally supervised by the photographer.

12] *Mexican Heritage. Photographs by George Hoyningen-Huené,* text by Alfonso Reyes, Mexico City: The Mexico Press, 1946.

13] "Mexiko," in *Du—Schweizerische Monatsschrift,* ed. Arnold Kübler, vol. 10, no. 7, July 1950, with photos by Armin Haab, pp. 4–12, 21–24.

14] Haab 1977, p. 39.

15] Ibid., p. 40.

16] Galería de Arte Mexicano, founded in 1934 by Inés Amor, is a meeting point for potential international buyers of Mexican art; there are no other galleries at this time. Galerie Prisse first opens in 1952. Until then, there is virtually no art market in Mexico, most art works are sold in the U.S. Prints are an exception as they are distributed mainly through the TGP in Mexico City. The opening of commercial galleries fosters the development of young Mexican artists who work outside of the state cultural policies beginning in the mid-1950s. Haab undertakes his journeys to Mexico in this era, which is shaped by a pluralism of styles and internationalism.

17] Cf. Haab 1957. Text and book design are by Armin Haab. The clichés for the illustrations were made by Schwitter AG in Basel. They are currently the property of the Zürcher Kunstgesellschaft. Haab 1977, p. 41.

18] Haab 1977, p. 52. It was not possible to determine when and where Dorothea Christ's (1921–2009) review was broadcasted.

19] Haab 1956.

20] Eugen Kusch, *Mexiko im Bild,* Nuremberg: Carl, 1957, with photos by Armin Haab. The cover page of the book shows an Indian woman from the Tarascan people during the Día de los Muertos.

21] Reich 1967.

22] Haab 1977, p. 42.

23] The *Fränkische Tagespost* titled the exhibition talk: "Viel Gemischtwaren aus Mittelamerika (A lot of mixed goods from Central America)," the *Nürnberger Nachrichten* as "Bilder für die Barrikaden (Images for the barricades)," and the *Nürnberger Zeitung* as "Totenschädel und Flugblätter fürs Volk (Skulls and pamphlets for the people)." See Haab 1977, p. 42.

24] Tibol 1970.

25] Haab 1977, p. 42, 48.

26] Posada 1972, see Library Kunsthaus Zürich.

27] Armin Haab and Walter Haettenschweiler, *Lettera 1: A standard book of fine lettering. Standardbuch guter Gebrauchschriften,* Teufen: Niggli, 1954; *Lettera 2,* 1961; *Lettera 3,* 1968; *Lettera 4,* 1972. Alex Stocker died before publication of the first volume. See Gäbi Lutz, "Arthur Niggli, Teufen (1923–2000). Nekrolog," in *Appenzellische Jahrbücher,* ed. Appenzellische Gemeinnützige Gesellschaft, no. 128, 2000, pp. 202–203.

28] Including at the Library of Congress in Washington, D.C., the library of the Gutenberg Museum in Mainz, at the University of Tokyo Library, in the National Library of Russia in Moscow, in the library of the Kunsthaus Zürich and at the Media and Information Center of the Zurich University of the Arts.

29] Armin Haab, "Totennacht auf Janitzio," in *Zuger Neujahrsblatt 1968,* ed. Gemeinnützige Gesellschaft des Kantons Zug, Zug: Kalt-Zehnder, 1968, pp. 57–60; Haab 1977, p. 58.

30] The index of the Fotostiftung Schweiz, Winterthur provides a complete list of literature on Armin Haab.

31] Haab 1977, p. 76; Hans Rudolf Bosch-Gwalter, "Prix Paul Bonet 1992: Paul Bonet. 15. Februar 1889 bis 3. März 1971," in *Librarium. Zeitschrift der Schweizerischen Bibliophilen-Gesellschaft,* vol. 34, no. 2–3, 1991, p. 187.

32] *Zug.* Photographiert und kommentiert von Armin Haab, Text: Paul Stadlin, Zug: Buchhandlung zur Schmidgasse, 1981.

33] Armin Haab, *Zug und seine Nachbarschaften/Zug and its Surroundings,* Zug: Kalt-Zehnder, 1987.

34] Zug 1990.

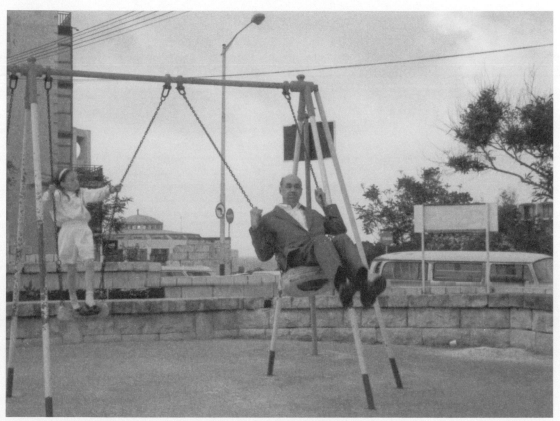

Armin Haab and his daughter Stephanie on a swing, Malta, 1989 (photo: Jutta Motz)

↓ Spectator at a horse race, Fiesta María Candelaria, Tlacotalpan, Veracruz, 1949
→ Village square, Taxco, Guerrero

← Sugarcane cutter, between Atlixco and Acatlán, Puebla
↓ Peasants harvesting sugarcane, between Atlixco and Acatlán, Puebla

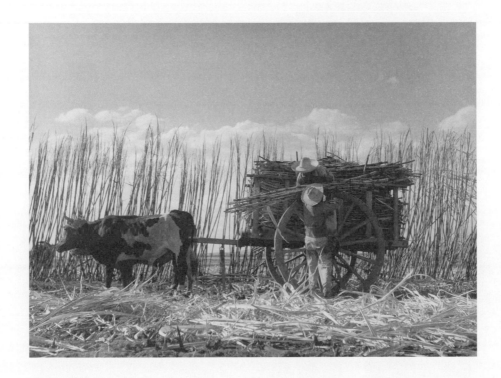

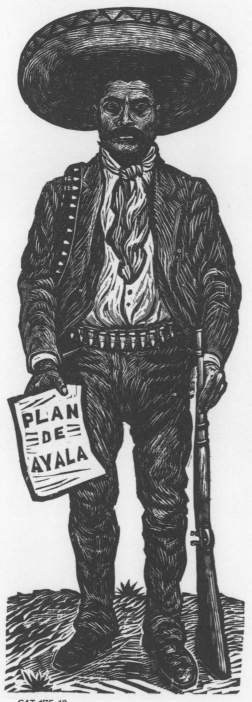

CAT. 175-13

Tijuana · Mexicali

BAJA CALIFORNIA SONO

BAJA CALIFORNIA SUR

Laz

NORTH PACIFIC OCEAN

0 200 400 km

The History of Mexico

and of Mexican Graphic Art

Blue: History of Mexico
Red: History of Mexican Graphic Art

14,000 BC–2000 BC First human traces and first settlements in the Mesoamerican region. The area of Mesoamerica comprises extensive stretches of the current countries of Mexico, Belize, Guatemala, El Salvador, Honduras, and Costa Rica.

1200 BC–200 BC Preclassic Era
Olmec is Mesoamerica's first major civilization.

300–900 AD Classic Era Advanced Maya and Zapoteca civilizations.

900–1200 Postclassic Era More recent Maya and Toltec civilizations.

1321–1521 Late Postclassic Era Rise and fall of the Aztec empire.

1350–1400 Founding of the city of Tenochtitlán by the Aztecs, today Mexico City.

1519–1521 The Spanish conquistador Hernán Cortés (1485–1547) seizes the Aztec empire; the main city of Tenochtitlán is overthrown. Mexico moves to the forefront of European economic interests. Cortés becomes governor of the new colony, Nueva España.

1525 Mexico is annexed by the Spanish crown. It is now a part of the viceroyalty New Spain (until 1535).

1535 The first printing press on the American continent is founded in Mexico. The first printed book has the title *La escuela espiritual.* Woodcuts for the cover are from Europe.

1556 A woodcut cover for a religious book is created by a Mexican Indio for the first time.

1781 After the introduction of copperplate engraving by the Belgians, Jerónimo Antonio Gil (1731–1798) founds the first school for graphic design in Casa de Moneda. King Carlos III from Spain founds the Real Academia de las Tres Nobles Artes de San Carlos de México (today, Academia de San Carlos).

1810 Miguel Hidalgo y Costilla (1753–1811), a priest and leader of the popular revolutionary movement, calls for armed battle against the Spanish on September 16 (known as Grito de Dolores or Cry of Dolores). The Mexican independence movement continues until 1821.

1821 Declaration of the Mexican monarchy after eleven years of war.

1822 Agustín de Iturbide (1783–1824) has himself instated as the first Emperor of Mexico, as Augustín I. The emperor is overthrown one year later. Intervention and appropriation of land by European and North American states continues until 1854.

1824 On October 4, Mexico becomes a republic with a constitution, which establishes the federal republic model. Unstable governments and multiple military revolts persist until 1851.

1826 The Italians Claudio Linati (1790–1832) and Gaspar Franchini found a workshop for lithography in Mexico City.

1831 Formation of a department for lithography at the Academy with Linati's lithography press.

1846–1848 Mexico loses roughly half of its territory in the Mexican-American War, including what are currently the U.S. states of Arizona, California, Nevada, Utah, parts of Colorado, New Mexico, and Wyoming.

1847 The satirical magazine *Don Bullebulle* with woodcuts by Gabriel Vicente Gahona, known as "Picheta," is published in Mérida, Yucatán.

1853 Jorge Agustín Periam from Great Britain becomes professor of graphic arts at the Academia de San Carlos.

1857 A liberal constitution is enacted.

1858–1872 Inauguration of Benito Juárez, the first Indio president of Mexico (1806–1872). He symbolizes patriotic resistance against foreign usurpers until the present day.

1861–1867 French intervention: France occupies Mexico due to outstanding debt payments. Emperor Napoleon III (1808–1873) wants to establish a Mexican monarchy, dependent on France, and appoints Prince Ferdinand Maximilian of Austria (1832–1867) as emperor of Mexico. On May 5, 1867 the Mexican Republicans under Juárez defeat the French army. Following this, prisoners are taken and Maximilian is executed.

1874 End of the liberal government.

1876–1910 Duration of the Porfiriato (with interruptions), that is, the dictatorship of General Porfirio Díaz (1830–1915). The country's domestic economy booms and simultaneously merges with the global economy. Numerous liberal and oppositional magazines emerge, with illustrations by José María Villasana (1848–1904), Manuel Manilla, and José Guadalupe Posada, among others. The publishing house Vanegas Arroyo publishes thousands of popular flysheet newspapers in this epoch.

1900 Total population of Mexico reaches 13 million; illiteracy is at 84 percent. Real estate is concentrated in the hands of just a few families as a consequence of the divestment of Indian peasants and rural small property owners. The emerging industrialization is propped up by the mining industry, which is also essential for the railway's laying of tracks, with a view to ore and oil exports.

1909 Founding of Ateneo de la Juventud, an intellectual association, which positions itself against the ideology of the dictatorship.

1910 Celebration of the 100th anniversary of the start of the Mexican Revolution against Spanish rule. Díaz is once again voted in as president of Mexico. Mexican landowner Francisco I. Madero (1873–1913) initiates a campaign opposing Díaz's re-election and plans an attack from the U.S. against the Mexican government for November 20 ("Plan de San Luis Potosí"). Until today, the date signifies the start of the Mexican Revolution.

1911 Díaz goes into exile to Paris. Madero comes to power thanks to the support of Emiliano Zapata (1879–1919), Francisco "Pancho" Villa (1878–1923), and Pascual Orozco (1882–1915). Madero's government resembles Díaz's. Zapata and Villa continue to fight for justice ("Plan de Ayala") and dedicate themselves to agricultural reform (return of the land to the indigenous population). Artists and fine-arts students strike against the aesthetic dictatorship of European-centered cultural politics at the Academia de San Carlos in Mexico City.

1913 In February, the violence escalates for ten days ("Decena Trágica"). Madero is murdered. General Victoriano de la Huerta (1850–1916) has himself inaugurated as president and sets up a military dictatorship. Venustiano Carranza (1859–1920) advocates a new constitution and declares war on Huerta. Founding of the first open-air painting school (Escuela de Pintura al Aire Libre) in Santa Anita.

1914 Fall of Huerta. Carranza forms a provisional government. Villa and Zapata ally against his government.

1915 Carranza's military commander Álvaro Obregón (1880–1928) defeats Villa's army.

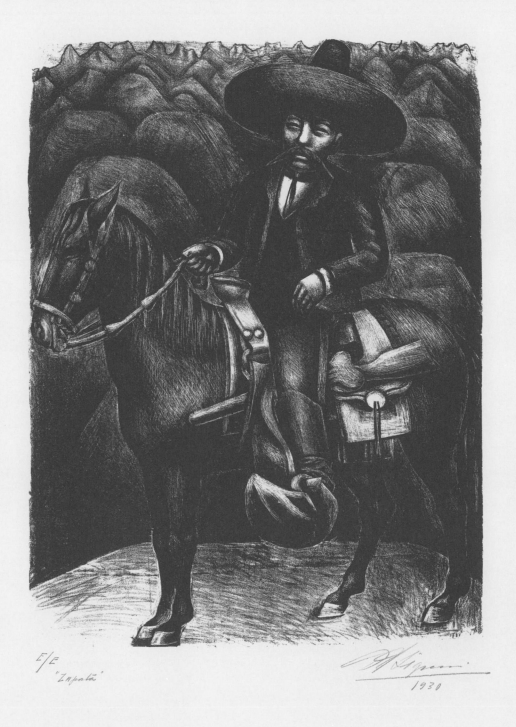

E/E
"Zapata"

1930

↑ CAT. 139
David Alfaro Siqueiros, *Zapata*, 1930

1917 The Mexican constitution was signed in Querétaro. This remains valid until today and contains, among others, the following key points: no re-election of the president; natural resources are national property; education is mandatory, free, and secular; the church is not authorized to provide education, have access to land ownership, or engage in politics; an eight-hour workday with Sunday as a holiday; sufficient minimum wage; free expression of opinion and union organization. Additionally, the Escuela Nacional de Bellas Artes and the National Graphic Arts Workshops (Talleres Gráficos de la Nación) are founded.

1918–1939 The Republic consolidates in the post-revolutionary period.

1919 Zapata's murder contracted by Carranzas, founding of Mexican Laborist Party (Partido Laborista Mexicano, PLM) and the Mexican Communist Party (Partido Comunista de México, PCM).

1920 End of the Revolution, which cost the lives of nearly two million people. Obregón becomes president. Implementation of educational reforms and literacy campaigns follow in the rural areas of the country under Minister of Education José Vasconcelos (1882–1959), the so-called Cultural Missions. Start of the mural movement *muralismo*.

1921 French artist Jean Charlot immigrates to Mexico and teaches woodcut and lithography techniques at the Open Air School.

1923 Murder of Francisco "Pancho" Villa. Signing of the Bucareli agreement (Tratado de Bucareli) between Mexico and the U.S.

1923–1926 Launching of the Syndicate of Technical Workers, Painters, and Sculptors (Sindicato de los Obreros Técnicos Pintores y Escultores, SOTPE); publication of the organ *El Machete*.

1925–1928 Under the presidency of Plutarco Elías Calles (1877–1945), national capitalism and the battle of the cultures develop.

1926–1929 Rebellion of Catholic militia against the Mexican government (so-called Guerra Cristera).

1928 Founding of the artist group ¡30–30!

1929 Founding of the National Revolutionary Party (Partido Nacional Revolucionario, PNR), which is renamed the Party of the Mexican Revolution (Partido de la Revolución Mexicana, PRM) in 1938 and Institutional Revolutionary Party (Partido Revolucionario Institucional, PRI) in 1946. Diego Rivera becomes director of the Academia de San Carlos.

1930–1932 Total population of Mexico reaches 17 million; Pascual Ortiz Rubio (1877–1963) takes over presidency of the Republic. Rufino Tamayo becomes head of the Ministry of Education's Department of Fine Arts.

1932 As head of the Department of Fine Arts in the Ministry of Education, Leopoldo Méndez sets up a workshop for graphic arts and lithography.

1934 Founding of the League of Revolutionary Writers and Artists (Liga de Escritores y Artistas Revolucionarios, LEAR); opening of the Palacio de Bellas Artes in Mexico City.

1934–1940 Presidency of Lázaro Cárdenas del Río (1895–1970). He supports the unions and stabilizes democracy. Cárdenas grants asylum to republican refugees from Spain. Inflation rises to nearly 50 percent and continues until 1940.

1935 Carolina Amor founds the first gallery in Mexico: Galería de Arte Mexicano, which will later be run by Inés Amor.

1936 American Artists' Congress in New York; print exhibition by LEAR in Valencia (Spain) on the occasion of the anti-fascist writers' congress. Major strike by the oil workers.

1937 LEAR congress in Mexico. Dissolving of the league; founding of the Workshop for Popular Graphic Art (Taller de Gráfica Popular, TGP). Nationalization of the railway. On mediation by Diego Rivera, Mexican government grants asylum to Leon Trotsky (1879–1940).

1938 Nationalization of the oil industry. Refugees from the Spanish Civil War arrive in Mexico.

1940 Total population of Mexico reaches 20 million. World War II triggers an economic boom due to demand for raw materials for the U.S. wartime economy. A Stalinist agent murders Trotsky.

1941 The government seizes the Axis powers' ships that are docked in Mexican harbors.

1942 Founding of La Estampa Mexicana publishing house by the Swiss architect Hannes Meyer (1889–1954), who was active at Bauhaus in Dessau and later as an urban planner in the Soviet Union. German journalist Georg Stibi (1901–1982) takes over as director. German submarines sink two Mexican oil tankers in the Caribbean. Mexico enters World War II on the side of the Allies; extreme food shortages and price hikes follow.

1944–1947 Major literacy campaigns take place.

1947 Publication of the successful TGP portfolio *Estampas de la Revolución Mexicana*. Founding of the Mexican Society of Engravers (Sociedad Mexicana de Grabadores).

1947–1950 Graphic Workshops in the U.S., founded by Julio/Jules Heller in Los Angeles.

1948 Founding of the Popular Party (Partido Popular, PP), the later Popular Socialist Party (Partido Popular Socialista, PPS). Founding of the National Indigenist Institute (Instituto Nacional Indigenista). Founding of the Society for the Mobilization of the Visual Arts (Sociedad para el Impulso de las Artes Plásticas).

1950 Total population of Mexico reaches 26 million. INBA organizes post-war exhibitions of Mexican art in 1950 and 1952 at the Venice Biennale and in Paris (Orozco, Rivera, Siqueiros, and Tamayo participate).

1951 The Real y Pontificia Universidad de México, today: Universidad Nacional Autónoma de México (UNAM) celebrates its 400th anniversary (1551–1951). The northern part of the territory of Baja California becomes a member state in the federation of Mexican states.

1952 Founding of the National Front for the Visual Arts (Frente Nacional de Artes Plásticas, FNAP).

1953 Introduction of women's suffrage (instituted with limitations in 1947). The Peace Prize (Premio Internacional de la Paz) is awarded to Leopoldo Méndez and his staff at TGP at the World Peace Congress in Vienna.

1954 At the 10th Inter-American Conference in Caracas, Mexico challenges the U.S.'s proposal to create a supranational anticommunist authority on the American continent.

1956 Restoration of financial stability and economic growth ("Mexican miracle"), which continues into the 1970s; 150th birthday of Benito Juárez. The VII Mexican Book Fair is devoted to the festivities celebrating this birthday. The TGP has its own sales stand that includes a printing press.

1957 Celebration of the 100-year anniversary of the constitution; major earthquake in Mexico. The third National Graphic Salon organized by INBA is devoted to the festivities; twentieth anniversary of TGP.

1958 Founding of the publishing house Fondo Editorial de la Plástica Mexicana.

1960 Total population of Mexico reaches 35 million. Nationalization of the electrical industry.

1968 Conflicts between students and the government escalate and lead to the massacre of Tlatelolco on October 2, just a few days before the opening of the Olympic Games in Mexico City.

1970s Era of the Dirty War ("Guerra sucia"). Secret service and army proceed against radical opponents to the regime.

1980 Total population of Mexico reaches 70 million.

1982 Mexico announces the upcoming debt moratorium (Latin American debt crisis).

1985 Severe earthquake in Mexico City.

1988 Founding of the Instituto de Artes Gráficas de Oaxaca.

1994 The North American Free Trade Agreement (NAFTA), comes into force. An armed revolt of the peasant movement of neo-Zapatistas (Ejército Zapatista de Liberación Nacional, EZLN) takes place in the state of Chiapas, followed by an economic crisis.

2000 Total population of Mexico reaches 100 million. The results of the presidential and parliamentary elections mark a break in the traditional system of the Partido Revolucionario Institutional (PRI) that has developed since the revolution.

2006 The candidate of the National Action Party (Partido Acción Nacional, PAN), Felipe Calderón (*1962), wins the presidential election with a slight majority. The Left protests the election results. A social conflict in the state of Oaxaca escalates to a violent dispute between the people and the local PRI government. Calderón proclaims the war on drugs to be one of his most important goals. This leads to armed conflict between police and military units, and also against Mexican drug cartels and among the drug cartels themselves.

2010 The Mexican government publishes the portfolio *Estampas, Independencia y Revolución* with fifty-one prints and a sculpture for the 200th anniversary of Mexico's independence and the 100th anniversary of the Mexican Revolution (edition of 100).

2012 Total population of Mexico reaches 120 million. The PRI representative Enrique Peña Nieto (*1966) is elected as Mexico's new president.

1] Information is from Jorge Alberto Lozoya, Helga Prignitz, Juan Puig, Monica Mora, Olav Münzberg, and Michael Nungesser, among others. See Cited and Selected Literature, pp. 314–319.

Diarchy

1864–1867 Emperor Maximilian I
(Ferdinand Maximilian Joseph Maria,
1832–1867) and simultaneously,
Mexican president Benito Juárez forms
a liberal counter-government

Presidents
from 1858 to 1911

1858–1872 Benito Juárez
1872–1876 Sebastián Lerdo de Tejada
1876 José María Iglesias
1876 Porfirio Díaz
1876–1877 Juan Nepomuceno Méndez
1877–1880 Porfirio Díaz
1880–1884 Manuel González Flores
1884–1911 Porfirio Díaz

Mexican Revolution
from 1911 to 1915

1911 Francisco León de la Barra
1911–1913 Francisco I. Madero
1913 Pedro Lascuráin
1913–1914 Victoriano Huerta
1914 Francisco S. Carvajal
1914–1915 Eulalio Gutiérrez
1915 Roque González Garza
1915 Francisco Lagos Cházaro

Presidents under
the Constitution of 1917

1914–1920 Venustiano Carranza
1920 Adolfo de la Huerta
1920–1924 Álvaro Obregón
1924–1928 Plutarco Elías Calles

Maximato
from 1928 to 1934

1928–1930 Emilio Portes Gil
1930–1932 Pascual Ortiz Rubio
1932–1934 Abelardo L. Rodríguez

Modern Mexico
since 1934

1934–1940 Lázaro Cárdenas del Río
1940–1946 Manuel Ávila Camacho
1946–1952 Miguel Alemán Valdés
1952–1958 Adolfo Ruíz Cortines
1958–1964 Adolfo López Mateos
1964–1970 Gustavo Díaz Ordaz
1970–1976 Luis Echeverría Álvarez
1976–1982 José López Portillo
1982–1988 Miguel de la Madrid
1988–1994 Carlos Salinas de Gortari
1994–2000 Ernesto Zedillo
2000–2006 Vicente Fox
2006–2012 Felipe Calderón Hinojosa
since 2012 Enrique Peña Nieto

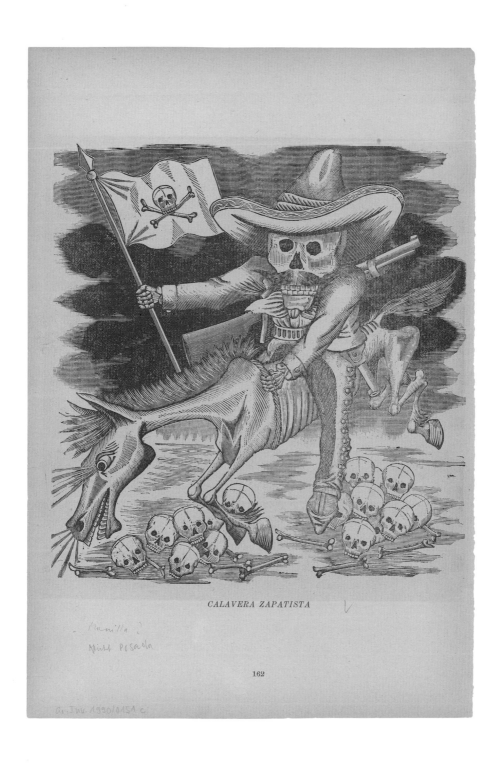

CALAVERA ZAPATISTA

162

↑ CAT. 123-8
José Guadalupe Posada (attributed), *Calavera Zapatista*

The Beginnings of
Graphic Art

on the American Continent

No Mexican artist can ignore the rich pre-Hispanic heritage, that still lives in his best creations.[1]

Mexico's tradition in the field of printing technology is the oldest and among the most prolific on the entire American continent. This tradition extends back for centuries: The Spanish instituted the art of printing in Mexico in the first half of the sixteenth century, a hundred years before it would reach North America. Already in 1533, just fourteen years after Spanish conquistador Hernán Cortés (1485–1547) first laid foot on Mexican soil, the Franciscan Juan de Zumárraga (1468–1548) asked the Council of the Indies in Seville for permission to open a printing press in Mexico. There was an urgent need for Christian teaching material for the new monasteries and the schools associated with them, and for dictionaries to improve understanding. The desired printing machine arrived in Mexico under Viceroy Antonio de Mendoza (ca. 1490–1552). The German Johann Cromberger (†1540) founded the first printing house in Mexico. Together with Zumárraga and Mendoza, he had a ten-year license that provided exclusive rights to printing and distribution. Cromberger appointed the Italian Juan Pablos (ca. 1500–1560/61) to run the press. Pablos is the first printer on the American continent to be cited by name, and for a long time would remain the only printer authorized by the Spanish administration.[2]

In the sixteenth century, printing was used to cultivate and educate the Mexican people. It was strictly regulated and limited to mainly Christian treatises based on European models. Independent graphics were virtually non-existent, as they were prohibited during Spanish colonial rule over Mexico.[3] The first well-known graphic artist from Mexico cited by name is the Frenchman Juan Ortiz, who worked under the printer Pedro Ocharte in 1570.[4] No other graphic artist from the sixteenth or seventeenth century has been recorded by name; the only sources of information about the various printers' shops are provided by the publications.[5]

The nineteenth century gave rise to a democratic and politically educational form of print graphics in Mexico. Mexican artists used it to print and disseminate the most socially progressive ideas of their times. The people, the opposition, and also the Revolution used political prints as a means of communication, and the works were not designated as collectors' objects.[6]

The Spaniard Jerónimo Antonio Gil (1732–1798) founded the first Mexican school of graphic art in 1781. A mere two years later, the Real Academia de las Tres Nobles Artes de San Carlos de México, the first art academy on the American continent, was opened by decree from King Carlos III of Spain.[7] Although the Academia de San Carlos had the most abundant collection of prints on the continent, it played no significant role in the development of political and popular prints of the nineteenth and twentieth centuries.[8] Additionally, the demand for Christian images originally stirred by the missionaries increased so greatly that it was no longer possible for all of them to be

produced by European-trained artists. This area of production was gradually replaced by folk art, which paid no regard to the European styles.

Mexican Graphic Art after Mexico's Independence

Mexican self-confidence in the face of Spanish colonial rule first grew with the independence movements of the Mexican middle class from 1810 onwards. This likewise marked a change in the status of graphic arts and the creation of the first acknowledged prints in the area of Mexican folk art. These were no longer perceived as mere mass goods; instead, their creative achievement was recognized and appreciated as a powerful impulse. Work with popular folk iconography, with an unbiased handling of colors, and simplification of forms provided stimuli for a new composition of the image.[9] Although the graphic artists in the first half of the nineteenth century were predominantly Europeans, Mexicans were increasingly featured on the prints.[10]

The nineteenth century also brought innovations from Europe, such as political-satirical magazines;[11] a new branch of the press that consistently deployed illustrated satirical pieces, journalistically. Achievements in printing technology also arrived in Mexico, such as the lithography process, a requirement for large runs of popular satirical magazines and pamphlets.[12] Following the country's independence, Mexico's own art history grew successively. Of the Mexican graphic artists from the first half of the nineteenth century marked as significant, Gabriel Vicente Gahona, known as "Picheta," is the only one who was active in the Yucatán province. Working in the capital were Ignacio Cumplido (1811–1887), Constantino Escalante (1836–1868),[13] and José María Villasana (1848–1904). Lithographic institutes, which additionally integrated printing presses, publishing houses, and libraries, flourished in Mexico City from 1835. The production of lithography albums and an immense amount of humorous and combative illustrations made depictions of Mexican life, places of interest, and historical events available for the first time to a larger circle of the middle class interested in art.[14]

Graphic arts took on an important socio-political function, especially for the development and consolidation of the middle-class state and its national culture. As a media of agitation and propaganda, it served for instructing the poorly educated popular masses. At issue here is not mere illustration or artistic achievement: the artists had the mandate to make an impact on society. Their pictorial language was thereby accorded an eminently important meaning.[15] So that the public could understand their message, the artists deliberately chose the stylistic devices of representative art.

1] "Ningún artista mexicano puede ignorar la rica herencia prehispánica, cuya vida perdura en sus mejores creaciones." in Meyer 1949, p. III.

2] Westheim 1954, p. 234.

3] See Schilling 1934, pp. 166–170, 173–180; Romero de Terreros y Vincent 1948; Douglas C. McMurtrie, *The Golden Book: The Story of Fine Books and Bookmaking—Past & Present*, 3rd edition, Chicago: Pascal Covici, 1934, pp. 225–234.

4] Clive Griffin, "La primera imprenta en México y sus oficiales," in Idalia García and Pedro Rueda, *Leer en tiempos de la colonia: Imprenta, bibliotecas y lectores en la Nueva España*, Mexico: UNAM, 2010, pp. 3–19; Williams/Lewis 1993, pp. 289–291.

5] Printing presses were run by Germans: Johann Cromberger and Enrico Martínez (Heinrich Martin); Italians: Juan Pablos and Antonio Ricardo; Frenchmen: Pedro Ocharte and his son Melchior Ocharte; and Spaniards: Pedro Balli. See Fernández 2006.

6] Helga Prignitz, "Zur Volkstümlichkeit der politischen Grafik in Mexiko," in Berlin 1974, p. 97.

7] Eduardo Báez Macías, *Jerónimo Antonio Gil y su traducción de Gérard Audran*, Mexico: UNAM, 2001, pp. 13, 18, 136.

8] The Museo Nacional de la Estampa currently has the largest collection of print graphics in Mexico. See Prignitz 1990, p. 6.

9] See Atl 1921, vol. I, pp. 11–12, 15–17.

10] Prignitz 1981, p. 15. The first active graphic artists in Mexico were Jorge Augustín Periam, who depicted idyllic lanes and picturesque landscapes in his engravings, J. Campillo, who is renowned for his genre-like belittling of the handicrafts, as well as José María Villasana and Constantino Escalante, whose lithographs adapted the European style of Honoré Daumier. See Haab 1957, p. 4.

11] Satirical magazines were, for instance, from France, *La Caricature* and *Le Charivari* or from Germany, *Simplicissimus*. See Fernández 1969, p. 140.

12] Metal etchings and woodcuts allow only limited runs because their production is very time-consuming. The lithographic process, which first enabled high print runs and rapid work, only reached Mexico after a certain delay in 1825. See O'Gorman/Fernández 1955.

13] Escalante was a journalist and is considered Mexico's first political caricaturist.

14] Prignitz 1990, pp. 12–14.

15] Michael Mathias Prechtl, "Die besondere mexikanische Situation," in Nuremberg 1971, [pp. 3–4]; Charlot 1963, p. 248.

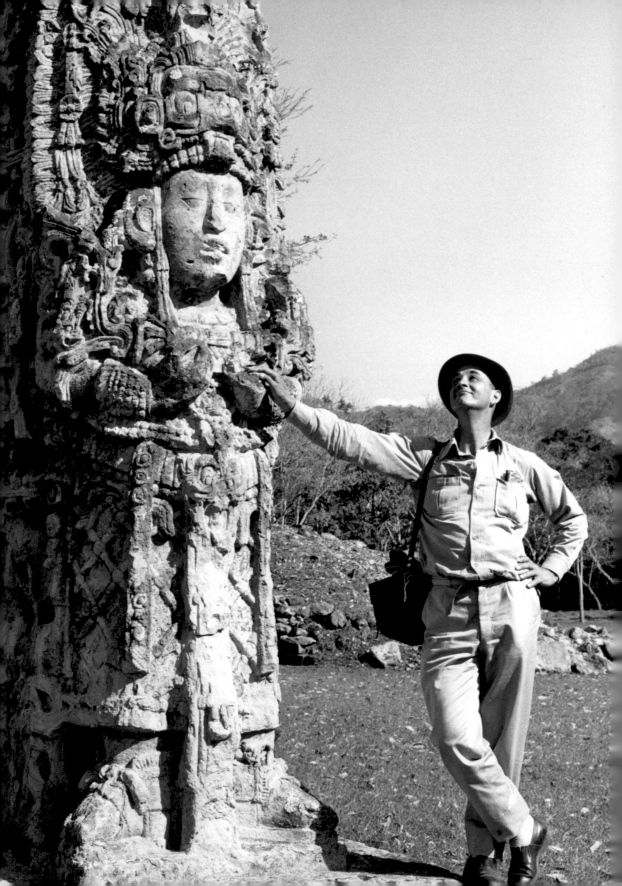

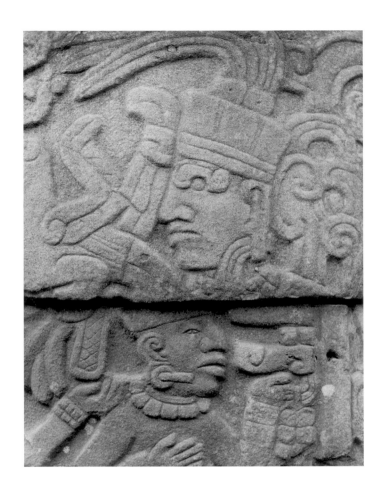

← Armin Haab next to a Maya stele, Copán, Honduras, 1962
(photo: Doris de Buys-Roessingh)

↑ *El Tajín* (The Lightning Bolt), Totonac culture, Papantla

Maya civilization

The Maya are a group of indigenous people in Central America especially well known for the empire they founded in pre-Columbus Mesoamerica and their highly developed civilization. The Maya civilization was concentrated on the Yucatán peninsula in the Gulf of Mexico. The region where the Maya lived is currently dispersed among five countries: Mexico, Guatemala, Belize, Honduras, and El Salvador. The first of the finds attributed to the Maya is dated as 2000 BC. The collapse of many centers of classic Maya civilization occurred in 10 AD. The impressive Maya architecture includes temple complexes, palaces, pyramids, huge stone figures, and also irrigation and drainage systems. Additionally, Maya cities are connected by an extensive road network. An important achievement of the Maya is their highly developed written language composed of more than 800 signs or glyphs. Furthermore, they created astronomical maps, such as the Maya calendar, which rest on advanced mathematical knowledge.

Maya rubbing

Palenque in Chiapas is an exalted city of ruins from the Maya civilization. Dozens of buildings, pyramids, and temple complexes boasting artistically developed decorative motifs are found on a clearing in the rain forest. The Palenque civilization existed around 300 BC, but it first reached its heyday as a religious and political center of the entire region between 600 and 800 AD.

Armin Haab's Collection contains a stone rubbing from the *Tablero del Palacio* (Tablet of the Palace) CAT. 1, P. 61 and four additional stone rubbings from the *Tablero de los Esclavos* (Tablet of the Slaves), all from Palenque CAT. 2–5, PP. 60, 210. All of the works have been authorized by the Instituto Nacional de Antropología y Historia in Mexico City.

The *Tablero del Palacio*[1] from Palenque is found in the northern corridor of the building A–D and is mounted at the center of the north-facing outer wall CAT. 1.[2] The tablet was made during the regency of ruler K'inich K'an Joy Chitam I (644–721 AD) and tells of the life of his predecessor. It was created between 702 and 720 AD and dedicated on August 14, 720.[3]

On the stone rubbings, two hieroglyphs can be found, to the left on the *Tablero del Palacio.* The upper hieroglyph entitled *O Kins,* depicts on the left side the figure of the god number zero with a floral pattern on its arm. The figure on the right shows Kin (The Day), a howler monkey, with the distinctive facial mark of the sun god and three dots under the eye.[4]

The lower hieroglyph entitled *11 Ahau* captures in the left figure god number 11, recognizable by his symbols on the arms and legs, which resemble question marks. The right figure in the cartridge shows *Ahau* (The Day), also identified as young sun god, depicted here as a spider monkey.[5]

The *Tablero de los Esclavos*[6] from Palenque is in Building 1 of Group IV, slightly north of the palace. It shows the coronation scene of king K'inich Ahkal Mo' Naab III (678–736 AD) with a face-front depiction of the crowned king who assumes the classical arm-on-chest position.[7] The stone rubbings show, on the one hand, the figure in the middle CAT. 4, of which only the upper body is depicted; and the two figures to the left CAT. 5 and right CAT. 2+3 of her.

New information shows that the scene on the *Tablero de los Esclavos* deals with the inauguration of the ruler K'inich Ahkal Mo' Naab III CAT. 4.[8] The figure to the left is the father who is wearing a helmet-like feather headdress CAT. 5. The figure of the mother on the right side holds a Tok' Pakal, a flint shield, in her hands CAT. 2+3. Both are characteristics of a king. The figures sit on an anthropomorphic or zoomorphic throne, which presents an anthropomorphized howler monkey and on the right side an anthropomorphized stag.[9]

1] *Tablero del Palacio*, limestone; see Schele 1979, p. 52, ill. 10, SD121; Stuart 2012, pp. 1–34, ill. 2.

2] Greene Robertson 1991, p. 54.

3] The date corresponds with the Maya calendar date: 9.14.8.14.15 9 Men 3 Yax; Prager 2013, pp. 455–456, ill. 275. On the *Tablero del Palacio*, the field framed by the text field is a frontal depiction of the ruler between his two parents, who hand him, on the one side, the Teotihuacan warrior helmet, and on the other side, the war emblem "flint and shield" as signs of royal honor. The inscription refers to important stations in the life cycle—events such as his birth, initial blood sacrifice, his participation in rituals ending the period, the death of his father, and takeover of the office by his older brother K'inich Kan Balam II (635–702 AD), his death and burial, his own inauguration, and finally, the ritual consecration of the enthronement site in the temple of a god, the most recent date of the inscription (720 AD).

4] Greene Robertson 1991, p. 56, ill. 258–259: sixth hieroglyphic.

5] Ibid.: seventh hieroglyphic.

6] *Tablero de los Esclavos,* limestone, 270 × 253 cm.

7] Prager 2013, p. 383.

8] Merle Greene Robertson, *The Sculpture of Palenque,* Princeton N.J.: Princeton University Press, vol. 3: *The late Buildings of the Palace,* 1985, pp. 66–68, ill. 228–230; Prager 2013, p. 383, ill. 221; Wald 1997, pp. 2–4; Linda Schele, "The Demotion of the Palenque Ruler Chac-Zutz: Lineage Compounds and Subsidiary Lords at Palenque," in Virginia M. Fields (ed.), *Sixth Palenque Round Table,* Norman: University of Oklahoma Press 1986, vol. VIII, 1990, pp. 6–11, ill. 1, SD131; Skidmore 2008, p. 82; Stuart 2012, pp. 1–34, ill. 6 b.

9] Wald 1997, p. 9.

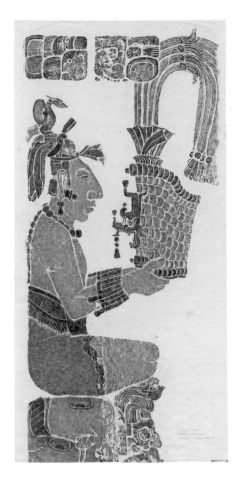 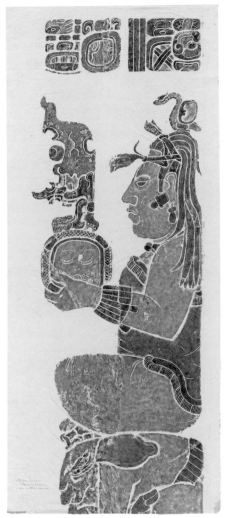

↑ CAT. 5
Tablero de los Esclavos: Tiwol Chan Mat

↗ CAT. 2
Tablero de los Esclavos: Ix Kinuw Mat

→ CAT. 1
Glifos del *Tablero del Palacio: 0 Kins / 11 Ahau*

Anonymous, Maya civilization, Late Classic, ca. 720 AD

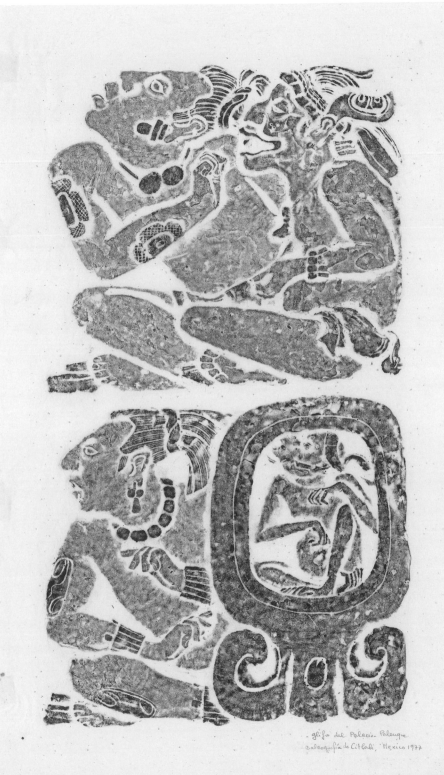

glifo del Palacio Palenque
calcografía de Citlali, México 1977

El pueblo responde. Viva Juárez
The People Respond. Long Live Juárez

The print dramatically reflects the people's rejection of imperial encroach-
ment and is remarkable from both an artistic and semiotic perspective. Benito
Juárez (1806–1872) denied the coach of Emperor Maximilian I (1832–1867) and
Empress Charlotte (1840–1927) entry into Chapultepec Palace in Mexico City. While
Juárez is not explicitly present in the image, the print shows the Mexican people—
represented by two male figures front right—stopping the imperial couple's pomp-
ous coach and turning it back by closing the wooden entry gate. Juárez's function
as the leader of the resistance against the French intervention from 1864 to 1867 is
alluded to by the banner on the gate bearing the inscription "Viva Juárez," which is
also written on the broadsides fluttering toward the coach.

The festivities for Juárez's 150th birthday shaped the VII Mexican Book Fair in
1956, and the Taller de Gráfica Popular (TGP) participated in these activities. More
than fifty prints were created on this theme CAT. 21, P. 64 and eight further prints from
this series were enlarged to approx. 4 × 8 meter-large wall decorations at the book
fair, shaping the "Juárez hall," the center of the exhibition. These prints were also
available in smaller versions as postcards.[1]

French Intervention in Mexico from 1864 to 1867:
Historical Background

French emperor Napoleon III (1808–1873) wanted to found an empire in
Mexico, militarily and economically based on France. He had already intervened
with troops beginning in 1861 as under President Juárez, Mexico had expelled the
Spanish envoy as well as the papal legate from the country. For two years, Juárez
also refused to make the large debt payments demanded by the Europeans. Based
on false promises from the part of Napoleon III, Maximilian I assumed the Mexican
crown on April 10, 1864 and moved with his wife Charlotte into the neo-Gothic
Chapultepec Palace on a hill in the outskirts of Mexico City.[2]

Towards the end of the American Civil War in 1866, the French withdrew their
troops from Mexico under pressure from the U.S. Afterward, Emperor Maximilian I
was unable to successfully assert himself for very long against the popular Juárez,
as his calls for help in Europe also remained unanswered. The emperor was there-
upon intent on leaving the country, but changed his mind after receiving a letter
from his mother in which she urged him to stay. In the end, Maximilian I barricaded
himself with his last troops in the city of Santiago de Querétaro, which fell after a
siege on May 14, 1867—due to treason rather than the besiegers.

Colonel Miguel López had opened the gates to the city for the troops of the opposing General Mariano Escobedo (1826–1902) in the night from May 14th to 15th. He had, however, first offered the emperor a chance to escape, which Maximilian I had nonetheless refused.[3]

The emperor was removed from power, sentenced to death by a military court, and after a confirmation of the death penalty by President Juárez, who had regained power, executed according to martial law together with the generals Miguel Miramón and Tomás Mejía on the hill Cerro de la Campaña outside the city of Querétaro on June 19, 1867.[4]

1] Nine thousand pieces were sold at the book fair in 1956, alone. See Prignitz 1981, p. 171.

2] Cf. *Maximilian von Habsburg: Ein Kaiser für Mexiko,* Documentary, Director: Franz Leopold Schmelzer, 2015.

3] Jasper Ridley, *Maximilian and Juárez,* New York: Ticknor & Fields, 1992; Kristine Ibsen, *Maximilian, Mexico, and the Invention of Empire,* Nashville: Vanderbilt University Press, 2010; Johann Lubienski, *Der maximilianeische Staat: Mexiko 1861–1867: Verfassung, Verwaltung und Ideengeschichte,* Vienna: Böhlau Verlag, 1988.

4] The French artist Édouard Manet (1832–1883), acting as a type of correspondent, painted *The Execution of Emperor Maximilian* several times (from 1867 to 1869). In the first version the members of the firing squad still wear Mexican uniforms. In the final, Mannheim version, which ends the series, the guardsmen have French uniforms. See Oskar Bätschmann, *Édouard Manet. Der Tod des Maximilian,* Frankfurt a. M./ Leipzig: Suhrkamp, 1993.

↘ CAT. 21
Alberto Beltrán, *El pueblo responde. Viva Juárez,* 1956

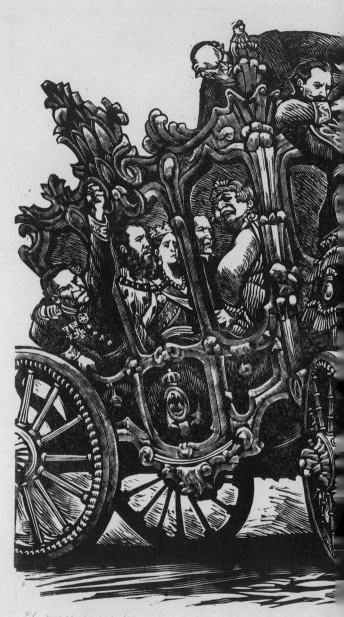

El pueblo responde

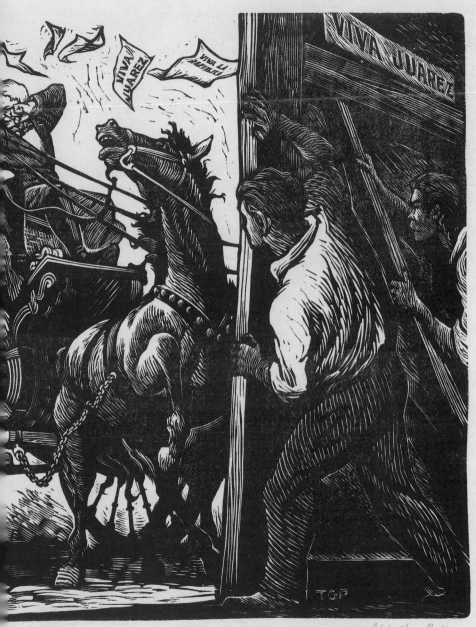

Alberto Beltran

Tlacotalpan, Veracruz, 1949

An Introduction

to Mexican Graphic Art

After a brief period of liberal development under Benito Juárez (1806-1872) came the long reign, from 1874 to 1910, of the general and dictator Porfirio Díaz (1830-1915). Henceforth, art followed a course of rejecting local production and admiringly copying European styles. Numerous liberal and oppositional magazines were published during this period, which, despite being largely banned, were handed down along with their titles and the caricatures published in them.[1] The traditional woodcut, which the artists preferred, was the most convenient and inexpensive tool to use with the press since, in contrast to lithography and copperplate engraving, illustrations could be printed at the same time as text.

The images, reproduced on the least expensive tissue paper, illustrated diverse printed matter. Only a few of these fragile prints remain preserved until today in print collections throughout the world. Although numerous reprints were produced from the original blocks, the connections to the texts that these illustrations represent, and the frequently impressive ornamental frames for the prints commonly executed on colored paper, are missing. Without the connection of text and image, the background of the social themes in the depictions remains unexplained.

Gabriel Vicente Gahona, known as "Picheta"

Picheta, Manuel Manilla, and José Guadalupe Posada are the three most important representatives of nineteenth-century Mexican graphic arts. Little is known about the life and work of the autodidact engraver Gabriel Vicente Gahona who worked under the pseudonym Picheta. He was born in Mérida in the State of Yucatán in 1828 and displayed great talent and potential as a caricaturist, illustrator, painter, graphic artist, and editor. His first woodcuts were created in Yucatán and reveal his powerful understanding of politics and social themes.

In 1845, as a student, the young Gahona received a foreign exchange scholarship from the state of Yucatán where his talent was discovered. This led him first to Italy where he grappled with the art of the Frenchmen Honoré Daumier (1808-1879), Paul Gavarni (1804-1866), and Gustave Doré (1832-1883).[2] For unknown reasons, Gahona's journey led him to Cuba, where he became familiar with diverse etching techniques. He returned to his homeland two years later where he joined a group of young artists and founded the magazine *Don Bullebulle*. As its editor, he first took on his pseudonym Picheta, which is derived from the French word *pichet*, pitcher, and is a reference to a French novel written by Eugène Sue (1804-1857).[3] Picheta created a number of prints in which he used irony, humor, and fantasy to reassemble everyday life in a realistic-representative style. He became an effective, critical commentator of

his times.[4] The popularity of his work grew quickly due to his subtle sense for political and social critique, and he enjoyed the favor of the readership. Nonetheless, under pressure from the authorities, the magazine was soon forced to permanently cease production.

Picheta was a patron of the arts in Yucatán and founded the first academy for teaching engraving techniques; his printing blocks from the local wood of the sapote tree were masterfully carved. Gahona also became mayor in Mérida in 1881 under the governance of Teodosio Canto (1825–1907).[5]

As an artist who was critical of the era, Picheta caricatured the customs and habits of Yucatán society. He was able to skillfully transpose traditional wisdom in his graphic prints. His most important subjects include the battle between the centralists and federalists and scenes from everyday life on the island. After his death in 1899, his work was forgotten until his family donated several of the original printing blocks to the Museo Regional de Antropología de Yucatán in 1938.[6] His seminal prints were first published as a portfolio many years after his death CAT.108, PP.83–85.

According to the artist Francisco Diaz de León (1897–1975) and the art historian Justino Fernández (1904–1972), Picheta, who worked and taught the art of engraving in his workshop, far from the capital and its art scene, was not only the forerunner to José Guadalupe Posada, but also José Clemente Orozco.[7]

Manuel Manilla

The work of Manuel Manilla was first rediscovered by the French artist Jean Charlot in 1926 and outlined in the article "Manuel Manilla: Mexican Engraver," published in *Revista de Revistas*.[8] Charlot does not provide much personal information on the engraver, about whom little is known to the present day. Manilla was born in Mexico City in 1830 and worked from 1850 to 1890 for the printer and graphic artist Juan Lagarza.[9] He first began his work as graphic artist at the age of fifty-two, with the publisher Antonio Vanegas Arroyo (1852–1917). His caricatures were first published in the press in 1888.[10]

Manilla's oeuvre includes roughly 500 prints depicting characters from novels, street scenes, and events related to bull fighting, religion, and magic. His main work and source of income came from designing pamphlets. The majority of his prints are considered lost. However, the stereos still exist from many of them, of which the Vanegas Arroyo family is meant to possess more than 300. The unity of Manilla's work is distinguished by his personal style, which harmoniously combines ingenuity and know-how, rather than by his choice of motifs. His illustrations remained singular for many years until Posada likewise began to work for Vanegas Arroyo as a graphic artist in 1892, the same year that Manilla retired.[11]

During the colonial era, printed folk culture was limited to card games, prayer books, pictures of saints, and representations of the Madonna and Christ, which Manilla specialized in during his younger years.[12] Soon, however, he answered popular demand for new formats: brochures, pamphlets, board games CAT.85, theater leaflets, school texts, and caricatures for the press, as well as chapbooks, stories, recipes, riddles, verses, embroidery patterns, and instructions for writing letters. His posters for bullfights, circus and theater performances, puppet shows, magic shows, and cockfights received particular attention. On the one hand, the popularity of these illustrated publications can be traced back to the technical innovations and their development in illustrated media, advertising, and journalism. On the other hand, it can also be attributed to high illiteracy rates.

They made it possible to break new ground in seeing and writing in the media.[13] Manilla worked mainly with the etcher's needle on zinc plates, a method that promoted the spontaneity of the craft and the straight lines of this particular tool.

A portfolio containing 330 of Manilla's engravings on lead plates was published as a first edition in 1971 CAT.86, P.220. With his prints of skeletons CAT.86-1, P.72, the majority of which are involved in everyday activities, he was considered the forerunner to José Guadalupe Posada, with whom he worked together briefly. He drew his well-known skeleton prints primarily to sell on Día de los Muertos (All Souls' Day), celebrated from October 31 to November 2.

José Guadalupe Posada

"There have always existed in Mexico two very well defined tendencies in the field or [sic] art,—one having positive values and the other negative qualities. The latter is simian and colonial. ... The other tendency, the positive, has been the work of the people and comprehends the totality of production, pure and rich, which is called popular art. ... Of these artists, without doubt, the greatest is the genial engraver José Guadalupe Posada."[14]

As a seminal artist of *arte popular*, Mexico's nineteenth-century folk art, Posada left behind a diverse oeuvre, free of European influence, which first reached the public again in the mid-1920s via the French artist Jean Charlot.[15] The first monograph on Posada containing more than 400 prints was subsequently published by the Mexican Folkways publishing house CAT.123, P.230.[16] Posada, who is of indigenous heritage, was born in Aguascalientes in the state of the same name in 1852. He began his artistic career as a member of a ceramics workshop and as a draughtsman of religious images. In 1866, he learned the art of lithography in José Trinidad Pedroza's (1837–1920) workshop and from 1871 worked for the local newspaper *El Jicote*. In 1887 he moved to the

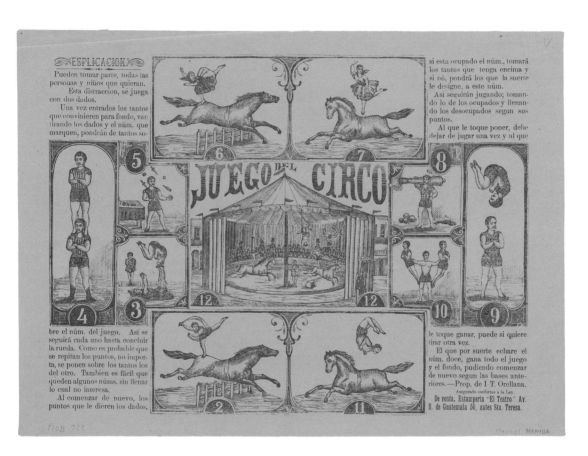

↑ CAT. 86-1

Manuel Manilla, *Calavera la penitenciaría. La Torre de Eiffel*

CAT. 110

CAT. 111

country's center of image production where there was a hunger for education, and received a permanent position as illustrator at Antonio Vanegas Arroyo's publishing house in Mexico City. Vanegas Arroyo published the magazine *Gaceta Callejera* in 1892, for which Posada provided the illustrations CAT. 110+111. He became a "flying reporter" for various magazines, although he did not personally experience many of the events, but instead, crafted his images from statements made by others, or during the revolutionary period, mainly from photographs. A short time later, he opened his own studio on Calle de Santa Inés, which would later be renamed Calle de Moneda, near the Academia de San Carlos.[17] José Clemente Orozco and Diego Rivera were among the youngsters who passed by on their way to school and watched Posada at work.[18] During this period, Posada engraved in metal and etched in zinc for any opportunity to illustrate: news, advertisements, stories, songs, board games, playing cards, posters, and prayers.[19] In addition to this work, he was given commissions for opposition pamphlets; he worked as a caricaturist and published primarily political works and pamphlets opposing Porfirio Díaz's government and the repression practiced by the Mexican upper class. From the start of the Mexican Revolution until his death, he took a stand for the concerns of the rebels, and was an extremely productive graphic artist from 1871 to 1912.[20] Yet, already during his lifetime, Posada's work fell into oblivion, and he died in poverty on January 20, 1913. Just a few years later, Charlot discovered the master's printing blocks in Vanegas Arroyo's publishing house

and granted the key founder of Mexican print graphics his deserved place of honor in the country's art history.[21]

Posada preferred wood or metal plates to lithography, as he could then craft his prints with an etching needle while on the road or on site while visiting his clients, which the heavy stone plates used for lithography renders impossible. He perfected the technique of relief printing under Manilla's guidance. However, around 1900 Posada's style changed; with the appropriation of a zinc etching technique he could work rapidly, as the process gave the artist greater liberties. His motifs were more dynamic and ornamental than before.[22] The Mexican writer Rubén M. Campos (1876–1945), whom Posada knew personally, wrote about his studio and working methods: "A swinging door led into his studio, a type of cage with broken window panes and cardboard covering the holes. He carried out extremely diverse commissions here, and, without any preliminary drawings and just a moment's contemplation about the format, the enlargement or reduction scale, he began to work based on the model, the idea, or the story told."[23]

Posada's artistic legacy is extensive: the work for Vanegas Arroyo's publishing house alone is meant to number 15,000 plates. Posada captured the historical moments and everyday episodes of the Mexican people in a steady chronicle over the course of nearly thirty years. In his illustrations for *cuadernos*,[24] *corridos*, *ejemplos*, *cécimas*, and *calaveras* he played through the entire breadth of his natural talent in extremely diverse disciplines. There were different types of chapbooks: song books, children's books and various brochures, as well as user guides.[25]

Yet Posada seemed to take particular delight in creating *calaveras*, skeleton caricatures, which he developed to a proper Mexican category of print graphics. These allegorical prints were humorous and the daily papers refrained from censoring their pictorial language. Thus, even ruthless, avenging President Victoriano Huerta (1850–1916), whom the people deeply detested, was shown in a *calavera* portrait as a nauseating spider with a skull head surrounded by maggots CAT.123-9, P.76. The *calaveras* confidently claimed a field of graphics that went far beyond illustration and became a metaphor for transposing all things human into an imaginary hereafter populated by skeletons. Medieval European *danse macabre* cycles and pre-Hispanic skeletons and skulls most likely provided the role models for this remarkable development.[26] Already the Indian people had decorated temples and ritual sites with skeletons and skulls. *Calaveras* are not depictions of the dead, but rather, of life, a form of autochthonous Mexican folk graphic arts, which was part of the Mexican people's uprising. With their cheery mannerisms, the *calaveras* were understandable within the indigenous concept of death—that of a joyful transition void of any horror.

Posada was a man of the people and considered himself a craftsman. His works had a social function before and during the time of the Revolution. Georg Stibi wrote about the artist's works: "Print graphics is the medium par excellence for the revolutionary process."[27] The prints' mass reproducibility conveyed the contents to broad social classes. Posada's work contributed to the democratization of art in Mexico, as it reflects the life of the people, thereby thwarting official art in which only artists who imitate foreign styles are appreciated.

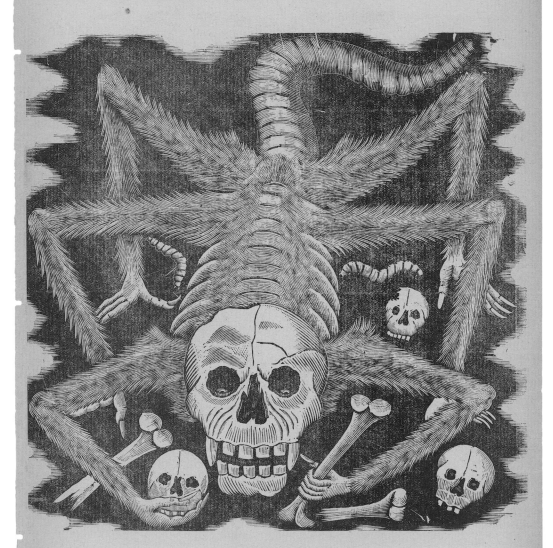

CALAVERA HUERTISTA

nicht Posada

↑ CAT. 122-9
José Guadalupe Posada, *El Doctor Improvisado,* ca. 1905

↑ CAT. 122-8
José Guadalupe Posada, *El testarazo del diablo,* ca. 1905

↑ CAT. 122-17
José Guadalupe Posada, *De Torreón a Lerdo,* ca. 1905

Mexican Revolution

In 1910, Porfirio Díaz (1830–1915), the longtime president, planned major festivities to celebrate the 100-year anniversary of Mexican independence. Citizens and peasants, however, demanded free elections, which he did not grant. Instead, Díaz had himself elected for the seventh time in 1910, which resulted in a revolt against the existing order.[28] This period of socio-political transition led to Díaz's overthrow by oppositional groups supporting Francisco I. Madero (1873–1913).[29] The uprising against Díaz marks the start of a series of in part bloody battles and riots that encompassed large parts of Mexico and did not let the country settle down until well into the 1920s. Vital in the social revolutionary opposition were mainly the radical movements under Emiliano Zapata (1879–1919) in the south, which for their part, rested on the ideas of the anarchist Magonistas, and the movements under Francisco "Pancho" Villa (1878–1923) in the north. With the slogan "Tierra y Libertad" (Land and Liberty), the Flores Magón brothers propagated indigenous collectivism and libertarian socialism. Conditions in Mexico first appeared consolidated in the early 1940s, although small rebel movements still flared up from time to time CAT. 174-22, P. 100.

Battles lasting centuries and revolutions over the course of decades played an important role in Mexican art in the form of bloodthirsty representations. Constantino Escalante (1836–1868) and José María Villasana (1848–1904) were still influenced from abroad in the creation of their lithographs. However, Posada, building on the country's woodcut tradition, succeeded in creating a bridge to Mexico's character, which blossomed in the *calaveras;* a creation of fascinating originality. The Mexican people identified so greatly with his work, they saw these images as a part of themselves. The origins of Posada's formal language can be seen as this period's inheritance, in general. The combination of traditional pictorial language and old master techniques typical at the time in Mexico can be traced back, on the one hand, to colonial stagnation and on the other hand, to the underdeveloped state of the graphic arts. Posada, nonetheless, successfully revitalized this archaic heritage with his stylistic development towards narrative drama and satirical burlesque.

The events of the Civil Revolution in Mexico changed the artists' social and political tasks. Most of them made linocuts because they were quick and easy to produce. But first and foremost, the linocut presented the least expensive reproduction technique. Their prints now no longer had the sole function of expressing social critique in the form of caricatures and satirical sheets. Their new, main task was to enlighten the people and support the people's struggles for realization of the Revolution's proclaimed goals.[30]

1] Prignitz 1990, p. 15.

2] Justino Fernández, *Arte moderno y contemporáneo de México*, Mexico City: Imprenta Universitaria, 1952, pp. 167–171.

3] Lyle W. Williams, "Evolution of a revolution. A brief history of printmaking in Mexico," in Philadelphia 2006, pp. 4–6.

4] Westheim 1954, pp. 235–236.

5] Ibid., pp. 247–248.

6] Raúl Casares G. Cantón, Juan Duch Colell, Silvio Zavala Vallado et al., *Yucatán en el tiempo*, Mérida, Yucatán: Inversiones Cares. Enciclopedias y diccionarios, 1998.

7] Williams 2007 (see note 3), pp. 4–6.

8] Mercurio López, "Advertencia," in López Casillas 2005, p. 10.

9] López Casillas 2005, pp. 206.

10] Antonio Vanegas Arroyo (1852–1917) was a Mexican publisher and pioneer in journalism who became highly important in the development of Mexican art at the time of the Revolution, no least through his intense cooperation with Manilla and Posada.

11] Jean Charlot, "Manuel Manilla. Grabador Mexicano," in López Casillas 2005, pp. 7, 12, 44, 89, 147.

12] Ibid., p. 17; Ninety-five percent of Mexico City's inhabitants are Catholic.

13] Ibid., pp. 13–15, 87, 179.

14] Diego Rivera, "José Guadalupe Posada;" in *Monografía. Las obras de José Guadalupe Posada. Grabador Mexicano*, with an introduction by Diego Rivera, eds. Frances Toor, Paul O'Higgins, and Blas Vanegas Arroyo, Mexico City: Mexican Folkways, 1930; "En México han existido siempre dos corrientes de producción de arte verdaderamente distintas, una de calores positivos y otra de calidades negativas, simiesca y colonial, que tiene como base la imitación de modelos extranjeros [...]. La otra corriente, la positiva, ha sido obra de pueblo, y engloba el total de la producción, pura y rica, de lo que se ha dado en llamar 'arte popular.' [...] De estos artistas más grande es, sin duda, José Guadalupe Posada, el grabador de genio"; cf. Fernández 1965, p. 33–34.

15] Charlot contacted Antonio Vanegas Arroyo's son Blas and discovered all of the blocks, which Blas had saved. The publisher had glued into the sample books all of the works that were created at the publishing house; cf. Rafael Barajas Durán, *Posada. Mito y Mitote. La caricatura política de José Guadalupe Posada y Manuel Alfonso Manilla*, Mexico City: Fondo de Cultura Económica, 2009; Rafael Barajas Durán, *Historia de un país en caricatura. Caricatura mexicana de combate, 1821–1872*, Mexico City: Fondo de Cultura Económica, 2013.

16] *Monografía: Las obras de José Guadalupe Posada*, 1930 (see note 14).

17] Barajas 2009.

18] Orozco 1999, p. 10.

19] López Casillas 2005, pp. 1–2.

20] Ibid., p. 15.

21] Tyler 1979, pp. 3–5; see Jean Charlot, "José Guadalupe Posada and his Successors," in Tyler 1979, pp. 29–57.

22] Olav Münzberg, "José Guadalupe Posada 1851–1913," in Berlin 1974, p. 109.

23] "[Su taller estaba] situado en una puerta cochera, una especie de jaula con vidrios rotos y cartones pegados en los huecos sin cristales ... donde ... recibía los encargos más variados sin ningún dibujo previo, y sin más que una ojeada para calcular la reducción o aumento del modelo o la reproducción de un modelo imaginario o, sirviéndose de una simple indicación escrita [ejecutaba el grabado]." In *José Guadalupe Posada. Ilustrador de la vida mexicana*, Mexico City: Fondo Editorial de la Plástica Mexicana, 1992 (Prignitz 1990, p. 21), translation Lisa Rosenblatt.

24] At issue are the so-called Penny Chapbooks from Penny-Press, published by Vanegas Arroyo.

25] López Casillas 2005: for song books, p. 25; for children's books, p. 79; for handbooks, p. 155; song books: CAT. 122-15, p. 40; CAT. 122-17, p. 64; CAT. 122-24, p. 42; CAT. 122-35, p. 50; CAT. 112, p. 70; CAT. 113, p. 49; CAT. 114, p. 66; CAT. 115, p. 35; children's books: CAT. 122-1, p. 143; CAT. 122-9, p. 106; CAT. 122-10, p. 132; CAT. 122-13, p. 141; CAT. 122-16, p. 137; CAT. 109, p. 150; handbooks: CAT. 122-8, p. 201.

26] Haab 1957, p. 5.

27] Georg Stibi, "Soziale Grafik," in *Bildende Kunst*, Berlin 1948, no. 3, p. 11.

28] The first shots fell on November 18, 1910 in Puebla. See CAT. 174-22, P. 100.

29] The "Plan de San Luis Potosí" is a program of political and social action announced by Madero, whose goal is to realize democratic rights and the end of the exploitation of the indigenous population and lack of rights of the labor force. The "Plan de Ayala" from 1911 is the political program of Emiliano Zapata, leader of the Mexican Revolution, and his followers. See Berlin 1974, pp. 122–127; Hans Schlirf, "Die ökonomische und politische Entwicklung der mexikanischen Revolution," in Berlin 1974, pp. 63–71.

30] Helga Prignitz, "Zur Volkstümlichkeit der politischen Grafik in Mexiko," in Berlin 1974, p. 97.

15 Grabados de Picheta / 15 Prints by Picheta

Gabriel Vicente Gahona was the first to depict current events in Mexico in a universal artistic visual language. His woodcuts are renowned for their original interpretations and authentic depictions of ordinary life. In his works, which are intentionally critical and satirical, Gahona caricatured people and scenes from everyday life in Mérida on the Yucatán Peninsula from the middle of the nineteenth century.[1] He was the first artist in Mexico to use a pseudonym for his work: Gahona published the prints under the name "Picheta."

The magazine *Don Bullebulle,* founded by Picheta, published the edition of fifteen impressions in 1847. The title impression corresponds with the magazine cover's rich, floral adornment and shows five portraits arranged around an ornamentally designed medallion. This bears the magazine's literary information *(D. Bullebulle. Periodico burlesco y de extravagancias. Redactado por una sociedad. Bulliciosos. Tom. II. Mérida de Yucatán)*. The five portrayed people were most likely the editors or authors of the magazine. Above the vignette is a stripe with the label "Año de 1847," which can be interpreted as the founding year of the magazine.[2] Depicted under the medallion are two burlesque scenes. In the lower center, a globe crowned by a goddess of victory wearing a laurel wreath, points to a portrait of Picheta who holds his working instrument in his right hand.

In the portfolio's introductory words, Francisco Díaz de León (1897–1975), a Mexican graphic artist, art critic, and founding member of the Academia de Artes in Mexico City, describes Picheta as one of the most important interpreters of nineteenth-century Mexican life and folk life.[3]

1] Lyle W. Williams, "Evolution of a Revolution. A Brief History of Printmaking in Mexico," in Philadelphia 2006, pp. 4–6.

2] Prignitz 1981, p. 16. Other satirical magazines include: *La Orquestra* with caricatures by Constantino Escalante (1836–1868), which was published from 1861 to 1875, and *El Ahuizote* with caricatures by José María Villasana (1848–1904)—and later also by José Guadalupe Posada—which was published from 1874 to 1875.

3] "Uno de los más grandes intérpretes de la vida popular mexicana en el siglo pasado." Introduction by Leopoldo Peniche Vallado, in *15 Grabados de Picheta,* ed. Editorial Provincia, Mérida, Yucatán, January 30, 1949.

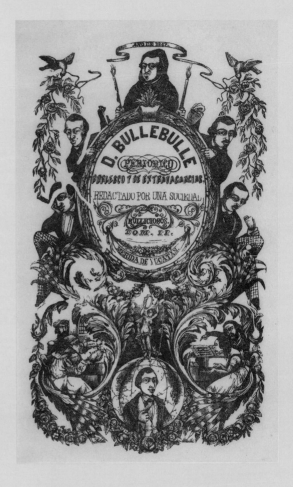

CAT. 108-B

↗ CAT. 108-1
Picheta, *Don Bullebulle*, 15.4.1847

CAT. 108-9

→ CAT. 108-12
Picheta, *El escribano público / Este es el buen
hermano llamado Don Escribano*

330 Grabados originales / 330 Original Engravings

Manuel Manilla left behind a diverse artistic inheritance that was first compiled and published in 1971 in the portfolio *330 Grabados originales.* Providing testimony to Manilla's technical skill are 330 lead engravings on 89 colored sheets. The prints, based on the original relief plates, reveal illustrations for widespread Mexican literary productions such as lyrics, tales, novels, songs, programs, events, alphabets, and depictions of famous personalities, bullfighters, virgins, as well as circus pieces, and magic acts.[1] In addition, Manilla illustrated games, handbooks, bullfighting scenes, and covers for stories and created the famous *calaveras.* One of his most popular pieces is entitled *Calavera la penitenciaría,* also known as *La Torre de Eiffel* CAT. 86-1, P. 72.

Since only the relief plates of Manilla's prints were available for the portfolio made in 1971, these are printed separately. The texts, for which the prints were created as illustrations, are missing. A detailed connection between the image and context could not be reconstructed in all cases. A few publications and broadsides from Manilla's era have, however, been preserved to the present day. The content of these prints first truly comes to light in the connection of text and image.[2]

1] *Corridos, cuentos, novenas, canciones, programas, sucedidos, alfabetos,* and illustrations for *tipos populares, personajes taurinos, virgenes,* and *escenas de circo y de magia.*

2] *Calavera la penitenciaría,* 1910, broadside, printed by Antonio Vanegas Arroyo, see Tylor 1979, p. 124.

330
GRABADOS
ORIGINALES
—
MANUEL
MANILLA

CAT. 86-A

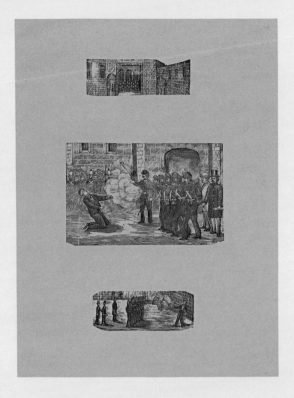

↗ CAT. 86-2
Manuel Manilla, folio 48: *Fusilamiento*

La ofrenda en Janitzio / The Offering on Janitzio

With flowers, candles, and incense, those who are alive commemorate the times they shared with those who have died. In this way, they sacrificially or even meditatively spend Día de los Muertos with their ancestors, at their decorated graves. Traditional altars to the dead or gift tables, so-called *ofrendas,* are set up. Food and drinks, flowers, and personal memorabilia are meant to provide sustenance for the deceased after their long journey from the realm of the dead and remind them of the past. This typical Mexican tradition is shown in the work *La ofrenda en Janitzio,* created by Ángel Zamarripa Landi in 1953.[1]

In contrast to Europe's All Souls' Day, the Día de los Muertos is not a day of mourning in many parts of Mexico. The Mexicans pilgrimage to the graves of the deceased; however, their relationship with them is not expressed in calm ceremonies and silent pain, but instead, with what is occasionally boisterous communication, in the family circle, with food and drink at the grave. Altars for children are decorated with toys, and musicians play their songs.[2] Perpetuating in this archaic relic are some of the Indio life and death concepts who comprehend the birth of a child as the return of an ancestor, and death therefore as a mere transition into another form of life.[3]

Janitzio is the largest island in the middle of Lake Pátzcuaro in the state of Michoacán, and is reachable only by ferry. The town of the same name, Janitzio, which means "it is raining," currently encompasses the entire island, although earlier it was only a small settlement on the hill.[4] The island is known primarily for its brilliant Indio festivities commemorating Día de los Muertos from October 31 until November 2. A sea of candlelight accompanies the processions taking place by boat and on land.

Armin Haab visited these festivities, which were already commonly attended by tourists in November 1954 and made a note of his memories. In the early morning he witnessed the artist Diego Rivera, with a Tarascan sombrero on, dressed in a flamboyantly patterned *sarape,* buying pencils and little toy canoes for Indio children at a souvenir stand. There are numerous photos of Haab's visit to the Tarascan people.[5] He writes that Rivera sat on the cemetery wall the entire night and drew grave scenes.

ÁNGEL ZAMARRIPA LANDI

1] Zurich 2012, p. 11.

2] Jas Reuter, "The popular traditions," in Tyler 1979, p. 74.

3] Olav Münzberg, "José Guadalupe Posada 1851–1913," in Berlin 1974, p. 110.

4] Since 1933, the forty-meter-high statue *Monumento a José María Morelos* has been located on the island's highest point. Morelos (1765–1815) is a priest and revolutionary leader of the Mexican independence movement who is considered a hero.

It is possible to climb up the inside of the statue. On the inner walls, murals by Ramón Alva de la Canal (1892–1985) and other Mexican muralists speak of Morelos's life.

5] Armin Haab, "Totennacht auf Janitzio," in *Zuger Neujahrsblatt 1968,* ed. Gemeinnützige Gesellschaft des Kantons Zug, Zug: Kalt-Zehnder, 1968, pp. 57–60.

↑ All Souls' Day, Janitzio island, Lake Pátzcuaro, Michoacán, 1949

↘ CAT. 168

Ángel Zamarripa Landi, *La ofrenda en Janitzio,* 1953

LA OFRENDA EN JANITZIO

Homenaje a Posada / Homage to Posada

Leopoldo Méndez shows the graphic artist José Guadalupe Posada in his workshop in 1902, as eyewitness to the scene of a street revolt, which he is etching directly on the printing plate. Posada holds his tool like a weapon while he gazes attentively out the window and observes the violent confrontation between the attacking, armed cavalry—representatives of Porfirio Díaz's (1830–1915) regime—and unarmed indigenous peasants. Standing behind Posada in the printers' shop are the brothers Enrique (1887–1954) and Ricardo Flores Magón (1873–1922).[1] The latter holds in his hand the text written on the scene bearing the inscription:

"No habrá leva / ese pretexto / conque los actua / les Caciques arran / can de su hogar / a los hombres / a quienes / odian." (There will be no forced recruitment. Under this pretext, the current *caciques* tear the people they despise from their families.)

Next to him is the typesetter Lázaro Gutiérrez de Lara (1870–1918), a trailblazer of the Mexican Revolution, reaching for letters in a letter case.[2] The calendar on the wall confirms the year 1902, the year Leopoldo Méndez was born. The Flores Magón brothers worked at the time as editors of the satirical newspaper *El Hijo del Ahuizote,* which Posada illustrated with his caricatures.

Méndez shows Posada as a witness to the events and a mediator between past and present. Posada also takes on the role of forerunner for the activities of artists during the revolutionary era. Méndez intended the scene as homage to Posada rather than historical documentation. It is an idealized composition.[3] Although a realistic portrait of Posada is depicted, the print shows an imaginary construction of his person before the Mexican Revolution, portrayed together with the revolt's two most important vanguards.

LEOPOLDO MÉNDEZ

1] London 2009, pp. 13–14.

2] Caplow 2007, pp. 226–228. The Flores Magón brothers worked as Mexican journalists and politicians and supported the international anarchist movement in Mexico with great fervor. They fought uncompromisingly against the dictatorship of Porfirio Díaz and popularized the demand "Tierra y Libertad" (Land and Liberty), which was adopted by the revolutionaries Francisco Villa and Emiliano Zapata CAT. 174-59, P. 105; CAT. 18, P. 102; CAT. 68, P. 103; CAT. 119, P. 226.

In 1902 the third brother, Jesús Flores Magón (1871–1930), was deported to the U.S., but he returned to Mexico in 1910 and developed a constitution for the overthrow of Díaz. In late 1903 Enrique and Ricardo were likewise forced into exile in the U.S. A mere two years later, Ricardo founded the Partido Liberal Mexicano (PLM).

3] Monsiváis 2002, p. 55.

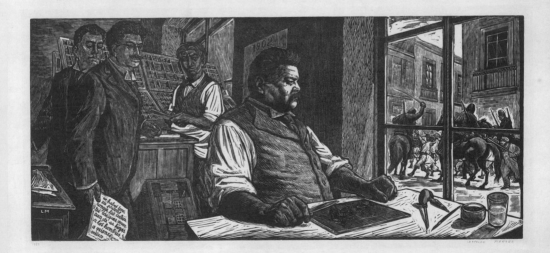

↑ CAT. 90
Leopoldo Méndez, *Homenaje a Posada,* 1955

Calavera Catrina / Calavera revolucionaria
Revolutionary Calavera

The *calaveras*—skeleton depictions displaying a biting sarcasm and black humor—are among José Guadalupe Posada's most well-known works. With them, he alludes to the Mexican upper class before and during the Revolution and thereby amuses the readership.[1]

Calavera Catrina, one of Posada's popular characters, leads a superficial life and pays homage to the latest fashions like a dolled-up model. This print covertly casts a glance at society women in general.[2] The illustration first appeared on a broadside entitled *La Calavera garbancera*[3] and thereby refers to the people of indigenous heritage who, ashamed of their origins, adopt the imported, upmarket clothing style from Europe. With the illustration, Posada also makes fun of government members who turn away from their Mexican heritage and take on the European style. But mainly, it mocks the dictator Porfirio Díaz, whose economic policies oriented on Europe and the U.S. ultimately led to the Mexican Revolution. In 1913 *Catrina* was depicted on another broadside within the *Calaveras de la cucaracha.*[4]

The print *Calavera revolucionaria* can be seen on the same sheet. The armed skeleton with crossed cartridge belt, distinctive moustache, and sombrero is a portrait of the legendary revolutionary figure Emiliano Zapata (1879–1919). On a broadside from 1912 entitled *La Calavera de Emiliano Zapata,* printed by Antonio Vanegas Arroyo, a thirty-five-verse *corrido* (romance) accompanies the depiction.[5]

The approach to death takes a unique form in Mexico. For the Christian world, it signifies a decisive break in which earthly life ends and there is a transition to the hereafter. The pre-Hispanic people, on the contrary, were not afraid of dying; for them, it was a completion of life. Constant reference to the end of life in the depiction of skulls and skeletons represents life's continuity. In twentieth-century Mexican culture, death moved into people's everyday lives. Among the symbols that aided artists and intellectuals involved in the Revolution to find new meaning, that of death led to the richest forms. Posada achieved a milestone by including death as an expression of life in the nation's fine arts. To live alongside danger is neither a romantic attitude nor a literary recommendation in Mexico, but instead, results from deep historical roots that permeate everyday life and cultural expressions.[6]

JOSÉ GUADALUPE POSADA

1] Tyler 1979, p. 7, 46; Jas Reuter, "The popular traditions," in Tyler 1979, pp. 59–83, on *calaveras*, see pp. 74–75.

2] Zurich 2012, p. 8.

3] *Remate de calaveras alegres y sandungueras las que hoy son empolvadas garbanceras pararon en deformes calaveras,* 1912, broadside, Antonio Vanegas Arroyo; see Tyler 1979, p. 269.

4] *Calaveras de la Cucaracha. Una fiesta en Ultratumba* (Skeleton of the cockroach. A feast in the hereafter), see Tyler 1979, p. 269. Another broadside showing *Calavera Catrina* is entitled *El Panteón de las Pelonas* (The Pantheon-crypt of the baldheaded women).

5] Friedrich 1979, p. 137. The broadside is owned by the Art Gallery at the Grand Valley State University, Allendale, MI, USA.

6] Ida Rodríquez-Prampolini, "Das Mexikanische in der mexikanischen Kunst," in Vienna 1988, pp. 49–50; Fernando Benítez, "Die Dämonen des José Guadalupe Posada," in Vienna 1988, pp. 87–90; Victor Fosado, "Requiescat in Pace – der Tod in Mexiko," in Vienna 1988, pp. 101–102.

↑ José Guadalupe Posada with his son
Juan Sabino Posada, ca. 1895

→ CAT. 123-A
José Guadalupe Posada, *Monografía,* 1900–1913

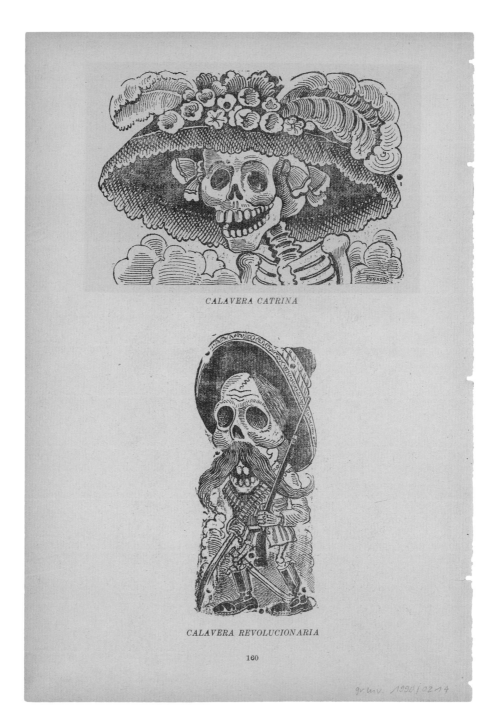

CALAVERA CATRINA

CALAVERA REVOLUCIONARIA

160

↑ CAT. 123-7
José Guadalupe Posada, *Calavera Catrina / Calavera revolucionaria*

Corrido "EL FIN DEL MUNDO"

Corrido "EL FIN DEL MUNDO"

89

José Guadalupe Posada, *Corrido "El fin del mundo"*

Aquiles Serdán y su familia inician en Puebla la revolución armada. 18 de noviembre de 1910 / Aquiles Serdán and His Family Start the Armed Revolution in Puebla. November 18, 1910

The Mexican Revolution comprised a transitional socio-political period, the start of which is dated as 1910. Oppositional groups around Francisco I. Madero precipitated the fall of long reigning dictatorial Porfirio Díaz (1830–1915).

In 1910 Díaz, eighty years old at the time, decided to hold an election in order to secure a further term in office as president. He was convinced that he had eliminated all viable opposition in Mexico. Nonetheless, Madero, a scholar from a wealthy family, decided to run against him. Within a short time Madero garnered major public support despite the fact that Díaz had him thrown in jail. When the official results were read it was announced that Díaz won the election with almost no opposing votes, and that only a few hundred people in the entire country had voted for Madero. However, Díaz's election fraud was too obvious for the population to accept. This led to insurgencies breaking out throughout the nation. Madero published the "Plan de San Luis Potosí," in which he calls the population to take up arms and take action against the Díaz government, on November 20, 1910. This date marks the start of the Mexican Revolution.[1]

Aquiles Serdán was a leader of the revolutionary efforts opposing Díaz's re-election. He fought on the side of the revolutionary Madero. On the morning of Friday, November 18, 1910, something unanticipated occurred as the police monitored and surrounded the Serdán family's home: Aquiles and his sister Carmen opened fire on the police officers. As reinforcement, they called out from the balcony: "¡Vengan con nosotros! ¡Esto es la Revolución!" (Come join us! This is the Revolution!).[2] The covert oppositionists subsequently shot two police officers and then retreated to the building's rooftop terrace, while the women remained on the ground floor. Aquiles's brother Máximo died in the gunfight, and just a few hours later, Aquiles also died.

Fernando Castro Pacheco's linocut shows the opening of the battle by the Serdán family on November 18, 1910. The uprising against Díaz marked the start of a series of battles and unrest, some of which were extremely bloody, involving large parts of Mexico, which did not allow the country to quiet down until well into the 1920s. With the emphatic accentuation of the typical black-and-white linocut style, the print shows two men and two women in a bedroom: Aquiles Serdán (1877–1910) and his wife Filomena, his older sister Carmen (1875–1949) and his younger brother Máximo (†1910). All figures are armed with rifles and are shooting from the windows. With deep cuts, Castro Pacheco carved strong contrasts in the linoleum, thus not allowing any gray tones to arise. The present sheet is his most famous print.[3]

FERNANDO CASTRO PACHECO

For the social revolutionary side of the Mexican Revolution, essential first and foremost was the Zapatista movement. Escobedo CAT. 68, P. 103 and Siqueiros CAT. 139, PP. 44, 233 provide heroic depictions of the rebels Emiliano Zapata (1879–1919) and Francisco "Pancho" Villa (1878–1923). They give a national face to Mexican art and represent the graphic artists' confrontation with socio-political themes, such as Beltrán's representation of Villa, the idealistic, unruly, popular gang leader CAT. 18, P. 102.[4]

Before the appearance of the tradition of the *Adelita* character glorified sentimentally in the *corridos* CAT. 156, P. 110, Carmen Serdán who together with her brothers Aquiles and Máximo defended her family's house in the city of Puebla was considered the ultimate woman Revolutionary. Tribute was paid to her bravery with posthumous recognition and admiration for all *soldaderas* whose names were not listed in the records of the Mexican Revolution. Carmen Serdán is considered an honorable personality, a witness to and actor in the twentieth century's first armed social movement in Mexico.[5]

1] Madero was arrested in San Antonio, TX, but his plan was realized. Diverse revolutionary groups, led by, among others, Emiliano Zapata in the south and Francisco "Pancho" Villa and Pascual Orozco in the north, defeated the federal army. Díaz stepped down from office "in the name of the country's peace" on May 25, 1911 and went into exile in France, where he died in 1915.

2] Serdán 2010; cf. also Velasco 1930.

3] Prignitz 1981, pp. 233–234.

4] Zurich 2012, pp. 6–9.

5] See Mujeres revolucionarias 1992; Serdán 2010.

↘ CAT. 174-22
Fernando Castro Pacheco, *Aquiles Serdán y su familia inician en Puebla la revolución armada. 18 de noviembre de 1910*, 1947

22 AQUILES SERDAN Y SU FAMILIA INICIAN EN PUEBLA LA
REVOLUCION ARMADA. 18 DE NOVIEMBRE DE 1910.
Grabado de Fernando Castro Pacheco.

M6 65

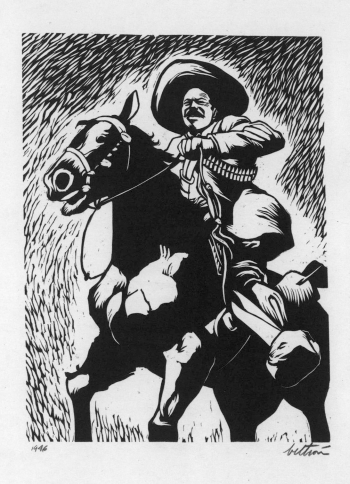

1946

El guerrillero Pancho Villa

M6 49

↑ CAT. 18
Alberto Beltrán, *El guerillero Pancho Villa (1877–1923),* 1946

→ CAT. 68
Jesús Escobedo, *Zapata,* 1951

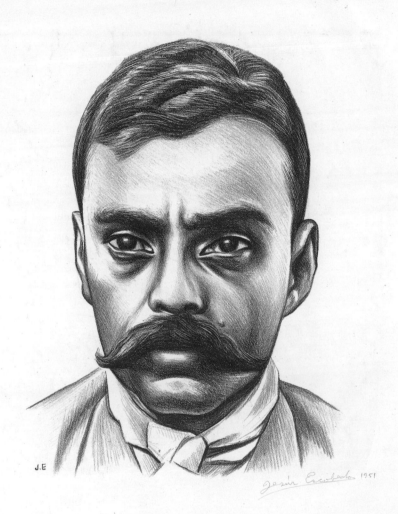

J.E

Jesús Escobedo 1951

116 56

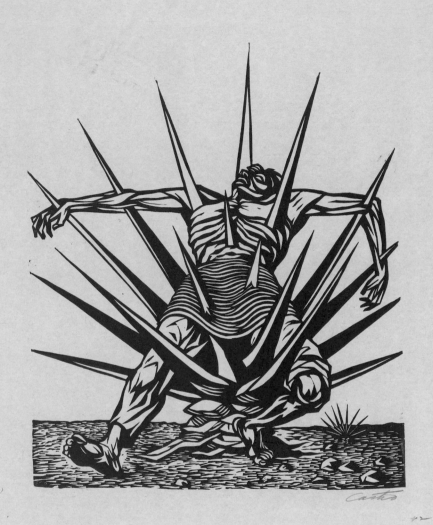

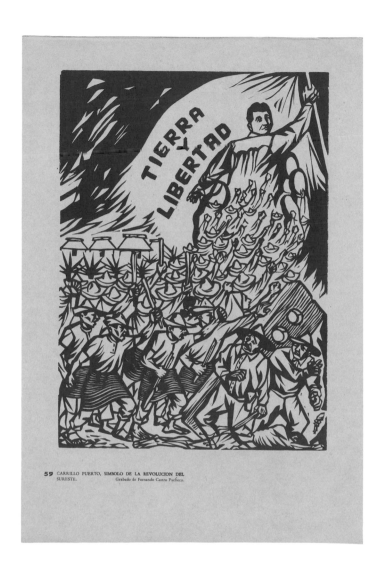

59 CARRILLO PUERTO, SÍMBOLO DE LA REVOLUCION DEL
SURESTE. Grabado de Fernando Castro Pacheco.

← CAT. 30
Fernando Castro Pacheco, *Henequén / Henequenero,* 1947

↑ CAT. 174-59
Fernando Castro Pacheco, *Carrillo Puerto, símbolo de
la revolución de sureste,* 1947

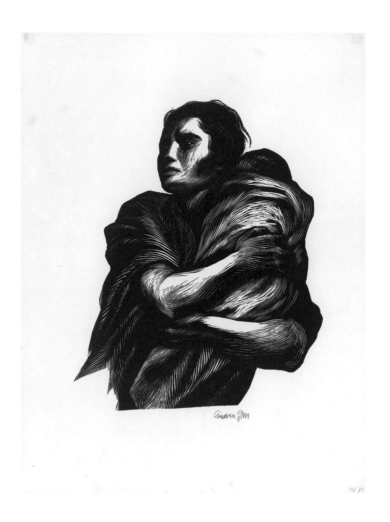

↑ CAT. 75
Andrea Gómez, *Madre contra la guerra,* 1952

→ CAT. 69
Arturo García Bustos, *Hecho en USA. Ayuda norteamericano para Asia,* 1948

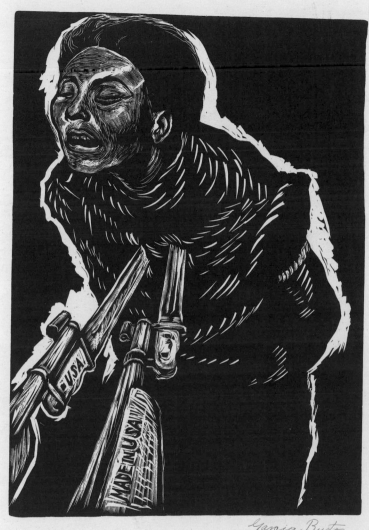

García Bustos

Ayuda norteamericana para Asia

AH 115

Adelita

Adelita was a legendary *soldadera* during the Mexican Revolution who symbolizes Mexican women's courage, power, and willingness to fight. *Soldaderas* were female soldiers who fought against Porfirio Díaz (1830–1915) for more rights and freedom. In most cases women joined the revolutionary movement for civil rights and feminist reasons, yet after the successful Revolution they once again largely disappeared from military offices. The name Adelita later came to refer to all women who resisted and fought for their rights.

Mariana Yampolsky depicts the figure of Adelita in a bell-bottomed skirt with hat and weapon. She holds the weapon determinedly with both hands. The broadside displays several verses of the famous ballad-like *corrido, Adelita* CAT. 156, P. 110. As a revolutionary *corrido,* the quatrain sings of the militant happenings: the figure of the *soldadera,* who is just as handsome as she is courageous, follows a beloved Villista leader to the Revolution.

The name "Adelita" serves in general to identify all *soldaderas.* However, Adelita was probably a woman from Durango who joined the movement around Francisco I. Madero (1873–1913) at the start of the Revolution and fell in love with him. The stereotypical Adelita additionally surfaces as a motif in images that symbolize action and inspiration. *Adelita* has usually been handed down orally, thus leading to various versions of the text.[1]

The charming Marieta is one of Adelita's forerunners. In contrast to Adelita, whose existence has not been reliably confirmed, this figure can be traced back to the real person Marieta Martínez, who was among the followers of the Revolutionary Francisco "Pancho" Villa (1878–1923). She, too, is considered a mythical inspiration and is sung about in many folk songs about the Mexican Revolution.[2]

Another forerunner from the revolutionary movement in Mexico whose existence and participation has been historically confirmed is Carmen Serdán (1875–1948). She participated in the Mexican Revolution's first armed conflict on November 18, 1910 CAT. 174-22, P. 100. Although she is celebrated as a war hero, no sentimental glorification or inspirational *corridos* were devoted to her.[3] Nonetheless, in her memory, Rubén Guzmán Santos designed a bronze statue of her shown with a rifle in her hand, which was erected as a monument in Puebla on November 18, 1957.[4]

MARIANA YAMPOLSKY

1] The *corridos* are an extremely popular form of song about bandits, revolutions, catastrophes, and love tragedies. Originating in the Spanish Romance, these folk-song-like ballads transformed in Mexico from rigid eight-syllable verses to simple quatrains, which were created prolifically by publishing houses specifically for this purpose, and based on the desired tone. Engravers contributed professional illustrations printed on colorful paper, which were pulled for audiences at markets and *fiestas* and sold for a few centavos. While *corridos* dedicated to politics and current events enjoyed only a short life, solemn ones, on the contrary, such as *La Chabela* or *La Adelita* have lost none of their popularity from Villa's era until today. Cf. Tyler 1979, pp. 3–27.

2] Serdán 2010.

3] Cf. Velasco 1930; Mujeres revolucionarias 1992.

4] The *Plazuela y Monumento a Carmen Serdán* is found between the streets 6 Norte and 10 Oriente and the Avenida 12 Oriente, Centro, 7200 Heroica Puebla de Zaragoza in Puebla, Mexico.

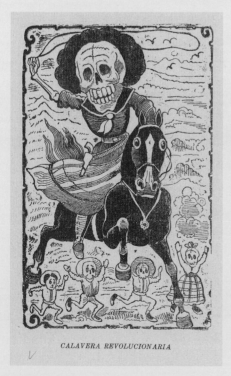

CALAVERA REVOLUCIONARIA

↑ CAT. 123-6
José Guadalupe Posada, *Calavera revolucionaria,*
page 156 from the portfolio: *Monografía* (detail)

ADELITA

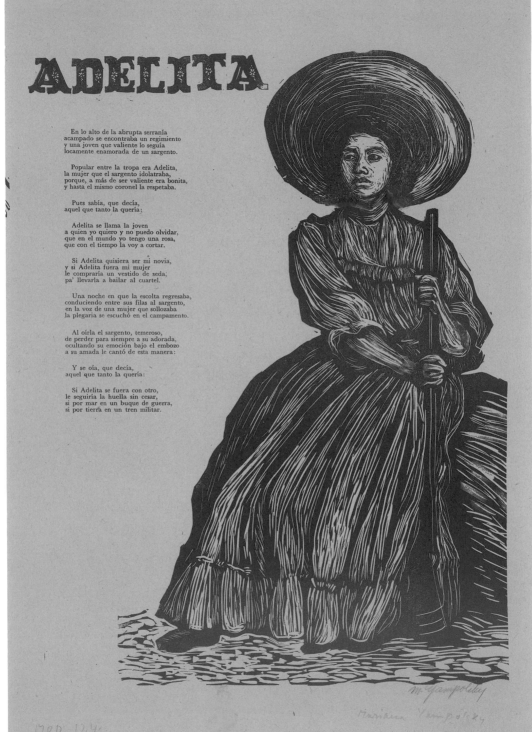

En lo alto de la abrupta serranía
acampado se encontraba un regimiento
y una joven que valiente lo seguía
locamente enamorada de un sargento.

Popular entre la tropa era Adelita,
la mujer que el sargento idolatraba,
porque, a más de ser valiente era bonita,
y hasta el mismo coronel la respetaba.

Pues sabía, que decía,
aquel que tanto la quería;

Adelita se llama la joven
a quien yo quiero y no puedo olvidar,
que en el mundo yo tengo una rosa,
que con el tiempo la voy a cortar.

Si Adelita quisiera ser mi novia,
y si Adelita fuera mi mujer
le compraría un vestido de seda,
pa' llevarla a bailar al cuartel.

Una noche en que la escolta regresaba,
conduciendo entre sus filas al sargento,
en la voz de una mujer que sollozaba
la plegaria se escuchó en el campamento.

Al oírla el sargento, temeroso,
de perder para siempre a su adorada,
ocultando su emoción bajo el embozo
a su amada le cantó de esta manera:

Y se oía, que decía,
aquel que tanto la quería:

Si Adelita se fuera con otro,
le seguiría la huella sin cesar,
si por mar en un buque de guerra,
si por tierra en un tren militar.

M. Zampolsky

Mariana Yampolsky

En lo alto de la abrupta serranía
acampado se encontraba un regimiento
y una joven que valiente lo seguía
locamente enamorada del sargento.

Popular entre la tropa era Adelita,
la mujer que el sargento idolatraba,
porque, a más de ser valiente era bonita,
y hasta el mismo coronel la respetaba.

Pues sabía, que decía,
aquel que tanto la quería:

Adelita se llama la joven
a quien yo quiero y no puedo olvidar,
que en el mundo yo tengo una rosa
que con el tiempo la voy a cortar.

Si Adelita quisiera ser mi novia,
y si Adelita fuera mi mujer
le compraría un vestido de seda,
pa' llevarla a bailar al cuartel.

Una noche en que la escolta regresaba,
conduciendo entre sus filas al sargento,
en la voz de una mujer que sollozaba
la plegaria se escuchó en el campamento.

Al oírla el sargento, temeroso,
de perder para siempre a su adorada,
ocultando su emoción bajo el embozo
a su amada le cantó de esta manera:

Y se oía, que decía,
aquel que tanto la quería:

Si Adelita se fuera con otro,
la seguiría la huella sin cesar,
si por mar en un buque de guerra,
si por tierra en un tren militar.

On the heights of a steep mountain range
a regiment was encamped,
and a young woman bravely followed them,
madly in love with the sergeant.

Popular among the troop was Adelita,
the woman that the sergeant idolized,
and besides being brave she was pretty,
so that even the colonel respected her.

And it was heard that the one who
loved her so much said:

Adelita is the name of the girl
that I love and can't forget,
that I have a rose in this world,
which I will cut when the time comes.

If Adelita wanted to be my fiance,
and if Adelita was my wife,
I would buy her a silk dress
and go dance with her at the barracks.

One night when the escort returned,
in their ranks they headed to the sergeant,
and the voice of a sobbing woman
spoke a prayer that could be heard in the camp.

When the sergeant heard her, he was afraid
of losing her forever, his beloved,
hiding his feelings under a cloak,
he sang to his beloved in this way:

And he, who loved her so much,
could be heard saying:

If Adelita were to leave with another man,
I'd follow her by land and sea
if by sea, in a warship;
if by land, on a military train.

The Spanish spelling is based
on the original.

Janitzio island, Lake Pátzcuaro, Michoacán, 1949

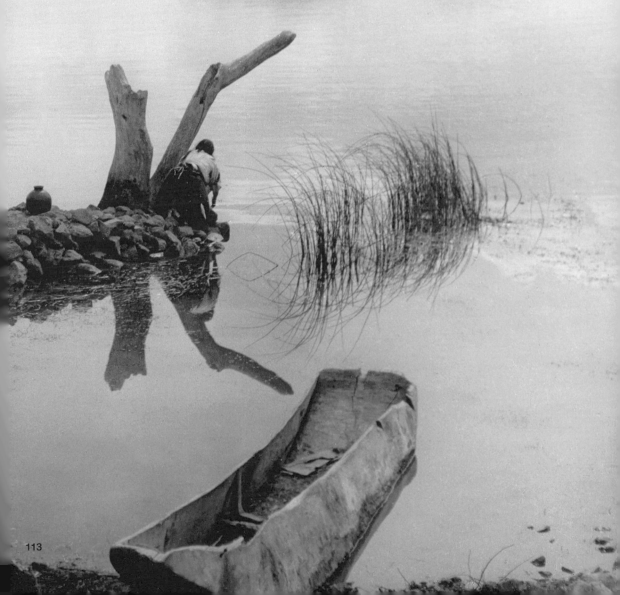

The Revolution

and Its Consequences

No direct successor followed Posada and his work: While the national Academia de San Carlos did function first as a school of graphic arts, and later as a painting school, it nonetheless upheld conservative Western ideals of art and overlooked the emerging trends in its own country. The Mexican Revolution had spurred a simultaneous revolution in the arts, which culminated in a break with the Academy and receptiveness to Europe's intellectual and artistic avant-gardes. New appointments in the Academy's directorship and reformation of the curriculum—one of the rebelling artists' first achievements—led to the founding of the first Open-Air School in 1913.[1]

The economic and political events of the Mexican Revolution allowed for the creation of a true *Kunstfrühling* or "art spring." Artists were integrated into the cultural and political life of the still-young state.[2] From the early 1920s, muralists designed historical panoramas throughout the country, mainly glorifying the goals of the Revolution, and the Mestizo population as its protagonists.[3] Revolution painting, also identified as "Mexican Renaissance,"[4] marks the start of *muralismo,* or Mexican muralism. Through graphic arts as a medium, artists expressed broad classes of the population's desires that had been unleashed through the Revolution, and by virtue of the newly won freedom of the press, continued the struggle. For this, they relied on political-pedagogic graphic arts and led the extremely high-quality, folk-oriented graphic arts to an unparalleled heyday in the first half of the twentieth century. Initially, graphic arts were the only artistic medium for expressing the people's political will and political opinion, and which represented the nation's identity in its aggressive engagement.[5]

President Adolfo de la Huerta (1881–1955) appointed the humanist José Vasconcelos (1882–1959) as Minister of Public Education in order to lower the high rates of illiteracy in Mexico. Vasconcelos introduced a humanization of the Revolution. Equipped with generous financial means, he started a fundamental, government-based educational and cultural offensive. Under the subsequent government of Álfaro Obregón (1880–1928), he reformed the school system, set up schools as well as libraries, and initiated literacy programs for the Mexican population.[6] He pursued cultural projects and fostered the fine arts through commissions for monumental murals addressing national themes. Vasconcelos propagated public, socially engaged art with content related to a specific program.

This state promotion of culture enabled the formation of the school of Mexican muralists around José Clemente Orozco, Diego Rivera, and David Alfaro Siqueiros who would enter art history as "Los tres grandes" (The Big Three). They created a new iconography of popular culture, of the Indian world, even; of the beauty of the Mexican people, their everyday lives, rituals, and festivals.

Los tres grandes
(The Big Three)

In the early 1920s, a painting tradition began to develop in Mexico with the explicit aim of creating a purely Mexican art. In 1922, Rivera, Orozco, and Siqueiros founded what was actually an art triumvirate, which with authoritative clarity glorified the national Revolution and social rebellion in large-scale murals. Rivera defined this trend as the new face of national art directed toward all people. His belief was, "Fresco painting is the collective art par excellence, which belongs to everyone and can be accessed by everyone, like public buildings [...]."[7]

Rivera received his first commission one year later. Over the course of the following four years—with a break for a short trip to Russia—he created 124 frescoes for the walls, hallways, and stairways in the building of the Ministry of Public Education in Mexico City. Rivera's representation of Mexico's social life became a characteristic expression of the country. He painted a chronological historical panorama with a large number of portraits, and additional murals on Mexico's history and culture.[8] In addition to these utopias of the Revolution were ideologically critical works created by Mexican artists such as Fernando Leal, Carlos Jurado, Fernando Castro Pacheco, José Chávez Morado, Federico Cantú, and Alfredo Zalce.[9]

At the start of the mural movement, the artists did not see the necessity of prints. They felt that the mural alone was suitable for expressing their ideas in a down-to-earth, public way. Only later did they realize that the walls bearing their paintings were available to only a limited audience, and prints would better suit their aim of broader distribution of revolutionary ideas. However, Rivera produced only a few prints, mainly reproductions of his most popular frescoes, so-called portable works, which were destined for sale CAT.136–137, P.171.[11] Siqueiros also devoted himself to prints, yet in contrast to his brightly colored, cheerful, popular painting style, his print works were contemplative and somber CAT.139, PP.44,233; CAT.140, P.173. In addition, Orozco produced several impressions of the revolutionary period in the series *Horrores de la Revolución* (The Horrors of the Revolution / Mexico in Revolution). The Armin Haab Collection contains a print from this series CAT.102, P.116. Like many works, it expresses a resigned attitude with regard to the Revolution.[12]

Many artists painted—in what was often an emotive, overly allegorical Realism—war scenes and images of the working world, the luxurious life of the middle class, and Spain's historical conquest of Mexico. They agitated against the clergy and colonialism. As an interpreter of socio-cultural reality, Rivera paved the way for Magical Realism,[13] which created a connection to Indian heritage through its frugal, symbolic gestures and tendency toward

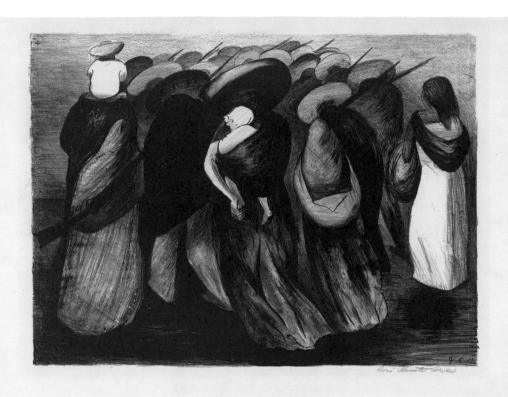

↖ CAT.102
José Clemente Orozco, *Inditos (Magueyes y nopales)*, 1929

↑ CAT.101
José Clemente Orozco, *La retaguardia*, 1929

↗ CAT.121
José Guadalupe Posada, *Admirabilisimo milagro, inexplicable prodigio*, undated

→ CAT.100
Pablo O'Higgins, *Obreros comiendo*, 1948

119

plastic modeling. The artists fell back on ancient techniques in order to rev-
olutionize art. They hereby aimed to achieve a pure, archaic, and new au-
thenticity [14] and thus bring forth an ideologically founded style, which can
be categorized between Socialist Realism and Modernism.[15] In their attempt
to produce strongly realistic works, and aided by abstraction and aestheti-
cizing, they foregrounded themes from working life aspiring toward a mood
of optimism. They demanded a turning away from European patterns and a
return to cultural traditions of the pre-Hispanic era, to Indian high culture.
Art was meant to speak to people directly, to educate; which was achieved by
the didactically oriented and publicly effective mural programs and prints as
mass-produced art. Revolutionary art aspired to the goal of having an effect
on society, or of even causing change. Radically penned manifestos served as
a basis for this.

Mexican graphic art reveals a long tradition relating to Realism, as it is
a prime medium of social communication and has an outstanding role as a
source of reception.[16] Artists took polemical positions on political issues and
showed the life of the common people in Mexico in optimistic depictions of
everyday social life and its heroes.[17] In the course of this, in 1921 a group of
avant-gardists inspired by Italian Futurism formed in search of artistic mod-
ernization and a new aesthetic. *Estridentismo* also invoked a revitalization of
print techniques, as the artists pursued the idea of having their works avail-
able to all. The Estridentists' anti-academic position later evolved further in
the group ¡30–30!

SOTPE—Sindicato de Obreros Técnicos, Pintores y Escultores
(Syndicate of Technical Workers, Painters, and Sculptors)

In 1923, Diego Rivera, Xavier Guerrero, Fermín Revueltas Sánchez, José
Clemente Orozco, Ramón Alva Guadarrama, Germán Cueto, and Carlos
Mérida published the manifesto formulated by David Alfaro Siqueiros for
the Sindicato de Obreros Técnicos, Pintores y Escultores (SOTPE) founded
in 1922.[20] The members of this syndicate of revolutionary painters, sculp-
tors, and graphic artists were combative and even militant-minded. With
their journal *El Machete* they called into existence an instrument with which
they were able to confront the state, and attempted to create the basis for a
radical, socially engaged artistic movement.[21] In it, Siqueiros wrote: "in this
very same way that you promote agricultural reform and laws protecting the
working class and our country's economic independence, you must also sup-
port democratic art, public art, that is capable of reaching all segments of
the population."[22]

The manifesto's stated goals are: "To socialize art; to destroy bourgeois in-dividualism; to reject panel painting and all other art that arises from ultra-intellectual and aristocratic circles; and to produce only monumental works for the public realm. This is the historical moment in the transition from a crumbling order to a new one, to realize a rich art for the people, rather than an expression of individual pleasure. Creating beauty that incites struggle and should therefore serve to inspire it."[23]

Likewise emerging from the manifesto was: "The art of the Mexican people is the greatest and purest intellectual expression in the world, and its Indian tradition is our greatest possession. [...] we announce that the highest goal of art [...] should be an art for all, an art of education and of the struggle."[24] In a 1938 lecture, Siqueiros formulated the goals associated with *El Machete:* "Our political development led us in a natural way, that is, functionally from the task at hand, to try out the mass production of prints. This became the occasion for the founding of the journalistic organ of the Syndicate of Revolu-tionary Artists, El Machete."[25]

After all, those viewing the murals were not the masses, but a bureau-cracy composed of ideologically antiquated followers of Porfirio Díaz; and a narrow-minded, student audience. With *El Machete*, the artists confronted new viewers: the mass of workers, peasants, and indigenous people, rather than university professors and students. The politically radical journal opened access to labor unions and agricultural communes; it was the link to the Com-munist Party. *El Machete* led the artists into the real life of Mexico, to the social problems, and introduced a battle at the level of aesthetic education. Its graphics heralded solidarity with workers and peasants. After just a few months, the journal became the official organ of Mexico's fledgling Commu-nist Party.[26] Although artists were, indeed, involved in running it, the graphic design nonetheless strongly took a backseat.

The members of SOTPE supported the campaign of Plutarco Elías Calles (1877–1945), a general and later president, in the hope that more so than any other personality in government, his decisively revolutionary position would guarantee an improvement in the situation of Mexico's productive classes.

¡30–30!
(Revolutionary and Anti-Academic Group of Artists)

"Treinta-treinta" was a group of revolutionary, anti-academic artists from the circles of the Open-Air Schools, which formed around 1928 in Mexico's post-revolutionary period. Among the founding members were Fernando Leal and Erasto Cortés Juárez.[27] The group's name refers, on the one hand, to .30–30 Winchester bullets. The corresponding rifle was the opposition's most

commonly used weapon during the Mexican Revolution. On the other hand, the term goes back to the Mexican revolutionaries' typical bullet belt, worn crossed-over, with thirty bullet pockets each. The group existed until 1930 and gathered thirty members, among them artists, patrons of the arts, and students at the Escuelas de Pintura al Aire Libre, that is, the Open-Air School. They published five manifestoes and their own journal *¡30-30! Organo de los Pintores de México,* which nonetheless appeared only three times.[28] The manifestos were aimed "against academics, public officials, thieves of public offices, and in general, all kinds of layabouts and rascals who pretend to be intellectuals."[29]

The group carried out harsh attacks against the conservative educational methods and against the teaching staff and students at the Escuela Nacional de Bellas Artes. In opposition, those attacked attempted to minimize the number of free training courses offered at community art schools.

The first manifesto was created as a broadsheet in July 1928, at the time of President Álvaro Obregón's assassination. The *Treintatrentistas* set their hopes on the continuation of Obregón's educational reforms. He had supported the Escuelas de Pintura al Aire Libre as an alternative to the art academies. The change in the political situation added fuel to insecurities in the educational system between the conservatives and avant-garde representatives. The *Treintatrentistas* furthered their demands for art education and their actions against the conservatives via four further manifestoes, a protest, their own journal, various art works, and exhibitions.[30]

Under Lázaro Cárdenas del Río (1895-1970), large estates under feudal ownership were nationalized and redistributed as *ejidos* (common land) among the collective farms. The railway was likewise nationalized. Mexico delivered weapons to Republican Spain in 1938 and in return, took in intellectuals who emigrated from the Franco government. Among those in exile were the German journalist Georg Stibi (1901-1982), the Swiss architect Hannes Meyer (1889-1954), and his wife Lena Bergner (1906-1981), who would successfully run the Taller de Gráfica Popular (TGP).[31] The nationalist attitude of the holy heritage of Indian culture replaced that of the Spanish as the epitome of all things progressive. Unions, with which many artists felt strongly connected, were allowed again. The constitution, which had been hard won during the Revolution, would finally become reality.[32]

LEAR—Liga de Escritores y Artistas Revolucionarios
(League of Revolutionary Writers and Artists)

The election of Lázaro Cárdenas del Río (1895-1970) as president in 1934 led to increasing union and political activities in the country; the Ministry of Public Education and the Department of Fine Arts supported proletarian art,

revolutionary art, and Socialist Realism.[33] A great number of artists convened in Mexico City to be a part of this. They joined together in the new organization, within which they wanted to realize their aims: receiving government commissions for murals, leading negotiations with unions, and founding a common workshop. The Liga de Escritores y Artistas Revolucionarios (LEAR) was founded 1933 at the home of Leopoldo Méndez on the initiative of the Mexican writer José Mancisidor (1894–1956) after the disbanding of SOTPE. Méndez became the first president of LEAR, which disbanded again in 1938.[34] The association was made up of sections for literature, theater, music, film, photography, painting, and printmaking, and declared itself the Mexican section of the Unión Internacional de Escritores y Artistas Revolucionarios, which was founded in the Soviet Union by the Communist International in 1930. Just a few years later, rivalry among the members led to a failure of the stated goal, for all artistically active participants to creatively engage in revolutionary happenings. Among the first members were Ángel Bracho, Xavier Guerrero, Pablo O'Higgins, and Alfredo Zalce.

The LEAR artists wanted to devote more attention to print graphics. With their works, they also reached the poorest segments of society, in particular, the workers and farmers, and in this way supported efforts to improve literacy among the rural population.[35] The direct confrontation with the population's problems resulted in a significant change in the graphic expression. The artists switched from formally challenging, expressionist graphic arts to vernacular depictions obliged to Realism.[36]

In autumn of 1935, LEAR opened the Taller-Escuela de Artes Plásticas (TEAP), a collective workshop of the fine arts section. The school was run by Ignacio Aguirre, Luis Arenal Bastar, Ángel Bracho, Leopoldo Méndez, Pablo O'Higgins, and Rufino Tamayo, among others.[37] As a political-artistic platform for Mexican intellectuals and artists, it supported the struggle against imperialism predominantly by preventing the intrusion of imperialist culture, and it also aided in the literacy campaign. The league fought in particular against growing fascist tendencies. Emerging from it in 1937 was the Taller de Gráfica Popular (TGP), which, following from José Guadalupe Posada, furthered the tradition of developing easily legible print graphics on current events; the new images would be distributed in large editions that appealed directly to the population, largely independent of commercial art activities.[38]

In 1936 LEAR sent a delegation to New York for the American Artists' Congress, where the Mexican art movement attracted great interest. Various, extremely successful exhibitions, lectures, and a workshop at the Museum of Modern Art initiated by Siqueiros were crucial in the development of Mexican graphic arts.[39] The seemingly melancholic portrait of a woman in profile by Luis Arenal Bastar, an outstanding example of mature, monumental

Mexican graphic arts, emerged from the "Siqueiros experimental workshop. A laboratory of modern techniques in art" CAT.16, P.127.

These artists' numerous activities in support of Cárdenas's struggle against fascism led to a huge upsurge in the graphic arts; the main task of art was seen in its social function and its reflection of social conditions.[40] In many cases the motifs were realistic, aggressive depictions. There were no abstract realizations in Mexico at this time. LEAR nonetheless disbanded, due to the prolonged absence of the board and several important members during their support of the anti-fascist writers' congress in Valencia, Spain in 1937. Only the section of graphic artists stayed together and remained truly loyal to the basic principles of shared work and a collective workshop.

Frente a Frente, the journal published by LEAR from 1934 to 1937, which was illustrated mainly by Méndez, was vastly important for the fine arts. The magazine reached its peak in 1937 with an edition of 10,000 copies.[41] A further key work of commercial art produced by LEAR is a two-volume textbook intended for use at night schools for workers. The government under Cárdenas supported its publication and distributed an edition of one million copies in 1938. Eleven LEAR artists worked on the 110 prints, which were meant to help workers learn to read.[42]

TGP—Taller de Gráfica Popular
(Workshop for Popular Graphic Art)

Founded under the socialist government of Mexican President Cárdenas in 1937, the Taller de Gráfica Popular (TGP) had the privilege of bringing together the most powerful exponents of print graphics, and thereby supplying the people with artistic prints via the channels that had originated under Posada's authority. The TGP was a consortium of international artists in Mexico founded after several meetings and discussions in 1937 by Raúl Anguiano, Luis Arenal Bastar, Leopoldo Méndez, and Pablo O'Higgins.[43] The collective work adhered to the defense of the people's democratic rights and aimed to not separate social goals from artistic ones. The artists who came together in TGP composed broadsides and posters with political prints for the proletariat. TGP prints shaped an entire epoch, and its reputation soon spread far beyond Mexico's borders. The workshop thereby enriched international art history in the area of print graphic productions. The majority of the works in the Armin Haab Collection are by TGP artists.

Initially the artists met in the premises of LEAR and signed their works "LEAR" and "TGP."[44] The TGP began work with its first poster for the founding of the Confederación de Trabajadores de México (CTM), the Confederation of Mexican Workers, which was the Mexican confederation of labor unions.

LOS CAÑONES DE LOS FUSILES DE LA REACCION, Y A N O DEBEN ENCONTRARTE SOLO. TU VALOR PERSONAL NO ES SUFICIENTE

NECESITAS EL RESPALDO DE TU COMUNIDAD CREA EL AMBIENTE PROPICIO POR MEDIO DE LA

Propaganda Gráfica

D. Siqueiros 1948

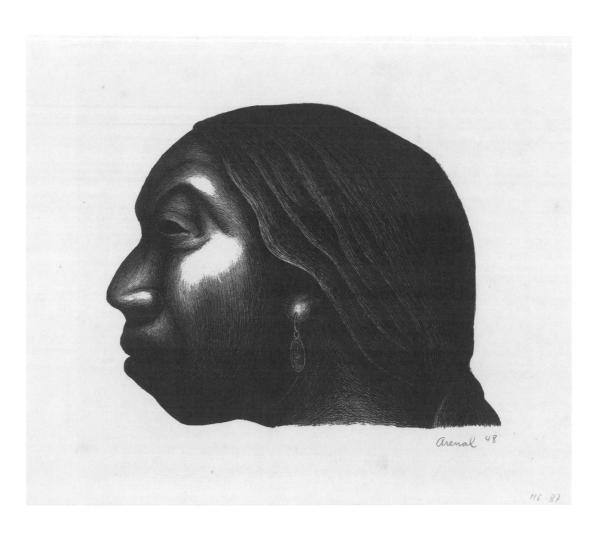

← CAT. 11
Raúl Anguiano, *Retrato de una mujer mexicana*, 1948

↑ CAT. 16
Luis Arenal Bastar, *Cabeza de indigena. Mujer de Taxco,* 1948

Telegrafos

← CAT. 45
José Chávez Morado, *Telégrafos,* 1938

↑ CAT. 49
José Chávez Morado, *Hojas gigantes,* 1950

Portfolios by individual artists and artists' associations followed. In July 1938, TGP settled into separate spaces for the print machines, a studio for design works, and a meeting and sales room. TGP's founding declaration obliged its anti-imperialistic and anti-fascist members to collective work, to favoring the interests of the people's democratic rights, to not separating social from artistic goals, and to cooperating with labor organizations.

The TGP was a free association without any legal form; nonetheless, a first declaration of principles was necessary already on March 17, 1938, in which the members established the following statutes: "This workshop was founded to support graphic production in the interest of the Mexican people. For this purpose, the workshop aims to gather as many artists as possible to improve the works with the help of a collective approach. The workshop members can realize any work, whether created individually or collectively, as long as it does not support fascism or internal reaction."[45]

The document then lists the twelve rights of the workshop and the eleven rights of the members. Guerrero designed the emblem for the TGP, which would remain unchanged until 1943.[46]

The artists worked without remuneration for the Popular Front and for the unions, which is why they and the TGP were initially not in a very good position financially. Monetary resources were rare, yet in return, the personal involvement and enthusiasm of the artists was that much greater. TGP members act with great idealism, and are politically aggressive in support of Cárdenas's policies, and against fascism. The posters and prints of the first years are unrivaled with their references to current political events, vibrant illustrations, and vivid language.

Special about the TGP from the very outset was its collective working method. Most artists were members of the Communist Party, which made it self-evident that they would work democratically and produce for the league in the Popular Front. At the members' weekly meetings, commissions were discussed, mutual critiques were given of completed works, and the necessary changes were made before being allowed to bear the TGP signature. The members did not pay dues, but contributed a portion of the profits from the print sales and delivered a certain number of copies to the archive.[47] In addition to the collectively produced prints were many individual works: graphics printed on high-quality paper for sale to tourists and collectors or to be used as exhibition pieces.[48] At the start of World War II, the TGP provided the anti-fascist press with illustrations and decorations for mass events and organized traveling exhibitions.[49]

After the end of the Cárdenas government in 1940, the TGP received only a few commissions. The strong core, comprising Leopoldo Méndez, Pablo O'Higgins, Ignacio Aguirre, Ángel Bracho, and Alfredo Zalce, remained.

However, many members left because they felt that the work in the collective was run undemocratically or it no longer appealed to them and they opened their own, commercially oriented galleries.[50] In the early years of TGP, the artists produced primarily lithographs, as all they had available was a lithography press. The most famous examples are the picturesque works by Pablo O'Higgins CAT.97, P.222, CAT.98, P.132, which emphasize the Mexican people's oneness with their environment; and the complex, finely nuanced works by Alfredo Zalce CAT.158, P.235.

Swiss architect Hannes Meyer and the TGP celebrated great success in 1943 with the publication of *El libro Negro del Terror Nazi en Europa*,[51] which revealed to Latin Americans the background and crimes of the national socialist regime. The book became an important educational weapon. The chapter "Exterminio de los Judíos" (Extermination of the Jews) by the Jewish writer Dr. Leon Weiss is illustrated by Leopoldo Méndez's work *Deportación a la muerte* from the Armin Haab Collection CAT.87, P.134. But the TGP also creatively supported the population's struggle within the country: by designing broadsides for strikes, working out teaching curricula, and becoming involved in the literacy campaigns. Using simple means, the artists produced hundreds of thousands of prints.[52] Added to that were several thousand illustrations in newspapers, magazines, and books. The TGP realized the multiple reproducibility that Siqueiros had promoted and given a theoretical base.[53] Popularity is, however, not only a question of high print runs and distribution. Posada's graphic art, which was characterized by a narrative gesture, was the role model. As a leading figure at the TGP, Leopoldo Méndez created depictions from the view of the worker rather than the artist or intellectual.[54] With his images, the successor to Posada recuperated his vernacular approach, ability, and popularity.

La Estampa Mexicana
(Publishing House of the TGP)

Upon invitation by the Mexican government under Cárdenas, Meyer, who had previously held the position of second director at Bauhaus in Dessau and had worked as an urban planner in the Soviet Union, was elected director of the newly founded Instituto de Urbanismo y Planificación with headquarters in Mexico City in 1939. His meeting with the TGP established La Estampa Mexicana publishing house[55] in 1942, where the workshop could realize its own publications and print portfolios. From 1947 to 1949 Meyer managed the press together with his wife Lena Bergner.[56] Owing to his contact with German, Italian, and Spanish exile groups, Meyer brought in new clients and assured the survival of the TGP, which served as a place for travelers to meet,

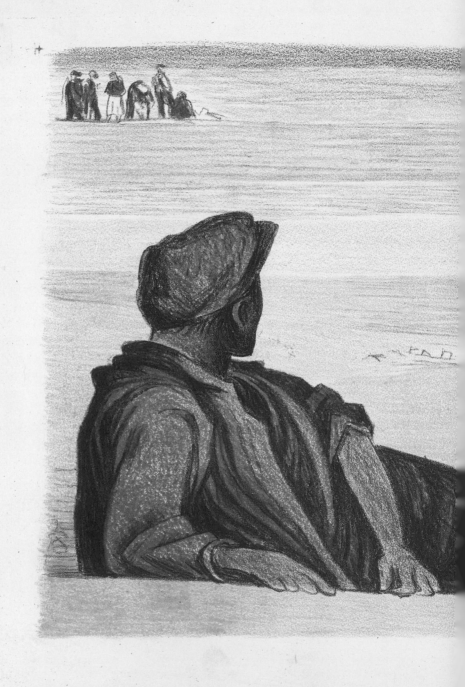

Pablo O'Higgins 1942

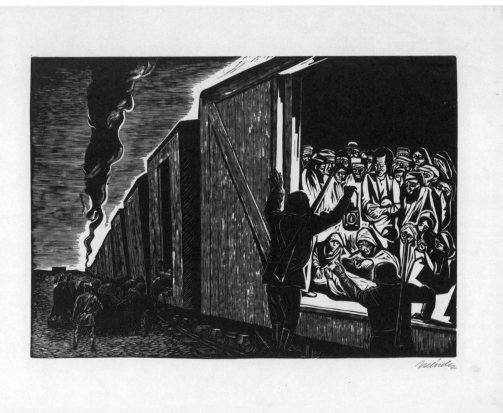

↖ CAT. 98
Pablo O'Higgins, *Atletas*, 1942

↑ CAT. 87
Leopoldo Méndez, *Deportación a la muerte*, 1942

and cooperative living.[57] The first project under Meyer's directorship was a graphic portfolio with works by José Guadalupe Posada C̅A̅T̅.̅1̅2̅2̅,̅ ̅P̅.̅2̅2̅7̅. This was followed by, among others, the seminal print portfolios of the 1940s, including *Estampas de la Revolución Mexicana* C̅A̅T̅.̅1̅7̅4̅,̅ ̅P̅.̅1̅8̅7̅ by TGP, *Mexihkanantli* by Jean Charlot C̅A̅T̅.̅4̅4̅,̅ ̅P̅.̅1̅8̅4̅, and the edition *Incidentes Méledicos del mundo* by Leopoldo Méndez C̅A̅T̅.̅9̅1̅,̅ ̅P̅.̅1̅4̅4̅, which are part of the Armin Haab Collection. Further individual works from this very collection are *El carrusel* C̅A̅T̅.̅8̅9̅,̅ ̅P̅.̅1̅3̅6̅ by Leopoldo Méndez, four travel impressions from the eight-part lithography series *Estampas de Yucatán* by Alfredo Zalce C̅A̅T̅.̅1̅5̅9̅-̅1̅6̅1̅,̅1̅6̅4̅,̅ ̅P̅P̅.̅1̅3̅8̅,̅2̅3̅5̅ as well as *Aserradero* C̅A̅T̅.̅1̅6̅3̅,̅ ̅P̅.̅1̅3̅8̅ from the *Mexican People* portfolio, which includes twelve lithographs and was published by the Associated American Artists in New York in 1946. Meyer and the TGP artists secured the German communist Georg Stibi for managerial and publishing work. Stibi, who was living in exile in Mexico, generated major financial means for the press, and established contacts with renowned galleries in the U.S.[58] José Sánchez worked as a printer at TGP and was also available for the publishing house, which thus increased the quality of the works; in addition, he inspired Francisco Dosamantes and Everardo Ramírez to return to the TGP in 1945. The association gained two further members with Jesús Escobedo and Ramón Sosamontes.

Meyer set up a photo archive of all works and separated the publishing house from the workshop. In addition to further achievements, he secured a new printing machine for the TGP and organized the production of a film providing information about the TGP and its works. Under Meyer's leadership, 1,500 lithographs, 24,000 postcards, and more than 60,000 prints were produced within a mere two years.[59] However, more than half of these runs were allotted to the portfolio produced in 1947, *Estampas de la Revolución Mexicana* C̅A̅T̅.̅1̅7̅4̅,̅ ̅P̅.̅1̅8̅7̅.[60] The popular edition is the result of a detailed study of the most recent phase of Mexican history and includes eighty-five plain linocuts on colored paper on the Revolution's progression designed by sixteen artists. It was the house's first publication in which all members of the TGP were involved. The lithograph album was not a luxurious product for North American collectors, but rather, an affordable edition for the national market. The prints were also published as a series in the daily papers, which, in addition to the typical black-and-white linocut impressions, explains the popularity of the images.[61] The prints link up with well-known pictures and must have been immediately recognizable by the Mexican people as they are modeled on illustrations of the Revolution, photographs from the Casasola family, and film recordings made during the Revolution by Mexico's first filmmaker, Salvador Toscano (1872–1947).

The new principles formulated by the members of the TGP are on the cover of the portfolio *Estampas de la Revolución Mexicana:* "The TGP is a

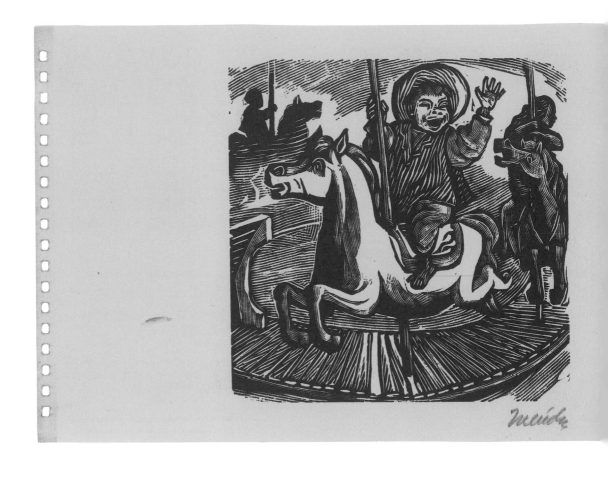

↑ CAT. 89
Leopoldo Méndez, *El carrusel,* 1948

↗ CAT. 162
Alfredo Zalce, *Títeres,* 1946

→ CAT. 19
Alberto Beltrán, *Danzantes de los Indios (Fiesta en Chiapas),* 1948

(59)

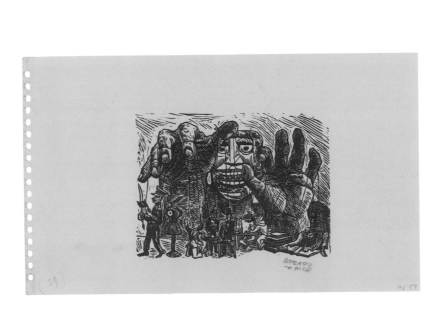

M6 59

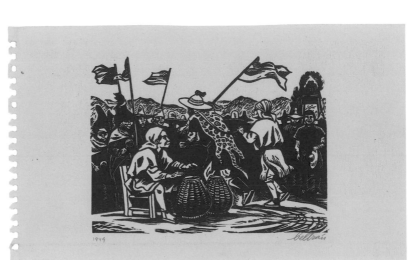

1949

beltran

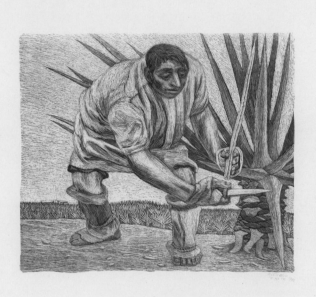

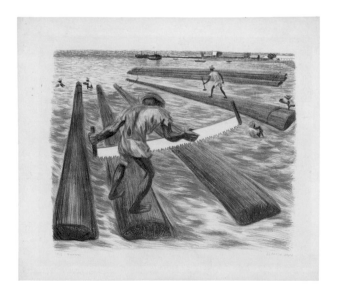

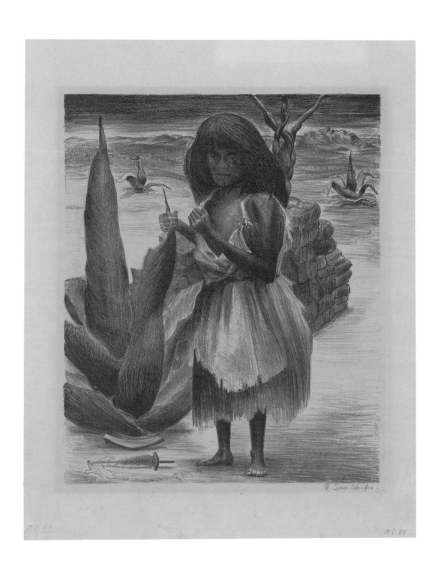

↖ CAT. 161
Alfredo Zalce, *Cortando henequén,* 1945

← CAT. 163
Alfredo Zalce, *Aserradero,* 1946

↑ CAT. 141
Ramón Sosamontes, *Niña otomí,* 1946

center of collective work for the functional study and production, of the different branches of engraving and painting. The TGP undergoes a constant effort in order to benefit by its works the progressive and democratic interests of the Mexican people, especially in the fight against fascist reaction. Considering that the social claim of plastic art is inseparable from good artistic quality, the TGP strives to develop the individual technical capacity of its members. The TGP lends its professional cooperation to similar workshops and cultural institutions, to popular or labor organizations, and to all progressive movements and institutions. The TGP protects the professional interests of all artists. Mexico City, March 1945." [62]

In addition to numerous postcard series, the press also published two albums: *Río Escondido* by Leopoldo Méndez (two individual prints are in the Armin Haab Collection) CAT. 88-1+2, P. 198 and *Vida en mi barriada* by Everardo Ramírez (two individual prints depicting the various professions of the inhabitants of Coyoacán, also in the Armin Haab Collection) CAT. 133-1+2, PP. 141, 232. Meyer personally wrote a monograph about the TGP's first twelve extremely productive years. There were roughly twenty-five active members and just as many guest members at this time and ten to fifteen members were always active in the workshop, including almost all of the founding members. [63] As World War II came to a close, many of those in exile left Mexico, signifying a new phase for the TGP. Among those who left was Stibi, who returned to Germany in 1946. Additionally, the departure of Meyer in 1949 meant an abrupt end to the publishing house; only the workshop continued to work successfully. [64] As a whole, with all of the works of the 1950s, an incredible oversimplification of technique can be detected, which can be traced back to mass production and the new, young members still in search of their own style.

In the 1950s, the TGP produced its final works as art for the people. In 1952 the TGP artists were awarded the Premio Internacional de la Paz of the World Peace Council, which would be handed over in Vienna a year later to Leopoldo Méndez for his artistic works opposing the war. [65] The TGP thereby attracted attention not only in Mexico, but also throughout the world. Several countries held exhibitions of Mexican prints.

The TGP artists adopted Posada's folk art style and contemporariness, the Open-Air Schools' expressionist view of nature, the mural movement's monumentality and collective work, and the political clarity and didactics from the literacy campaigns. [66]

Leopoldo Méndez was able to seamlessly unite the TGP's art and program over the course of twenty years. Méndez's leadership, which was polemic and dogmatic, but always driven by a sense of social justice, did not go unnoticed. Thematically and artistically, his work in graphic arts was congruent

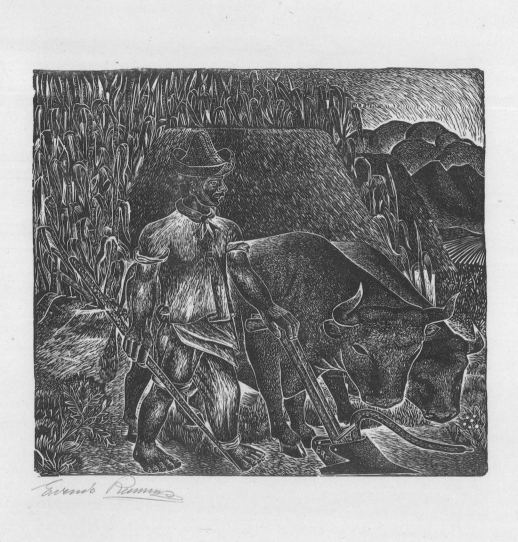

↑ CAT. 133-1

Everardo Ramírez, *La tierra. El campesino,* 1948

with the goals of the TGP, which he embodied, par excellence. Other artists, such as Ignacio Aguirre, imitated his skilled linocut technique. Characteristic of Méndez's prints are parallel, cross-layered fine lines, which he created with the typical multiple cutting tools used for woodcut.[67] After the war he was occupied with depictions for which he fell back on pre-Hispanic forms and decoratively expressive animal fables based on Maya songs written in the indigenous language Náhuatl CAT. 91, P. 144. The successful interplay of texts, note samples from folk music, and the forty illustrations by Méndez caused quite a sensation and was awarded first prize for Mexico's most beautiful illustrated book in 1946.[68]

His first attempts at uniting prints with film began in 1947 CAT. 88-1+2, P. 198. Méndez also worked on a plan for so-called graphic murals, the first being commissioned in 1947 by the UNESCO for their first congress, which was held in Mexico.[69] He was by far the most talented and diverse graphic artist in Mexico and had a great influence on other graphic artists.

The Instituto Nacional de Bellas Artes (INBA) organized a postwar exhibition of Mexican art at the Venice Biennale in 1950 with Rivera, Siqueiros, Orozco, and Tamayo. Their works were also the focus of the exhibition in Paris in 1952. The exhibitions attracted an extraordinary amount of attention, whereupon the INBA sent exclusively print works to the biennials. Successful exhibitions followed in other cities in Europe and beyond, such as in Moscow and China. After all, the print is the exemplary medium for understanding the fundamental tasks and effectiveness of the artistic work.[70]

FNAP—Frente Nacional de Artes Plásticas
(National Front for Visual Arts)

In an appeal to all artists in Mexico, a national congress was called in 1952 in order to achieve closer ties to cultural policies and continue the support of cultural exchange. The main demands were aimed at the state and private patrons. Grievances were aired about their lack of commitment to Mexico's young artists who received little public support.[71] It was mainly the TGP who advocated for a government program to benefit artists. Almost half of the TGP members were likewise members of FNAP, which is why primarily projects and exhibitions related to print graphics could be realized. Revolutionary graphic arts were shown in the socialist countries of Eastern Europe as a contrast to the exhibitions taking place worldwide, organized by the Ministry of Foreign Affairs with objects from the pre-Hispanic epochs. This great interest in pre-Hispanic and modern Mexican art led to a great number of international catalogs, reviews, and critiques, among others, from Armin Haab *(Mexikanische Graphik, 1957)*.

TGP—1950s to 1960s

In 1956 Mexico held numerous national commemorative celebrations in honor of Benito Juárez's 150th birthday CAT. 21, P. 64 and the 100-year anniversary of the constitution, which represented the peak of the liberal reform movement. The VII Feria del Libro Mexicano (Mexican Book Fair) 1956 was shaped by the festivities and the artists contributed more than fifty prints to the theme. The TGP had its own s ales stand where a new album with twenty-three reproductions of new prints by the members was sold for just nine pesos each CAT. 175, PP. 201, 238. Within just four weeks, 33,000 prints had been sold at the book fair. In order to continue to satisfy demand, prints were made on colored tissue paper on a printing machine set up for demonstration purposes and sold for one peso each.[72]

Joining the workshop in the 1950s and 1960s were many new, young members who had narrowed their studies more and more to the graphic art forms developed in Mexico by Posada and Méndez, and also mural painting rather than learning from European or North-American role models. Individual works had less of a commercial arts character and were more artfully designed. Among the outstanding talents were Alberto Beltrán, Celia Calderón de la Barca, Arturo García Bustos, Andrea Gómez, Adolfo Mexiac, Fanny Rabel, and Mariana Yampolsky, who depicted Mexican women and children in a downright emotional way.

In the late 1950s in Mexico, abstract art began to carve out its place alongside Realism. The young artists practicing this style, still little known in Mexico, began to vehemently criticize the TGP for its stagnation and adherence to old forms. The new statutes of the TGP in 1956 nonetheless represented the preservation and fostering of America's national cultures, the strengthening of cultural exchange, and the defense of free expression. For the twentieth anniversary of the TGP in 1957, exhibitions and a commemorative publication were planned and prints were produced in the popular papers, which led to their extremely broad distribution. The seminal exhibition *Vida y drama de México. 20 años de vida del Taller de Gráfica Popular* at the Palacio de Bellas Artes in Mexico City rounded out the anniversary celebrations.[73] Nonetheless, arguments flared up around the leadership and the political orientation within the association, which led to the downfall of commonalities in the group. A broad palette of non-figurative art was shown for the first time in 1958 at the Bienal Interamericana de Pintura y Grabado (Inter-American Biennial of Paintings and Prints) in Mexico City. The TGP ultimately ruptured in 1960, and many artists left. The remaining active members no longer worked collectively, which led to a change in the statutes; moreover, the workshop remained largely empty, and there were no longer any regular assemblies.[74]

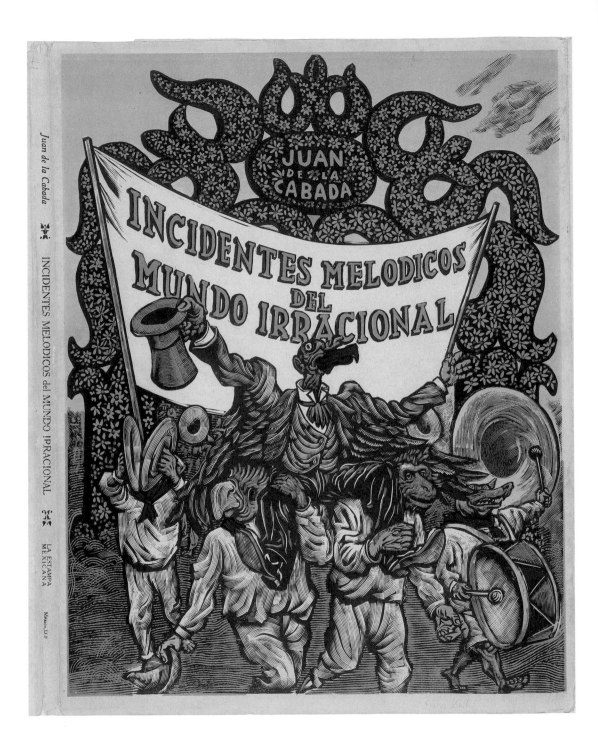

↑ CAT. 91-A
Leopoldo Méndez, *Incidentes melódicos del mundo irracional*, 1944

CAT. 91-B

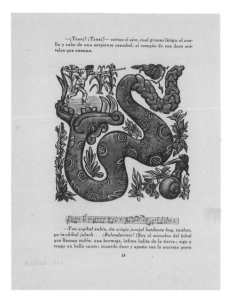

CAT. 91-1

CAT. 91-2

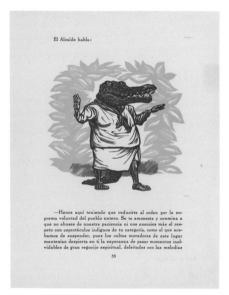

CAT. 91-3

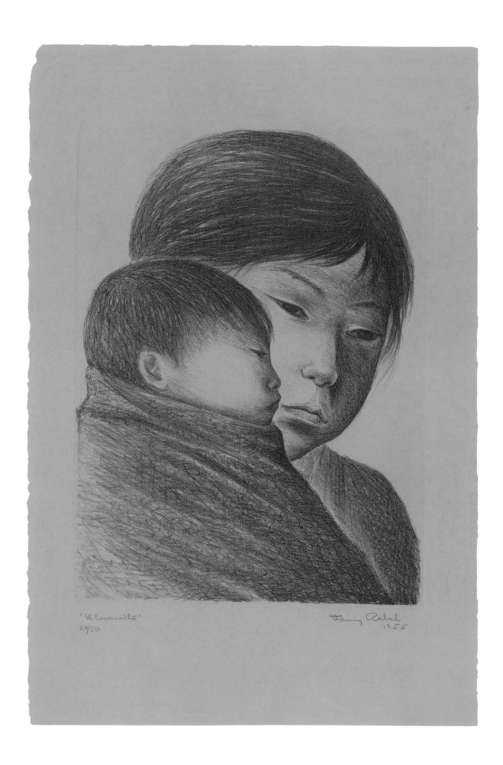

"El hermanito"
20/50

Fanny Rabel
1955

↑ CAT. 128
Fanny Rabel (Rabinovich), *El hermanito. Niño enfermo,* 1955

Those involved politically in defending the national culture remained in the TGP for the time being, among them, Ignacio Aguirre, Ángel Bracho, Elizabeth Catlett, Celia Calderón de la Barca, Arturo García Bustos, Marcelino L. Jiménez, Francisco Luna, Francisco Mora, Adolfo Quinteros, and Ramón Sosamontes. Particularly notable are the depictions by Elizabeth Catlett, which are defined by a round, calm form, and rigorously modeled edges CAT.34–36, PP.149, 213, as well as the large-format, somber linocuts by Adolfo Quinteros CAT.124–125, PP.151, 231. However, the TGP also noted new entries of still unknown young artists coming from the Academy. The Méndez disciples, who were interested in the development of art, resigned; among them, Andrea Gómez, Adolfo Mexiac, Pablo O'Higgins, and Mariana Yampolsky. From then on, the development of Mexican print graphics occurred outside of the TGP. Most of the artists whose works are represented in the Armin Haab Collection resigned in the late 1960s. The TGP, which still officially exists today, has meanwhile shifted its activities to the "enrichment of national culture," and has largely retreated from politics.[75]

For decades, the TGP's public actions shed light on its ideologies and ambitions. The workshop, which was founded in politically turbulent times, attempted to influence the fate of the country, in its own, clarifying way, and in exchange, assumed social responsibilities. Since a non-representational or even surreal formal language was incomprehensible for the people, the TGP's artistic directors—first Leopoldo Méndez and later Ignacio Aguirre—dogmatically limited themselves to working towards clear, representative illustration. Similar to Posada's era, when metal engraving in black-and-white appeared as an inexpensive and easy-to-handle method for mass production, the TGP preferred the single-color linocut to the manufacture of lithographs, which were more expensive and more elaborate.[76] Due to the collaborative work, the TGP oeuvre is, as a whole, relatively homogenous in retrospect, but individual stylistic developments did occur over the course of its long history. After all, the workshop was also distinguished by the individual artistic achievements of its members. The TGP's production is without a doubt a pinnacle in twentieth-century graphic arts.

Sociedad Mexicana de Grabadores
(Mexican Association of Graphic Artists)

The independent abstract graphic artists, rebelling against the TGP, joined together in the Sociedad Mexicana de Grabadores in 1947 to counter TGP's monopoly on exhibitions. Abelardo Ávila, Ángel Zamarripa Landi, José Julio Rodríguez, and others founded the society and did not commit to either a political ideology or collective work. The society did not have a shared workshop or

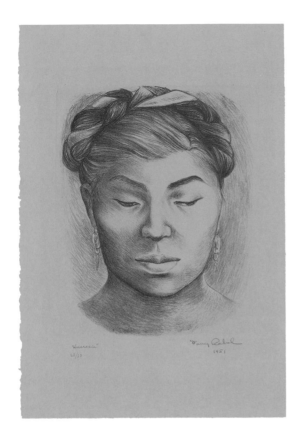

↑ CAT. 126
Fanny Rabel (Rabinovich), *Lucrecia, 1951*

↗ Diego Riveras' model Nieve, Hacienda Vista Hermosa, Cuernavaca, 1949

→ CAT. 35
Elizabeth Catlett, *Mother and Child,* 1947

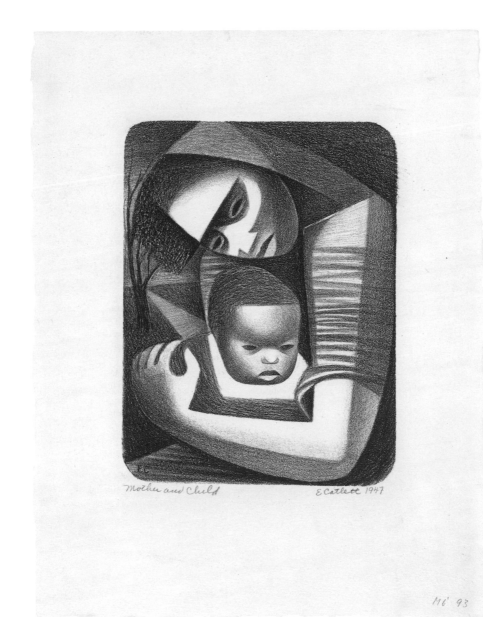

Mother and Child E Catlett 1947

MC '93

149

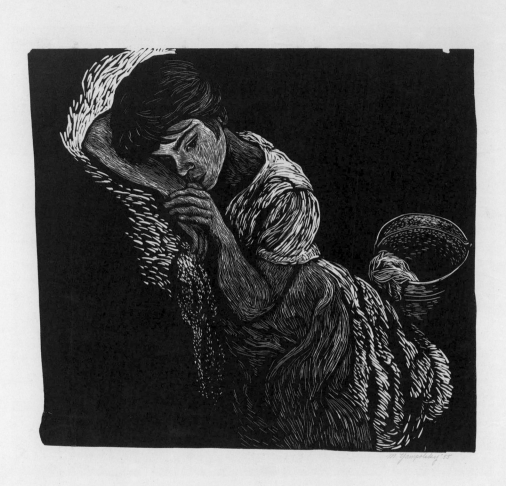

↑ CAT. 155
Mariana Yampolsky, *Descanso*, 1955

→ CAT. 125
Adolfo Quinteros, *Tarahumara (Raramuri)*, 1959

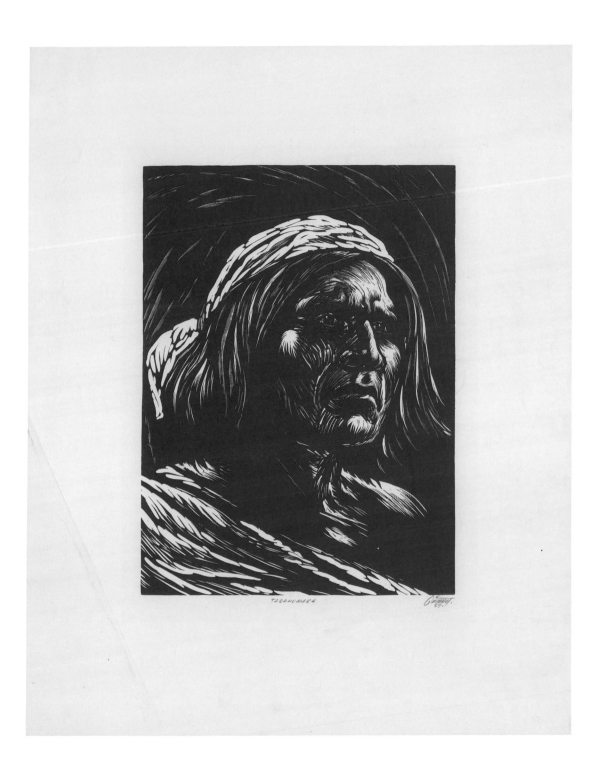

TARAHUMARA

gallery. It saw its aim in merely sharing workspace, exchanging artistic experiences, and organizing group exhibitions. It allowed great scope to the personal freedom of its members. The artists created graphic arts committed to fine handicrafts. The society aimed to foster new techniques in the graphic arts and depoliticize the works' contents. Several TGP members also joined later. In the 1950s, Erasto Cortés Juárez determined the society's fate by organizing a number of exhibitions and the publication of several books.[77]

Artists who had never belonged to an association, or only briefly, created and worked according to their own ideas. Abelardo Ávila CAT.17, P.154, Francisco Dosamantes, Delfino García CAT.72-74, PP.156,219, Agapito Rincón Piña CAT.135, P.157, and Isabel Villaseñor CAT.153, P.155, for example, relied on nineteenth-century motifs. García and Amador Lugo Guadarrama presented mainly naïve looking subjects from the everyday peasant life, which employed the tendency toward Indian colored folk art derived from mural painting. Unaffected by the political commotion, their scenes showed simple modesty and drama, and furthermore, dealt with themes such as tragedy, melancholy, and romance. Examples of this are Castro Pacheco's picturesque lithographs CAT.29,32-33, PP.159,213, which he devoted himself to alongside the striking, roughly carved linocuts, or Ramírez's somber works in a style characterized by fine, white lines CAT.133-1+2, PP.141,232. In addition, however, are the lively encounters with the Mexican people, which are the focus of the works by Luis Arenal Bastar CAT.16, P.127, Francisco Dosamantes CAT.59-66, PP.203,217, and Guillermo Monroy. José Miguel Covarrubias, who was extremely successful as a young graphic artist in New York, is also worthy of individual mention. He was able to reduce the typical elements of a worldwide folklore to a decorative but nonetheless utterly masterful formula CAT.53-56, PP.164,217.

Abstract Mexican Graphics

The socio-politically motivated, agitating print graphics of the first half of the twentieth century was shaped by Realism, which was easy to process for the Mexican population, the majority of whom were unable to read or write. A confrontation with avant-garde art thus began relatively late. In literature, a new, modernist artistic movement led to the founding of the intellectual group Los Contemporáneos quite early on. Their goal was for Mexico's fine arts to also open up to international currents and move away from nationalism at a cultural level. Avant-garde trends in Mexican art, which no longer acted politically, initiated a synthesis of international modernism and the potential of the pre-Hispanic culture.[78] Los Contemporáneos artists, such as Rufino Tamayo and Francisco Toledo, broke away from Realism and turned to Abstract Expressionism. They were successful in formulating a language with which

they could continue the search for what was innately Mexican; not necessarily anecdotal and representational elements, but rather, Mexico's traditions.[79] In contrast to the realists' narrative works, the works created in this countercurrent—by the Grupo de contracorriente—have a strong poetical sense, as discernible in works by Tamayo, Toledo, and Leticia Tarragó. They are responsible for the development of an independent artistic expression that reflects the essence of the Mexican people.

In his abstract-figurative lithographs, Tamayo brings together a modernist pictorial language with design principles from the pre-Hispanic cultures.[80] His prints show a view that relates purely to the artistic element, allowing him to condense Mexican themes in a surrealist style, as known in Europe CAT.145, P.207, and also schematize figures and animals to their essentials through simplification and reduction CAT.142-147, PP.165,233. Tamayo succeeded in introducing Mexico's archaic folk art to the avant-garde. Also, the works by Toledo, which achieve a connection to Mexico's Zapotec civilization and the mythology of the pre-Hispanic people, can be viewed in this context. He considers the animal as an allegory of everything living, as a symbol of fertility and sensuality.[81] Toledo's self portraits are also highly significant CAT.152, P.167. Decomposed into individual elements, they draw their inspiration from the fundus of indigenous art.

Leticia Tarragó and Maria Luisa Parraguirre likewise distance themselves from Realism in their work. In a surrealist style, Tarragó combines figures and motifs from everyday life with fantastical animals and fictive architecture. Dreamlike children's stories seem transported in tangible images CAT.148+149, PP.169,234: mixing fantasy and reality without constraints.[82] In contrast, Parraguirre has devoted herself to vegetable motifs from the 1970s onward. She employs plant-like elements compositionally and in this way, achieves a structure of poetic landscapes CAT.106+107, P.223.

Mexican print graphics pursued the rhythm of the country's history for decades and documented the dawn of an independent nation. From Posada's macabre *calaveras* to the TGP's socially engaged prints, graphic arts transformed to Tamayo's surreal figures. Mexico's prints, in addition to its tremendous mural painting, were the source from which the "Mexican Renaissance" gained in scope and significance. The graphic arts are among the most popular art genres there. Although contemporary artists no longer present a uniform image, traditional print techniques continue to expand and Mexican graphic arts are currently realized in a way that is as universal as it is country-specific. Their particular "Mexican," that is, popular, appeal and active political engagement has transformed along with internal politics.

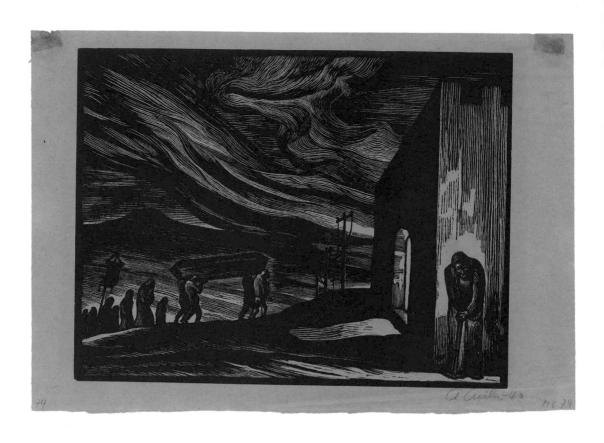

74

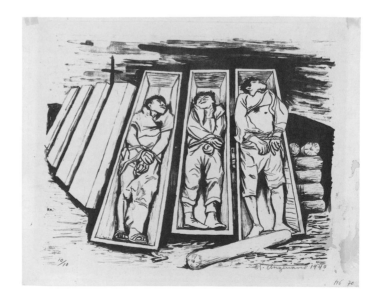

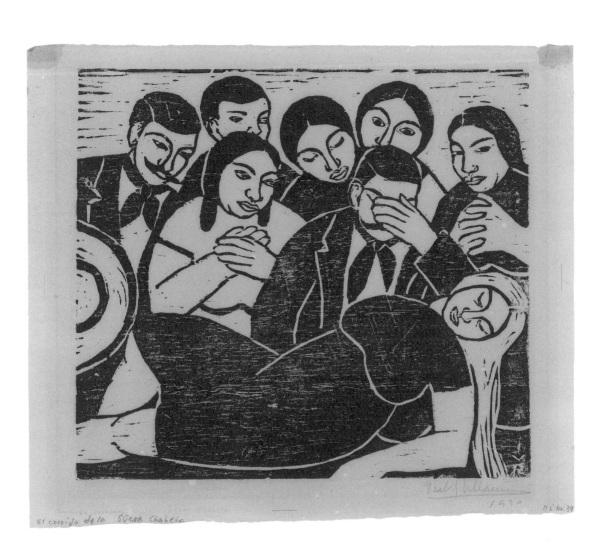

El corrido de la Güera Chabela

↖ CAT. 17
Abelardo Ávila, *Al cementerio,* 1940

← CAT. 9
Raúl Anguiano, *Campesinos asesinados. Víctimas de las guardias blancas,* 1940

↑ CAT. 153

155 Isabel Villaseñor, *Corrido de la Güera Chabela,* 1930

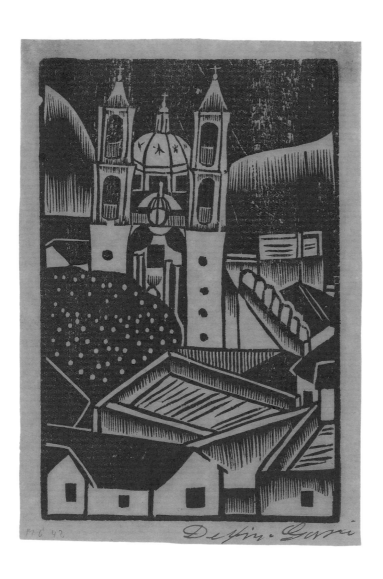

↑ CAT. 73
Delfino García, *La catedral de Taxco*, 1939

→ CAT. 135
Agapito Rincón Piña, *Guanajuato*, 1953

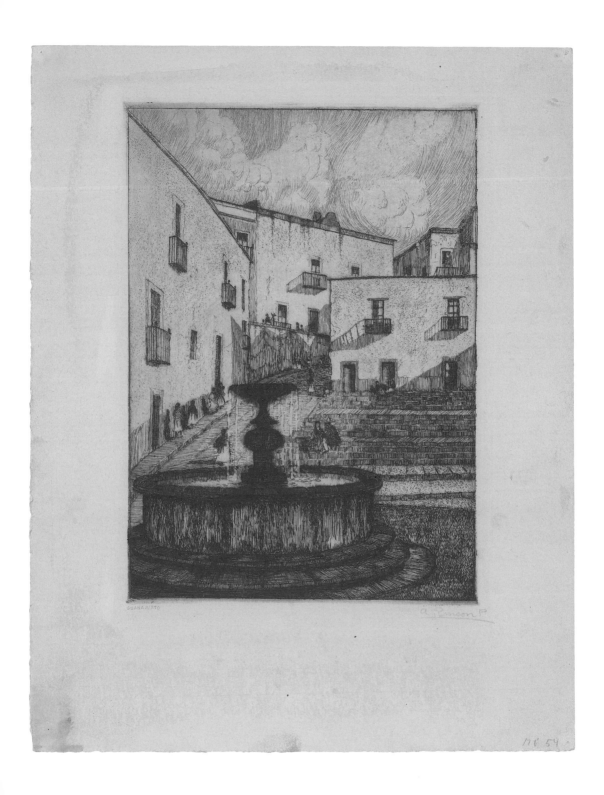

GUANAJUATO

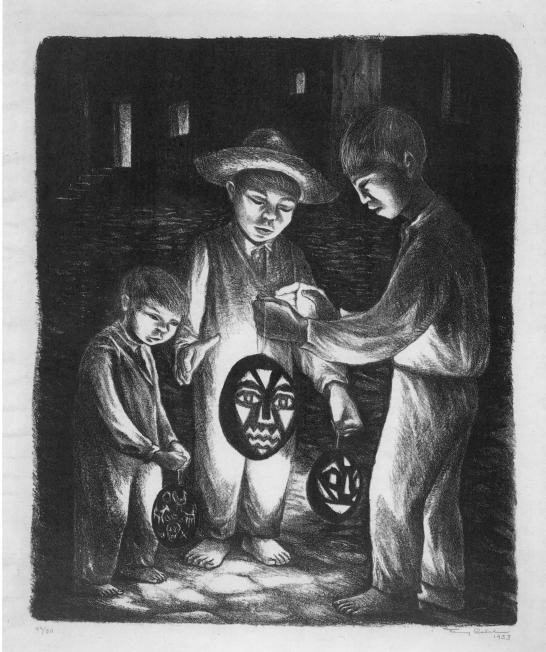

47/50

Fanny Rabel
1953

Noche de difuntos chicos

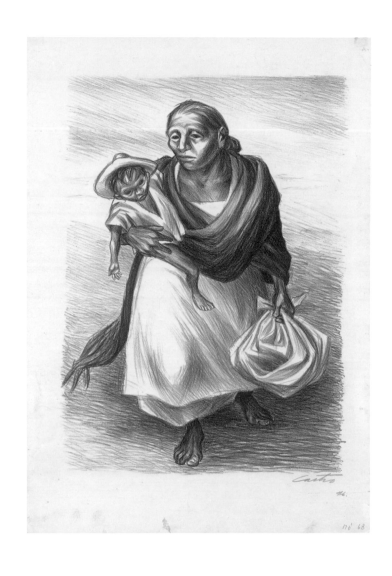

← CAT. 127
Fanny Rabel (Rabinovich), *Noche de difuntos chicos,* 1953

↑ CAT. 29
159 Fernando Castro Pacheco, *Mujer y niño (La vida en marcha),* 1946

1] Referred to here is the Santa Anita Open-Air School. Further *al aire libre* schools followed, which offered good educational opportunities for graphic artists. They dealt with pre-Hispanic and also common art themes. By integrating Mexican docents they supported the national arts. European-centered cultural policies and a backward-oriented teaching program were reserved for the Academy. See Sylvia Pandolfi, "Die Malschule im Freien (1913–1935)," in Vienna 1988, pp. 130–136.

2] See María Carmen Ramírez, "Nationalismus und Avantgarde: Ideologische Bilanz der mexikanischen Wandmalerei 1920–1940," in Vienna 1988, pp. 104–108.

3] Einfeldt 2010, p. 54; see Schlirf 1974, pp. 63–71.

4] Einfeldt 2010, p. 46.

5] See Siqueiros 1975, pp. 208–216. The manifesto by Dr. Atl [Gerardo Murillo] directed at young Mexican artists in 1906 proposed an art that is open and focused on the problems of the nation and the people. This resulted in the students' strike against the Academy of Fine Arts in 1911, with the goal of artistic innovation.

6] Carlos Monsiváis, "Der Muralismo und sein Publikum," in Berlin 1982, pp. 11–12.

7] Diego Rivera, quoted by Münzenberg 1928 [unpag.].

8] The frescoes cover an area of 1,500 m^2. See Lozano/Coronel 2008, pp. 28–33; Einfeldt 2010, pp. 47–48; Münzenberg 1928.

9] See Hans Haufe, "Der Muralismo – Eine Kunst der Selbstbegründung," in Vienna 1988, pp. 91–103.

10] Prignitz 1990, p. 23; Siqueiros 1975, p. 115.

11] Indych-López 2009, pp. 151–153.

12] See Orozco 2004. The series is from 1913–1917. The prints were listed among the best lithographs in the U.S. in 1928 and were created based on paintings *(The Horrors of the Revolution/Mexico in Revolution)*. The back sides of the departing *soldaderos* and *soldaderas* in *La retaguardia* correspond with those on the Revolution fresco in the Escuela Nacional Preparatoria. See Indych-López 2009, pp. 66–67.

13] See "Magischer Realismus," in Röhrl 2013, pp. 218–219.

14] See the works by Jean Charlot and Fernando Leal; David Alfaro Siqueiros, *A un joven pintor mexicana. Colección de los mensajes,* Mexico City: Empresas Editoriales, 1967, p. 12; Leonor Morales, *Arturo García Bustos y el realismo de la escuela mexicana,* Mexico City: Universidad Ibero-americana, 1992.

15] Herrera/Valero 2001, pp. 50, 56; cf. also Siqueiros 1975, pp. 208–239.

16] Kenzler 2012, p. 580.

17] See Röhrl 2013, pp. 234–240.

18] *Estridente,* Spanish for "shrill, dazzling." *Estridentismo* is the name of Mexico's avant-garde movement. The manifesto was written by Manuel Maples Arce (1898–1981).

19] Flores 2013, pp. 1, 2, 17, 21, 27, 42, 45, 167, 265, 281.

20] The first manifesto of the Syndicate of Technical Workers, Painters, and Sculptors—written by Siqueiros—was signed on December 9, 1923 by Ramón Alva de la Canal (1892–1985), Germán Cueto (1893–1975), Ramón Alva Guadarrama, Xavier Guerrero (1896–1974), Carlos Mérida (1891–1984), José Clemente Orozco, Fermín Revueltas Sánchez (1901–1935), and Diego Rivera.

21] *El Machete* is a Mexican journal that was published from 1924 to 1938 by SOTPE, which Úrsulo Galván Reyes and David Alfaro Siqueiros edited as editors-in-chief, printed in oversize format in red and black. The paper's four-line motto was penned by Siqueiros's wife, Graciela Amador (†1951): "El Machete sirve para cortar la cana / para abrir las veredeas en los bosques umbrios / decapitar sulebras, tronchar toda cizana / y humillar la sobreria de los ricos impios." (The machete is used to reap cane, / To clear a path through an underbrush, / To kill snakes, end strife, / And humble the pride of the impious rich.) See John Lear, "Revolución en blanco, negro y rojo: arte, política y obreros en los inicios del periódico *El Machete*," in *Signos Históricos,* no. 15, January–June, Iztapalapa 2006, pp. 108–147; Fabio Sousa, "El Machete: prensa obrera y comunismo en México," in *Fuentes Humanísticas,* vol. 28, 2nd half of the year, no. 49, Azcapotzalco 2014, pp. 171–180.

22] David Alfaro Siqueiros, *A un joven pintor mexicano. Colección de los mensajes,* Mexiko-City: Empresas Editoriales, 1967; see Siqueiros 1975, p. 270.

23] "Socializar el arte. Destruir el individualismo burgués. Repudiar la pintura de caballete y cualquier otro arte salido de los círculos ultraintelectuales y aristocráticos. Producir solamente obras monumentales que fueran del dominio público. Siendo este momento histórico, de transición de un orden decrépito a uno nuevo, materializar un arte valioso para el pueblo en lugar de ser una expresión de placer individual. Producir belleza que sugiera la lucha e impulsa a ella.", in *Autobiografía de José Clemente Orozco,* Mexico: Ediciones Era, 1999 (original edition 1945), pp. 66–67; German translation in Berlin 1974, p. 143.

24] Berlin 1982, pp. 134–135.

25] Berlin 1974, p. 141.

26] Partido Comunista Mexicano (PCM), 1919–1981; Adalbert Dessau, "Die ideologische Basis," in Berlin 1974, p. 75.

27] Additional important members are: Rosario Cabrera, Ramón Alva de la Canal (1892–1985), Martín Casanovas (1894–1978), Francisco Díaz de Leon (1897–1975), Gabriel Fernández Ledesma (1888–1939), Leopoldo Méndez, Fermín Revueltas Sánchez (1901–1935), and Rafael Vera de Córdova.

28] ¡30–30! 1993; Marley 2014, pp. 69, 562; Helga Prignitz, "Zur Volkstümlichkeit der politischen Grafik in Mexiko," in Berlin 1974, pp. 99–100.

29] "Los academicos, los covachuelistas, los salteadores de puestos públicos y en general contra toda clase de zánganos y sabandijas intelectualoides." Cf. El Grupo de Pintores ¡30–30! 1er. Manifiesto Treintatrentista, Mexico City: [s. n.], 1928, see International Center for the Arts of the Americas at the Museum of Fine Arts, Houston, Documents of 20th-century Latin American and Latino Art. A digital archive and publications project at the Museum of Fine Arts, http://icaadocs.mfah.org, last accessed: February 2016.

30] El Grupo de Pintores ¡30–30!. 1er. Manifiesto Treintatrentista, Mexico City: [s. n.], 1928, photocopy, private archive of Fernando Leal Audirac, Milan, see International Center for the Arts of the Americas at the Museum of Fine Arts, Houston (see note 29), last accessed: February 2016; Leticia Torres, CURARE. Espacio crítico para las artes, Mexico City, see http://icaadocs.mfah.org, last accessed: February 2016.

31] Pohle 1986, p. 24.

32] See Tibol 1974, pp. 91–95.

33] Carlos Monsiváis, "Die Moderne und ihre Feinde: Zur Entwicklung der zeitgenössischen Kultur in Mexiko," in Vienna 1988, p. 58.

34] Prignitz 1981, pp. 27–55; LEAR fell apart due to an argument between rival artists Rivera and Siqueiros.

35] In 1921, Obregón called to life the Misiones Culturales (Cultural Missions), which were supported by Cárdenas. Almost all LEAR members worked in these Cultural Missions until they disbanded in 1938. See Tibol 1974, pp. 92–93.

36] Prignitz 1981, p. 12.

37] Caplow 2007, pp. 111–113.

38] Münzberg/Nungesser 1981, p. 204.

39] Me llamaban el Coronelazo. Memorias de David Alfaro Siqueiros, [Mexico]: Grijalba, 1977.

40] Tibol 1974, p. 93.

41] Prignitz 1981, p. 46. This is with reference to the March 1937 volume.

42] Libro de lectura para uso de las escuelas nocturnas para trabajadores, primer grado, series S. E. P., Mexico City: Comisión Editora Popular de la Secretaría de Educación Pública, 1938.

43] Important members in TGP's early days included: Aguirre, Anguiano, Arenal Bastar, Bracho, Chávez Morado, Castro Pacheco, Guerrero, Méndez, Ocampo, O'Higgins, Paz Pérez, Pujol, Ramírez, and Zalce. Work by most of these graphic artists is represented in the Armin Haab Collection. Cf. Prignitz 1981, pp. 56–243.

44] At first the sheets were stamped with the imprint TEGP (Taller Editorial de Gráfica Popular), as originally the workshop also considered itself a publishing house.

45] "Estatutos del Taller de Gráfica Popular, aprobados en la Asamblea General del 17 de marzo de 1938," photocopy, Francisco Reyes Palma Archive, Mexico City, see International Center of the Arts of the Americas at the Museum of Fine Arts, Houston (see note 29); last accessed: February 2016: "Este taller se funda con el fin de estimular la producción gráfica en beneficio de los intereses del pueblo de México, y para ese objeto se propone reunir al mayor número de artistas alrededor de un trabajo de superación constante, principalmente á través de método de producción colectiva. Todo producción de los miembros del Taller, sea individual o colectiva, podrá realizarse en tanto no tienda de alguna manera á favorecer á la reacción o al fascismo."

46] Ill. see Priginitz 1981, pp. 60–61.

47] By the end of the 1960s, the print archive grew to more than 10,000 works. Parts of the archive were auctioned off by the TGP in the early 1970s to bridge tight financial times.

48] Prignitz 1981, p. 13.

49] Helga Prignitz, "Zur Volkstümlichkeit der politischen Grafik in Mexiko," in Berlin 1974, p. 103.

50] Prignitz 1981, p. 80.

51] Hannes Meyer, *El libro negro del terror nazi en Europa. Testimonios de escritores y artistas de 16 naciones,* Mexico City: El libro libre, 1943. Meyer took over design of the Spanish edition of the publication *Schwarzbuch über den Nazi-Terror in Europa* and took over the selection of illustrations by Aguirre, Bracho, Méndez, O'Higgins, and Paz Pérez. Noack 2000, p. 97. The publication appeared in what was a remarkably high run for a first edition—10,000 copies—considering the Latin-American conditions of the time. See Pohle 1986, pp. 276–277; Kiessling 1974, vol. 1, pp. 220–221, 228–230, vol. 2, pp. 270–273; Kiessling 1980, p. 444.

52] Cf. Berlin 2002.

53] David Alfaro Siqueiros, "José Clemente Orozco - der Vorläufer im Formalen," 1944, in Siqueiros 1975, p. 115.

54] Prignitz 1981, pp. 11–12.

55] Noack 2000, pp. 91–92. Although the press already published work portfolios in 1942 and 1943, it was first formally founded with legal statutes in February 1944.

56] Prignitz 1981, pp. 81–90.

57] Noack 2000, p. 95; cf. James Clifford, "Kulturen auf der Reise," in Karl H. Hörning and Rainer Winter (eds.), *Widerspenstige Kulturen: Cultural Studies als Herausforderung,* Frankfurt a. M.: Suhrkamp 1999, pp. 476–513.

58] List of the most important contacts in the U.S., promoted by Stibi and Meyer, in Prignitz 1981, p. 109; Pohle 1986, p. 95.

59] Meyer 1949, p. XXIII.

60] Helga Prignitz, "Zur Volkstümlichkeit der politischen Grafik in Mexiko," in Berlin 1974, p. 103; Prignitz 1981, pp. 113–120, 135.

61] Less luminous colored prints by Jean Charlot and Rufino Tamayo are the exception. See Mexico City 2012, p. 21.

62] "Declaración de Principios del Taller de Gráfica Popular: El Taller de Gráfica Popular es un centro de trabajo colectivo para la producción funcional y el estudio de las diferentes ramas del grabado y la pintura. / El Taller de Gráfica Popular realiza un esfuerzo constante para que su producción beneficie los intereses progresistas y democráticos del pueblo mexicano, principalmente en su lucha contra la reacción fascista. / Considerando que la finalidad social de la obra plástica es inseparable de su buena calidad artística, el Taller de Gráfica Popular lucha por desarrollar las capacidades técnicas individuales de sus miembros. / El Taller de Gráfica Popular prestará su cooperación profesional a otros Talleres o Instituciones culturales, a las organizaciones de trabajadores y populares, y a todos los movimientos e instituciones progresistas en general. / El Taller de Gráfica Popular defenderá los intereses profesio-nales de los artistas. México, D. F., marzo de 1945."; English translation: digitalrepository.unm.edu/cgi (Mary Theresa Avila, *Chronicles of Revolution);* Meyer 1949, p. 1.

63] Meyer 1949, p. XXI.

64] After his return to Switzerland in 1951, Meyer organized, together with Johannes Itten whom he knew from his time at the Bauhaus, an exhibition at the Kunstgewerbemuseum Zurich. Cf. Zurich 1951.

65] Caplow 2007, p. 222; Leopoldo Méndez is a member of the Comité por la Paz Mexicano.

66] Prignitz 1990, p. 38.

67] Krejča 1980, pp. 42–45, 48. Different cutting and etching tools are required for linoleum engraving: gouge, parting tool, contour knife, and engraving stylus. See Koschatzky 1980, pp. 49, 64–66, 98; Wolfsturm/Burkhardt 1994, pp. 37–41, 68–70, 78; Gale 2010, pp. 111–123. Cf. Mexico City 1987, pp. 34–35: Méndez writes about his use of the linocut.

68] Caplow 2007, pp. 177–181.

69] Ibid., p. 210.

70] Prignitz 1981, pp. 154–159.

71] Cf. Guadarrama 2005; see Prignitz 1981, pp. 160–162.

72] Prignitz 1981, p. 171.

73] Ibid., p. 174.

74] Ibid., pp. 191–206; Prignitz 1990, p. 42; Mexico City 1987, p. 30.

75] After thousands of older graphic works were sold from the archives under the TGP's new leadership due to dire financial straits, Jesús Álvarez Amaya handed over the rest of the nearly 3,600 pages to the Academy of Arts in 1973. The departing members' intention of founding a "Museo de la Estampa Mexicana," never materialized. The government under President Luis Echeverría Álvarez gave the TGP an offset print machine and moved it to a new building for its fiftieth anniversary. In the end, the Museo de la Estampa Militante del TGP was opened there in 1976. See Prignitz 1981, pp. 209–216. A major exhibition took place in 1987 for the fiftieth anniversary. See Mexico City 1987.

76] Mexico City 1987, p. 32.

77] Cf. Cortés Juárez 1951.

78] See Krumpel 2006, pp. 55–56; Rita Eder, "Der Bruch mit dem Muralismo – eine neue Generation setzt sich durch," in Vienna 1988, pp. 137–140.

79] Alicia Azuela, "Imagen de México – Das Bild von Mexiko," in Vienna 1988, p. 43.

80] Pereda 2012, pp. 128–129.

81] Billeter 2012, p. 171; Jorge Alberto Manrique, "Eine Kunst zweier Kulturen: Francisco Toledo," in Vienna 1988, pp. 141–144.

82] Anonymous, *Leticia Tarragó, mujer surrealista artífice de su propio universo*, Veracruz: Universidad Veracruzana, 2005.

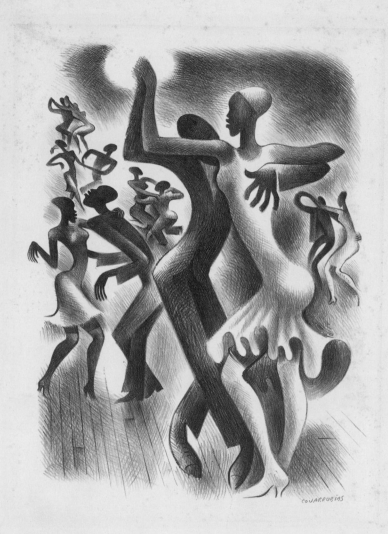

COVARRUBIAS

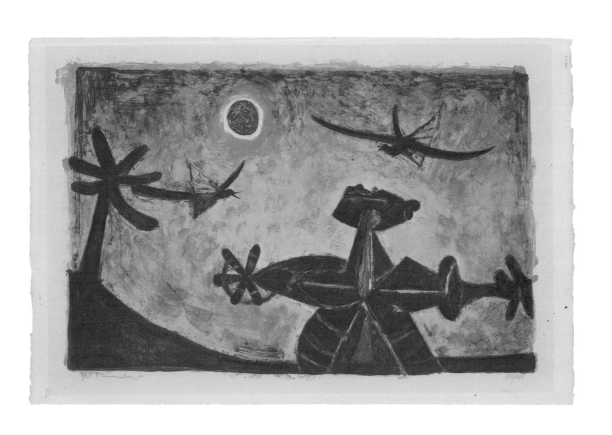

← CAT. 53
José Miguel Covarrubias, *Lindy Hop,* ca. 1927

↑ CAT. 142

Rufino Tamayo, *Observador de pájaros,* 1950

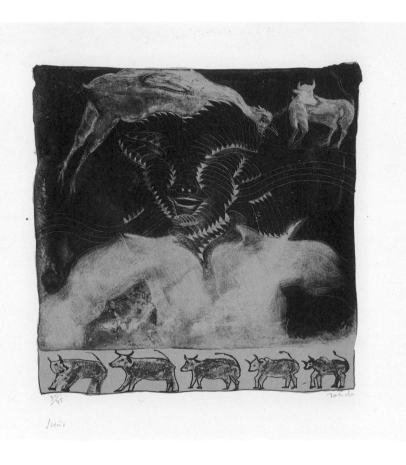

↑ CAT. 150
Francisco Toledo, *Sueño,* 1969

→ CAT. 152
Francisco Toledo, *El alumno de Siqueiros,* 1975

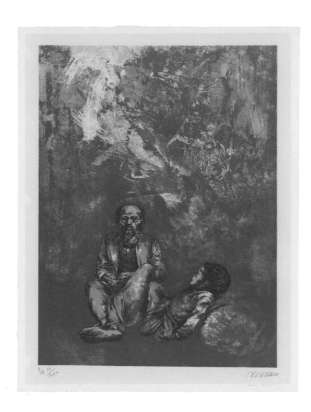

↑ CAT. 50
Rafael Coronel Arroyo, *El abuelo,* undated

→ CAT. 149
Leticia Tarragó, *Romance de la luna,* ca. 1965

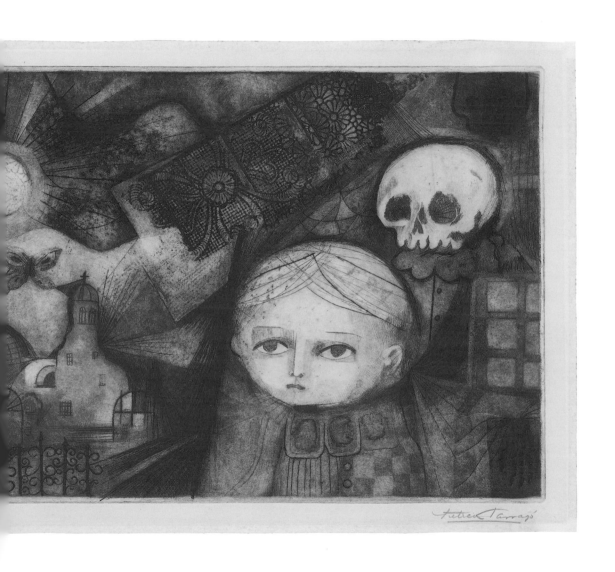

Los frutos de la educación. Los frutos de la tierra /
El niño del taco
The Fruits of Education. The Fruits of the Earth /
The Boy with the Taco

An indigenous youth sits on the ground next to a dog and eats a tortilla, a staple food for Mexico's rural population.[1] Next to him is a wooden frame that belongs to a piece of agricultural equipment. The surroundings reveal a pastoral scene; a straw-roofed hut is visible in the background.

This lithograph shows a detail from the fresco *La lluvia* (The Rain),[2] which is part of the mural series in the round-arch niches of the Secretaría de Educación Pública (Ministry of Public Education) in Mexico City.[3] The mural shows soldiers with cloaks of plant fronds taking shelter with an indigenous peasant family.

In 1932, Diego Rivera had five lithographs made of this series of work and printed in New York. Carl Zigrosser, director of the Weyhe Gallery in New York, commissioned the work and exhibited it in his gallery. All five lithographs show details from different murals in the Secretaría de Educación Pública that Rivera had painted several years earlier. George C. Miller from the U.S. printed the lithographs in an edition of 100 in New York.[4]

Los frutos de la educación. Los frutos de la tierra is a detail from the eponymous mural in one of the round-arch niches[5] in which a revolutionary teacher shares fruit and knowledge with the indigenous population. The portrayals in the Patio de las Fiestas (Courtyard of Festivities) developed on the themes of *Corridos de la Revolución* and the major public festivals, as emphasized by Rivera.[6]

1] London 2009, p. 82.

2] *La lluvia,* 1924, 433 × 184 cm, Secretaría de Educación Pública, Mexico City, 3rd floor, west wall *(Ballads of the Peasant Revolution / Ballads of the Agricultural Revolution,* no. 79).

3] Lozano/Coronel 2008, pp. 28–133, on *La lluvia* see p. 120.

4] 1. *Fruits of Labor (Los frutos de la tierra),* 2. *Open Air School,* 3. *Boy with the Taco (El niño del taco),* 4. *Zapata* and 5. *Sleep.* Four of the five lithographs are details from a fresco in the Ministry of Public Education; *Zapata* replicates a detail from the mural at the Museum of Modern Art in New York. See Indych-López 2009, p. 152; John Ittmann, "Diego Rivera," in Philadelphia 2006, pp. 147–153.

5] *Los frutos de la tierra,* 1924, 433 × 159 cm, Secretaría de Educación Pública, Mexico City, 3rd floor, north wall *(Ballads of the Peasant Revolution/Ballads of the Agricultural Revolution,* no. 87); Lozano/Coronel 2008, p. 129.

6] Münzenberg 1928, [unpag.]

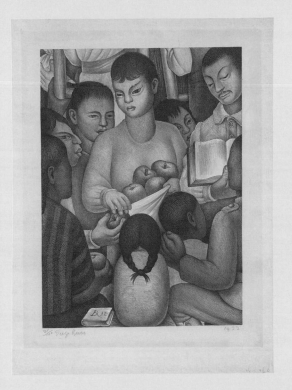

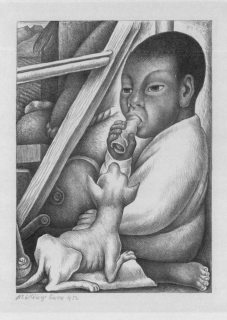

↑ CAT. 136
Diego Rivera, *Los frutos de la educación. Los frutos de la tierra,* 1932

↗ CAT. 137
171 Diego Rivera, *El niño del taco,* 1932

Retrato de Moisés Sáenz / Portrait of Moisés Sáenz

State promotion of mural painting largely ceased under Plutarco Elías Calles (1871–1945), who ruled the country from 1924 until 1928, whereupon a drastic change in cultural politics occurred and a majority of the mural artists lost their jobs. However, mural painting was then institutionalized and had to fulfill the new function of an officially legitimated art.[1] During Calles's reign, Moisés Sáenz (1888–1941) was Director of the Ministerio de Educación Pública under Secretary José Manuel Puig Casauranc (1888–1939). A celebrated educational advocate in post-revolutionary Mexico, he subsequently founded a comprehensive school system for the country's rural regions. Additionally, he supported institutionalized mural art and was considered a patron of Siqueiros.[2]

The format of the portrait hints at the colossal figures in Siqueiros's murals. Light-dark contrasts strongly enhance the facial expression. By isolating the head from the rest of the body, Siqueiros drew a reference to the pre-Hispanic style of gigantic sculpted heads of basalt of the Olmecs, the first Mesoamerican civilization.[3]

Siqueiros prepared these drawings during his time in Taxco and had them printed in New York in an edition of thirty-five, of which he kept fifteen for himself.[4] However, the Taxco prints were so popular, a new edition of twenty followed.

1] Maria Carmen Ramírez, "Nationalismus und Avantgarde: Ideologische Bilanz der mexikanischen Wandmalerei 1920–1940," in Vienna 1988, p. 105.

2] Andrea Buhmann, *Der Umgang mit dem indianischen Erbe in der zeitgenössischen mexikanischen Malerei am Beispiel von drei Künstlern aus Oaxaca,* Munich: Grin Verlag, 2009; London 2009, p. 85.

3] Elisabeth Casellas Cañellas, *El contexto arqueológico de la cabeza colosal olmeca número 7 de San Lorenzo, Veracruz, México,* Bellaterra: Universitat Autònoma de Barcelona, 2004.

4] John Ittmann, "David Alfaro Siqueiros," in Philadelphia 2006, pp. 164–165.

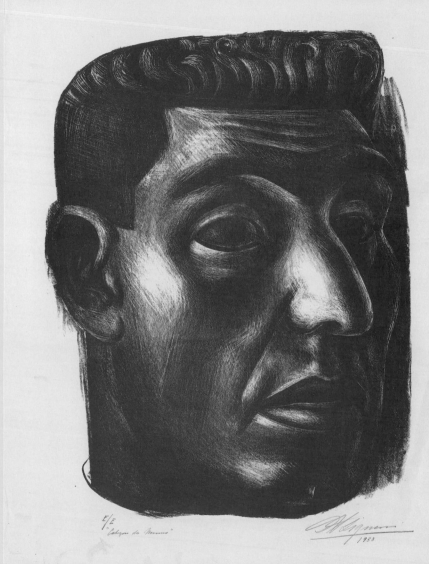

↑ CAT. 140

David Alfaro Siqueiros, *Retrato de Moisés Sáenz,* 1930

Catarsis / Catharsis

Under President Lázaro Cárdenas del Río, who was newly elected in 1934, various artists completed murals in government buildings, but also in communal facilities such as market halls, schools, libraries, and union buildings. In 1934, the Ministry of Public Education commissioned José Clemente Orozco to create a mural[1] for the Palacio de Bellas Artes in Mexico City.[2] In this work he focused on the social conflict surrounding the value of the machine age as well as the relationship of humans and machines. The artist hereby depicts the machine as an instrument repressing humanity, a symbol of mechanical and moral destruction. Men fighting with one another, rifles, machine parts, and a safe are individual motifs on the mural. These fragments plummet over one another, people are kicked, smothered, stabbed, and humiliated. A revolting mass—for its part, goaded on by an expressive, red, blazing fire burning and spreading on the horizon—drives this on in front of them. In the foreground there are naked women lying on their backs, their faces turned to the viewer. On the one hand, they represent exploitation and corruption, but on the other hand, are also symbols of moral decay.[3]

Orozco's *Catarsis* deals with man's grappling with the machine world, with humanity's self-destruction. The artist denounces those who exploit the confusion during the collapse of social relations to swindle the people, and mainly, the working class.[4] The work's title can be attributed to Justino Fernández (1904–1972), friend and biographer of the painter. According to Fernández, in the picture, Orozco legitimizes war as a means of cleansing, whereby the human will be freed from the fangs of mechanistic and materialistic civilization. Other interpretations point out, however, that Orozco opposes all war with his painting. He suggests not war, but revolution as catharsis, as a means of cleansing.[5]

The Armin Haab Collection contains two prints produced by Orozco in connection with the mural *Catarsis. Mujer muerta* (Dead Woman), shows the naked prostitute lying in the foreground of the mural with additional women in the background CAT. 104, P. 176. Heavily made up, nearly mask-like faces and exuberant jewelry adorn their lascivious bodies and point to their sexual desires.[6] *La chata* (The Pug-Nosed) shows the portrait of one of the two women lying on the side with a pearl necklace around her neck CAT. 103.[7]

JOSÉ CLEMENTE OROZCO

1] José Clemente Orozco, *Catarsis,* 1934, Fresco, 11.46 × 4.46 m, Palacio de Bellas Artes, Mexico City; see Berlin 1982, ill. p. 144.

2] Reed 1979, p. 173.

3] Olav Münzberg and Michael Nungesser, "Orozcos mexikanische Wandbilder der dreissiger Jahre. Soziale Kämpfe der Gegenwart und Vergangenheit," in Egbert Baqué and Heinz Spreitz (eds.), *José Clemente Orozco. 1883–1949,* Berlin 1981, pp. 204–205.

4] Raquel Tibol, "Die Kulturpolitik der Cárdenas-Regierung 1934–1940," in Berlin 1974, pp. 91–95.

5] Justino Fernández, *Orozco: forma e idea,* Mexico City 1942.

6] Reed 1979, p. 174.

7] Jas Reuter, "Die Frau Symbol des Negativen?," in Baqué/Spreitz 1981 (see note 3), pp. 200–201.

↑ CAT. 103
José Clemente Orozco, *La chata / La borracha,* 1935

↘ CAT. 104
José Clemente Orozco, *Mujer muerta / Dead Woman,* 1935

III/140

F. C. Orozco

Mujer con iguanas / Woman with Iguanas

In 1949, Raúl Anguiano traveled with an expedition team from the Instituto Nacional de Bellas Artes to the Lacandon, indigenous people living in the eastern state of Chiapas on the border with Guatemala, and to the ruins of the Maya city of Bonampak, which is renowned for its well-preserved murals. His diary entries attest to his intense confrontation with the customs, traditions, and peculiarities of the Lacandon people and his cultivation of respectful relations with them.[1] CAT. 12, P. 211 presents an extraordinary portrait of Margarita, a Lacandon woman who together with other locals accompanied the expedition party through the jungle.[2]

Anguiano portrayed an ideal image of the popular folk cultures of Mexico. He sings the praises of the beauty of women who originate from various cultures,[3] and also stages the woman with the three iguanas CAT. 14 in this way. Armin Haab's entries on this print describe how Anguiano asked a Tehuana woman from the Zapotec culture in the state of Oaxaca, to put a basket on her head. Because she misunderstood, she draped the contents rather than the basket on her head, which is why she has a crown of three iguanas.[4]

Anguiano provided emotional images of exotic surroundings and is considered a master of Mexican portraiture. In his works, he expresses the emotions of the common people. In doing so, he places the self-confident woman at the center of artistic interest. He created extraordinary portraits of famous women, and also female archetypes as representatives of the Mexican people.

1] Raúl Anguiano, *Expedición a Bonampak. Diario de un Viaje,* Mexico City, Instituto de Investigaciones Estéticas/Universidad Nacional Autónoma de México, 1959.

2] Noelle 2015, last accessed: 1/18/2016. Haab commissioned Anguiano with the work.

3] Núñez Mata 1971, pp. 39–45.

4] List of the Works of the Armin Haab Collection, Kunsthaus Zürich, Collection of Prints and Drawings. In 1954 and 1962, Haab undertook journeys to the Lacandon people in Chiapas together with Gertrude Duby-Blom (1901–1993), a Swiss socialist, photographer, and anthropologist who documented the Maya culture of Chiapas in Mexico for five decades. See Gertrude Duby and Frans Blom, *La selva Lacandona,* Mexico City: Editorial Cultura, 1955; Gertrude Duby-Blom et al. (eds.), *Das Antlitz der Mayas,* Gütersloh: Bertelsmann, 1982.

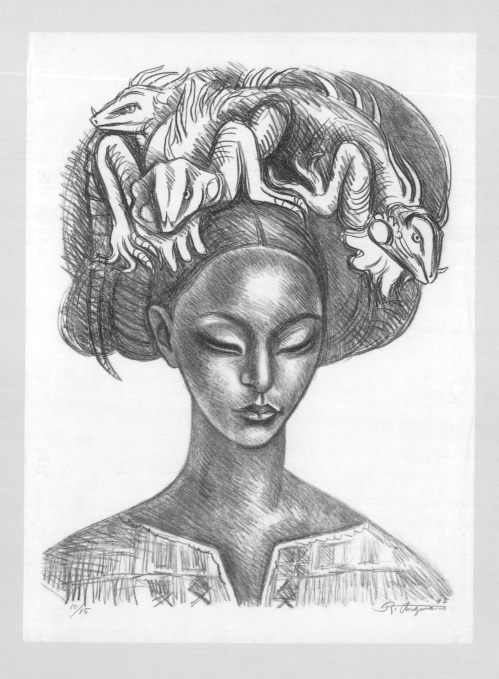

↑ CAT. 14
Raúl Anguiano, *Mujer con iguanas*, 1975

Retrato de una muchacha mexicana
Portrait of a Mexican Girl

When the Bolivian graphic artist Roberto Berdecio went to Mexico in 1934 to study Mexican murals, he became a member of Liga de Escritores y Artistas Revolucionarios (LEAR). In 1936 he exhibited in New York together with Luis Arenal Bastar, Leopoldo Méndez, and Alfredo Zalce. After working in the studios of David Alfaro Siqueiros and Jackson Pollock (1912–1956) for several years, he returned to Mexico in 1947 and became a guest member of Taller de Gráfica Popular (TGP).[1]

Berdecio's graphic art can be categorized within the Romantic ethnographic tradition. He designed a great number of studies of peasant landscapes and delicate portraits of children. CAT. 22 shows the portrait of a Mexican girl leaning against a wall, captivating the viewer frontally with her eyes.[2] The fine hatchings in various shadings model her face, which is framed by her hair that falls in waves over her shoulders.

1] Meyer 1949, pp. 54–55.

2] London 2009, p. 39.

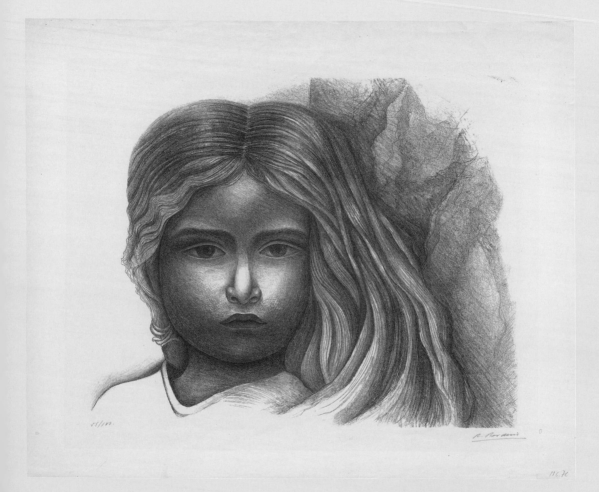

↑ CAT. 22
Roberto Berdecio, *Retrato de una muchacha mexicana,* 1947

Mexihkanantli / Mexican Mother

Under the title *Mexihkanantli,* Jean Charlot published sixteen works created from January 1946 to March 1947 that illustrate Náhuatl texts. From them, in 1947, ten selected chromolithographs were compiled in the portfolio *Mexihkanantli*— which in Náhuatl, an indigenous language, means "Mexican mother"—, hand pulled by José Sánchez under the supervision of the artist at TGP and published by La Estampa Mexicana publishing house in Mexico City CAT. 44, P. 184.[1]

A unique style characterizes the colored lithographs, which are a remarkable study of motherhood. Each one depicts a mother as she helps her small child take its first steps or get dressed, or as they make tortillas together in the kitchen, or as she accompanies her child to a procession. The rectilinear formal language is characteristic of Charlot's work and can be traced back to his confrontation with analytical Cubism in Europe. The voluminous figures display a sculptural, blocky structure, which Charlot would increasingly abandon over the years, in order to pay respect to the model rather than the arrangement. The composition of the works is self-contained; perspective and depth are barely suggested.

In his works, Charlot turns frequently to Diego Rivera's model Luz (Luciana Jiménez), a beautiful, indigenous Mexican woman CAT. 39, P. 214. With her help, he is able to deepen his knowledge of the Aztec language Náhuatl, which he acquired in lessons with Robert H. Barlow at the Museum of Anthropology in Mexico City, as she speaks the language very well.[2] Luz is meant to have later also stirred his interest in and increased his knowledge of popular Mexican culture.

Yechiwald / Mexican kitchen
Tlatiankizoskeh / Return from market
Nantli tekiti noka konetl kochi / Rest and work
Momalin ihtotihke / Preparing for the dance
Konenehnemitia / First steps
Konenehnemitia / First steps
Tlazohtlalistle / Trio
Kikahtia Ciwakonetl / Sunday shoes
Kimachita Tlaxkalmanas / Tortilla lesson
Mowentihke Chalman / Chalma pilgrims

1] Morse 1976, pp. 257–269, cat. 487–502.

2] Ibid., p. 258. Jean Charlot's engagement with the Aztec language already began in his youth.

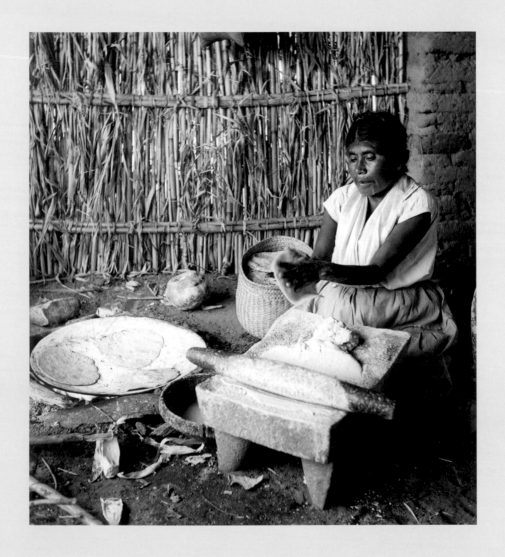

↑ Woman making tortillas,
Fiesta, Santiago, Cuilapán, Oaxaca, Mexico, 1949

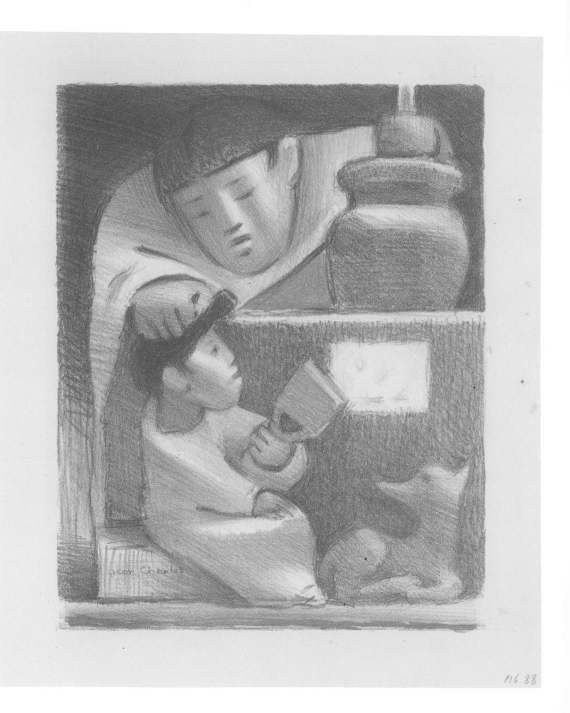

↑ CAT. 44-1
Jean Charlot, folio 1: *Yechiwalo* from the portfolio: *Mexihkanantli,* 1947

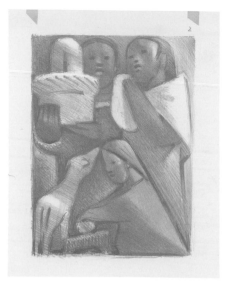

CAT. 44-2

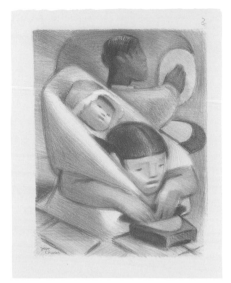

CAT. 44-3

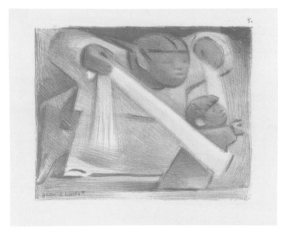

CAT. 44-5

Estampas de la Revolución Mexicana
Prints of the Mexican Revolution

The portfolio *Estampas de la Revolución Mexicana* with eighty-five linocuts by the Taller de Gráfica Popular (TGP) was published by La Estampa Mexicana press in 1947.[1] The eleven-page accompanying booklet contains a foreword and explanations of the individual prints by Alberto Morales Jímenez as well as TGP's Declaration of Principles *(Declaración de Principios del Taller de Gráfica Popular)* from November 20, 1947.[2] Lena Bergner (1906–1981) was responsible for the layout while Hannes Meyer (1889–1954),[3] the exiled Swiss architect, was technical director of the edition. Higinio Arias Urzay published the prints at Editorial Galatea on colored paper, which satisfied popular taste at the time and was meant to break the uniformity of the incisive black-and-white linocut technique. This collective publishing piece was the first in which all TGP members participated. Work on the portfolio began in July 1945 with participation in a competition called by the city administration's office of public affairs on topics related to the Mexican Revolution. The work continued until November 1947. In the end, the portfolio was published in an edition of 550, of which the numbers 1 through 500 bear Arabic numerals and 501 to 550, Roman numerals CAT. 174, PP. 190–195.

The portfolio was published on the occasion of the tenth anniversary of the TGP and cost fifty Mexican pesos, which meant that it was available for only the middle and upper classes.[4] It is, however, not a luxuriously furnished, elaborate lithograph album for North American collectors, but rather, an affordable edition for the national market. Nevertheless, half of the edition was printed in English.[5] Two-thirds of the portfolios were sold within the first year. One tenth was exhibited in culturally progressive organizations throughout the world, for instance in Cape Town, Buenos Aires, Jerusalem, Montreal, Moscow, New York, Lisbon, Berlin, and Geneva.[6] Furthermore, all of the prints were published in daily newspapers such as *El Nacional* as a series, which greatly increased their popularity.[7]

National and international upheavals provided the conditions for work on the portfolio. World War II came to a close in spring 1945, and the artists of TGP gathered to grapple with their working program in accordance with the new political situation. The TGP members' aim was to use graphic art in sustaining the battle to preserve the goals of the Mexican Revolution. During the production process, the graphic artists critiqued each individual sheet in the plenum. The portfolio emerged from the artists' patriotic and revolutionary convictions. Despite the great qualitative differences among the sixteen artists, a harmony within the popular edition of simple linocuts was achieved due to the uniform format and technique, and shared political and revolutionary ideas.

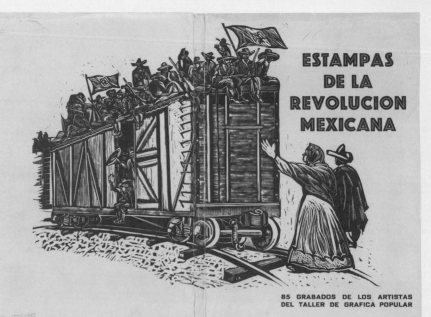

↑ CAT. 174-A

Cover: *Estampas de la Revolución Mexicana.*
85 Grabados del Taller de Gráfica Popular

187 Editado por La Estampa Mexicana, México, D. F., 1947

Because of its loose, chronological structure, the portfolio has often been interpreted as a simple account of Mexican history. The prints offer a sequential illustration of historical events and show personalities from the late 1800s through to the 1940s who mediate the history of Mexico and depict the legacy of the Revolution: from the dictatorship of Porfirio Díaz, from 1876 to 1911, also known as the Porfiriato, to the Mexican Revolution (from 1910 through to 1920), to the projects of rebuilding the nation promoted by the post-revolutionary government. The sheets show a number of heroes and villains from Mexican history.[8] The TGP created a graphic pictorial language for this, with which it informed the Mexican population as well as the audience abroad, and had an educational effect. The productions thus focus on issues of national and international political and social issues, such as Mexico's heritage and history, poverty and suppression of the indigenous population, human rights of the working class, defending the nationalization of natural resources, and civil liberties for workers.

The artists gathered information on historical details from archives before starting on the works. There are examples in which the graphic artists incorporated well-known images that were immediately familiar to Mexicans. The images include widely known depictions of the revolution based on the Casasola family's photographs and film recordings by Mexico's first filmmaker Salvador Toscano (1872–1947). They came into being during the revolution.[9] With the individual scenes, the TGP developed a national, culturally specific pictorial language, which showed a reformulated version of Mexican history. The story told by *Estampas de la Revolución Mexicana* is clearly shaped by the members' ideology. For example, the portfolio coins the institutionalized idea of "familia revolucionaria," the revolutionary family, which includes Francisco I. Madero (1873–1913), Venustiano Carranza (1859–1920), Álvaro Obregón (1880–1928), and Emiliano Zapata (1879–1919). Although this alliance did not actually exist, it was thematized by post-revolutionary movements. In fact, each of these personalities had posed their own opposition during the Mexican Revolution.

The portfolio also shows caricature-like images of the expropriation of the oil fields, exploitation of the working class, and plague of false revolutionaries who were scattered among the people as game changers. Other prints direct opinion against Francoist Spain and Nazi-Germany, against Yankee imperialism, illiteracy, and the high cost of living.

The portfolio thus refers to the narratives of the Mexican Revolution spread by the post-revolutionary governments, but also represents the way that these governments participated in the Revolution. To this extent, the prints inevitably contain the TGP's criticism of the activities of past as well as present governments. The images are symbols of remembering, of the resurgence of the Mexican Revolution, and serve to recall events and personalities in the country's history while highlighting the social injustices and atrocities directed against the indigenous population and the working class.

In the foreword to the portfolio, the artists state that the prints resulted from recalling the events, their beginnings and results, with the goal of helping the people in their struggle against the enemies and falsifiers of the Revolution and warned that the conquests of Mexico put the people in acute danger of being attacked by imperialism from within and without the country. According to Paul Westheim, the TGP created this visual report about the revolution "with the aim of forming true history into a legend."[10]

The sixteen participating artists were: Ignacio Aguirre, Luis Arenal Bastar, Alberto Beltrán, Ángel Bracho, Fernando Castro Pacheco, Jesús Escobedo, Antonio Franco, Arturo García Bustos, Julio/Jules Heller, Leopoldo Méndez, Francisco Mora, Isidoro Ocampo, Pablo O'Higgins, Everardo Ramírez, Mariana Yampolsky, and Alfredo Zalce.

1] Prignitz 1981, pp. 368–373, cat. 628–712. Several of the works were reproduced in the TGP portfolio from 1960, see: Mexico City 1960.

2] According to the TGP's new declaration of principles, the portfolio defended the democratic rights of the people by not separating social goals from artistic ones.

3] Hannes Meyer was a Swiss architect who as successor to Walter Gropius greatly influenced Bauhaus Dessau in his role as teacher and director. In 1939 the Mexican government under Lázaro Cárdenas del Río summoned him to Mexico. He became director of the newly founded Instituto Politécnico Nacional with headquarters in Mexico City. In 1942 he founded the publishing house La Estampa Mexicana of the artist's association TGP, for which he summoned the German publicist Georg Stibi (1901–1982) as director. See Prignitz 1981, pp. 81–86, 304, 309.

4] Avila 2008, p. 65.

5] Prignitz 1981, pp. 114–125.

6] Meyer 1949, p. XXV.

7] Ibid., p. XVII.

8] Cf. Avila 2008; Avila 2013.

9] Prignitz 1981, pp. 117–123; Avila 2008, p. 64; Schreiber 2008, p. 41.

10] "De volver leyenda la historia documental," in Francisco Mora, La función social del grabado, Mexico City 1962, typescript of a lecture.

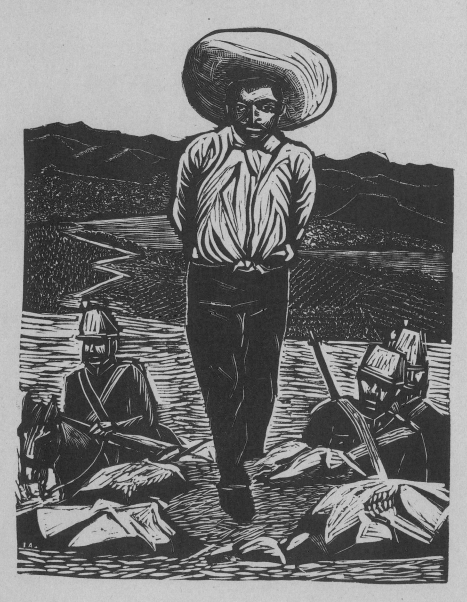

16 EMILIANO ZAPATA HECHO PRISIONERO POR SU LUCHA EN
FAVOR DE LOS CAMPESINOS. 1908.
Grabado de Ignacio Aguirre.

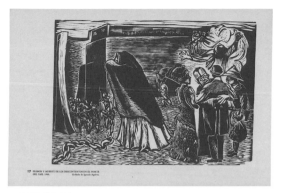

CAT. 174-17

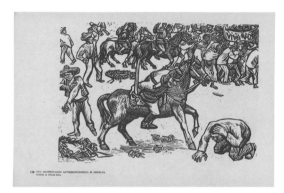

CAT. 174-18

CAT. 174-20

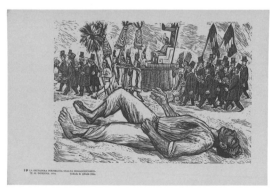

CAT. 174-19

← CAT. 174-16
Ignacio Aguirre, folio 16: *Emiliano Zapata hecho prisonero
en su lucha en favor de los campesinos. 1908,* 1947
From the portfolio: *Estampas de la Revolución Mexicana. 85 Grabados del Taller
de Gráfica Popular.* Editado por La Estampa Mexicana, México, D. F., 1947

7 TRABAJOS FORZADOS EN EL VALLE NACIONAL, 1890-1900.
Grabado de Alfredo Zalce

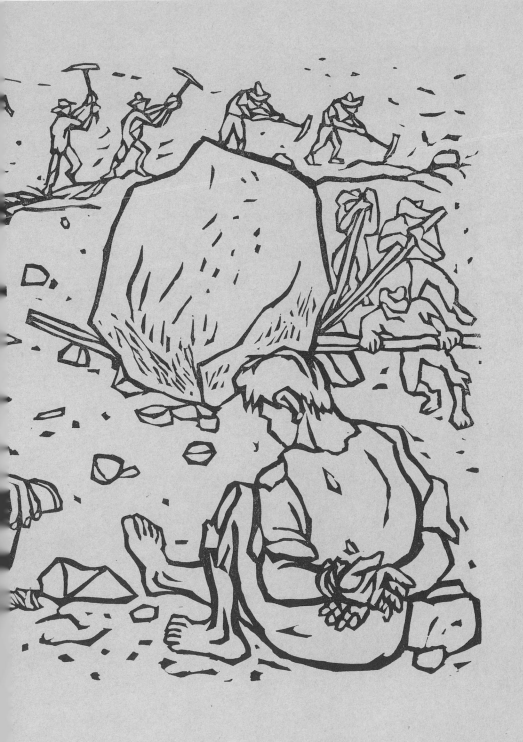

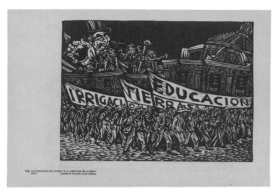

CAT. 174-76

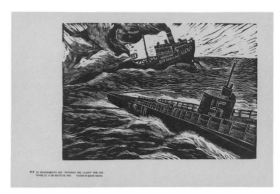

CAT. 174-77

CAT. 174-78

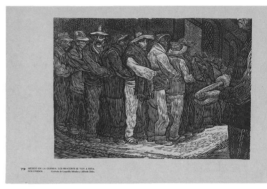

CAT. 174-79

→ CAT. 174-80
Alfredo Zalce, folio 80: *Quitémos la venda! (Campaña de alfabetización),* 1947
From the portfolio: *Estampas de la Revolución Mexicana. 85 Grabados del Taller
de Gráfica Popular.* Editado por La Estampa Mexicana, México, D. F., 1947

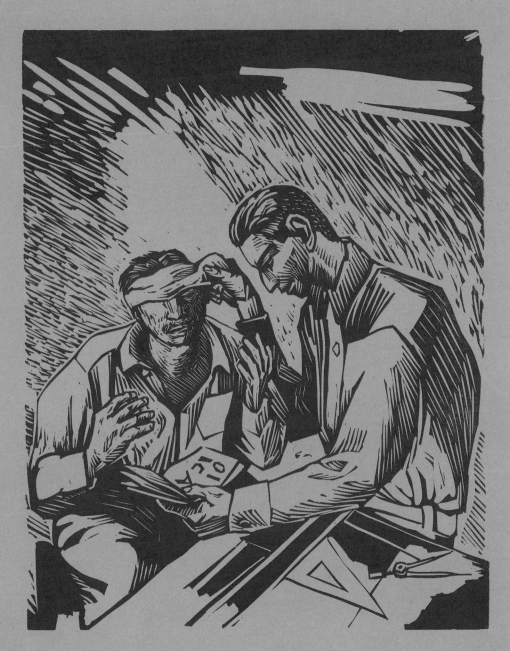

80 ¡QUITEMOS LA VENDA! (CAMPAÑA DE ALFABETIZACION).
Grabado de Alfredo Zalce.

Las antorchas / The Torches

At the foreground of the linocut is a peasant wearing a straw hat, holding a burning torch in his right hand with which he lights up his path. His left hand is clenched in a fist. In the background is a mob of other peasants with burning torches marching quickly through a desert. The prominent figure, with his frightening gaze fixed straight ahead, mediates an uncanny colossal dynamic depicting the discharging of the storming mass' pent-up rage. Leopoldo Méndez forcefully accentuates the nocturnal sky on the right side of the print with short, mainly horizontally oriented strokes. On the left side and in the background, fine parallel lines intensify the tension and the turbulent events. For this parallel layer, Méndez worked with his typical multiple-cutting tool, a veining gouge with several small, parallel blades CAT. 88-2, P.199.[1] The composition was inspired by Käthe Kollwitz's (1867–1945) prints of rebelling peasants from the cycle *Bauernkrieg* (Peasant War), which she created from 1902 to 1908.[2] Since Georg Stibi, who was also active in the Taller de Gráfica Popular (TGP), sent packages to Méndez after he returned to Germany in 1946 which included, among other things, catalogs of Kollwitz's work.[3]

The print *Las antorchas* is part of the ten-part linocut series *Río Escondido*. However, in the Armin Haab Collection at Kunsthaus Zürich, it is presented by itself as a single sheet. The scene appears in the trailer to the film *Río Escondido* (Hidden River, 1947), which was shot by the Mexican director Emilio Fernández (1904–1986). The print refers to a scene in the film in which the peasants rebel against the president's violent and repressive reign. All ten prints were originally created for the film. They function as intertitles and act as key words to describe the film's themes.[4] With this work, Méndez fulfilled his dream of realizing graphic murals.[5] His prints attain the desired mural size on the movie screen, and also a striking effect and poignancy. The theme of the peasant revolt is embedded in the film as a fictional tale, but presented in the print as a fact. The agricultural reform dealt with in the film was one of the most important reasons behind the Mexican Revolution. The print is thereby a striking example of how the TGP artists visually perpetuated the Revolution's unsolved issues.[6]

LEOPOLDO MÉNDEZ

1] Krejča 1980, pp. 42–45, 48. Different cutting
and etching tools serve for the linocut. In addition
to the gouge, parting tool, and contour knife,
Méndez also worked with the veining gouge.
Koschatzky 1980, pp. 49, 64–66; for the gouge
see ibid., p. 98; Gale 2010, pp. 111–123.

2] See Käthe Kollwitz, *Losbruch* (Outbreak), 1902/03,
the fifth impression from the cycle *Bauernkrieg* (Peasant's
War), drypoint, line etching, aquatint, reservage, and
vernis mou with the imprint of two fabrics and Ziegler's
transfer paper, 51.5 × 59.2 cm. See Alexandra von
dem Knesebeck, *Käthc Kollwitz: Werkverzeichnis der
Graphik,* Bern: Kornfeld, 2002, vol. 1, pp. 207–333:
Bauernkrieg, pp. 222–227, no. 70: *Losbruch.* The Chinese
graphic artist Li Hua (1907–1994) was also inspired by
Käthe Kollwitz for his 1935 woodcut *Flood of Rage.*
There is no evidence as to whether Leopoldo Méndez
knew of Hua's work.

3] Prignitz 1981, p. 107.

4] The film deals with the story of a Mexican village,
which with the help of a young village teacher is able
to free itself from the local caciques. See Prignitz 1981,
pp. 129–130, 373–374; Meyer 1949, pp. 94–95;
Caplow 2007, pp. 204–207.

5] Leopoldo Méndez, "Es mi primer intento de llevar
indirectamente los cortes del pequeño buril al tamaño
de la pantalla" (This is my first attempt with my
small burin to create a full-canvas print.), 1948, in
Meyer 1949, p. 94.

6] London 2009, p. 122.

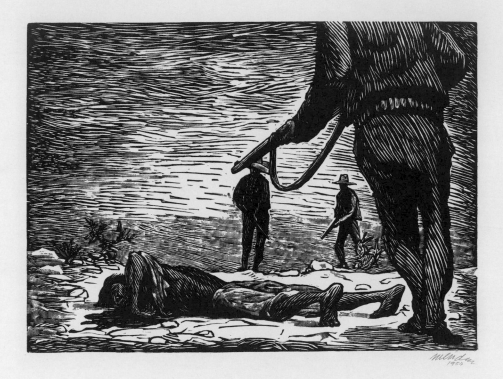

↑ CAT. 88-1
Leopoldo Méndez, folio 4: *También la tierra bebe tu sangre,* 1948
From the portfolio: *Río Escondido*

→ CAT. 88-2
Leopoldo Méndez, folio 9: *Las antorchas,* 1948
From the portfolio: *Río Escondido*

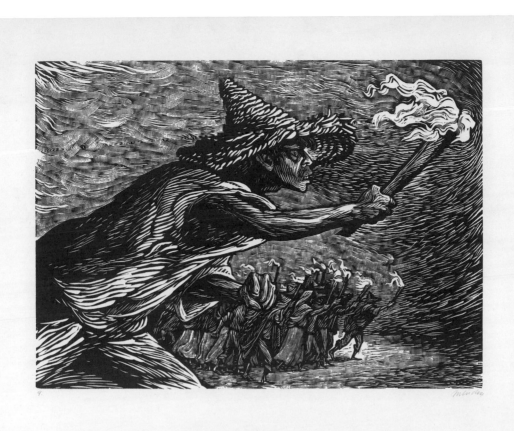

4. Mendez

Grabados del Taller de Gráfica Popular
Engravings of the Workshop for Popular Graphic Art

The portfolio, which was published in 1956, contains twenty-three linocuts and lithographs by each one of the members of the Taller de Gráfica Popular (TGP).[1] The coversheet illustrates the interior of a workshop where the members are gathered around a table, depicting Leopoldo Méndez, who acted as Secretary General of TGP beginning in January 1956, speaking to them. The first page of the portfolio comprises short artist biographies, with a portrait of each. On the inside cover is a statement by the TGP on its activities and Mexican prints in general. The back of the portfolio shows a small depiction of a lithographer at work.

The prints concentrate primarily on social themes that influenced Mexico in the 1940s and 1950s, including environmental pollution, war, agriculture, and labor issues. Several sheets show peasant life in the countryside, field workers or women going about their work. A number of artists also present portraits of important figures, such as the Mexican writer and politician Ignacio Manuel Altamirano (1834–1893), CAT. 175-22, P. 240, or the revolutionary Emiliano Zapata (1879–1919), CAT. 175-13, P. 40, who is holding a weapon in one hand and in the other, a slip of paper with the slogan "Plan de Ayala."[2] One print is devoted to Benito Juárez (1806–1872), the reformer and Mexican president from 1858 to 1872, who is depicted in the midst of historical events with a crown of laurels CAT. 175-15, P. 239.

The portfolio was created in 1956, when Mexico celebrated Juárez's 150th birthday with numerous commemorative activities. The VII Mexican Book Fair in 1956, in which the TGP was involved, was shaped by the festivities. More than fifty new prints were created for this occasion. The TGP had their own sales stand where the new portfolio with twenty-three reproductions of current prints was available for nine pesos. Within four weeks at the book fair, 33,000 individual sheets were sold. In order to meet this demand, the printing machine set up for demonstration purposes was used to pull prints on colored tissue paper, which cost one peso each.[3]

The twenty-three participating artists were: Ignacio Aguirre, Raúl Anguiano, Luis Arenal Bastar, Alberto Beltrán, Ángel Bracho, Celia Calderón de la Barca, Elizabeth Catlett, Arturo García Bustos, Andrea Gómez, Lorenzo Guerrero, Elena Huerta Múzquiz, Xavier Iñiguez, Marcelino L. Jiménez, Sarah Jiménez, Carlos Jurado, Francisco Luna, María Luisa Martín, Leopoldo Méndez, Adolfo Mexiac, Francisco Mora, Pablo O'Higgins, Fanny Rabel, and Mariana Yampolsky.

1] See Prignitz 1981, p. 381, cat. 839–861. Prignitz states that the work is lost, that is, the portfolio is not traceable in the TGP collection (status: 1976), or in the Academia de San Carlos or in individual artist estates.

2] The "Plan de Ayala" from 1911 is the political program of Emiliano Zapata, head of the Mexican Revolution, and his followers. The text was signed on November 25, 1911 and announced in Ayala City. The plan calls for the population to take up arms and redistribute the land among the peasants to whom it belongs and from whom it was snatched. The slogan is "Libertad, Justicia y Ley" (Freedom, Justice, and Law), which was later shortened to "Tierra y Libertad" (Land and Freedom).

The main points of the plan are the resignation of President Francisco I. Madero and free elections, the naming of Pascual Orozco as leader of the Revolution and Emiliano Zapata as his representative, redistribution of the land to the farmers and emphasis on the rural character of the Mexican Revolution; see http://academic.brooklyn.cuny.edu/history/johnson/ayala.htm.

3] Prignitz 1981, p. 171.

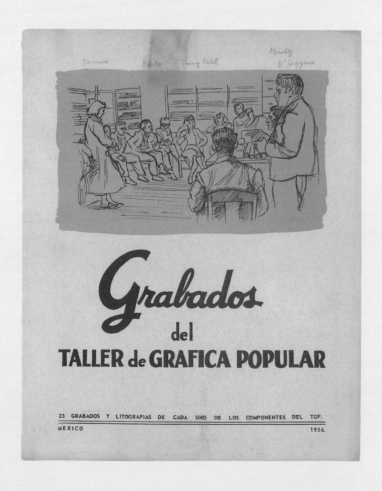

↑ CAT. 175-A
Cover: *Grabados del Taller de Gráfica Popular. 23 grabados y litografías de cada uno de los componentes del TGP*, México 1956

Mujeres Yalaltecas / Yalaltecan Women

The print shows three Indio women standing with their backs to the viewer. They are dressed in the typical clothing of indigenous women from the southern Mexican state of Oaxaca.[1] The most remarkable feature of their appearance is their long hair worn in two carefully plaited braids, which fall down their backs. In a rhythmic arrangement, the print highlights the women of Yalalteca's characteristically simple, traditional clothing and hairstyle. Rather than showing them as individuals, their identical appearance is emphasized.

A distinctive feature of Francisco Dosamantes's work is its expressionist style, which due to his intense participation in the Cultural Missions[2] led to a calm and folk-like expression. The sheet is among Dosamantes's best-known lithographs and was published by the American Artist's Concress in New York as *Women of Oaxaca* in 1946.[3]

1] London 2009, p. 164.

2] See p. 161, note 35.

3] Lyle W. Williams, "Francisco Dosamantes," in Philadelphia 2006, pp. 196–199.

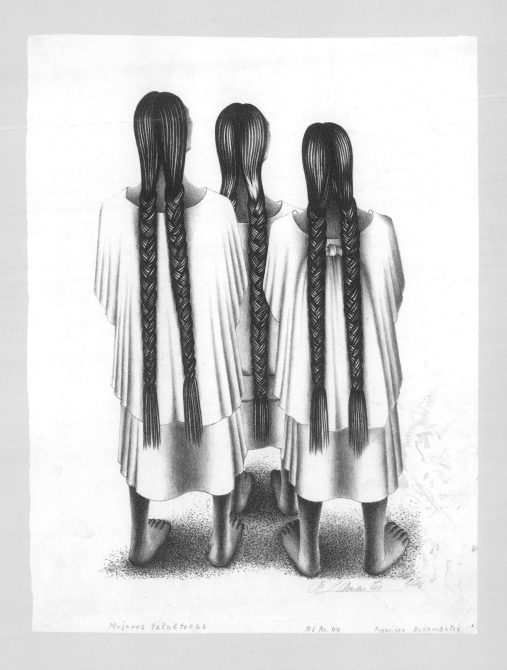

↑ CAT. 63
Francisco Dosamantes, *Mujeres Yalaltecas. Mujeres de Oaxaca*, 1946

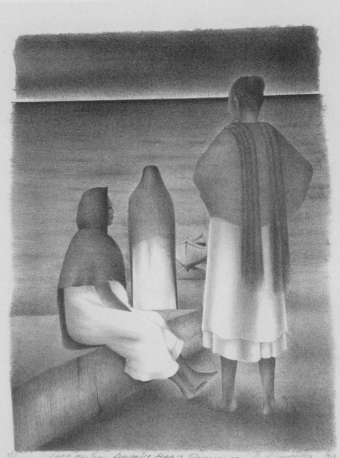

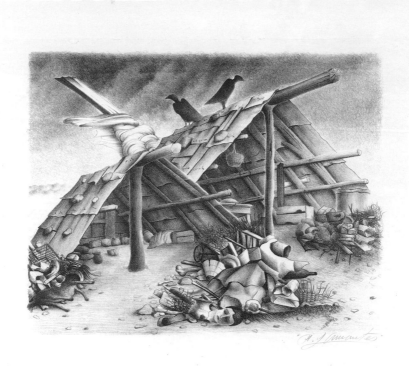

← CAT. 65
Francisco Dosamantes, *Mujeres al mar. La espera,* 1947

↑ CAT. 66
Francisco Dosamantes, *Los basureros. Arquitectura funcional II,* 1955

Pastèque no. 2 / Watermelon no. 2

Essential elements in Rufino Tamayo's art are a simple two-dimensionality, a sparseness and geometric arrangement of his composition. Pyramid-shaped watermelon pieces[1] in intense red, white, and green, and two cherries before a white-gray structured base correspond with the colors of the Mexican flag, but are also of personal significance to the artist. When Tamayo was orphaned at the age of eight, his aunt took him into her family. Already as a child he helped out in her shop and later, as a youth, at the fruit stand at the market in Mexico City, selling tropical fruit, among them, local watermelons.[2] From this personal reference, the artist created the folk figure of the fruit and flower seller, but also the melon still lifes, as symbols of national identity. The favored fruit motif reflected the experiences of everyday Mexican life and showed the melons in both their monumental power and poetic calm.

Tamayo was never interested in telling stories with his images. For him, among the most important creative aspirations were capturing the poetics of a moment and the beauty of a chance encounter.[3]

1] Pereda 2004, cat. 119.

2] Pereda 2012, p. 136; Xavier Villaurrutia, *Rufino Tamayo. Pinturas y Litografías,* exh. cat. Instituto de Arte Moderno, Buenos Aires 1951.

3] Mexico City 2012, pp. 32–33, 97–107, 109–123.

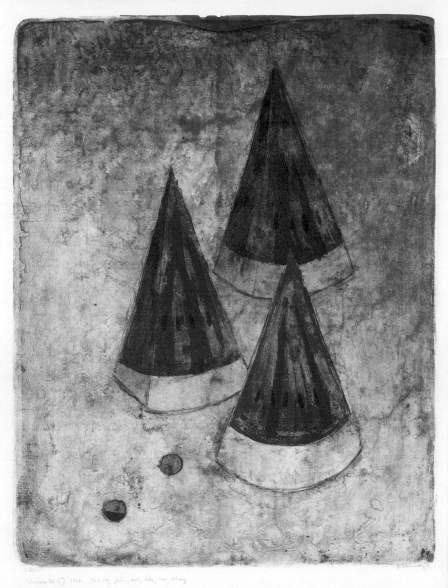

↑ CAT. 145
Rufino Tamayo, *Pastèque no. 2 (Sandía no. 2)*, 1969

Appendix

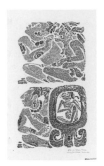

CAT. 1

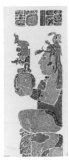

CAT. 2

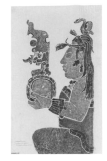

CAT. 3

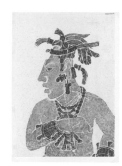

CAT. 4

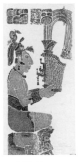

CAT. 5

CAT. 6

CAT. 7

CAT. 9

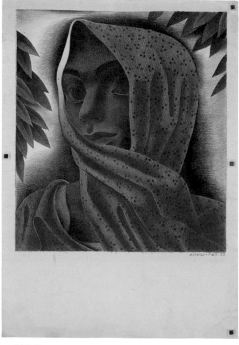

CAT. 8

CAT. 10

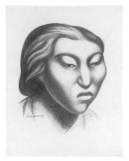

CAT. 11

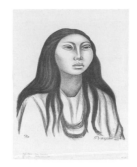

CAT. 12

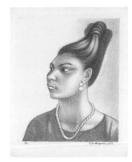

CAT. 13

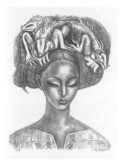

CAT. 14

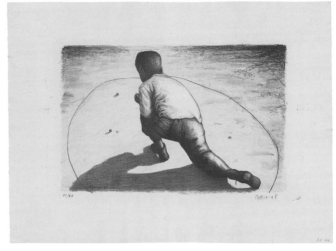

CAT. 15

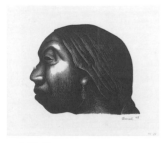

CAT. 16

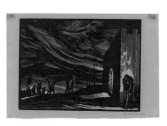

CAT. 17

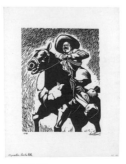

CAT. 18

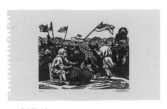

CAT. 19

CAT. 20

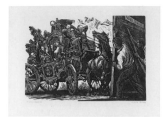

CAT. 21

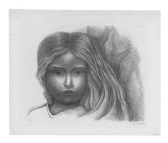

CAT. 22

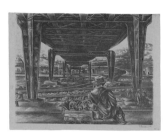

CAT. 23

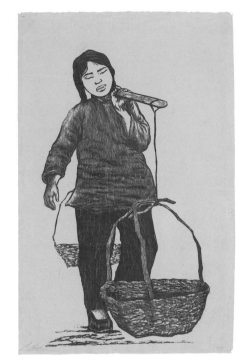

CAT. 24

CAT. 25

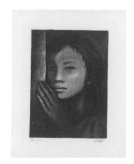

CAT. 26

CAT. 27-A

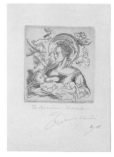

CAT. 27-1

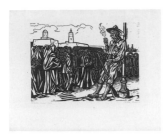

CAT. 28

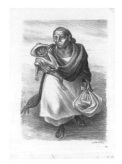

CAT. 29

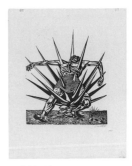

CAT. 30

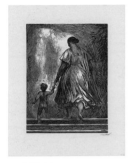

CAT. 31

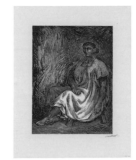

CAT. 32

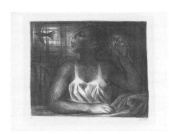

CAT. 33

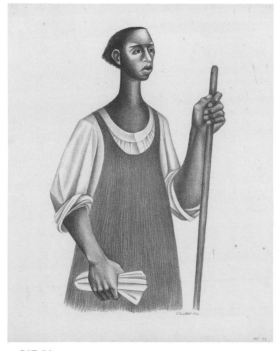

CAT. 34

CAT. 35

CAT. 36

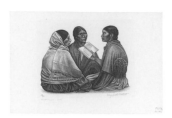

CAT. 37

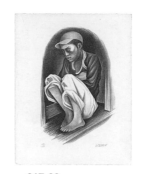

CAT. 38

CAT. 39

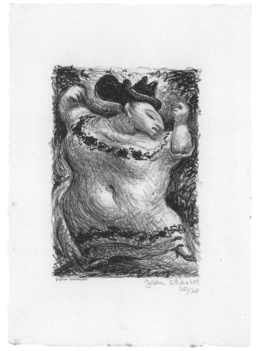

CAT. 40

CAT.41

CAT. 42

CAT. 43

CAT. 44-A

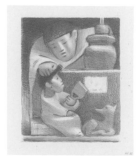

CAT. 44-1

CAT. 44-2

CAT. 44-3

CAT. 44-4

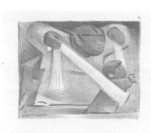

CAT. 44-5

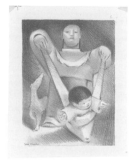

CAT. 44-6

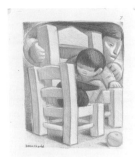

CAT. 44-7

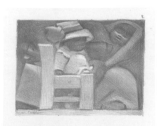

CAT. 44-8

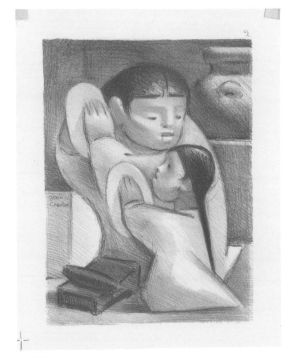

CAT. 44-9

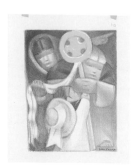

CAT. 44-10

CAT. 45

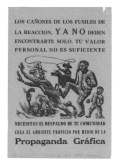

CAT. 46

CAT. 47

CAT. 48

CAT. 49

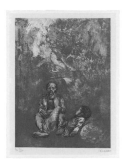

CAT. 50

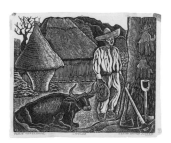

CAT. 51

CAT. 52-1

CAT. 52-A

CAT. 52-2

CAT. 52-3

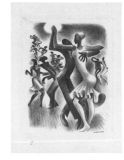

CAT. 53

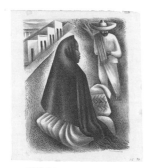

CAT. 54

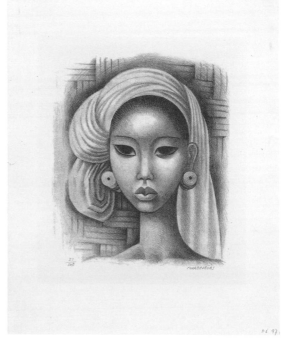

CAT. 55

CAT. 56

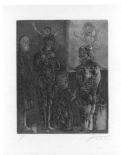

CAT. 57

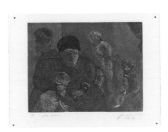

CAT. 58

CAT. 59

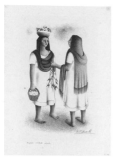

CAT. 60

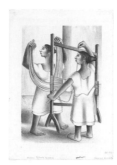

CAT. 61

CAT. 62

CAT. 63

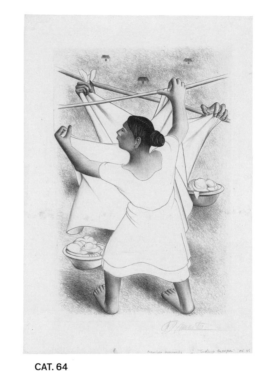

CAT. 64

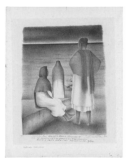

CAT. 65

CAT. 66

CAT. 67

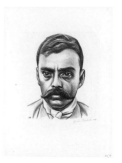

CAT. 68

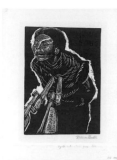

CAT. 69

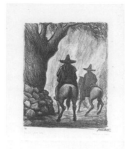

CAT. 70

CAT. 71

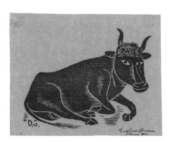

CAT. 72

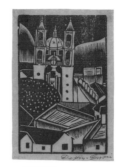

CAT. 73

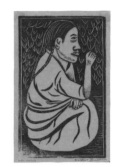

CAT. 74

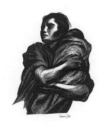

CAT. 75

CAT. 77

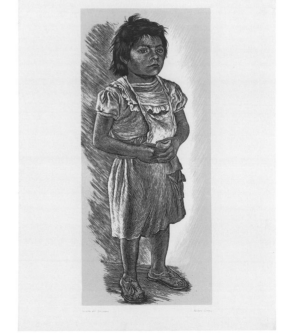

CAT. 76

CAT. 78

CAT. 80

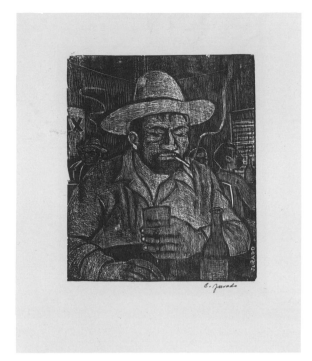

CAT. 79

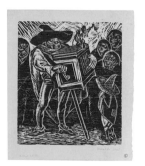

CAT. 81

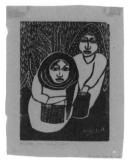

CAT. 82

CAT. 83

CAT. 84

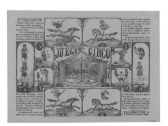

CAT. 85

CAT. 86-A

CAT. 86-1

CAT. 86-2

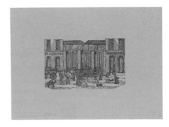

CAT. 86-3

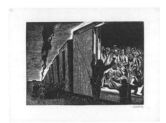

CAT. 87

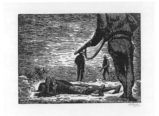

CAT. 88-1

CAT. 88-2

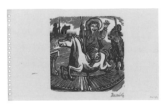

CAT. 89

CAT. 90

CAT. 91-A

CAT. 91-B

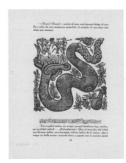

CAT. 91-1

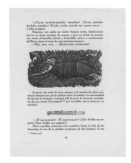

CAT. 91-2

CAT. 91-3

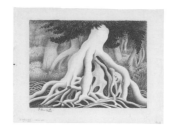

CAT. 92

CAT. 93

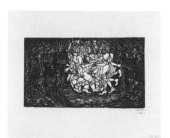

CAT. 94

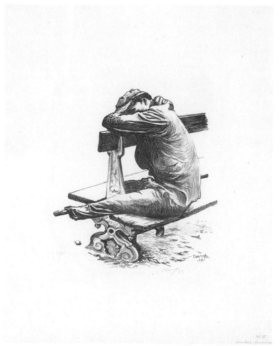

CAT. 95

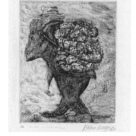

CAT. 96

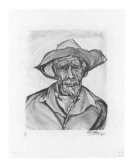

CAT. 97

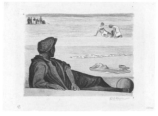

CAT. 98

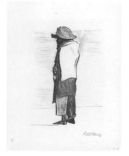

CAT. 99

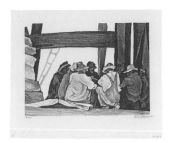

CAT. 100

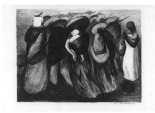

CAT. 101

CAT. 102

CAT. 103

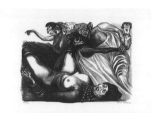

CAT. 104

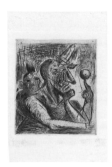

CAT. 105

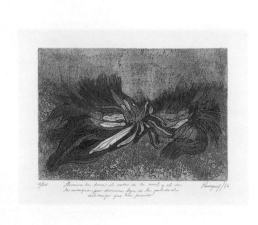

CAT. 106

CAT. 107

CAT. 108-A

CAT. 108-B

CAT. 108-1

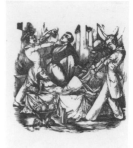

CAT. 108-2

CAT. 108-3

CAT. 108-4

CAT. 108-5

CAT. 108-6

CAT. 108-7

CAT. 108-8

CAT. 108-9

CAT. 108-10

CAT. 108-11

CAT. 108-12

CAT. 108-13

CAT. 108-14

CAT. 108-15

CAT. 109

CAT. 110

CAT. 111

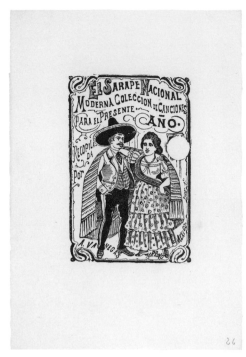

CAT. 112

CAT. 113

CAT. 114

CAT. 115

CAT. 116

CAT. 117

CAT. 118

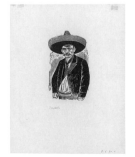

CAT. 119

CAT. 120

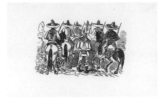

CAT. 121

CAT. 122-A

CAT. 122-1

CAT. 122-3

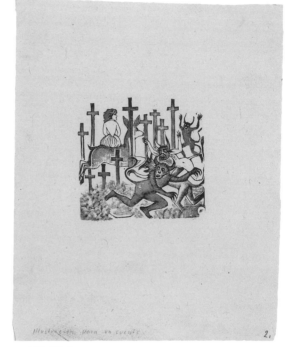

CAT. 122-2

CAT. 122-4

CAT. 122-5

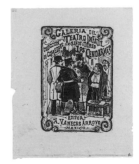

CAT. 122-6

CAT. 122-7

CAT. 122-8

CAT. 122-9

CAT. 122-10

CAT. 122-11

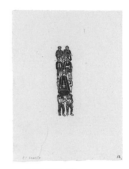

CAT. 122-12

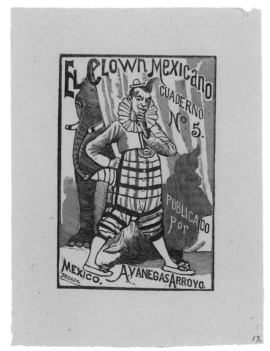

CAT. 122-13

CAT. 122-14

CAT. 122-15

CAT. 122-16

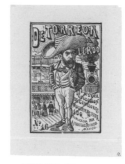

CAT. 122-17

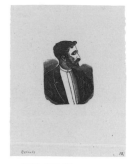

CAT. 122-18

CAT. 122-19

CAT. 122-21

CAT. 122-20

CAT. 122-22

CAT. 122-23

CAT. 122-24

CAT. 122-25

CAT. 123-A

CAT. 123-B

CAT. 123-1

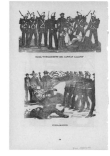

CAT. 123-2

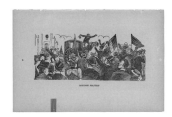

CAT. 123-3

CAT. 123-4

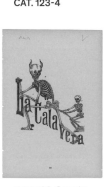

CAT. 123-6 recto

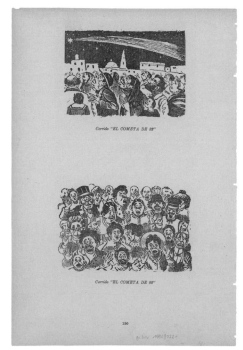

CAT. 123-5

CAT. 123-6 verso

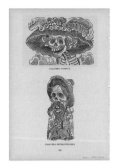

CAT. 123-7

CAT. 123-8

CAT. 123-9

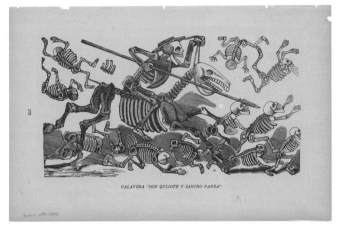

CAT. 123-10

CAT. 123-11

CAT. 124

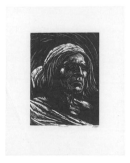

CAT. 125

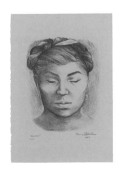

CAT. 126

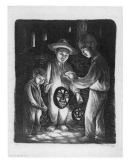

CAT. 127

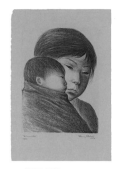

CAT. 128

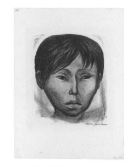

CAT. 129

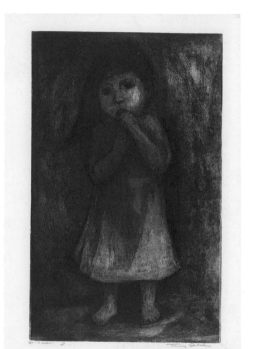

CAT. 130

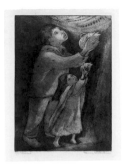

CAT. 131

CAT. 132

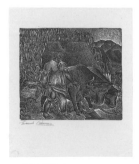

CAT. 133-1

CAT. 133-2

CAT. 134

CAT. 135

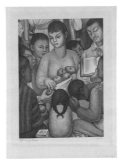

CAT. 136

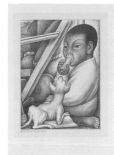

CAT. 137

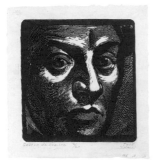

CAT. 138

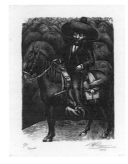

CAT. 139

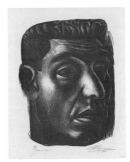

CAT. 140

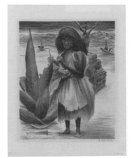

CAT. 141

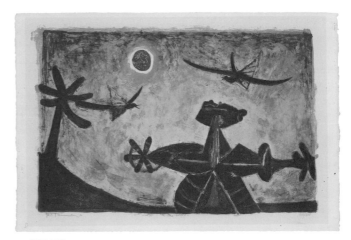

CAT. 142

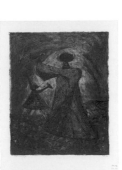

CAT. 143

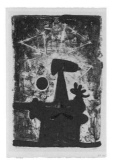

CAT. 144

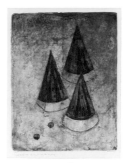

CAT. 145

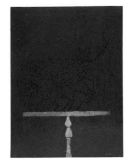

CAT. 146

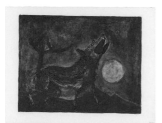

CAT. 147

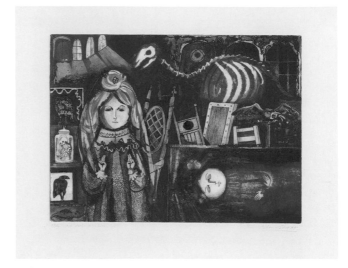

CAT. 148

CAT. 149

CAT. 150

CAT. 151

CAT. 152

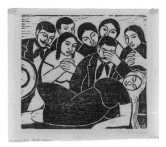

CAT. 153

CAT. 154

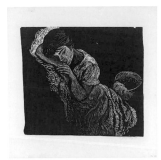

CAT. 155

CAT. 156

CAT. 157

CAT. 158

CAT. 159

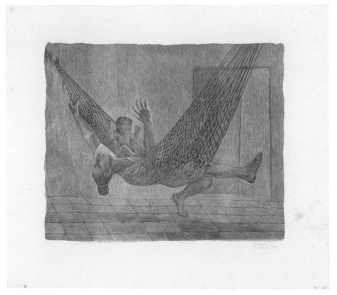

CAT. 160

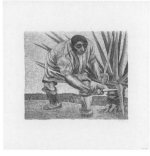

CAT. 161

CAT. 162

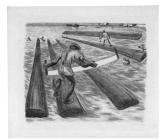

CAT. 163

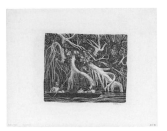

CAT. 164

CAT. 165

CAT. 167

CAT. 166

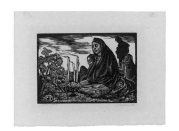

CAT. 168

CAT. 169

CAT. 170

CAT. 171

CAT. 172

CAT. 173

CAT. 174-A

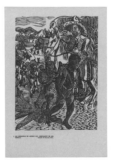

CAT. 174-1

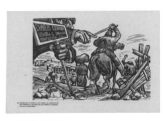

CAT. 174-2

CAT. 174-3

CAT. 174-4

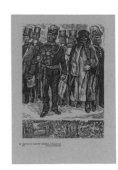

CAT. 174-5

CAT. 175-A

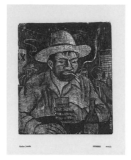

CAT. 175-1

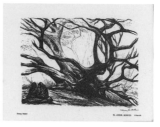

CAT. 175-2

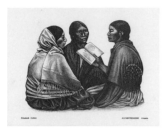

CAT. 175-3

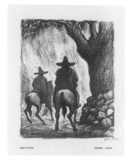

CAT. 175-4

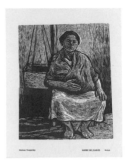

CAT. 175-5

CAT. 175-6

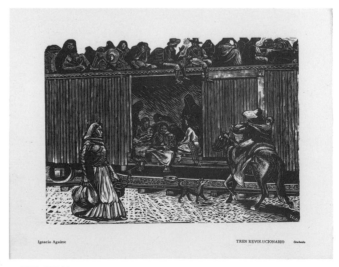

CAT. 175-7

CAT. 175-8

CAT. 175-9

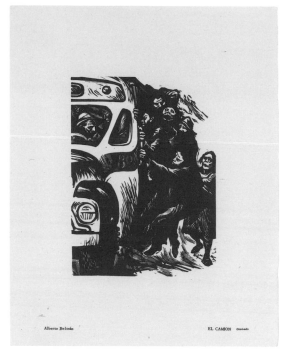

CAT. 175-10

CAT. 175-11

CAT. 175-12

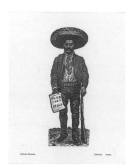

CAT. 175-13

CAT. 175-14

CAT. 175-15

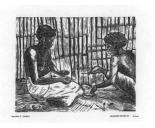

CAT. 175-16

CAT. 175-17

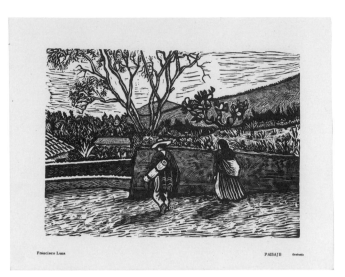

Francisco Luna PAISAJE Grabado

CAT. 175-18

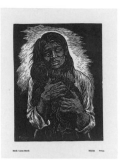

CAT. 175-19

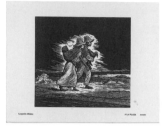

CAT. 175-20

CAT. 175-21

CAT. 175-23

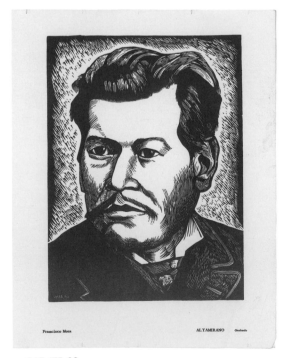

Francisco Mora ALTAMIRANO Grabado

CAT. 175-22

All works are original graphic works, excluding the portfolio pieces by Picheta and Manuel Manilla as well as works by José Guadalupe Posada except CAT. 110, 111, 118, which were printed from the original plates in a limited edition. Apart from the two portfolio works CAT. 174, 175 all works have been listed in alphabetical order below their respective artists.

¡30–30!: Group of Revolutionary, anti-academic artists. The name refers to the .30-30 Winchester bullets. The corresponding rifle was the most frequently used weapon by the opposition during the Mexican Revolution. The group existed from 1928 to 1930 and had thirty members. They published several manifestos as well as their own journal. See P. 121.

Academia de San Carlos: Founded as Real Academia de San Carlos de las Nobles Artes for architecture, painting, and sculpture in the historical center of Mexico City by the Spanish King Carlos III in 1783. It was renamed several times: in 1821 as the Academia Nacional de San Carlos de México, in 1863 as Academia Imperial de San Carlos de México, and in 1867 as Escuela Nacional de Bellas Artes (ENBA). In 1929 it was separated into the Escuela Nacional de Artes Plásticas (National School of Visual Arts) and Escuela Nacional de Arquitectura (National School of Architecture), which for its part was moved to the UNAM campus in 1933 and became the Facultad de Arquitectura (Department of Architecture).

FNAP: Frente Nacional de Artes Plásticas (National Front for Visual Arts). See P. 142.

INBA / INBAL: Instituto Nacional de Bellas Artes/Instituto Nacional de Bellas Artes y Literatura, Mexico City (National Institute of Fine Arts/Fine Arts and Literature).

La Esmeralda: Escuela Nacional de Pintura, Escultura y Grabado, commonly called "La Esmeralda." University department of the INBA.

LEAR: Liga de Escritores y Artistas Revolucionarios (League of Revolutionary Writers and Artists) LEAR was founded in 1933 and disbanded in 1938. See P. 122.

SOTPE: Sindicato de Obreros Técnicos, Pintores y Escultores (Syndicate of Technical Workers, Painters, and Sculptors). In 1923 Siqueiros, Rivera, Guerrero Fermín, Revueltas Sánchez, Orozco, Alva Guadarrama, Germán Cueto, and Carlos Mérida published the SOTPE manifesto. Their graphic organ was *El Machete.* See P. 120.

TGP: El Taller de Gráfica Popular (The Workshop for Popular Graphic Art): The TGP is an association of international artists in Mexico that was founded in 1937. The collective work is devoted to the defense of the people's democratic rights and does not separate social goals from artistic goals. The artists who were united at TGP composed political pamphlets and posters for the populace. See P. 124.

UNAM: Universidad Nacional Autónoma de México (National Autonomous University of Mexico). UNAM is among the oldest and largest universities on the entire American continent. The state university was founded in Mexico City in 1551.

Anonymous (Maya culture)

Late Classic, ca. 720 AD

CAT. 1 [PP. 61, 210]
Glifos del *Tablero del Palacio: 0 Kins / 11 Ahau*
Glyphs of the *Palace Tablet: 0 kins / 11 Ahau*
Stone rubbing from a cast of a Maya relief of
the Palacio Palenque, Yucatán, Mexico,
on Japanese paper
Paper: 55.7 × 32.9 cm; Image: 25 × 23 cm
Inscr. b. r. in graphite: Glifos del Palacio Palenque /
Calcografía de Citlali, Mexico 1977; Stamp b. r.:
Calca de Reproducción autorizada por el I.N.A.H.
[Gr.Inv.1990/0253]

CAT. 2 [PP. 60, 210]
Tablero de los Esclavos: Ix Kinuw Mat, undated
Tablet of the Slaves: Ix Kinuw Mat
Stone rubbing from a cast of a Maya relief of
the Tablero de los Esclavos, Palenque,
Yucatán, Mexico, on Japanese paper
Paper: 109.8 × 46.1 cm; Image: 107 × 37 cm
Inscr. b. l. in graphite: Mujer Palenque /
Tablero de los Esclavos / calc. de Citlali 1977,
Mexico; Stamp b. r.: Calca de Reproducción
autorizada por el I.N.A.H.
[Gr.Inv.1990/0045]

CAT. 3 [P. 210]
Tablero de los Esclavos: Ix Kinuw Mat, detail
Tablet of the Slaves: Ix Kinuw Mat, detail
Stone rubbing from a cast of a Maya stucco
relief of the *Tablero de los Esclavos,* Palenque,
Yucatán, Mexico, on Japanese paper
Paper: 76.2 × 46.8 cm; Image: 69.5 × 37 cm
Inscr. b. l. in graphite: Mujer Palenque / Tablero
de los Esclavos / Calcografía de Citlali, 1977,
Mexico; Stamp b. r.: Calca de Reproducción
autorizada por el I.N.A.H.
[Gr.Inv.1990/0272]

CAT. 4 [P. 210]
Tablero de los Esclavos: K'inich Ahkal Mo' Naab III
Tablet of the Slaves: K'inich Ahkal Mo' Naab III
Stone rubbing from a cast of a Maya relief
of the Citlali, Palenque, Yucatán, Mexico,
on Japanese paper
Paper: 67 × 47.2 cm; Image: 60 × 41 cm
Inscr. t. r. in graphite: Sacerdote, Palenque /
calc. de Citlali, 1977, Mexico; Stamp t. r.: Calca de
Reproducción autorizada por el I.N.A.H.
[Gr.Inv.1990/0274]

CAT. 5 [PP. 60, 210]
Tablero de los Esclavos: Tiwol Chan Mat
Tablet of the Slaves: Tiwol Chan Mat
Stone rubbing from a cast of a Maya stucco
relief of the *Tablero de los Esclavos,* Palenque,
Yucatán, Mexico, on Japanese paper
Paper: 110.5 × 53.2 cm; Image: 106.4 × 48.8 cm
Inscr. b. r. in graphite: Personaje Palenque /
Tablero de los Esclavos / Calcografía de Citlali,
1977, Mexico; Stamp b. r.: Calca de Reproducción
autorizada por el I.N.A.H.
[Gr.Inv.1990/0108]

Aguirre, Ignacio

CAT. 6 [P. 210]
La Adelita. Si por tierraen un tren militar, 1947
Adelita. If by Land, on a Military Train
Linocut
Paper: 47 × 63.3 cm; Image: 34.3 × 45.6 cm
Inscr. b. c. in the plate: I.A.; b. l. in graphite: 1947;
b. r. in graphite: Ignacio Aguirre
[Gr.Inv.1990/0259]

CAT. 7 [P. 210]
En el tren / On the train, 1947
Etching, ed. 7/25
Paper: 35.2 × 31.8 cm; Image: 12.5 × 9.9 cm
Inscr. b. l. in the plate: I A; b. l. in graphite: 7/25;
b. c. in graphite: En el Tren; b. r. in graphite: Aguirre
[Gr.Inv.1990/0228]

Amero, Emilio

CAT. 8 [P. 210]
Mujer con rebozo / Woman with Rebozo, 1938
Lithograph in violet, ultramarine, yellow, and black
Paper: 40.8 × 28.5 cm; Image: 29 × 25.5 cm
Inscr. b. r. in graphite: AMERO – MEX. 38
[Gr.Inv.1990/0114]

Anguiano, Raúl

CAT. 9 [PP . 154, 210]
*Campesinos asesinados. Víctimas de
las guardias blancas,* 1940
Murdered Peasants. Victims of the White Guard
Lithograph, ed. 10/10
Paper: 28.9 × 36.1 cm; Image: 24.8 × 31.2 cm
Inscr. b. l. on the stone: RA; b. l. in graphite: 10/10;
b. r. in graphite: R. Anguiano 1940
[Gr.Inv.1990/0084]

CAT. 10 [P. 210]
La leprosa / Leprose Woman, 1940
Lithograph, ed. 7/20
Paper: 63.2 × 47.9 cm; Image: 36 × 27.1 cm
Inscr. b. l. in graphite: 7/20; b. r.: R. Anguiano 1940
[Gr.Inv.1990/0252]

CAT. 11 [PP. 126, 211]
Retrato de una mujer mexicana, 1948
Portrait of a Mexican Woman
Drawing after the lithograph of 1939
Paper: 65.6 × 50 cm; Image: 48.5 × 38 cm
Inscr. b. l. in colored pencil in black:
R. Anguiano 1948
[Z.Inv.1990/0170]

CAT. 12 [P. 211]
Ná K'in. Lacandona, 1951
Ná K'in. Lacandon Woman
Lithograph, ed. 23/30
Paper: 66.5 × 50.5 cm; Image: 49.9 × 47.8 cm
Inscr. b. l. in graphite: 23/30;
b. r. in graphite: R. Anguiano 1951
[Gr.Inv.1990/0041]

CAT. 13 [P. 211]
Istmeña / Woman from the Isthmus, 1957
Lithograph on handmade paper, ed. 1/50
Paper: 66.5 × 50.6 cm; Image: 54.7 × 41.5 cm
Inscr. b. l.: 1/50; b. r.: R. Anguiano 1957
[Gr.Inv.1990/0065]

CAT. 14 [PP. 179, 211]
Mujer con Iguanas / Woman with Iguanas, 1975
Lithograph in brown-black on FA5
Fabriano paper, ed. 10/15
Paper: 75.8 × 55.8 cm; Image: 67.6 × 51 cm
Inscr. b. l.: 10/15; b. r.: 75 / R. Anguiano
[Gr.Inv.1990/0054]

Arenal Bastar, Luis

CAT. 15 [P. 211]
Niño jugando canicas, 1945
Boy Playing with Marbles
Color lithograph in yellow, blue, and black, ed. 31/35
Paper: 44.2 × 59 cm; Image: 27 × 41.5 cm
Inscr. b. l. on the stone: Arenal 45; b. l. in graphite:
31/35; b. r. in graphite: L Arenal
[Gr.Inv.1990/0040]

CAT. 16 [PP. 127, 211]
Cabeza de indigena. Mujer de Taxco, 1948
Head of a Indigene. Woman from Taxco
Lithograph
Paper: 32.6 × 38.1 cm; Image: 22.7 × 27.7 cm
Inscr. b. r. in graphite: Arenal 48
[Gr.Inv.1990/0103]

Ávila, Abelardo

CAT. 17 [PP. 154, 211]
Al cementerio / To the Cemetery, 1940
Woodcut on yellow paper
Paper: 17.7 × 25.2 cm; Image: 15.5 × 20.1 cm
Inscr. b. r. in graphite: A. Avila – 40
[Gr.Inv.1990/0239]

Beltrán, Alberto

CAT. 18 [PP. 102, 211]
El guerillero Pancho Villa (1877–1923), 1946
The Guerillero Pancho Villa (1877–1923)
Linocut
Paper: 42.7 × 32.1 cm; Image: 29.5 × 21.9 cm
Inscr. b. l.: 1946; b. r.: Beltrán
[Gr.Inv.1990/0263]

CAT. 19 [PP. 137, 211]
Danzantes de los Indios (Fiesta en Chiapas), 1948
Indio Dancers (Fiesta in Chiapas)
Linocut on greenish paper, ed. of 1800
Paper: 17 × 28.8 cm; Image: 12.6 × 16.8 cm
Inscr. b. l. in graphite: 1949;
b. r. in graphite: Beltrán
[Gr.Inv.1990/0206]

CAT. 20 [P. 212]
La leyenda del milagro de la Virgen Generala, 1952
The Legend of the Miracle of the Holy Virgin
Linocut on green paper, original broadside
Paper: 30.4 × 20.3 cm; Image: 26.8 × 15.8 cm
Año Posada 1952 – a.d.g. México T.G.P.
[Gr.Inv.1990/0164]

CAT. 21 [PP. 64, 212]
El pueblo responde. Viva Juárez, 1956
The People Respond. Long Live Juárez
Linocut
Paper: 39 × 52.9 cm; Image: 30 × 42 cm
Inscr. b. r. in the plate: TGP;
verso in graphite: Alberto Beltrán
[Gr.Inv.1990/0059]

Berdecio, Roberto

CAT. 22 [PP. 181, 212]
Retrato de una muchacha mexicana, 1947
Portrait of a Mexican Girl
Lithograph, ed. 55/100
Paper: 55.7 × 66.7 cm; Image: 42.9 × 51.9 cm
Inscr. b. l. in graphite: 55/100;
b. r. in graphite: R. Berdecio
[Gr.Inv.1990/005]

Bracho, Ángel

CAT. 23 [P. 212]
*El puente y el tilichero. El desnivel
de Nonalco,* 1944
*The Bridge and the Beggar.
The Nonalco Overpass*
Lithograph on gray paper
Paper: 49.3 × 64.1 cm; Image: 46.8 × 58.8 cm
Inscr. b. r. in graphite: A. Bracho 1944
[Gr.Inv.1990/0273]

Calderón de la Barca, Celia

CAT. 24 [P. 212]
Niña china / Chinese Girl, 1950
Linocut
Paper: 71 × 44.5 cm; Image: 18.2 × 20.1 cm
Inscr. b. l. in graphite: C. Calderón;
b. r. in graphite: 1950
[Gr.Inv.1990/0071]

CAT. 25 [P. 212]
La enferma / The Invalid, 1950
Etching and aquatint
Paper: 22.4 × 27.4 cm; Image: 18.2 × 20.1 cm
Inscr. b. r. in graphite: C. Calderón
[Gr.Inv.1990/0229]

CAT. 26 [P. 212]
La puerta / The Door, 1969
Etching and aquatint, ed. 17/30
Paper: 66.6 × 50.7 cm; Image: 48.5 × 34 cm
Inscr. b. l. in graphite: 17/30 La Puerta;
b. r. in graphite: C. Calderón / 1969
[Gr.Inv.1990/0064]

Cantú, Federico / Book, CAT. 27

Trece Buriles de Federico Cantú. Con una nota
de Octaviano Valdés. México 1951

CAT. 27-1 [P. 212]
Title page
Paper: 22.5 × 15.5 cm
[Gr.Inv.1990/0279.1]

CAT. 27-2 [P. 212]
Madona / Madonna, 1950–1955
Etching
Paper: 22.5 × 15.5 cm; Image: 11.4 × 10.2 cm
Inscr. b. in graphite: To Armin Haab /
Federico Cantú / 1955
Supplement to: *Trece Buriles de Federico Cantú*
[Gr.Inv.1990/0279.2]

Castro Pacheco, Fernando

CAT. 28 [P. 213]
La intervención yanqui. 21 de abril de 1914, 1940
The Yankee Intervention. April 21, 1914
Linocut, ed. 407/500
Paper: 32.5 × 40 cm; Image: 21 × 28.5 cm
Inscr. b. l. in graphite: Invasion Yankee 1914;
b. r. in graphite: Castro Pacheco; verso b. r.
in graphite: Castro Pacheco
Double from the portfolio: *Estampas de la
Revolución Mexicana* no. 45
[Gr.Inv.1990/0093]

CAT. 29 [PP. 159, 213]
Mujer y niño (La vida en marcha), 1946
Woman and Child (On the Move)
Lithograph
Paper: 46.5 × 32.3 cm; Image: 37.6 × 26.8 cm
Inscr. b. r. in graphite: Castro / 46
[Gr.Inv.1990/0112]

CAT. 30 [PP. 104, 213]
Henequén / Henequenero, 1947
Sisal / Sisal Cutter
Linocut
Paper: 56.2 × 43.3 cm; Image: 35.6 × 29.7 cm
Inscr. b. l. on the plate: F.C.P.; b. r. in graphite:
Castro; Watermark b.: TOLTECA BOND
[Gr.Inv.1990/0264]

CAT. 31 [P. 213]
La vida en marcha / On the Move, 1954
Etching
Paper: 63.5 × 48.3 cm; Image: 45.7 × 33.5 cm
Inscr. b. r. on the stone: Castro; b. l. in graphite:
"La vida en marcha"; b. r.: Castro 54
[Gr.Inv.1990/0262]

CAT. 32 [P. 213]
Mujer sentada / Sitting Woman, 1954
Etching
Paper: 63.3 × 48.2 cm; Image: 45.1 × 32.9 cm
Inscr. b. r. on the stone: Castro;
b. l. in graphite: Castro 54
[Gr.Inv.1990/0242]

CAT. 33 [P. 213]
Colibrí, 1956
Lithograph on handmade paper, ed. 2/10
Paper: 50.7 × 66.6 cm; Image: 41.5 × 50 cm
Inscr. b. l. in graphite: 2/10;
b. r. in graphite: Castro
[Gr.Inv.1990/0066]

Catlett, Elizabeth

CAT. 34 [P. 213]
Domestic Worker, 1946
Lithograph
Paper: 62 × 47.7 cm; Image: 52.1 × 31.6 cm
Inscr. b. r. in graphite: ECatlett 46
[Gr.Inv.1990/0258]

CAT. 35 [PP. 149, 213]
Mother and Child, 1947
Lithograph
Paper: 32 × 24.8 cm; Image: 19.7 × 14.8 cm
Inscr. b. l. on the stone: E. C.; b. l. in graphite:
Mother and Child; b. r.: E Catlett 1947
[Gr.Inv.1990/0225]

CAT. 36 [P. 213]
Negro Woman, 1947
Lithograph
Paper: 35.6 × 24 cm; Image: 30.7 × 22 cm
Inscr. b. l. in graphite: Negro Woman;
b. r.: Elizabeth Catlett 1947
[Gr.Inv.1990/0121]

CAT. 37 [P. 214]
Alfabetización / Alphabetization, 1953
Lithograph, ed. 18/30
Paper: 33.2 × 49.2 cm; Image: 22 × 29 cm
Inscr. b. r.: Elizabeth Catlett; b. l.: Alfabetización,
Litho; [added later] b. r.: 59,5 % / AH 112;
verso: Taller de Grafica Popular [Stamp]
[Gr.Inv.1990/0037]

CAT. 38 [P. 214]
Niño papelero / Newsboy, 1962
Lithograph, ed. 12/40
Paper: 33.3 × 25.2 cm; Image: 26 × 16 cm
Inscr. b. l. in graphite: 4/12;
b. r. in graphite: E Catlett
[Gr.Inv.1990/0224]

Charlot, Jean

CAT. 39 [P. 214]
Luz Seated (to the Right), 1929
Zincography, ed. 15/30
Paper: 29 × 22 cm; Image: 15.7 × 11.5 cm
Inscr. b. r. on the plate: Jean Charlot;
b. r. in graphite: Jean Charlot / 15/30
[Gr.Inv.1990/0227], Morse 1976, cat. 86

CAT. 40 [P. 214]
Jarana / Yucatecan Folk Dance, 1930
Zincography, ed. 20/30
Paper: 28.8 × 20.4 cm; Image: 17.7 × 12.7 cm
Inscr. b. l. on the plate: Jean Charlot;
b. r.: Jean Charlot / 20/30
[Gr.Inv.1990/0226], Morse 1976, cat. 97

CAT. 41 [P. 214]
Head with Rebozo, April 1937
Color lithograph on aluminum, offset in
brown and blue, ed. 31/50
Paper: 22.7 × 33.5 cm; Image: 18.7 × 22.1 cm
Inscr. b. r. in graphite: Jean Charlot 31/50
[Gr.Inv.1990/0116], Morse 1976, cat. 386

CAT. 42 [P. 214]
Tortillera with Child. Rest and Work, 1941
Color lithograph on zinc in gray-brown,
slate-gray, red-brown, and gray, offset
Paper: 33 × 50.7 cm; Image: 31.7 × 47.2 cm
Inscr. b. r. on the stone: Jean Charlot 1941;
b. r. in graphite: Jean Charlot
[Gr.Inv.1990/0038], Morse 1976, cat. 451

CAT. 43 [P. 214]
Sunday Dress, 1947
Color lithograph on stone in green, blue,
brown, and carmine red, A. P.
Paper: 44.3 × 55.9 cm; Image: 31 × 41.6 cm
Inscr. b. l. in graphite: artist's proof; b. r. in graphite:
Jean Charlot; verso t. l. in graphite: Proof Printed
before Edition (#14) / Peter Charlot / July 20, 1979
[Gr.Inv.1990/0081], Morse 1976, cat. 504

Charlot / Portfolio, CAT. 44

Mexihkanantli (Mexican Mother), **10 chromo-
lithographs on stone by Jean Charlot, La Estampa
Mexicana 1947, ed. 26/150, hand-pulled by
José Sanchez under supervision by the artist**

CAT. 44-A [P. 214]
Cover

CAT. 44-1 [PP. 184, 214]
Folio 1: *Yechiwalo,* 1947
Mexican Kitchen
Color lithograph in purple, sepia, and gray
Paper: 28.3 × 23.8 cm; Image: 23.6 × 18.6 cm
Inscr. b. r. on the inside of the portfolio: Jean Charlot;
Inscr. t. r.: 1; b. r. on the stone: Jean Charlot
[Gr.Inv.1990/0174], Morse 1976, cat 457

CAT. 44-2 [PP. 185, 215]
Folio 2: *Tlatiankizosken,* 1947
Return from the Market
Color lithograph in orange, turquoise, and green
Paper: 28.3 × 23.8 cm; Image: 24.4 × 18 cm
Inscr. b. r. on the inside of the portfolio:
Jean Charlot; t. r.: 2
[Gr.Inv.1990/0175], Morse 1976, cat. 493

CAT. 44-3 [PP. 185, 215]
Folio 3: *Nantli Tekiti Noka Konetl Kochi,* 1947
Rest and Work
Color lithograph in purple, gray, blue, and sepia
Paper: 28.3 × 23.8 cm; Image: 24 × 18 cm
Inscr. b. r. on the inside of the portfolio: Jean Charlot;
t. r.: 3; b. l. on the stone: Jean Charlot
[Gr.Inv.1990/0176], Morse 1976, cat. 488

CAT. 44-4 [P. 215]
Folio 4: *Momalin Ihtotihke,* 1947
Preparing for the Dance
Color lithograph in yellow, ultramarine, and black
Paper: 28.3 × 23.8 cm; Image: 23.2 × 18.2 cm
Inscr. b. r. on the inside of the portfolio: Jean Charlot;
t. r.: 4; b. l. on the stone: Jean Charlot
[Gr.Inv.1990/0177], Morse 1976, cat. 498

CAT. 44-5 [PP. 185, 215]
Folio 5: *Konenehnemitla / First Steps,* 1947
Color lithograph in turquoise, green, and orange
Paper: 23.8 × 28.3 cm; Image: 18.5 × 22.7 cm
Inscr. b. r. on the inside of the portfolio: Jean Charlot;
t. r.: 5; b. l. on the stone: Jean Charlot
[Gr.Inv.1990/0178], Morse 1976, cat. 492

CAT. 44-6 [P. 215]
Folio 6: *Konenehnemitla / First Steps,* 1947
Color lithograph in purple, sepia, and gray
Paper: 28.3 × 23.8 cm; Image: 25 × 18.5 cm
Inscr. b. r. on the inside of the portfolio: Jean Charlot;
t. r.: 6; b. l. on the stone: Jean Charlot
[Gr.Inv.1990/0118], Morse 1976, cat. 489

CAT. 44-7 [P. 215]
Folio 7: *Tlazohtlalistle / Trio,* 1947
Color lithograph in yellow, ultramarine, and black
Paper: 28.3 × 23.8 cm; Image: 23.5 × 17.6 cm
Inscr. b. r. on the inside of the portfolio: Jean Charlot;
t. r.: 7; b. l. on the stone: Jean Charlot
[Gr.Inv.1990/0117], Morse 1976, cat. 495

CAT. 44-8 [P. 215]
Folio 8: *Kikahtia Ciwakonetl,* 1947
Sunday Shoes
Color lithograph in green, orange,and blue
Paper: 23.8 × 28.3 cm; Image: 18.5 × 24.5 cm
Inscr. b. r. on the inside of the portfolio: Jean Charlot;
t. r.: 8; b. l. on the stone: Jean Charlot
[Gr.Inv.1990/0179], Morse 1976, cat. 494

CAT. 44-9 [P. 215]
Folio 9: *Kimachtia Tlaxkalmanas,* 1947
Tortilla Lesson
Color lithograph in purple, brown, and gray
Paper: 28.3 × 23.8 cm; Image: 24.8 × 18.2 cm
Inscr. b. r. on the inside of the portfolio: Jean Charlot;
t. r.: 9; c. l. on the stone: Jean Charlot
[Gr.Inv.1990/0180], Morse 1976, cat. 490

CAT. 44-10 [P. 215]
Folio 10: *Mowentihke Chalman* 1947
Chalma Pilgrims
Color lithograph in yellow, sepia, and ultramarine
Paper: 28.3 × 23.8 cm; Image: 24.8 × 18.2 cm
Inscr. b. r. on the inside of the portfolio: Jean Charlot;
t. r.: 10; b. r. on the stone: Jean Charlot
[Gr.Inv.1990/0181], Morse 1976, cat. 497

Chávez Morado, José

CAT. 45 [PP. 128, 216]
Telégrafos / Telegraph Wires, 1938
Lithograph, ed. 3/10
Paper: 61.3 × 48.5 cm; Image: 32.5 × 26.5 cm
Inscr. b. r. on the stone: Ch. M.; b. l. in graphite: 3/10;
b. r.: Chavez / Morado 38
[Gr.Inv.1990/0265]

CAT. 46 [PP. 125, 216]
*Los cañones de los fusiles de la reacción, ya no
deben encontrarte solo. Tu valor personal no
es suficiente. Necesitas el respaldo de tu comunidad,
crea el ambiente propicio por medio de
la Propaganda Gráfica,* 1938
*The Gun Barrels of the Reaction Should Not
Hit You Alone. Your Personal Valor Is Not Enough.
You Need the Support of Your Community, Create
the Right Environment Through Graphic Propaganda*
Linocut on green-brown paper, original broadside
Paper: 33.7 × 23.3 cm; Image: 28.2 × 20.2 cm
México T.G.P. [Gr.Inv.1990/0165]

CAT. 47 [P. 216]
Hombre descansando / Muerto sentado, 1939
Resting Man / Seated Corpse
Lithograph, ed. 15/25
Paper: 63 × 48 cm; Image: 45.3 × 37.8 cm
Inscr. b. r. on the stone: Ch. M.; b. l. in graphite:
Chavez / Morado 39; b. r.: 15/25
[Gr.Inv.1990/0240]

CAT. 48 [P. 216]
Los tres danzantes / The Three Dancers, 1940
Lithograph, ed. 15/35
Paper: 45.5 × 63 cm; Image: 31.3 × 44 cm
Inscr. b. r. on the stone: Ch. M.; b. l. in graphite:
15/35; b. r.: Chavez / Morado 40
[Gr.Inv.1990/0243]

CAT. 49 [PP. 129, 216]
Hojas gigantes / Giant Leaves, 1950
Lithograph on greenish paper, ed. 10/40
Paper: 44.8 × 58.4 cm; Image: 34.8 × 41.7 cm
Inscr. b. l. on the stone: Ch M; b. l. in graphite: 10/40;
b. r.: CHAVEZ / MORADO 50
[Gr.Inv.1990/0268]

Coronel Arroyo, Rafael

CAT. 50 [PP. 168, 216]
El abuelo / The Grandfather, undated
Lithograph in brown-red, yellow ochre,
yellow-brown, and black, ed. P/A IX/XXX
Paper: 65.5 × 50.3 cm; Image: 57.2 × 42.4 cm
Inscr. b. l. in graphite: P/A IX/XXX;
b. r. in graphite: R Coronel
[Gr.Inv.1990/0082]

Cortés Juárez, Erasto

CAT. 51 [P. 216]
Troje morelense / Granary in Morelos, 1940
Linocut
Paper: 24.6 × 29.2 cm; Image: 23.7 × 29.2 cm
Inscr. b. l. on the plate: E C; b. l. in graphite:
Troje Morelense; b. c.: Linoleo;
b. r.: ERASTO CORTEZ JUAREZ
[Gr.Inv.1990/0109]

Cortés Juárez / Portfolio, CAT. 52

*40 Grabados de Erasto Cortés Juárez,
tirados a mano por el autor,* Ediciones Mexicanas,
México 1950, ed. 204/275

CAT. 52-A, 1–3 [P. 216]
Fisonomias de Animales, 1950
Animal Physiognomies
40 woodcuts on colored paper
Paper: 30 × 23.5 cm
Inscr. b. c.: 204 / Erasto Cortés
[Gr.Inv.1990/0153]

Alberto Beltrán [P. 302]

Roberto Berdecio [P. 302] Ángel Bracho [P. 302]

Covarrubias, José Miguel

CAT. 53 [PP. 164, 217]
Lindy Hop, ca. 1927
Lithograph
Paper: 45 × 32.7 cm; Image: 33 × 24.4 cm
Inscr. b. r. in graphite: Covarrubias
[Gr.Inv.1990/0122]

CAT. 54 [P. 217]
Strada mexicana, 1935
Mexican Street
Lithograph, ed. 6/60
Paper: 35.7 × 31.2 cm; Image: 26.3 × 25.1 cm
Inscr. b. l. in graphite: 6/60 B;
b. r. in graphite: Covarrubias
[Gr.Inv.1990/0124]

CAT. 55 [P. 217]
Retrato de Ayu Ktut. Balinesa, 1935
Portrait of Ayu Ktut. Balinese
Lithograph
Paper: 42 × 33.7 cm; Image: 26.3 × 22.1 cm
Inscr. b. l. in graphite: 37/50 B;
b. r. in graphite: Covarrubias
[Gr.Inv.1990/0123]

CAT. 56 [P. 217]
Tío Tom orando, 1938
Praying Uncle Tom
Lithograph, A. P.
Paper: 29 × 20.3 cm; Image: 19.2 × 13.6 cm
Inscr. b. l. in graphite: A. P.;
b. r. in graphite: Covarrubias
Book illustration: Harriet Beecher, *Uncle Tom's Cabin;* or *Life among the Lowly,* New York: The Limited Editions Club, 1938
[Gr.Inv.1990/0223]

Cuevas, José Luis

CAT. 57 [P. 217]
Artistas / Artists, 30. 5. 1976
Etching and aquatint in gray-blue, beige, rose, gray-brown, and black, ed. 130/130
Paper: 65.9 × 50.1 cm; Image: 49.6 × 39.5 cm
Inscr. b. l. on the plate, backwards: 30.V.76 II;
b. l. in graphite: 130/130;
b. r. in graphite: Cuevas / 30. V. 76
[Gr.Inv.1990/0076]

CAT. 58 [P. 217]
La cocina / The Kitchen, 30. 5. 1976
Etching and aquatint in gray-blue, gray, light brown, dark brown, rose, and black, ed. 4/40
Paper: 55 × 66 cm; Image: 39.5 × 50 cm
Inscr. b. l. in graphite: 4/40 La Cocina;
b. r. in graphite: Cuevas / 30. V. 76
[Gr.Inv.1990/0077]

Dosamantes, Francisco

CAT. 59 [P. 217]
Lavando / Washing, 1940
Lithograph
Paper: 62 × 48.2 cm; Image: 42 × 28 cm
Inscr. b. r. in graphite: F. Dosamantes
[Gr.Inv.1990/0247]

CAT. 60 [P. 218]
Mujeres vendiendo pescados, 1940
Fish Vendors
Lithograph
Paper: 35.8 × 32.4 cm; Image: 34 × 20.8 cm
Inscr. b. r. in graphite: F. Dosamantes
[Gr.Inv.1990/0106]

CAT. 61 [P. 218]
Mujeres tejiendo hamaca, 1940
Women Weaving a Hammock
Lithograph
Paper: 41.8 × 29.1 cm; Image: 32.6 × 22.2 cm
[Gr.Inv.1990/0105]

CAT. 62 [P. 218]
Pueblo maya. Paysaje del sureste, 1942
Maya Village. Southeastern Landscape
Lithograph
Paper: 32.6 × 45.9 cm; Image: 26.1 × 34.9 cm
Inscr. b. r. in graphite: F. Dosamantes
[Gr.Inv.1990/0104]

CAT. 63 [PP. 203, 218]
Mujeres Yalaltecas. Mujeres de Oaxaca, September 1946
Yalaltecan Women. Women from Oaxaca
Lithograph
Paper: 38.8 × 29.2 cm; Image: 31.6 × 21.6 cm
Inscr. b. r. in graphite: F. Dosamantes 9/46
[Gr.Inv.1990/0110]

CAT. 64 [P. 218]
Tendiendo la ropa, 1946
Hanging Washing
Lithograph
Paper: 54.8 × 36.9 cm; Image: 44 × 28.4 cm
Inscr. b. r. in graphite: F. Dosamantes
[Gr.Inv.1990/0248]

CAT. 65 [PP. 204, 218]
Mujeres al mar. La espera, 1947
Women at the Sea. The Wait
Lithograph, ed. 98/100
Paper: 64.7 × 50 cm; Image: 47 × 36 cm
Inscr. b. l. in graphite: 98/100; b. c. in graphite:
PARA EL SN. ARMIN HAAB. SINCERAMENTE /
POR SU COOPERACION AL CONOCIMIENTO
DE NUESTRO / ARTE Y PAIS MÉXICO.
FEBRERO 17 1973; b. r. in graphite:
F. Dosamantes 1947
[Gr.Inv.1990/0060]

CAT. 66 [PP. 205, 218]
Los basureros. Arquitectura funcional II, 1955
Garbage Piles. Functional Architecture II
Lithograph
Paper: 44.8 × 58.2 cm; Image: 30.5 × 38 cm
Inscr. b. r. in graphite: F. Dosamantes
[Gr.Inv.1990/0061]

Escobedo, Jesús

CAT. 67 [P. 218]
Cabezas / Heads, 1945
Lithograph
Paper: 62 × 46.8 cm; Image: 40.5 × 26 cm
Inscr. b. r. in graphite: Jesús Escobedo / 1945
[Gr.Inv.1990/0244]

CAT. 68 [PP. 103, 218]
Zapata, 1951
Lithograph
Paper: 48 × 34.5 cm; Image: 27.5 × 20 cm
Inscr. b. l. on the stone: J. E;
b. r. in graphite: Jesús Escobedo
[Gr.Inv.1990/0113]

García Bustos, Arturo

CAT. 69 [PP. 107, 219]
*Hecho en USA. Ayuda norteamericano
para Asia,* 1948
Made in the USA. North-American Help for Asia
Linocut
Paper: 42.5 × 32.7 cm; Image: 30.4 × 21.3 cm
Inscr. b. r.: García Bustos
[Gr.Inv.1990/0101]

CAT. 70 [P. 219]
Jinetes / Horsemen, 1955
Lithograph, ed. 4/20
Paper: 61.3 × 48.3 cm; Image: 44.3 × 34.5 cm
Inscr. b. l. in graphite: 4/20; b. r.: García Bustos
[Gr.Inv.1990/0250]

García Robledo, Luis

CAT. 71 [P. 219]
Los juegos / Games, 1968
Lithograph, ed. 4/10
Paper: 55.6 × 66.4 cm; Image: 43.2 × 53.5 cm
Inscr. b. r. on the stone: LGR; b. l. in graphite:
4/10 p. a.; b. c. in graphite: – LOS JUEGOS – ;
b. r. in graphite: LG Robledo 68
[Gr.Inv.1990/0049]

García, Delfino

CAT. 72 [P. 219]
Toro / Bull, 1939
Linocut on greenish paper
Paper: 13.3 × 16.7 cm; Image: 11.1 × 14 cm
Inscr. b. l. on the plate: D.G.;
b. r.: Delfino García / Taxco G[uerre]ro
[Gr.Inv.1990/0202]

CAT. 73 [PP. 156, 219]
La catedral de Taxco, 1939
Cathedral of Taxco
Linocut on greenish paper
Paper: 16.7 × 11.3 cm; Image: 15.2 × 10 cm
Inscr. b. r. with ink: Delfino García
[Gr.Inv.1990/0203]

CAT. 74 [P. 219]
Indigena asentada, 1939
Seated Indigenous Woman
Linocut on greenish paper
Paper: 22 × 14 cm; Image: 20.6 × 12.6 cm
Inscr. b. r.: Delfino García
[Gr.Inv.1990/0269]

Gómez, Andrea

CAT. 75 [PP. 106, 219]
Madre contra la guerra, 1952
Mother against the War
Linocut
Paper: 60.3 × 45.1 cm; Image: 40.6 × 32.5 cm
Inscr. b. r. in graphite: Andrea Gómez
[Gr.Inv.1990/0183]

CAT. 76 [P. 219]
Niña del basurero, ca. 1953
Garbage Girl
Linocut in beige and black
Paper: 63.8 × 48.3 cm; Image: 55.7 × 24.7 cm
Inscr. b. c. on the plate: A.G.; b. l. in graphite: la Niña
del Basurero; b. r. in graphite: Andrea Gómez
[Gr.Inv.1990/0063]

CAT. 77 [P. 219]
La Calandria (De Manuel Hernández), 1954
The Lark (From Manuel Hernández)
Linocut on orange paper, original broadside
Paper: 34.5 × 23.5 cm; Image: 27 × 20.9 cm
Inscr. b. l. on the plate: ANDREA
[Gr.Inv.1990/0167]

CAT. 78 [P. 220]
Paloma Blanca / White Dove, undated
Linocut on red paper, original broadside
Paper: 34.5 × 23.4 cm; Image: 27 × 20.9 cm
Grabado Andrea. T.G.P.
[Gr.Inv.1990/0173]

Jurado, Carlos

CAT. 79 [P. 220]
Hombre / Man, 1955
Linocut
Paper: 36.8 × 30.7 cm; Image: 24.4 × 20.3 cm
Inscr. b. r. on the plate: JURADO;
b. l. with ink: C. Jurado
[Gr.Inv.1990/0100]

CAT. 80 [P. 220]
Grupo para Fotógrafo, 1970
Group for the Photographer
Silkscreen in rose, burnt sienna, anthracite,
dark brown, green, yellow, ocher, gray-green,
and black, ed. 9/30
Paper: 50.2 × 65.1 cm; Image: 40 × 50 cm
Inscr. b. l. in graphite: Copia de artista 9/30;
b. c. in graphite: "Grupo para Fotógrafo";
b. r. in graphite: C. JURADO – 70 –
[Gr.Inv.1990/0062]

Leal, Fernando

CAT. 81 [P. 220]
El organillero, 1924
The Barrel Organ Player
Woodcut
Paper: 29.3 × 24.3 cm; Image: 23.8 × 20.3 cm
Inscr. b. l. on the plate: FL
[Gr.Inv.1990/0090]

Lugo Guadarrama, Amador

CAT. 82 [P. 220]
Mujeres con chiquihuites, 1947
Women with Handle Baskets
Woodcut
Paper: 19 × 15 cm; Image: 14.8 × 11.1 cm
Inscr. b. r. on the plate backwards: A. Lugo
[Gr.Inv.1990/0204]

Luna, Francisco

CAT. 83 [P. 220]
Espinita. Chotís de Nico Jiménez, 1954
Little Thorn. Folk Dance by Nico Jiménez
Linocut on yellow paper, original broadside
Paper: 34.6 × 23.4 cm; Image: 27.3 × 21.2 cm
Inscr. b. l. on the plate: F. LUNA,
Grabado F. Luna. T.G.P.
[Gr.Inv.1990/0171]

CAT. 84 [P. 220]
Cuatro Milpas (M. de E. Vigil y Robles), undated
Four Cornfields (M. de Vigil y Robles)
Linocut on red paper, original broadside
Paper: 34.5 × 23.5 cm; Image: 27.3 × 20.2 cm
Grabado F. Luna. T.G.P.
[Gr.Inv.1990/0172]

Manilla, Manuel

CAT. 85 [PP. 71, 220]
Juego del circo / Circus Play, 1882–1892
Metalcut, original broadside (Game)
Paper: 29.6 × 39.9 cm; Image: 26.3 × 35 cm
[Gr.Inv.1990/0087]

Manilla / Portfolio, CAT. 86

330 Grabados originales, **Ed. A. Vanegas Arroyo,**
México 1971, ed. 13/375

CAT. 86-A [PP. 87, 220]
All works produced between 1882 and 1892
[Gr.Inv.1990/0182.1-89]

CAT. 86-1 [PP. 72, 220]
Folio 5: *Calavera la penitenciaría.*
La Torre de Eiffel
Skull Penitentiary. Eiffel Tower
Leadcut on green paper
Paper: 37.7 × 27.7 cm; Image: 23.2 × 14.5 cm
[Gr.Inv.1990/0182.5]

CAT. 86-2 [PP. 87, 221]
Folio 48: *Fusilamiento / Shooting*
Leadcut on brown paper
Paper: 37. x 7 × 27.7 cm; Image: 28.6 × 16.7 cm
[Gr.Inv.1990/0182.48]

CAT. 86-3 [P. 221]
Folio 64: *De Abarrotes / Variety Store*
Leadcut on brown paper
Paper: 37. x 7 × 27.7 cm; Image: 12.3 × 19.6 cm
[Gr.Inv.1990/0222]

Méndez, Leopoldo

CAT. 87 [PP. 134, 221]
Deportación a la muerte, 1942
Deportation to Death
Linocut
Paper: 47.9 × 63.2 cm; Image: 34.8 × 49 cm
Inscr. b. r. in graphite: Méndez
[Gr.Inv.1990/0260]

Méndez / Portfolio, CAT. 88

Río Escondido, La Estampa Mexicana,
México 1948, ed. 150
The original prints date from 1947 for the film
Río Escondido by Emilio Fernández

CAT. 88-1 [PP. 198, 221]
Folio 4: *También la tierra bebe tu sangre*
(Río Escondido), 1948
The Earth Also Drinks Your Blood
(Río Escondido)
Linocut
Paper: 40.2 × 50.8 cm; Image: 30.5 × 41.5 cm
Inscr. b. r. in graphite: Méndez / 1954
[Gr.Inv.1990/0266]

CAT. 88-2 [PP. 199, 221]
Folio 9: *Las antorchas (Río Escondido),* 1948
The Torches (Río Escondido)
Linocut
Paper: 40.5 × 50.9 cm; Image: 30.6 × 41.6 cm
Inscr. b. l. in graphite: 9; b. r.: Méndez
[Gr.Inv.1990/0261]

CAT. 89 [PP. 136, 221]
El carrusel, 1948
The Carousel
Motif used for the 1949 New Year's Card of
La Estampa Mexicana publishing house
Linocut, ed. 214/600 (total 1800)
Paper: 17 × 28.4 cm; Image: 13.9 × 13.9 cm
Inscr. b. r. in graphite: Méndez
[Gr.Inv.1990/0205]

CAT. 90 [PP. 93, 221]
Homenaje a Posada. "No habrá leva ese pretexto
conque los actuales caciques arrancan de su hogar
a los hombres a quines odian," 1955
Homage to Posada. "There will be no forced
recruitment. Under this pretext the present chiefs
take from their homes the men that they hate."
Linocut
Paper: 48.8 × 87 cm; Image: 35.5 × 78.5 cm
Inscr. b. l. on the plate: LM; b. r. in graphite: 1955;
b. l. in graphite: LEOPOLDO MENDEZ
[Gr.Inv.1990/0047]

Méndez / Portfolio, CAT. 91

Juan de la Cabada, *Incidentes melódicos del mundo irracional,* 40 grabados originales de Leopoldo Méndez, Editorial La Estampa Mexicana, Mexico 1944, ed. 1200

CAT. 91-A [PP. 144, 221]
Cover for paperback with 62 pages and 40 single- and two-color woodcuts
Paper: 28.5 × 22 cm; Image: 27 × 21 cm
[Gr.Inv.1990/0152.1]

CAT. 91-B [PP. 145, 221]
Title page: *Incidentes melódicos del mundo irracional,* 1944
Parade of the Fools
Paper: 27.6 × 21.1 cm
[Gr.Inv.1990/0152.2]

CAT. 91-1 [PP. 145, 221]
Page 14: *Serpiente de cascabel,* 1944
Rattlesnake
Wood engraving
Paper: 27.6 × 21.2 cm; Image: 13.8 × 13.7 cm
[Gr.Inv.1990/0231]

CAT. 91-2 [PP. 145, 221]
Page 23: *Armadillo,* 1944
Wood engraving in black and red
Paper: 27.6 × 21.2 cm; Image: 7 × 13.5 cm
[Gr.Inv.1990/0232]

CAT. 91-3 [PP. 145, 221]
Page 55: *El alcalde habla,* 1944
The Mayor Speaks
Woodcut in olive and black
Paper: 27.6 × 21.2 cm; Image: 13 × 14 cm
[Gr.Inv.1990/0234]

Monroy, Guillermo

CAT. 92 [P. 222]
Raíces / Roots, 1949
Lithograph
Paper: 49.8 × 65 cm; Image: 38.4 × 51 cm
Inscr. b. l. in graphite: G. Monroy B. / 1949
[Gr.Inv.1990/0184]

Montenegro, Roberto

CAT. 93 [P. 222]
Perfiles mayas / Maya Profiles, ca. 1960
Lithograph on handmade paper
Paper: 66.5 × 50.7 cm; Image: 43.7 × 32 cm
Inscr. b. l. on the stone: Montenegro;
b. l. in graphite: 10-12
[Gr.Inv.1990/0067]

Mora, Francisco

CAT. 94 [P. 222]
El baile / The Dance, 1945
Linocut
Paper: 31.7 × 38 cm; Image: 17.6 × 29.8 cm
Inscr. b. r. in graphite: – MORA – / – 45 –
[Gr.Inv.1990/0111]

Ocampo, Isidoro

CAT. 95 [P. 222]
Hombre durmiendo / Viene el otra / Hombre sin piernas, 1939
Sleeping Man / The Next One Will Come [War] / Man without Legs
Lithograph, ed. 12/25
Paper: 60 × 47.3 cm; Image: 31.8 × 28.9 cm
Inscr. b. r. on the stone: Ocampo 39;
b. l. in graphite: 12/25;
b. r. in graphite: Ocampo 39
[Gr.Inv.1990/0245]

CAT. 96 [P. 222]
Hombre con un costal de papas, 1960
Man with a Sack of Potatoes
Drypoint, ed. 7/12
Paper: 41.8 × 33.5 cm; Image: 34 × 26.5 cm
Inscr. b. l. on the plate: 1960 Isidoro Ocampo;
b. r.: l 60; b. r.: Isidoro Ocampo 60;
verso: Hombre con un costal de papas
Punta secagrabo Isidoro Ocampo
[Gr.Inv.1990/0039]

O'Higgins, Pablo

CAT. 97 [P. 222]
Cabeza de hombre (Don Nieves), 1942
Head of a Man (Don Nieves)
Lithograph on handmade paper, ed. 3/60
Paper: 66.5 × 50.7 cm; Image: 44.7 × 35.5 cm
Inscr. b. l. in graphite: 3/60; b. r. in graphite:
Pablo O'Higgins / 61 [Gr.Inv.1990/0068]

CAT. 98 [PP. 132, 222]
Atletas / Athletes, 1942
Lithograph in sepia, dark brown, light blue,
dark blue, and black, ed. 25/50
Paper: 35.5 × 38.2 cm; Image: 27.3 × 35.3 cm
Inscr. b. l. in graphite: 25/50; b. r.: Pablo
O'Higgins 1942 [Gr.Inv.1990/0115]

CAT. 99 [P. 222]
El Hombre del siglo XX, 1943
Man of the Twentieth Century
Lithograph, ed. 28/30
Paper: 61.3 × 46.3 cm; Image: 40.7 × 29 cm
Inscr. b. l. in graphite: 28/30; b. r.: Pablo
O'Higgins / 43 [Gr.Inv.1990/0241]

CAT. 100 [PP. 119, 223]
Obreros comiendo / Dining Workers, 1948
Lithograph, ed. 7/20
Paper: 43.5 × 51 cm; Image: 31.3 × 41.7 cm
Inscr. b. l. in graphite: 7/20; b. r.: Pablo
O'Higgins 48. [Gr.Inv.1990/0254]

Orozco, José Clemente

CAT. 101 [PP. 118, 223]
La retaguardia / The Rearguard, 1929
Lithograph on BFK France paper, ed. 100
Paper: 40.7 × 58 cm; Image: 34.4 × 47.5 cm
Inscr. b. r. on the stone: J.C.O.; b. r. in graphite:
José Clemente Orozco [Gr.Inv.1990/0267]

CAT. 102 [PP. 116, 223]
Inditos (Magueyes y nopales), 1929
Indians (Agaves and Prickly Pears)
Lithograph on BFK France paper, ed. 51/100
Paper: 38.6 × 58 cm; Image: 31 × 43.3 cm
Inscr. b. l. in graphite: 51/100; b. r. in graphite:
J. C. Orozco [Gr.Inv.1990/0069]

CAT. 103 [PP. 175, 223]
La chata / La borracha, 1935
The Pug Nose / The Drunk
Drypoint
Paper: 61 × 40 cm; Image: 14.5 × 19.5 cm
First edition: 25 prints; second edition: 75 prints
(Reprint by the family Orozco, ca. 1978)
[Gr.Inv.1990/0073]

CAT. 104 [PP. 176, 223]
Mujer muerta / Dead woman, 1935
Lithograph, ed. 111/140
Paper: 40.4 × 58 cm; Image: 31 × 43 cm
Inscr. b. l. in graphite: 111/140;
b. r. in graphite: J. C. Orozco
[Gr.Inv.1990/0074]

CAT. 105 [P. 223]
Payaso con una pelota, 1944
Clown with a Ball
Etching and aquatint
Paper: 42.6 × 27.5 cm; Image: 27 × 22.7 cm
First edition: 80 prints;
second edition, 1951: 75 prints
[Gr.Inv.1990/0075]

Parraguirre, María Luisa

CAT. 106 [P. 223]
Flor rosa / Pink Flower, 1976
Woodcut in rose, brown, green, anthracite
and black, ed. 5/25
Paper: 44.1 × 49.1 cm; Image: 20 × 28.7 cm
Inscr. b. l. in graphite: 5/25; b. c. in graphite:
"Llevas a la boca el sabor de la miel y el
de la amargura pero duermes lejos de
la soledad del cuerpo que has poseído";
b. r. in graphite: Parraguirre 76
[Gr.Inv.1990/0094]

CAT. 107 [P. 223]
Desordenes / Disorder, 1976
Woodcut in brown, dark brown, turquoise,
and blue, ed. 4/25
Paper: 44 × 48.1 cm; Image: 22.5 × 26.3 cm
Inscr. b. l. in graphite: 4/25; b. c. in graphite:
"Desordenes en un tiempo los palabros
que dice ahora"; b. r. in graphite: Parraguirre 76
[Gr.Inv.1990/0092]

Jean Charlot [P. 303]

Picheta / Portfolio, CAT. 108

15 Grabados de Picheta, Con una nota de
Leopoldo Peniche Vallado, Editorial provincia
Mérida Yucatán México, 1947.
Periodico burlesco y de Extravagancia.
Redactado por una sociedad. Bulliciosos. Tom II.
Mérida de Yucatán, 15. 4. 1847

CAT. 108-A [P. 223]
Cover
[Gr.Inv.1990/0185.1a]

CAT. 108-B [PP. 83, 224]
Title page
[Gr.Inv.1990/0185.1b]

CAT. 108-1 [PP. 83, 224]
Folio 1: *Don Bullebulle*
Woodcut
Paper: 21.3 × 12.9 cm; Image: 18.6 × 10.7 cm
[Gr.Inv.1990/0185.2]

CAT. 108-1b [PP. 83, 224]
Folio 1: *Don Bullebulle*
Woodcut, ed. 118
Paper: 20 × 11.2 cm; Image: 18.6 × 10.7 cm
[Gr.Inv.1990/0185.2b]

CAT. 108-2 [P. 224]
Folio 2: *Se hacían añicos las honras /*
La parábola soñada o el sueño parabólico
Honors Were Shattered / The Dreamed
Parable or the Parabolic Dream
Woodcut
Paper: 12.6 × 10.5 cm; Image: 9.1 × 9.6 cm
[Gr.Inv.1990/0186]

CAT. 108-2b [P. 224]
Folio 2: *Se hacían añicos las honras /*
La parábola soñada o el sueño parabólico
Honors Were Shattered / The Dreamed
Parable or the Parabolic Dream
Woodcut, ed. 118
Paper: 11 × 10.6 cm; Image: 9.1 × 9.6 cm
[Gr.Inv.1990/0186b]

CAT. 108-3 [P. 224]
Folio 3: *La paz o la guerra*
Peace or War
Woodcut
Paper: 11.8 × 8.6 cm; Image: 9.9 × 6.6 cm
[Gr.Inv.1990/0187]

CAT. 108-3b [P. 224]
Folio 3: *La paz o la guerra*
Peace or War
Woodcut, ed. 118
Paper: 11.8 × 8.2 cm; Image: 9.9 × 6.6 cm
[Gr.Inv.1990/0187b]

CAT. 108-4 [P. 224]
Folio 4: *La sobrina del tío Bigornia*
The Niece of Uncle Bigornia
Woodcut
Paper: 13.3 × 10.5 cm; Image: 12.9 × 9.5 cm
[Gr.Inv.1990/0188]

CAT. 108-4b [P. 224]
Folio 4: *La sobrina del tío Bigornia*
The Niece of Uncle Bigornia
Woodcut, ed. 118
Paper: 15 × 11.2 cm; Image: 12.9 × 9.5 cm
[Gr.Inv.1990/0188b]

CAT. 108-5 [P. 224]
Folio 5: *Niní va por lana y vuelve trasquilado*
Niní Goes for Wool and Comes Back Shorn
Woodcut
Paper: 12.9 × 10.9 cm; Image: 10.3 × 9.6 cm
[Gr.Inv.1990/0189]

CAT. 108-5b [P. 224]
Folio 5: *Niní va por lana y vuelve trasquilado*
Niní Goes for Wool and Comes Back Shorn
Woodcut, ed. 118
Paper: 12.8 × 12 cm; Image: 10.3 × 9.6 cm
[Gr.Inv.1990/0189b]

CAT. 108-6 [P. 224]
Folio 6: *Coronación de un marido por su mujer*
y su amigo (según Francisco Díaz de León)
Coronation of a Husband by His Wife and His Friend
(after Francisco Díaz de León)
Woodcut
Paper: 11.5 × 9.8 cm; Image: 9.5 × 8 cm
[Gr.Inv.1990/0190]

CAT. 108-6b [P. 224]
Folio 6: *Coronación de un marido por su mujer
y su amigo (según Francisco Díaz de León)*
*Coronation of a Husband by His Wife and His Friend
(after Francisco Díaz de León)*
Woodcut, ed. 118
Paper: 12.4 × 10.5 cm; Image: 9.5 × 8 cm
[Gr.Inv.1990/0190b]

CAT. 108-7 [P. 224]
Folio 7: *Perder por el pico (según Raquel Tibol)*
Bigmouth Has to Eat His Words (after Raquel Tibol)
Woodcut
Paper: 13.7 × 10.7 cm; Image: 12.7 × 10.5 cm
Inscr. b. r. on the plate: Picheta
[Gr.Inv.1990/0191]

CAT. 108-7b [P. 224]
Folio 7: *Perder por el pico (según Raquel Tibol)*
Bigmouth Has to Eat His Words (after Raquel Tibol)
Woodcut, ed. 118
Paper: 13.5 × 10.2 cm; Image: 12.7 × 10.5 cm
Inscr. b. r. on the plate: Picheta
[Gr.Inv.1990/0191b]

CAT. 108-8 [P. 224]
Folio 8: *Lolita y Panchito / Ingeniosa
invención para conservar entre los esposos
el amor que se profesan*
*Lolita and Panchito / Ingenious Invention
to Preserve the Love among Spouses*
Woodcut
Paper: 12.6 × 10.9 cm; Image: 9.4 × 9.4 cm
Inscr. b. c. on the plate: Picheta
[Gr.Inv.1990/0192]

CAT. 108-8b [P. 224]
Folio 8: *Lolita y Panchito / Ingeniosa
invención para conservar entre los esposos
el amor que se profesan*
*Lolita and Panchito / Ingenious Invention
to Preserve the Love among Spouses*
Woodcut, ed. 118
Paper: 12.2 × 12 cm; Image: 9.4 × 9.4 cm
Inscr. b. c. on the plate: Picheta
[Gr.Inv.1990/0192b]

CAT. 108-9 [PP. 84, 225]
Folio 9: *La nariz de Picheta / The Nose of Picheta*
Woodcut
Paper: 13 × 10.5 cm; Image: 10.8 × 8.9 cm
[Gr.Inv.1990/0193]

CAT. 108-9b [PP. 84, 225]
Folio 9: *La nariz de Picheta / The Nose of Picheta*
Woodcut, ed. 118
Paper: 11 × 10.6 cm; Image: 10.8 × 8.9 cm
[Gr.Inv.1990/0193b]

CAT. 108-10 [P. 225]
Folio 10: *Yo tengo mi almacén / Todito a
pedir de boca*
I Have My Store / All's Just Fine
Woodcut
Paper: 6.9 × 11.6 cm; Image: 4.4 × 9.7 cm
[Gr.Inv.1990/0194]

CAT. 108-10b [P. 225]
Folio 10: *Yo tengo mi almacén / Todito a
pedir de boca*
I Have My Store / All's Just Fine
Woodcut, ed. 118
Paper: 8.5 × 13.6 cm; Image: 4.4 × 9.7 cm
[Gr.Inv.1990/0194b]

CAT. 108-11 [P. 225]
Folio 11: *Unos monos en actitud y tren de literatos /
En una islasituada entre el cabo Catoche y la Siberia
(según Raquel Tibol)*
*Monkeys Putting on the Airs of Literates /
On an Island between Cape Catoche and La Siberia
(after Raquel Tibol)*
Woodcut
Paper: 13.8 × 10.8 cm; Image: 13 × 10 cm
Inscr. b. r. on the plate: Picheta
[Gr.Inv.1990/0195]

CAT. 108-11b [P. 225]
Folio 11: *Unos monos en actitud y tren de literatos /
En una islasituada entre el cabo Catoche y la Siberia
(según Raquel Tibol)*
*Monkeys Putting on the Airs of Literates /
On an Island between Cape Catoche and La Siberia
(after Raquel Tibol)*
Woodcut, ed. 118
Paper: 14.3 × 11 cm; Image: 13 × 10 cm
Inscr. b. r. on the plate: Picheta
[Gr.Inv.1990/0195b]

CAT. 108-12 [P. 225]
Folio 12: *El escribano público / Este es el buen
hermano llamado Don Escribano*
*The Public Notary / This Is the Good Brother
Called Don Escribano*
Woodcut
Paper: 9.7 × 8.7 cm; Image: 7.5 × 6.5 cm
Inscr. b. l. on the plate: Picheta
[Gr.Inv.1990/0196]

CAT. 108-12b [P. 225]
Folio 12: *El escribano público / Este es el buen
hermano llamado Don Escribano*
*The Public Notary / This Is the Good Brother
Called Don Escribano*
Woodcut, ed. 118
Paper: 9.5 × 8.5 cm; Image: 7.5 × 6.5 cm
Inscr. b. l. on the plate: Picheta
[Gr.Inv.1990/0196b]

CAT. 108-13 [P. 225]
Folio 13: *El confesor comía que se las pelaba /
Las beatas en carnaval*
*Father Confessor Ate till He Dropped /
The Pious Ladies at the Carnival*
Woodcut
Paper: 9.1 × 11.4 cm; Image: 7.5 × 10 cm
[Gr.Inv.1990/0197]

CAT. 108-13b [P. 225]
Folio 13: *El confesor comía que se las pelaba /
Las beatas en carnaval*
*Father Confessor Ate till He Dropped /
The Pious Ladies at the Carnival*
Woodcut, ed. 118
Paper: 10.7 × 12.8 cm; Image: 7.5 × 10 cm
Gr.Inv.1990/0197b

CAT. 108-14 [P. 225]
Folio 14: *Las locuras de Picheta /
Vaya un artículo de mentiras y verdades... subió
Picheta sobre la prensa....*
*The Follies of Picheta / What an Article on Lies
and Truths... Picheta Spread through the Press...*
Woodcut
Paper: 11.5 × 9.1 cm; Image: 9 × 7.6 cm
[Gr.Inv.1990/0198]

CAT. 108-14b [P. 225]
Folio 14: *Las locuras de Picheta /
Vaya un artículo de mentiras y verdades... subió
Picheta sobre la prensa....*
*The Follies of Picheta / What an Article on Lies
and Truths... Picheta Spread through the Press...*
Woodcut, ed. 118
Paper: 12.8 × 10.4 cm; Image: 9 × 7.6 cm
[Gr.Inv.1990/0198b]

CAT. 108-15 [P. 225]
Folio 15: *Esos son tropezones*
These Are Stumbles
Woodcut
Paper: 9.7 × 11.8 cm; Image: 7.5 × 9.7 cm
Inscr. b. l. on the plate: Picheta
[Gr.Inv.1990/0199]

CAT. 108-15b [P. 225]
Folio 15: *Esos son tropezones*
These Are Stumbles
Woodcut, ed. 118
Paper: 8.9 × 10.9 cm; Image: 7.5 × 9.7 cm
Inscr. b. l. on the plate: Picheta
[Gr.Inv.1990/0199b]

Posada, José Guadalupe

CAT. 109 [P. 225]
El pequeño adivinadorcito, 1890–1900
The Little Diviner
Metalcut on handmade paper
Paper: 24 × 16.5 cm; Image: 13.4 × 8.5 cm
Inscr. b. r. on the plate: Posada
Print TGP [Gr.Inv.1990/0158]

CAT. 110 [PP. 73, 225]
*Escándalo de balazos. Gaceta Callejera,
28. 9. 1893, N. 12, Imprenta de Antonio Vanegas
Arroyo, Calle Sta. Teresa, numero 1,
Mexico, 28. 9. 1893*
*Turmoil Following Shots Fired,
Street Paper, 28. 9. 1893*
Metalcut on yellow paper, original broadside
Paper: 41.5 × 32 cm; Image: 15.5 × 23.6 cm
[Gr.Inv.1990/0270b]

José Chávez Morado [P.303] José Miguel Covarrubias [P.304]

CAT. 111 [PP. 73, 225]
*Importantes detalles acerca del vuelo del
Sr. Romero. Gaceta Callejera, 26.8.1895, N. 15,
Imprenta de Antonio Vanegas Arroyo,
Calle Sta. Teresa, numero 1, Mexico, 26.8.1895*
*Important Details Concerning the Flight
of Sr. Romero, Street Paper, 26.8.1895*
Metalcut on violet paper, original broadside
Paper: 41 × 32 cm; Image: 15.2 × 22.6 cm
Inscr. b. r. on the plate: Posada
[Gr.Inv.1990/0088]

CAT. 112 [P. 226]
El sarape nacional, ca. 1905
The National Serape
Zinc-etching on handmade paper
Paper: 24 × 16.5 cm; Image: 13.2 × 8.6 cm
Inscr. c. r. on the plate: Posada
Print TGP [Gr.Inv.1990/0155]

CAT. 113 [P. 226]
La a / A, ca. 1905
Zinc-etching on handmade paper
Paper: 24 × 16.5 cm; Image: 13.1 × 8.5 cm
Inscr. b. r. on the plate: Posada
Print TGP [Gr.Inv.1990/0156]

CAT. 114 [P. 226]
Juan soldado / Soldier Juan, ca. 1905
Zinc-etching on handmade paper
Paper: 24 × 16.5 cm; Image: 13.7 × 8.8 cm
Inscr. b. r. on the plate: Posada
Print TGP [Gr.Inv.1990/0157]

CAT. 115 [P. 226]
M. Acuñaum, ca. 1905
Metalcut on handmade paper
Paper: 24 × 16.5 cm; Image: 13.5 × 8.8 cm
Inscr. b. r. on the plate: Posada
Print TGP [Gr.Inv.1990/0159]

CAT. 116 [P. 226]
Pordiosero y señor rico, ca. 1905
The Beggar and the Rich Señor
Metal etching on handmade paper
Paper: 24 × 16.5 cm; Image: 5.7 × 6.7 cm
Inscr. b. r. on the plate: Posada
Print TGP [Gr.Inv.1990/0161]

CAT. 117 [P. 226]
Ranchero y el buen Miguel, ca. 1905
Ranch Owner and Good Miguel
Metal etching on handmade paper
Paper: 24 × 16.5 cm; Image: 6.4 × 5.3 cm
Inscr. b. r. on the plate: Posada
Print TGP [Gr.Inv.1990/0162]

CAT. 118 [P. 226]
Muy interesante noticia, 1907
Very Interesting News
Metalcut on yellow broadside
Paper: 29.8 × 20 cm; Image: 8.8 × 13.8 cm
Insert in the booklet: *Posada, Artes de Mexico,*
Vol IV, Enero y Febrero de 1958
[Gr.Inv.1990/0213]

CAT. 119 [P. 226]
Zapata, ca. 1911
Zinc-etching
Paper: 30.9 × 23.5 cm; Image: 14.5 × 8.4 cm
Inscr. verso with ink: Certifico que este grabado
fué impreso de la plancha original de José
Guadalupe Posada. Antonio Vanegas Arroyo
[Gr.Inv.1990/0154a]

CAT. 119b [P. 226]
Zapata, ca. 1911
Zinc-etching on handmade paper
Paper: 24 × 16.1 cm; Image: 14.5 × 8.4 cm
[Gr.Inv.1990/0154b]

CAT. 120 [P. 227]
Bruja volanda con niño, undated
Witch Flying with a Child
Metalcut
Paper: 24 × 16.5 cm; Image: 5.9 × 6.8 cm
[Gr.Inv.1990/0200]

CAT. 121 [PP. 119, 227]
*Admirabilisimo milagro, inexplicable prodigio.
Por la intercesiòn de Maria Santísima
de los Remedios que se venera en Cholula
(Estado de Puebla),* undated
*What a Miracle, Inexplicable Miracle.
Thanks to the Workings of the Holy Mother of
Remedies, Who is Revered in Choluta (Puebla)*
Zinc-etching
Paper: 13.3 × 21.4 cm; Image: 7.7 × 13 cm
Inscr. verso: Antonio Vanegas Arroyo
[Gr.Inv.1990/0201a]

Posada / Portfolio, CAT. 122

25 Prints of José Guadalupe Posada, published by La Estampa Mexicana, México 1942

CAT. 122-A [P. 227]
Title page
Paper: 24 × 16.5 cm

CAT. 122-1 [P. 227]
Folio 1: *El clown mexicano,* ca. 1905
The Mexican Clown
Metalcut, ed. 19
Paper: 18.5 × 13.8 cm; Image: 13.2 × 8.8 cm
Inscr. b. r. on the plate: Posada
[Gr.Inv.1990/0126a]

CAT. 122-1b [P. 227]
Folio 1: *El clown mexicano,* ca. 1905
The Mexican Clown
Metalcut on handmade paper
Paper: 24 × 16.5 cm; Image: 13.2 × 8.8 cm
Inscr. b. r. on the plate: Posada
[Gr.Inv.1990/0126b]

CAT. 122-2 [P. 227]
Folio 2: *Ilustración para un cuento,* ca. 1905
Illustration for a Story
Metalcut, ed. 19
Paper: 18.5 × 13.8 cm; Image: 6.7 × 7 cm
[Gr.Inv.1990/0127]

CAT. 122-3 [P. 227]
Folio 3: *Te volví a ver,* ca. 1905
I Saw You Again
Metalcut, ed. 19
Paper: 18.5 × 13.8 cm; Image: 13 × 8.4 cm
[Gr.Inv.1990/0128a]

CAT. 122-3b [P. 227]
Folio 3: *Te volví a ver,* ca. 1905
I Saw You Again
Metalcut on handmade paper
Paper: 24 × 16.3 cm; Image: 13 × 8.4 cm
[Gr.Inv.1990/0128b]

CAT. 122-3c [P. 227]
Folio 3: *Te volví a ver,* ca. 1905
I Saw You Again
Metalcut
Paper: 24 × 17.5 cm; Image: 13 × 8.4 cm
Print TGP [Gr.Inv.1990/0128c]

CAT. 122-4 [P. 227]
Folio 4: *El brindador popular,* ca. 1905
The Populist Toast
Metalcut, ed. 19
Paper: 18.5 × 13.8 cm; Image: 13.6 × 8.8 cm
[Gr.Inv.1990/0129a]

CAT. 122-4b [P. 227]
Folio 4: *El brindador popular,* ca. 1905
The Populist Toast
Metalcut on handmade paper
Paper: 24 × 16.5 cm; Image: 13.6 × 8.8 cm
[Gr.Inv.1990/0129b]

CAT. 122-4c [P. 227]
Folio 4: *El brindador popular,* ca. 1905
The Populist Toast
Metalcut
Paper: 24 × 17.5 cm; Image: 13.6 × 8.8 cm
Print TGP [Gr.Inv.1990/0129c]

CAT. 122-5 [P. 227]
Folio 5: *La banda,* ca. 1905
The Band
Metalcut, ed. 19
Paper: 18.5 × 13.8 cm; Image: 3.3 × 8.3 cm
[Gr.Inv.1990/0212]

CAT. 122-6 [P. 227]
Folio 6: *Los gendarmes,* ca. 1905
The Gendarmes
Metalcut, ed. 19
Paper: 18.5 × 13.8 cm; Image: 13.2 × 8.6 cm
[Gr.Inv.1990/0131a]

CAT. 122-6b [P. 227]
Folio 6: *Los gendarmes,* ca. 1905
The Gendarmes
Metalcut on handmade paper
Paper: 24 × 16.4 cm; Image: 13.2 × 8.6 cm
[Gr.Inv.1990/0131b]

CAT. 122-7 [P. 228]
Folio 7: *Los patinadores,* ca. 1905
Metalcut, ed. 19
Paper: 18.5 × 13.8 cm; Image: 13.6 × 8.8 cm
Inscr. b. r. on the plate: Posada
[Gr.Inv.1990/0132a]

Jesús Escobedo　[P. 304]　　　　　Delfino García　[P. 305]

CAT. 122-7b [P. 228]
Folio 7: *Los patinadores,* ca. 1905
Metalcut on handmade paper
Paper: 24 × 16.4 cm; Image: 13.6 × 8.8 cm
Inscr. b. r. on the plate: Posada
[Gr.Inv.1990/0132b]

CAT. 122-7c [P. 228]
Folio 7: *Los patinadores,* ca.1905
Metalcut
Paper: 24 × 17.4 cm; Image: 13.6 × 8.8 cm
Inscr. b. r. on the plate: Posada
Print TGP [Gr.Inv.1990/0132c]

CAT. 122-8 [PP. 78, 228]
Folio 8: *El testarazo del diablo,* ca. 1905
The Devil's Headbutt
Metalcut, ed. 19
Paper: 18.5 × 13.8 cm; Image: 13.4 × 8.7 cm
Inscr. b. r. on the plate: Posada
[Gr.Inv.1990/0133a]

CAT. 122-8b [PP. 78, 228]
Folio 8: *El testarazo del diablo,* ca. 1905
The Devil's Headbutt
Metalcut on handmade paper
Paper: 24 × 16.4 cm; Image: 13.4 × 8.7 cm
Inscr. b. r. on the plate: Posada
[Gr.Inv.1990/0133b]

CAT. 122-8c [PP. 78, 228]
Folio 8: *El testarazo del diablo,* ca. 1905
The Devil's Headbutt
Metalcut
Paper: 24 × 17.4 cm; Image: 13.4 × 8.7 cm
Inscr. b. r. on the plate: Posada
Print TGP [Gr.Inv.1990/0133c]

CAT. 122-9 [P. 228]
Folio 9: *El doctor improvisado,* ca. 1905
The Pretended Doctor
Metalcut, ed. 19
Paper: 18.5 × 13.8 cm; Image: 13.3 × 8.6 cm
Inscr. b. r. on the plate: Posada
[Gr.Inv.1990/0134a]

CAT. 122-9b [P. 228]
Folio 9: *El doctor improvisado,* ca. 1905
The Pretended Doctor
Metalcut on handmade paper
Paper: 24 × 16.4 cm; Image: 13.3 × 8.6 cm
Inscr. b. r. on the plate: Posada
[Gr.Inv.1990/0134b]

CAT. 122-9c [P. 228]
Folio 9: *El doctor improvisado,* ca. 1905
The Pretended Doctor
Metalcut
Paper: 24 × 17.4 cm; Image: 13.3 × 8.6 cm
Inscr. b. r. on the plate: Posada
Print TGP [Gr.Inv.1990/0134c]

CAT. 122-10 [P. 228]
Folio 10: *El consultorio médico,* ca. 1905
The Doctor's Office
Zinc-etching, ed. 19
Paper: 18.5 × 13.8 cm; Image: 12.8 × 8.6 cm
[Gr.Inv.1990/0135a]

CAT. 122-10b [P. 228]
Folio 10: *El consultorio médico,* ca. 1905
The Doctor's Office
Zinc-etching on handmade paper, ed. 19
Paper: 24 × 16.4 cm; Image: 12.8 × 8.6 cm
[Gr.Inv.1990/0135b]

CAT. 122-11 [P. 228]
Folio 11: *Ilustración para un cuento,* ca. 1905
Illustration for a Story
Zinc-etching, ed. 19
Paper: 18.5 × 13.8 cm; Image: 10.3 × 16.2 cm
[Gr.Inv.1990/0136]

CAT. 122-12 [P. 228]
Folio 12: *El sepelio / The Funeral,* ca. 1905
Zinc-etching, ed. 19
Paper: 18.5 × 13.8 cm; Image: 8.7 × 2.1 cm
[Gr.Inv.1990/0211]

CAT. 122-13 [P. 228]
Folio 13: *El clown mexicano,* ca. 1905
The Mexican Clown
Metalcut, ed. 19
Paper: 18.5 × 13.8 cm; Image: 12.9 × 8.7 cm
Inscr. b. l. on the plate: Posada
[Gr.Inv.1990/0138a]

CAT. 122-13b [P. 228]
Folio 13: *El clown mexicano,* ca. 1905
The Mexican Clown
Metalcut on handmade paper, ed. 19
Paper: 24 × 16.4 cm; Image: 12.9 × 8.7 cm
Inscr. b. l. on the plate: Posada
[Gr.Inv.1990/0138b]

CAT. 122-13c [P. 228]
Folio 13: *El clown mexicano,* ca. 1905
The Mexican Clown
Metalcut
Paper: 24 × 17.4 cm; Image: 12.9 × 8.7 cm
Inscr. b. l. on the plate: Posada
Print TGP [Gr.Inv.1990/0138c]

CAT. 122-14 [P. 228]
Folio 14: *Los toreros (juguete),* ca. 1905
The Toreros (Toy)
Metalcut, ed. 19
Paper: 18.5 × 13.8 cm; Image: 11.5 × 5.7 cm
[Gr.Inv.1990/0139]

CAT. 122-15 [P. 228]
Folio 15: *Los lagartijos / Lizards,* ca. 1905
Metalcut, ed. 19
Paper: 18.5 × 13.8 cm; Image: 13 × 8.6 cm
Inscr. b. r. on the plate: Posada
[Gr.Inv.1990/0140a]

CAT. 122-15b [P. 228]
Folio 15: *Los lagartijos / Lizards,* ca. 1905
Metalcut on handmade paper
Paper: 24 × 16.4 cm; Image: 13 × 8.6 cm
Inscr. b. r. on the plate: Posada
[Gr.Inv.1990/0140b]

CAT. 122-15c [P. 228]
Folio 15: *Los lagartijos / Lizards,* ca. 1905
Metalcut
Paper: 24 × 17.4 cm; Image: 13 × 8.6 cm
Inscr. b. r. on the plate: Posada
Print TGP [Gr.Inv.1990/0140c]

CAT. 122-16 [P. 229]
Folio 16: *Por fingir [sic] espantos,* ca. 1905
To Feign Horror
Zinc-etching, ed. 19
Paper: 18.5 × 13.8 cm; Image: 12.5 × 7.4 cm
Inscr. b. r. on the plate: Posada
[Gr.Inv.1990/0141]

CAT. 122-16b [P. 229]
Folio 16: *Por fingir [sic] espantos,* ca.1905
To Feign Horror
Zinc-etching on handmade paper
Paper: 24 × 16.4 cm; Image: 12.5 × 7.4 cm
Inscr. b. r. on the plate: Posada
[Gr.Inv.1990/0141b]

CAT. 122-17 [PP. 79, 229]
Folio 17: *De Torreón a Lerdo,* ca. 1905
From Torreón to Lerdo
Zinc-etching on handmade paper, ed. 19
Paper: 24 × 16.4 cm; Image: 13.5 × 8.9 cm
Inscr. b. on the plate: Posada
[Gr.Inv.1990/0142a]

CAT. 122-17b [PP. 79, 229]
Folio 17: *De Torreón a Lerdo,* ca. 1905
From Torreón to Lerdo
Zinc-etching
Paper: 18.5 × 13.8 cm; Image: 13.5 × 8.9 cm
Inscr. b. on the plate: Posada
[Gr.Inv.1990/0142b]

CAT. 122-18 [P. 229]
Folio 18: *Retrato / Portrait,* ca. 1905
Metalcut, ed. 19
Paper: 18.5 × 13.8 cm; Image: 7.8 × 6 cm
[Gr.Inv.1990/0143]

CAT. 122-19 [P. 229]
Folio 19: *El jugador / The Player,* ca. 1905
Metalcut, ed. 19
Paper: 18.5 × 13.8 cm; Image: 8.2 × 5.1 cm
[Gr.Inv.1990/0144]

CAT. 122-19b [P. 229]
Folio 19: *El jugador / The Player,* ca. 1905
Metalcut on handmade paper
Paper: 24 × 16.4 cm; Image: 8.2 × 5.1 cm
[Gr.Inv.1990/0144b]

CAT. 122-20 [P. 229]
Folio 20: *Carnicero / Butcher,* ca. 1905
Metalcut, ed. 19
Paper: 18.5 × 13.8 cm; Image: 2.9 × 3.8 cm
[Gr.Inv.1990/0210]

CAT. 122-21 [P. 229]
Folio 21: *San Jorge / Saint George,* ca. 1905
Zinc-etching, ed. 19
Paper: 18.5 × 13.8 cm; Image: 7 × 6.9 cm
[Gr.Inv.1990/0146]

CAT. 122-22 [P. 229]
Folio 22: *La típica / The Typical,* ca. 1905
Metalcut, ed. 19
Paper: 18.5 × 13.8 cm; Image: 13 × 8.6 cm
Inscr. b. r. on the plate: Posada
[Gr.Inv.1990/0147a]

CAT. 122-22b [P. 229]
Folio 22: *La típica / The Typical,* ca.1905
Metalcut on handmade paper
Paper: 24 × 16.4 cm; Image: 13 × 8.6 cm
Inscr. b. r. on the plate: Posada
[Gr.Inv.1990/0147b]

CAT. 122c [P. 229]
Folio 22: *La típica / The Typical,* ca. 1905
Metalcut
Paper: 24 × 17.4 cm; Image: 13 × 8.6 cm
Inscr. b. r. on the plate: Posada
Print TGP [Gr.Inv.1990/0147c]

CAT. 122-23 [P. 229]
Folio 23: *El veterinario,* ca. 1905
The Veterinary
Metalcut, ed. 19
Paper: 18.5 × 13.8 cm; Image: 13 × 8.7 cm
Inscr. b. r. on the plate: Posada
[Gr.Inv.1990/0148a]

CAT. 122-23b [P. 229]
Folio 23: *El veterinario,* ca. 1905
The Veterinary
Metalcut on handmade paper
Paper: 24 × 16.4 cm; Image: 13 × 8.7 cm
Inscr. b. r. on the plate: Posada
[Gr.Inv.1990/0148b]

CAT. 122-23c [P. 229]
Folio 23: *El veterinario,* ca. 1905
The Veterinary
Metalcut
Paper: 24 × 17.4 cm; Image: 13 × 8.7 cm
Inscr. b. r. on the plate: Posada
Print TGP [Gr.Inv.1990/0148c]

CAT. 122-24 [P. 229]
Folio 24: *El automóvil / The Automobile,* ca. 1905
Zinc-etching, ed. 19
Paper: 18.5 × 13.8 cm; Image: 13.5 × 8.7 cm
Inscr. b. l. on the plate: Posada
[Gr.Inv.1990/0149a]

CAT. 122-24b [P. 229]
Folio 24: *El automóvil / The Automobile,* ca. 1905
Zinc-etching on handmade paper
Paper: 24 × 16.4 cm; Image: 13.5 × 8.7 cm
Inscr. b. l. on the plate: Posada
[Gr.Inv.1990/0149b]

CAT. 122-25 [P. 230]
Folio 25: *Morir soñando,* ca. 1905
To Die Dreaming
Zinc-etching, ed. 19
Paper: 18.5 × 13.8 cm; Image: 13.6 × 8.7 cm
Inscr. b. l.on the plate: Posada
[Gr.Inv.1990/0150a]

CAT. 122-25b [P. 230]
Folio 25: *Morir soñando,* ca. 1905
To Die Dreaming
Zinc-etching on handmade paper
Paper: 24 × 16.4 cm; Image: 13.6 × 8.7 cm
Inscr. b. l. on the plate: Posada
[Gr.Inv.1990/0150b]

CAT. 122-25c [P. 230]
Folio 25: *Morir soñando,* ca. 1905
To Die Dreaming
Zinc-etching
Paper: 24 × 17.4 cm; Image: 13.6 × 8.7 cm
Inscr. b. l. on the plate: Posada
Print TGP [Gr.Inv.1990/0150c]

Posada / Portfolio, CAT. 123

Monografía: Las obras de José Guadalupe Posada. Grabador mexicano. Monografía de 406 grabados, con introducción de Diego Rivera, editores: Francis Toor, Paul O'Higgins, Blas Vanegas Arroyo, Publicada por Mexican Folkways, Talleros Gráficos de la Nación, México 1930

CAT. 123-A [PP. 95, 230]
Cover
All works produced between 1900 and 1913

CAT. 123-B [P. 230]
Title page
Paper: 34.5 × 23 cm
[Gr.Inv.1990/0151]

Amador Lugo Guadarrama　[P.307]　　　　Leopoldo Méndez　[P.307]

CAT. 123-1 [P. 230]
Page 14: *Revolucionarios. Fusilamientos*
Revolutionaries. Shootings
Zinc-etching
Paper: 34.5 × 23 cm; Image: 7.7 × 13 cm
Inscr. verso: Antonio Vanegas Arroyo
[Gr.Inv.1990/0201b]

CAT. 123-2 [P. 230]
Page 32: *Fusilamiento. Corrido*
"Fusilamiento del capitán Calapiz,"
Shooting. Corrido "Shooting of Captain Calapiz"
Zinc-etching
Paper: 34.5 × 23 cm; Image: 27 × 19.3 cm
Inscr. b. r. on the plate: Posada
[Gr.Inv.1990/0219]

CAT. 123-3 [P. 230]
Page 49: *Discurso político*
Political Discourse
Zinc-etching
Paper: 23 × 34.5 cm; Image: 10.4 × 25.4 cm
[Gr.Inv.1990/0151e]

CAT. 123-4 [PP. 97, 230]
Page 89: *Corrido "El fin del mundo"*
Corrido "The End of the World"
Zinc-etching
Paper: 34.5 × 23 cm; Image: 26 × 21 cm
Inscr. b. r. on the plate: Posada
[Gr.Inv.1990/0220]

CAT. 123-5 [P. 230]
Page 150: *Corrido "El cometa de 82"*
Corrido "The Comet of 82"
Zinc-etching
Paper: 34.5 × 23 cm; Image: 26 × 14 cm
Inscr. b. r. on the plate: Posada
[Gr.Inv.1990/0221]

CAT. 123-6 [PP. 109, 230]
Page 155: *La Calavera*
Zinc-etching
Paper: 34.5 × 23 cm; Image: 20 × 15.6 cm
Page 156 (verso): *Calavera revolucionaria*
Revolutionary Calavera
Zinc-etching
Paper: 34.5 × 23 cm; Image: 18.8 × 11.7 cm
[Gr.Inv.1990/0151d]

CAT. 123-7 [PP. 96, 231]
Page 160: *Calavera Catrina / Calavera revolucionaria*
Calavera Catrina / Revolutionary Calavera
Zinc-etching
Paper: 34.5 × 23 cm; Image: 29.5 × 16 cm
[Gr.Inv.1990/0214]

CAT. 123-8 [PP. 49, 231]
(attributed to Posada)
Page 162: *Calavera Zapatista*
Zapata Calavera
Metalcut
Paper: 34.5 × 23 cm; Image: 22.5 × 21.3 cm
[Gr.Inv.1990/0151c]

CAT. 123-9 [PP. 76, 231]
(attributed to Posada)
Page 163: *Calavera Huertista*
Huerta Calavera
Metalcut
Paper: 23.2 × 14.5 cm; Image: 22.5 × 22 cm
[Gr.Inv.1990/0044]

CAT. 123-10 [P. 231]
Page 173: *Calavera Don Quijote y Sancho Panza*
Calavera Don Quixote and Sancho Panza
Zinc-etching
Paper: 23 × 34.5 cm; Image: 12 × 25.5 cm
Inscr. b. l. on the plate: Posada
[Gr.Inv.1990/0043]

CAT. 123-11 [P. 231]
Page 176: *Calavera "Guerra Mundial"*
Calavera "World War"
Zinc-etching
Paper: 34.5 × 23 cm; Image: 14.5 × 26.8 cm
Inscr. b. r. on the plate: Posada
[Gr.Inv.1990/0151b]

Quinteros, Adolfo

CAT. 124 [P. 231]
Henequenero, 1959
The Sisal Cutter
Linocut
Paper: 44.9 × 60.4 cm; Image: 32.4 × 43.2 cm
Inscr. b. r. in graphite: Quinteros. / 59.;
verso b. l. in graphite: Henequenero
[Gr.Inv.1990/0058]

CAT. 125 [PP. 251, 231]
Tarahumara (Raramuri), 1959
Tarahumara Indio
Linocut
Paper: 60.4 × 47.3 cm; Image: 37.5 × 27 cm
Inscr. b. c. in graphite: TARAHUMARA;
b. r. in graphite: Quinteros / 59
[Gr.Inv.1990/0246]

Rabel (Rabinovich), Fanny

CAT. 126 [PP. 148, 231]
Lucrecia, 1951
Lithograph on brownish paper, ed. 20/30
Paper: 50.6 × 33.8 cm; Image: 32.2 × 25.5 cm
Inscr. b. l. in graphite: "Lucrecia" / 20/30;
b. r.: Fanny Rabel / 1951
[Gr.Inv.1990/0255]

CAT. 127 [PP. 158, 232]
Noche de difuntos chicos, 1953
Night of the Dead Children
Lithograph, ed. 49/50
Paper: 66.3 × 50.4 cm; Image: 54 × 44.5 cm
Inscr. b. l.: 49/50 / Noche de difuntos Chicos;
b. r.: Fanny Rabel / 1953
[Gr.Inv.1990/0083]

CAT. 128 [PP. 146, 232]
El hermanito. Niño enfermo, 1955
The Little Brother. Sick Boy
Lithograph on gray paper, ed. 20/50
Paper: 50.7 × 33.6 cm; Image: 35 × 25.5 cm
Inscr. b. l. in graphite: "El Hermanito" / 20/50;
b. r.: Fanny Rabel / 1955
[Gr.Inv.1990/0256]

CAT. 129 [P. 232]
Muchacho maya / Maya Boy, 1961
Lithograph in red-brown and black
Paper: 48 × 35 cm; Image: 28.5 × 23 cm
Inscr. b. r. in graphite: Fanny Rabel
[Gr.Inv.1990/0120]

CAT. 130 [P. 232]
El misterio / The Mysterium, 1967
Aquatint with etching, ed. 3/10
Paper: 50.5 × 35 cm; Image: 45.5 × 28 cm
Inscr. b. l. in graphite: 3/10 "el misterio";
b. r.: Fanny Rabel
[Gr.Inv.1990/0257]

CAT. 131 [P. 232]
Navidad / Christmas, 1968
Aquatint with etching in yellow-brown, purple,
china blue, and black, ed. 14/15
Paper: 33 × 25.3 cm; Image: 29.6 × 21.1 cm
Inscr. b. l. in graphite: 14/15 "Navidad";
b. r. in graphite: Fanny Rabel
[Gr.Inv.1990/0119]

CAT. 132 [P. 232]
Rosita Alvirez, undated
Linocut on green-gray paper, original broadside
Paper: 34.5 × 23.4 cm; Image: 25.5 × 21 cm
Grabado. Fanny Rabel. T.G.P.
[Gr.Inv.1990/0170]

Ramírez, Everardo

Vida en mi barriada, 15 Grabados de E. R.
Editorial La Estampa Mexicana, 1948, ed. 75

CAT. 133-1 [PP. 141, 232]
Folio 1: *La tierra. El campesino,* 1948
The Earth. The Peasant
Linocut
Paper: 39.7 × 32.9 cm; Image: 24.3 × 27.2 cm
Inscr. b. c. on the plate: ERF;
b. l. in graphite: Everardo Ramírez
[Gr.Inv.1990/0089]

CAT. 133-2 [P. 232]
Folio 5: *Trio campesino,* 1949
Three Peasants
Motif used for the 1949 New Year's Card of
La Estampa Mexicana publishing house
Linocut
Paper: 40.1 × 30.3 cm; Image: 14.9 × 16.5 cm
Inscr. b. c. on the plate: ER;
b. l. in graphite: Everardo Ramírez
[Gr.Inv.1990/0236]

Reyes Meza, José

CAT. 134 [P. 232]
Niña con frutero, 1963
Girl with Fruit Bowl
Lithograph, ed. 3/15
Paper: 32.3 × 47.7 cm; Image: 25 × 28.5 cm
Inscr. b. r. in graphite: 3/15;
b. l. in graphite: Reyes Meza 63.
[Gr.Inv.1990/0125]

Rincón Piña, Agapito

CAT. 135 [PP. 157, 233]

Guanajuato, 1953
Etching
Paper: 32.4 × 25.3 cm; Image: 23 × 16.2 cm
Inscr. b. l. in graphite: GUANAJUATO;
b. r. in graphite: A. Rincón P
[Gr.Inv.1990/0238]

Rivera, Diego

CAT. 136 [PP. 171, 233]

*Los frutos de la educación. Los frutos
de la tierra,* 1932
The Fruits of Education. The Fruits of the Earth
Lithograph, ed. 21/100
Paper: 53.7 × 39.3 cm; Image: 42 × 30.3 cm
Inscr. b. l. on the stone: DR 32; b. l. in graphite:
Nr. 21/100 Diego Rivera; b. r. in graphite: 1932
[Gr.Inv.1990/0034]

CAT. 137 [PP. 171, 233]

El niño del taco, 1932
The Boy with the Taco
Lithograph, ed. 61/100
Paper: 58.2 × 40.5 cm; Image: 42 × 30.5 cm
Inscr. b. r., backwards, on the stone: DR 32;
b. l. in graphite: No 61 Diego Rivera 1932
[Gr.Inv.1990/0070]

Rodríguez, José Julio

CAT. 138 [P. 233]

Cabeza (Autorretrato), 1954
Head (Self-Portrait)
Woodcut, ed. 2/20
Paper: 31.7 × 29.2 cm; Image: 25.5 × 23.9 cm
Inscr. b. l. in graphite: cabeza de hombre 2/20;
b. l. in graphite: JOSE / JULIO
[Gr.Inv.1990/0102]

Siqueiros, David Alfaro

CAT. 139 [P. 233]

Zapata, 1930
Lithograph, E/E (Edítión Especial)
Paper: 65.2 × 50.3 cm; Image: 53.6 × 40.1 cm
Inscr. b. l. in graphite: E/E "Zapata";
b. r. in graphite: D. A. Siqueiros / 1930
[Gr.Inv.1990/0035]

CAT. 140 [PP. 173, 233]

Retrato de Moisés Sáenz, 1930
Portrait of Moisés Sáenz
Lithograph, ed. E/E (Edición Especial)
Paper: 65 × 50.4 cm; Image: 55 × 41.2 cm
Inscr. b. l. in graphite: E/E "Cabeza de Moises";
b. r. in graphite: D. A. Siqueiros / 1930
[Gr.Inv.1990/0055]

Sosamontes, Ramón

CAT. 141 [PP. 139, 233]

Niña otomí, 1946
Otomí Girl from the Mezqui Valley
Lithograph
Paper: 46.9 × 36.5 cm; Image: 36.7 × 29.6 cm
Inscr. b. r. in graphite: R. Sosa Montes
[Gr.Inv.1990/0251]

Tamayo, Rufino

CAT. 142 [PP. 165, 233]

Observador de pájaros / Bird Watcher, 1950
Lithograph in turquoise, china blue, purple,
and black, ed. 104/200
Paper: 38.5 × 57 cm; Image: 33.7 × 50.4 cm
Inscr. b. l. in graphite: R. Tamayo;
b. r. in graphite: 104/200
[Gr.Inv.1990/0036], Pereda 2004, cat. 31

CAT. 143 [P. 233]

Dos mujeres / Two Women, 1950
Lithograph in orange, scarlet, purple, blue,
and black, ed. 10/100
Paper: 65.2 × 50.5 cm; Image: 54 × 43 cm
Inscr. b. l. in graphite: Tamayo;
b. r. in graphite: 10/100
[Gr.Inv.1990/0051], Pereda 2004, cat. 35

CAT. 144 [P. 233]

Hombre, luna y estrellas, 1950
Man, Moon, and Stars
Lithograph in yellow, carmine red, violet,
and black, ed. 10/200
Paper: 57 × 38.3 cm; Image: 50.5 × 34.5 cm
Inscr. b. l. in graphite: Tamayo;
b. r. in graphite: 10/200
[Gr.Inv.1990/0080], Pereda 2004, cat. 30

CAT. 145 [PP. 207, 234]
Pastèque no. 2 (Sandía no. 2), 1969
Watermelon no. 2
Lithograph in red, purple, green,
and black, ed. 85/150
Paper: 75.8 × 57.2 cm; Image: 70 × 53.5 cm
Inscr. b. l. in graphite: 85/150;
b. r. in graphite: R Tamayo
[Gr.Inv.1990/0052], Pereda 2004, cat. 119

CAT. 146 [P. 234]
Langosta / Lobster, 1973
Lithograph in black, gray, brown, and red
Paper: 75.8 × 56 cm; Image: 75.8 × 56 cm
Inscr. b. l. with white crayon: H. C. [Hors
Commerce]; b. r. with white crayon: R Tamayo
[Gr.Inv.1990/0046], Pereda 2004, cat. 153

CAT. 147 [P. 234]
Coyote, 1950
Lithograph in yellow, carmine red,
blue, and black, ed. 12/100
Paper: 50.7 × 65.3 cm; Image: 42.3 × 53.5 cm
Inscr. b. l. in graphite: Tamayo;
b. r. in graphite: 12/100
[Gr.Inv.1990/0050], Pereda 2004, cat. 34

Tarragó, Leticia

CAT. 148 [P. 234]
Mi visita al chopo, ca. 1965
My Visit to the Cabinet of Curiosities
Etching and aquatint in yellow, light brown,
dark brown, violet, green, anthracite,
and dusty pink, ed. 23/50
Paper: 40 × 50.8 cm; Image: 29.7 × 39.5 cm
Inscr. b. l. in graphite: 23/50 mi visita al Chopo;
b. r. in graphite: Leticia Tarragó
[Gr.Inv.1990/0078]

CAT. 149 [PP. 169, 234]
Romance de la luna / Moon Romance, ca. 1965
Etching and aquatint in ocher, dark brown,
burnt sienna, blue-black, violet,
and green, ed. 30/50
Paper: 31.8 × 51.8 cm; Image: 28.4 × 47.5 cm
Inscr. b. l. in graphite: 30/50 "Romance de la luna";
b. r. in graphite: Leticia Tarragó
[Gr.Inv.1990/0079]

Toledo, Francisco

CAT. 150 [PP. 166, 234]
Sueño, 1969
Dream
Lithograph in sepia and night-blue, ed. 30/45
Paper: 34 × 36.5 cm; Image: 27 × 27 cm
Inscr. b. l. in graphite: 30/45; b. r. in graphite: Toledo
[Gr.Inv.1990/0091]

CAT. 151 [P. 234]
Muchacha chupandose los dedos, 1975
Girl Licking Her Fingers
Etching and aquatint in burnt sienna, brown,
gray and black, ed. 14/18
Paper: 37.7 × 28.1 cm; Image: 17.8 × 9.8 cm
Inscr. b. l. in graphite: Toledo; b. r. in graphite: 14/18
[Gr.Inv.1990/0209]

CAT. 152 [PP. 167, 234]
El alumno de Siqueiros, 1975
Siqueiros's student
Aquatint in violet, green-black, brown-red,
and black, ed. 11/20
Paper: 38 × 28.1 cm; Image: 20 × 16.4 cm
Inscr. b. l. in graphite: Toledo; b. r. in graphite: 11/20
[Gr.Inv.1990/0208]

Villaseñor, Isabel

CAT. 153 [PP. 155, 235]
Corrido de la Güera Chabela, 1930
Corrido of the "White Isabel"
Woodcut
Paper: 22 × 25.6 cm; Image: 19.1 × 21.3 cm
Inscr. b. r. on the plate: I / V / R;
b. r. in graphite: Isabel Villaseñor / 1930
[Gr.Inv.1990/0237]

Yampolsky, Mariana

CAT. 154 [P. 235]
*Adiós mi Chaparrita. Canción ranchera
de L. Espinosa,* 1954
Goodbye My Chaparrita. Ranch Song by L. Espinosa
Linocut on green paper, original broadside
Paper: 34.5 × 23.3 cm; Image: 26 × 21.1 cm
Grabado M. Yampolsky, T.G.P.
[Gr.Inv.1990/0169]

Guillermo Monroy [P. 308] Francisco Mora [P. 308]

Isidoro Ocampo [P. 308]

CAT. 155 [PP. 150, 235]
Descanso / Repose, 1955
Linocut
Paper: 48.4 × 47 cm; Image: 35 × 39.1 cm
Inscr. b. r. in graphite: M. Yampolsky, 55
[Gr.Inv.1990/0072]

CAT. 156 [PP. 110, 235]
Adelita, undated
Linocut on yellow paper, original broadside
Paper: 34.5 × 23.5 cm; Image: 28 × 17.4 cm
Inscr. b. r. in graphite: M. Yampolsky
[Gr.Inv.1990/0168]

CAT. 157 [P. 235]
La Jesusita, undated
Linocut on red paper, original broadside
Paper: 34.5 × 23.5 cm; Image: 26.8 × 21 cm
México T.G.P. [Gr.Inv.1990/0166]

Zalce, Alfredo

CAT. 158 [P. 235]
Cosecha / Harvest, 1942
Lithograph in yellow, olive, burnt sienna, and black
Paper: 35.5 × 48.2 cm; Image: 25.9 × 34.2 cm
Inscr. b. r. in graphite: ALFREDO / ZALCE. 1942
[Gr.Inv.1990/0095]

CAT. 159 [P. 235]
Tejiendo sombreros / Weaving Hats, 1945
Lithograph
Paper: 39.9 × 45.6 cm; Image: 29.5 × 33.4 cm
Inscr. b. r. in graphite: ALFREDO / ZALCE. 1945
Folio from the portfolio: *Alfredo Zalce.*
Estampas de Yucatán, Album with 8 lithographs
with a foreword by Jean Charlot, 100 copies,
Jan. 1946, La Estampa Mexicana
[Gr.Inv.1990/0096]

CAT. 160 [P. 235]
En la hamaca / In the Hammock, 1945
Lithograph
Paper: 40.1 × 45.3 cm; Image: 28 × 33.7 cm
Inscr. b. r. in graphite: ALFREDO / ZALCE. 1945
Folio from the portfolio: *Alfredo Zalce.*
Estampas de Yucatán, Album with 8 lithographs
with a foreword by Jean Charlot, 100 copies,
Jan. 1946, La Estampa Mexicana
[Gr.Inv.1990/0097]

CAT. 161 [PP. 138, 235]
Cortando henequén / Sisal Cutting, 1945
Lithograph
Paper: 48 × 45.8 cm; Image: 28.7 × 32.8 cm
Inscr. b. r. in graphite: Alfredo / Zalce. 1945
Folio from the portfolio: *Alfredo Zalce,*
Estampas de Yucatán, Album with 8 lithographs
with a foreword by Jean Charlot, 100 copies,
Jan. 1946, La Estampa Mexicana
[Gr.Inv.1990/0271]

CAT. 162 [PP. 137, 236]
Títeres / Puppets, 1946
Illustration for Bernardo Ortíz, *El Sombrerón*
Linocut on greenish paper
Paper: 17 × 28.8 cm; Image: 10.3 × 14 cm
Inscr. b. r. in graphite: Alfredo Zalce
From the album: *El Taller de Gráfica Popular,* 1949
[Gr.Inv.1990/0207]

CAT. 163 [PP. 138, 236]
Aserradero / Lumber Mill, 1946
Lithograph in red, turquoise, and black, ed. 1500
Paper: 38.5 × 43.8 cm; Image: 29 × 34.5 cm
Inscr. b. l. in graphite: 1946 maderos;
b. r. in graphite: ALFREDO ZALCE
Folio 5 from the portfolio: *Mexican People,*
12 original signed lithographs by artists
of the TGP, Mexico City, presented by
Associated American Artists, New York, 1946
[Gr.Inv.1990/0098]

CAT. 164 [P. 236]
Río Palizada / Palizada River, 1946
Lithograph
Paper: 45.2 × 58.3 cm; Image: 26 × 32 cm
Inscr. b. r. in graphite: Alfredo / Zalce. 46
Folio from the portfolio: *Alfredo Zalce.*
Estampas de Yucatán, Album with 8 lithographs
with a foreword by Jean Charlot, 100 copies,
Jan. 1946, La Estampa Mexicana
[Gr.Inv.1990/0249]

CAT. 165 [P. 236]
Madre y niña / Mother and Child, 1947
Etching in dark green, ed. 27/60
Paper: 37.4 × 29 cm; Image: 31.9 × 22.1 cm
Inscr. b. l. in graphite: 27/60;
b. r. in graphite: ALFREDO ZALCE. 47
[Gr.Inv.1990/0099]

CAT. 166 [P. 236]
Pesquero / Fisherman, undated
Etching in olive, blue, and black
Paper: 35 × 28.5 cm; Image: 24.7 × 15.5 cm
Inscr. b. r. in graphite: ALFREDO ZALCE
[Gr.Inv.1990/0230]

Zamarripa Landi, Ángel

CAT. 167 [P. 236]
Tragafuego / Fire-Eater, 1945
Lithograph
Paper: 56 × 38.8 cm; Image: 42.5 × 32 cm
Inscr. b. r. on the stone: AZ; b. l. in graphite:
TRAGAFUEGO; b. r. in graphite: A. Zamarripa
[Gr.Inv.1990/0057]

CAT. 168 [PP. 90, 236]
La ofrenda en Janitzio, 1953
The Offering on Janitzio
Woodcut
Paper: 27.5 × 36 cm; Image: 17 × 23.5 cm
Inscr. b. r. on the plate: AZ; b. l. in graphite:
La Ofrenda en Janitzio; b. r.: A. Zamarripa
[Gr.Inv.1990/0085]

CAT. 169 [P. 236]
Palenque. Templo de la Cruz, undated
Palenque. Temple of the Cross
Lithograph
Paper: 46.7 × 33.4 cm; Image: 26 × 20 cm
Inscr. b. l. in graphite: PALENQUE;
b. r. in graphite: A. Zamarripa
[Gr.Inv.1990/0107]

Zúñiga, Francisco

CAT. 170 [P. 236]
El grupo. Mujeres de México, 1973
The Group. Women from Mexico
Lithograph in burnt sienna, gray, and black
on handmade paper, ed. 6/20
Paper: 57 × 76.5 cm; Image: 57 × 76.5 cm
Inscr. b. l.: A. P. # 6/20 Zga 1973
[Gr.Inv.1990/0056]

CAT. 171 [P. 237]
En el umbral, 1973
On the Threshold
Lithograph in orange, scarlet, light olive,
blue, and black on handmade paper, ed. 6/20
Paper: 57 × 76.3 cm; Image: 57 × 76.3 cm
Inscr. b. l.: A. P. # 6/20; b. r.: Zga 1973
[Gr.Inv.1990/0048]

CAT. 172 [P. 237]
Descanso. Soledad acostada, 1973
Repose. Solitude Lying Down
Lithograph in orange, light orange, and black on
handmade paper, A. P. 5/20
Paper: 57.3 × 76.8 cm; Image: 57.3 × 76.8 cm
Inscr. b. r.: A. P. 5/20 Zga 1973
[Gr.Inv.1990/0276]

CAT. 173 [P. 237]
Mujeres con niño en la puerta, 1977
Women with Child at the Door
Lithograph in black and gray-green, ed. 18/100
Paper: 80 × 59.5 cm; Image: 80 × 59.5 cm
Inscr. b. l.: 18/100 Zga 1977
[Gr.Inv.1990/0275]

Pablo O'Higgins [P.308]

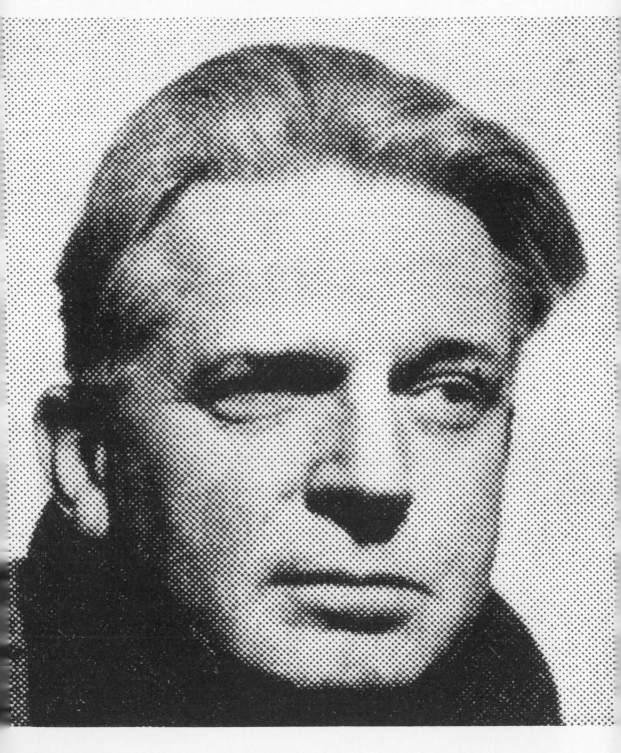

TGP / Portfolio 1947, CAT.174

Estampas de la Revolución Mexicana.
85 Grabados del Taller de Gráfica Popular,
editado por La Estampa Mexicana,
México, D. F., 1947, ed. 407/500

CAT.174-A [PP.187, 237]
Cover
Linocut of Ignacio Aguirre
La Adelita. Si por tierra en un tren militar
La Adelita. If by Land, on a Military Train
Paper: 41 × 29 cm
Draft for the cover of the album: Lena Bergner;
technical direction of the edition: Hannes Meyer;
published: 500 copies numbered from
1 to 500 and 50 copies numbered from I to L.
[Gr.Inv.1990/0163.1-85]

CAT.174-1 [P.237]
Mora, Francisco
Folio 1: *Los indígenas de México son despojados*
de sus tierras, 1947
Mexican Indigenous Peoples Are Evicted
from their Lands
Linocut on pink-colored paper
Paper: 40 × 27 cm; Image: 30 × 21.8 cm
[Gr.Inv.1990/0163.1]

CAT.174-2 [P.237]
Méndez, Leopoldo
Folio 2: *Despojo de la tierra a los Yaquis.*
El ejército de Don Porfirio al servicio de las
empresas Yanquis, 1947
Dispossessing the Yaquis of Their Land.
Don Porfirio's Army at the Service of Yankee
Companies
Linocut on greenish paper
Paper: 27 × 40 cm; Image: 21.8 × 30.2 cm
[Gr.Inv.1990/0163.2]

CAT.174-3 [P.237]
García Bustos, Arturo
Folio 3: *El peon acasillado,* 1947
Lawless Laborer
Linocut
Paper: 40 × 27 cm; Image: 30 × 22 cm
[Gr.Inv.1990/0163.3]

CAT.174-4 [P.237]
García Bustos, Arturo
Folio 4: *El descontento de los campesinos*
optiene su respuesta, 1947
The Discontent of the Farmers Is Answered
Linocut on blueish paper
Paper: 27 × 40 cm; Image: 21.6 × 30 cm
[Gr.Inv.1990/0163.4]

CAT.174-5 [P.237]
Zalce, Alfredo
Folio 5: *"¡Mátalos en caliente!". Veracruz 25*
de junio de 1879, 1947
"Kill them Quickly!". Veracruz June 25, 1879
Linocut on orange paper
Paper: 40 × 27 cm; Image: 30.3 × 21 cm
[Gr.Inv.1990/0163.5]

CAT.174-6 [no ill.]
Escobedo, Jesús
Folio 6: *Las Acordadas,* 1947
The Avengers
Linocut on pink-colored paper
Paper: 40 × 27 cm; Image: 30.2 × 21.2 cm
[Gr.Inv.1990/0163.6]

CAT.174-7 [P.192]
Zalce, Alfredo
Folio 7: *Trabajos forzados en el Valle*
Nacional, 1890–1900, 1947
Forced Labor in the National Valley, 1890–1900
Linocut on greenish paper
Paper: 40 × 27 cm; Image: 29.3 × 21.3 cm
[Gr.Inv.1990/0163.7]

CAT.174-8 [no ill.]
Yampolsky, Mariana
Folio 8: *La Juventud de Emiliano Zapata:*
Lección objetiva, 1947
The Youth of Emiliano Zapata: Objective Lesson
Linocut
Paper: 27 × 40 cm; Image: 21 × 30 cm
[Gr.Inv.1990/0163.8]

CAT. 174-9 [no ill.]
Méndez, Leopoldo
Folio 9: *Libertad de Prensa: "Adoptamos una*
política patriarcal," Porfirio Díaz, 1947
Freedom of the Press: "We Are Adopting Patriarchal
Politics," Porfirio Díaz
Linocut on blueish paper
Paper: 40 × 27 cm; Image: 30 × 21 cm
[Gr.Inv.1990/0163.9]

CAT. 174-10 [no ill.]
Beltrán, Alberto
Folio 10: *Persecución del Partido LIberal*
por el régimen pofiriano, 1947
Persecution of the Liberal Party by
the Porfirian Regime
Linocut on orange paper
Paper: 40 × 27 cm; Image: 30 × 21.8 cm
[Gr.Inv.1990/0163.10]

CAT. 174-11 [no ill.]
O'Higgins, Pablo
Folio 11: *La huelga de Cananea: Los obreros*
mexicanos reclaman igualdad de derechos frente
a los obreros yanquis, 1947
The Strike of Cananea: Mexican Workers Demand
the Same Rights as Yankee Workers
Linocut on pink-colored paper
Paper: 27 × 40 cm; Image: 21.7 × 30.4 cm
[Gr.Inv.1990/0163.11]

CAT. 174-12 [no ill.]
Ramírez, Everardo
Folio 12: *Mucho pulque y poca tinta, el método*
del caciquismo porifiano, 1947
A Lot of Pulque and Little Ink, the Method
of the Porfirian Reign
Linocut on greenish paper
Paper: 27 × 40 cm; Image: 21 × 30.4 cm
[Gr.Inv.1990/0163.12]

CAT. 174-13 [no ill.]
Castro Pacheco, Fernando
Folio 13: *La huelga de Río Blanco: Los obreros*
textiles se lanzan a la lucha. 7 enero de 1907, 1947
The Strike of Rio Blanco: The Textile Workers
Set out for Battle. January 7, 1907
Linocut
Paper: 40 × 27 cm; Image: 29.3 × 21.5 cm
[Gr.Inv.1990/0163.13]

CAT. 174-14 [no ill.]
Castro Pacheco, Fernando
Folio 14: *Epílogo de la huelga de Río Blanco.*
8 de enero de 1907, 1947
Epilogue of the Strike of Rio Blanco. January 8, 1907
Linocut on blueish paper
Paper: 40 × 27 cm; Image: 29.7 × 21.4 cm
[Gr.Inv.1990/0163.14]

CAT. 174-15 [no ill.]
Beltrán, Alberto
Folio 15: *Porfirio Díaz hace declaraciones*
al Mister Creelman sobre las libertades cívicas
del pueblo. 1908, 1947
Porfirio Díaz Makes Statements to Mister Creelman
about the Civil Rights of the People. 1908
Linocut on orange paper
Paper: 27 × 40 cm; Image: 21.8 × 29.5 cm
[Gr.Inv.1990/0163.15]

CAT. 174-16 [P. 190]
Aguirre, Ignacio
Folio 16: *Emiliano Zapata hecho prisonero en su*
lucha en favor de los campesinos. 1908, 1947
Emiliano Zapata Is Arrested because of His Fight
for Peasants' Rights. 1908
Linocut on pink-colored paper
Paper: 40 × 27 cm; Image: 28 × 22 cm
Inscr. b. l. on the plate: IA.
[Gr.Inv.1990/0163.16]

CAT. 174-17 [P. 191]
Aguirre, Ignacio
Folio 17: *Prisión y muerte de los descontentos*
en el norte del país. 1909, 1947
Imprisonment and Death of the Discontent in
the North of the Country. 1909
Linocut on greenish paper
Paper: 27 × 40 cm; Image: 22 × 30.4 cm
[Gr.Inv.1990/0163.17]

CAT. 174-18 [P. 191]
Zalce, Alfredo
Folio 18: *Una manifestación antireeleccionista*
es disuelta, 1947
An Anti-Reelection Protest Is Dissolved
Linocut
Paper: 27 × 40 cm; Image: 21.7 × 30.3 cm
[Gr.Inv.1990/0163.18]

CAT. 174-19 [P. 191]
Zalce, Alfredo
Folio 19: *La dictadura porfiriana exalta
demagogicamente al indigena,* 1947
*The Porfirian Dictatorship Demagogically
Extols the Indigenous People*
Linocut on blueish paper
Paper: 27 × 40 cm; Image: 21.6 × 30.2 cm
[Gr.Inv.1990/0163.19]

CAT. 174-20 [P. 191]
Ocampo, Isidoro
Folio 20: *Francisco I. Madero redacta en la prisión
el Plan de San Luis. 5 octubre de 1910,* 1947
*Francisco I. Madero Authors the Plan of San Luis
in Prison. October 5, 1910*
Linocut on orange paper
Paper: 40 × 27 cm; Image: 30.4 × 22.2 cm
[Gr.Inv.1990/0163.20]

CAT. 174-21 [no ill.]
Ramírez, Everardo
Folio 21: *El Plan de San Luis aterroriza a
la dictadura,* 1947
The Plan of San Luis Terrifies the Dictatorship
Linocut on pink-colored paper
Paper: 27 × 40 cm; Image: 21 × 30 cm
[Gr.Inv.1990/0163.21]

CAT. 174-22 [P. 100]
Castro Pacheco, Fernando
Folio 22: *Aquiles Serdán y su familia
inician en Puebla la revolución armada.
18 de noviembre de 1910,* 1947
*Aquiles Serdán and His Family Start the Armed
Revolt in Puebla. November 18, 1910*
Linocut on greenish paper
Paper: 27.1 × 40.1 cm; Image: 21.9 × 30.1 cm
[Gr.Inv.1990/0042]

CAT. 174-23 [no ill.]
Zalce, Alfredo
Folio 23: *La revolución y los estrategas,* 1947
The Revolution and the Strategists
Linocut on yellowish paper
Paper: 27 × 40 cm; Image: 22 × 30 cm
[Gr.Inv.1990/0163.23]

CAT. 174-23b [no ill.]
Zalce, Alfredo
Folio 23: *La revolución y los estrategas,* 1942
The Revolution and the Strategists
Linocut
Paper: 26.9 × 40 cm; Image: 22 × 30.2 cm
Inscr. b. r.: Zalce Alfredo
La Revolucion y los Estrategas (double)
[Gr.Inv.1990/0086]

CAT. 174-24 [no ill.]
Mora, Francisco
Folio 24: *Emiliano Zapata, lider de
la revolución agraria,* 1947
*Emiliano Zapata, Leader of the
Agrarian Revolution*
Linocut on blueish paper
Paper: 40 × 27 cm; Image: 29.3 × 21.5 cm
[Gr.Inv.1990/0163.24]

CAT. 174-25 [no ill.]
Bracho, Ángel
Folio 25: *Emiliano Zapata (1877–1919),* 1947
Linocut on orange paper
Paper: 40 × 27 cm; Image: 29.5 × 21.4 cm
[Gr.Inv.1990/0163.25]

CAT. 174-26 [no ill.]
Zalce, Alfredo
Folio 26: *"El Ipiranga": el pueblo despide
"30 años de paz". 31 de mayo de 1911,* 1947
*"The Ipiranga": The People Dismiss "30 Years
of Peace." May 31, 1911*
Linocut on pink-colored paper
Paper: 40 × 27 cm; Image: 21 × 29.8 cm
[Gr.Inv.1990/0163.26]

CAT. 174-27 [no ill.]
Méndez, Leopoldo
Folio 27: *León de la Barra, "El Presidente
Blanco". 1911,* 1947
León de la Barra, "The White President". 1911
Linocut on greenish paper
Paper: 40 × 27 cm; Image: 30.2 × 21 cm
[Gr.Inv.1990/0163.27]

CAT. 174-28 [no ill.]
Ocampo, Isidoro
Folio 28: *La entrada de Francisco I.*
Madero en la Ciudad de México.
7 de junio de 1911, 1947
Francisco I. Madero Marches into
Mexican City. June 7, 1911
Linocut
Paper: 40 × 27 cm; Image: 30 × 21 cm
[Gr.Inv.1990/0163.28]

CAT. 174-29 [no ill.]
Heller, Julio/Jules
Folio 29: *Francisco I. Madero,*
candidato popular, 1947
Francisco I. Madero, Candidate of the People
Linocut on blueish paper
Paper: 40 × 27 cm; Image: 29 × 20.7 cm
[Gr.Inv.1990/0163.29]

CAT. 174-30 [no ill.]
Ocampo, Isidoro
Folio 30: *Francisco I. Madero*, 1947
Linocut on orange paper
Paper: 40 × 27 cm; Image: 30 × 21.5 cm
[Gr.Inv.1990/0163.30]

CAT. 174-31 [no ill.]
Mora, Francisco
Folio 31: *Francisco I. Madero es rodeado*
por el antiguo aparato porfiriano, 1947
Francisco I. Madero Surrounded by the Old
Porfirian Military Apparatus
Linocut on pink-colored paper
Paper: 27 × 40 cm; Image: 22 × 29.7 cm
[Gr.Inv.1990/0163.31]

CAT. 174-32 [no ill.]
Zalce, Alfredo
Folio 32: *La Decena Trágica. 9–18 de*
febrero de 1913, 1947
The Ten Tragic Days. February 9–18, 1913
Linocut on greenish paper
Paper: 27 × 40 cm; Image: 21.2 × 27.7 cm
[Gr.Inv.1990/0163.32]

CAT. 174-33 [no ill.]
Méndez, Leopoldo
Folio 33: *El embajador Lane Wilson*
"arregla" el conflicto, 1947
Embassador Lane Wilson "Settles" the Conflict
Linocut
Paper: 40 × 27 cm; Image: 30 × 21.2 cm
[Gr.Inv.1990/0163.33]

CAT. 174-34 [no ill.]
Zalce, Alfredo
Folio 34: *El criminal Victoriano Huerta se aduena*
del poder. 19 de febrero de 1913, 1947
The Criminal Victoriano Huerta Seizes Power.
February 19, 1913
Linocut on blueish paper
Paper: 40 × 27 cm; Image: 30 × 21 cm
[Gr.Inv.1990/0163.34]

CAT. 174-35 [no ill.]
Mora, Francisco
Folio 35: *Asesinato de Abraham González.*
7 de marzo de 1913, 1947
Assassination of Abraham González. March 7, 1913
Linocut on orange paper
Paper: 40 × 27 cm; Image: 29.6 × 21 cm
[Gr.Inv.1990/0163.35]

CAT. 174-36 [no ill.]
Aguirre, Ignacio
Folio 36: *Venustiano Carranza arenga a los jefes*
constitucionalistas. 26 de marzo de 1913, 1947
Venustiano Carranza Gives a Speech in Front of the
Constitutional Leaders. March 26, 1913
Linocut on pink-colored paper
Paper: 27 × 40 cm; Image: 21.5 × 30 cm
[Gr.Inv.1990/0163.36]

CAT. 174-37 [P. 102]
Beltrán, Alberto
Folio 37: *El gran guerrillero Francisco Villa*
(1877–1923), 1947
The Great Guerrillero Francisco Villa (1877–1923)
Linocut on greenish paper
Paper: 40 × 27 cm; Image: 30.2 × 22 cm
[Gr.Inv.1990/0163.37]

José Julio Rodríguez [P. 310] David Alfaro Siqueiros [P. 311]

Ramón Sosamontes [P. 311]

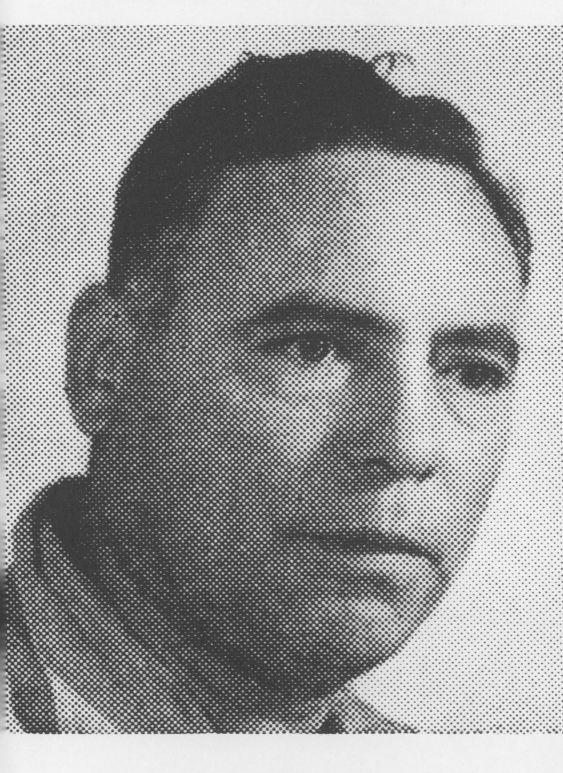

CAT. 174-38 [no ill.]
Aguirre, Ignacio
Folio 38: *Las tropas constitucionalistas hacen
el primer reparto de tierra en Matamoros.
6 de agosto de 1913*, 1947
*The Constitutionalists Distribute the First Land
in Matamoros. August 6, 1913*
Linocut
Paper: 27 × 40 cm; Image: 22 × 29.9 cm
Inscr. b. l. on the plate: IA.
[Gr.Inv.1990/0163.38]

CAT. 174-39 [no ill.]
Castro Pacheco, Fernando
Folio 39: *Asesinato del diputado Serapio Rendón por
Victoriano Huerta. 22 de agosto de 1913*, 1947
*The Assasination of Serapio Rendón by Victoriano
Huerta. August 22, 1913*
Linocut on blueish paper
Paper: 27 × 40 cm; Image: 21 × 30 cm
[Gr.Inv.1990/0163.39]

CAT. 174-40 [no ill.]
Aguirre, Ignacio
Folio 40: *El senador Belisario Domínguez protesta
contra el cuartelazo. 1913*, 1947
*Senator Belisario Domínguez Protests the
Military Coup. 1913*
Linocut on orange paper
Paper: 40 × 27 cm; Image: 30 × 21 cm
[Gr.Inv.1990/0163.40]

CAT. 174-41 [no ill.]
Zalce, Alfredo
Folio 41: *Victoriano Huerta clausura las cámaras.
10 de octubre de 1913*, 1947
*Victoriano Huerta Closes down the House of
Representatives. October 10, 1913*
Linocut on pink-colored paper
Paper: 27 × 40 cm; Image: 21 × 29.9 cm
[Gr.Inv.1990/0163.41]

CAT. 174-42 [no ill.]
Castro Pacheco, Fernando
Folio 42: *Victoriano Huerta, estandarte
de la reacción*, 1947
Victoriano Huerta, Banner of the Reaction
Linocut on greenish paper
Paper: 40 × 27 cm; Image: 29.6 × 21.3 cm
[Gr.Inv.1990/0163.42]

CAT. 174-43 [no ill.]
Beltrán, Alberto
Folio 43: *Las guerrillas contra la dictadura
de Victoriano Huerta*, 1947
*The Revolts against the Dictatorship
of Victoriano Huerta*
Linocut on yellow-green paper
Paper: 40 × 27 cm; Image: 30.6 × 21.2 cm
[Gr.Inv.1990/0163.43]

CAT. 174-44 [no ill.]
Beltrán, Alberto
Folio 44: *Intentos de la dictadura de Victoriano
Huerta de liquidar el zapatismo*, 1947
*Attempts of Dictator Victoriano Huerta
to Liquidate Zapatism*
Linocut on blueish paper
Paper: 27 × 40 cm; Image: 22 × 29.4 cm
[Gr.Inv.1990/0163.44]

CAT. 174-45 [no ill.]
Castro Pacheco, Fernando
Folio 45: *La intervención yanqui.
21 de abril de 1914*, 1947
The Yankee Intervention. April 21, 1914
Linocut on orange paper
Paper: 27 × 40 cm; Image: 21.2 × 29.4 cm
[Gr.Inv.1990/0163.45]

CAT. 174-46 [no ill.]
Mora, Francisco
Folio 46: *Venustiano Carranza protesta
contra la invasión yanqui de 1914*, 1947
*Venustiano Carranza Protests the Yankee
Invasion of 1914*
Linocut on pink-colored paper
Paper: 27 × 40 cm; Image: 23 × 30.7 cm
[Gr.Inv.1990/0163.46]

CAT. 174-47 [no ill.]
O'Higgins, Pablo
Folio 47: *Los constitucionalistas toman Zacatecas.
23 de junio de 1914*, 1947
The Constitutionalists Take Zacatecas. June 23, 1914
Linocut on greenish paper
Paper: 27 × 40 cm; Image: 22.9 × 30.8 cm
[Gr.Inv.1990/0163.47]

CAT. 174-48 [no ill.]
O'Higgins, Pablo
Folio 48: *El General Alvaro Obregón
con los Yaquis,* 1947
General Alvaro Obregón and the Yaquis
Linocut
Paper: 27 × 40 cm; Image: 21.7 × 30 cm
[Gr.Inv.1990/0163.48]

CAT. 174-49 [no ill.]
Yampolsky, Mariana
Folio 49: *Vivac de revolucionarios,* 1947
Camp of the Revolutionaries
Linocut on blueish paper
Paper: 27 × 40 cm; Image: 23.1 × 31 cm
[Gr.Inv.1990/0163.49]

CAT. 174-50 [no ill.]
Zalce, Alfredo
Folio 50: *La soldadera,* 1947
The Female Soldier
Linocut on orange paper
Paper: 27 × 40 cm; Image: 21 × 31 cm
[Gr.Inv.1990/0163.50]

CAT. 174-51 [no ill.]
Castro Pacheco, Fernando
Folio 51: *Victoriano Huerta abandona el país.
20 de julio de 1914,* 1947
Victoriano Huerta Leaves the Country. July 20, 1914
Linocut on pink-colored paper
Paper: 27 × 40 cm; Image: 22 × 30.3 cm
[Gr.Inv.1990/0163.51]

CAT. 174-52 [no ill.]
Ocampo, Isidoro
Folio 52: *La entrada del ejército constitucionalista en
la Ciudad de México. 20 de agosto de 1914,* 1947
*The Constitutionalist Army Marches into Mexico City.
August 20, 1914*
Linocut on greenish paper
Paper: 40 × 27 cm; Image: 29.7 × 21.6 cm
[Gr.Inv.1990/0163.52]

CAT. 174-53 [no ill.]
Beltrán, Alberto
Folio 53: *La convención de Aguascalientes.
10 de octubre de 1914,* 1947
The Aguascalientes Convention. October 10, 1914
Linocut
Paper: 27 × 40 cm; Image: 22 × 30.1 cm
[Gr.Inv.1990/0163.53]

CAT. 174-54 [no ill.]
Méndez, Leopoldo
Folio 54: *El hambre en la Ciudad de México.
1914–1915,* 1947
The Famine in Mexico City. 1914–1915
Linocut on blueish paper
Paper: 27 × 40 cm; Image: 20.9 × 29.7 cm
[Gr.Inv.1990/0163.54]

CAT. 174-55 [no ill.]
Escobedo, Jesús
Folio 55: *Obreros revolucionarios,* 1947
Revolutionary Workers
Linocut on orange paper
Paper: 40 × 27 cm; Image: 29.9 × 21 cm
[Gr.Inv.1990/0163.55]

CAT. 174-56 [no ill.]
Zalce, Alfredo
Folio 56: *Venustiano Carranza, promotor de la
constitución de 1917 (1859–1920),* 1947
*Venustiano Carranza, Creator of the Constitution
of 1917 (1859–1920)*
Linocut on pink-colored paper
Paper: 40 × 27 cm; Image: 30.1 × 21.1 cm
[Gr.Inv.1990/0163.56]

CAT. 174-57 [no ill.]
Ocampo, Isidoro
Folio 57: *La muerte de Emiliano Zapata.
10 de abril de 1919,* 1947
The Death of Emiliano Zapata. April 10, 1919
Linocut on greenish paper
Paper: 27 × 40 cm; Image: 21.5 × 30.4 cm
[Gr.Inv.1990/0163.57]

CAT. 174-58 [no ill.]
Aguirre, Ignacio
Folio 58: *El pueblo es soberano,* 1947
The People Are Sovereign
Linocut
Paper: 27 × 40 cm; Image: 21 × 28.2 cm
[Gr.Inv.1990/0163.58]

CAT. 174-59 [P. 105]
Castro Pacheco, Fernando
Folio 59: *Carrillo Puerto, símbolo de la
revolución de sureste,* 1947
*Carrillo Puerto, Symbol of the Revolution
of the Southeast*
Linocut on blueish paper
Paper: 40 × 27 cm; Image: 29.8 × 21.2 cm
[Gr.Inv.1990/0163.59]

Rufino Tamayo [P. 311] Isabel Villaseñor [P. 312]

CAT. 174-60 [no ill.]
Zalce, Alfredo
Folio 60: *Escuelas, caminos, presas:*
Programa y realización de los gobiernos
de Alvaro Obregón (1920–1923) y Plutarco
Elías Calles (1923–1928), 1947
Schools, Roads, Dams: Program and Realization
of the Governments of Alvaro Obregón (1920–23)
and Plutarco Elías Calles (1923–1928)
Linocut on orange paper
Paper: 40 × 27 cm; Image: 30.5 × 22 cm
[Gr.Inv.1990/0163.60]

CAT. 174-61 [no ill.]
Beltrán, Alberto
Folio 61: *El cerro "El Cubilete": comienzo de la*
agitación Cristera. 11 de enero de 1923, 1947
"El Cubilete" Mountain: Beginning of the Cristera
Movement. January 11, 1923
Linocut on pink-colored paper
Paper: 27 × 40 cm; Image: 21.5 × 30.6 cm
[Gr.Inv.1990/0163.61]

CAT. 174-62 [no ill.]
García Bustos, Arturo
Folio 62: *El resultado de una pastoral:*
El levantamiento Cristero. 1926–1927, 1947
The Result of a Pastoral: The Cristero
Uprising. 1926–1927
Linocut on greenish paper
Paper: 40 × 27 cm; Image: 30 × 22 cm
[Gr.Inv.1990/0163.62]

CAT. 174-63 [no ill.]
Yampolsky, Mariana
Folio 63: *Asalto al tren de Guadalajara, dirigido*
por el cura Angulo. 13 de abril de 1927, 1947
Attack on the Train from Guadalajara, Led
by Priest Angulo. April 13, 1927
Linocut
Paper: 27 × 40 cm; Image: 21.8 × 30.5 cm
[Gr.Inv.1990/0163.63]

CAT. 174-64 [no ill.]
Castro Pacheco, Fernando
Folio 64: *Asesinato del General Alvaro*
Obregón, dirigido por la reacción clerical.
18 de julio de 1928, 1947
Assasination of General Alvaro Obregón, Lead
by the Clerical Reactionaries. July 18, 1928
Linocut on blueish paper
Paper: 27 × 40 cm; Image: 22 × 30.6 cm
[Gr.Inv.1990/0163.64]

CAT. 174-65 [no ill.]
Beltrán, Alberto
Folio 65: *Plutarco Elías Calles, el Jefe Máximo*, 1947
Plutarco Elías Calles, the Greatest Leader
Linocut on orange paper
Paper: 27 × 40 cm; Image: 21.9 × 30.6 cm
[Gr.Inv.1990/0163.65]

CAT. 174-66 [no ill.]
García Bustos, Arturo
Folio 66: *La muerte del líder agrarista José*
Guadalupe Rodríguez, 1947
Death of the Peasants' Leader José Guadalupe
Rodríguez
Linocut on pink-colored paper
Paper: 40 × 27 cm; Image: 30 × 21.5 cm
[Gr.Inv.1990/0163.66]

CAT. 174-67 [no ill.]
Arenal Bastar, Luis
Folio 67: *Lázaro Cárdenas y la reforma*
agraria. 1934–1940, 1947
Lázaro Cárdenas and the Agrarian
Reform. 1934–1940
Linocut on greenish paper
Paper: 27 × 40 cm; Image: 20.5 × 30.2 cm
[Gr.Inv.1990/0163.67]

CAT. 174-68 [no ill.]
Zalce, Alfredo
Folio 68: *Choferes contra "Camisas Doradas"*
en el zócalo de la Ciudad de México.
20 de noviembre de 1935, 1947
Drivers against the "Gold Shirts" on the Main Square
of Mexico City. November 20, 1935
Linocut
Paper: 27 × 40 cm; Image: 21.7 × 30.2 cm
[Gr.Inv.1990/0163.68]

CAT. 174-69 [no ill.]
Zalce, Alfredo and Méndez, Leopoldo
Folio 69: *Plutarco Elías Calles es deportado
por órdenes del gobierno del General Lázaro
Cárdenas. 1936,* 1947
*Plutarco Elías Calles is Deported on the Orders of
the Government of General Lázaro Cárdenas. 1936*
Linocut on blueish paper
Paper: 27 × 40 cm; Image: 21.1 × 29.9 cm
[Gr.Inv.1990/0163.69]

CAT. 174-70 [no ill.]
Mora, Francisco
Folio 70: *Se construyen escuelas y se imparte
la enseñanza,* 1947
Schools Are Built and Lessons Are Given
Linocut on orange paper
Paper: 27 × 40 cm; Image: 22.6 × 30.6 cm
[Gr.Inv.1990/0163.70]

CAT. 174-71 [no ill.]
Castro Pacheco, Fernando
Folio 71: *Los Cristeros contra la enseñanza
en el campo,* 1947
The Cristeros against Education in Rural Areas
Linocut on pink-colored paper
Paper: 27 × 40 cm; Image: 21.2 × 29.8 cm
[Gr.Inv.1990/0163.71]

CAT. 174-72 [no ill.]
Aguirre, Ignacio
Folio 72: *El presidente Lázaro Cárdenas recibe
el apoyo del pueblo mexicano por sus medidas en
favor del progreso del país,* 1947
*President Lázaro Cárdenas Is Supported by the
Mexican People in His Plans to Benefit the Country's
Progress*
Linocut on greenish paper
Paper: 27 × 40 cm; Image: 21.1 × 30.8 cm
Inscr. b. l. on the plate: I. A.
[Gr.Inv.1990/0163.72]

CAT. 174-73 [no ill.]
Beltrán, Alberto
Folio 73: *Lázaro Cárdenas y la guerra de España.
1936–1939,* 1947
Lázaro Cárdenas and the War in Spain. 1936–1939
Linocut
Paper: 27 × 40 cm; Image: 22.2 × 31.2 cm
[Gr.Inv.1990/0163.73]

CAT. 174-74 [no ill.]
Mora, Francisco
Folio 74: *Contribución del pueblo a la expropiación
petrolera. 18 de marzo de 1938,* 1947
*Contribution of the People to the Expropriation of
the Oil Industry. March 18, 1938*
Linocut on blueish paper
Paper: 40 × 27 cm; Image: 30.5 × 22.2 cm
[Gr.Inv.1990/0163.74]

CAT. 174-75 [no ill.]
Zalce, Alfredo
Folio 75: *El traidor Saturnino Cedillo, agente
de las empresas petroleras. 1938,* 1947
*The Traitor Saturnino Cedillo, Agent of the Oil
Corporations. 1938*
Linocut on orange paper
Paper: 40 × 27 cm; Image: 30.6 × 22.5 cm
[Gr.Inv.1990/0163.75]

CAT. 174-76 [P.194]
Castro Pacheco, Fernando
Folio 76: *Las demandas del pueblo y la amenaza
de la reacción,* 1947
*The Demands of the People and the Threat
of the Reaction*
Linocut on pink-colored paper
Paper: 27 × 40 cm; Image: 21.3 × 29 cm
[Gr.Inv.1990/0163.76]

CAT. 174-77 [P.194]
Aguirre, Ignacio
Folio 77: *El hundimiento del "Potrero del Llano"
por los nazis. 13 de mayo de 1942,* 1947
*The Sinking of the "Potrero del Llano" by the Nazis.
May 13, 1942*
Linocut on greenish paper
Paper: 27 × 40 cm; Image: 21 × 29.7 cm
[Gr.Inv.1990/0163.77]

CAT. 174-78 [P.194]
Franco, Antonio
Folio 78: *La declaración de guerra al Eje.
1 de junio de 1942,* 1947
*Declaration of War against the Axis Powers.
June 1, 1942*
Linocut
Paper: 27 × 40 cm; Image: 20.7 × 28.8 cm
[Gr.Inv.1990/0163.78]

CAT. 174-79 [no ill.]
Méndez, Leopoldo
Folio 79: *México en la guerra: Los braceros
se van a Estados Unidos,* 1947
*Mexico at War: The Farm Workers Go to
the United States*
Linocut on blueish paper
Paper: 27 × 40 cm; Image: 21.4 × 29.7 cm
[Gr.Inv.1990/0163.79]

CAT. 174-80 [P. 195]
Zalce, Alfredo
Folio 80: *¡Quitémos la venda!
(Campaña de alfabetización),* 1947
*Let's Remove the Blindfold!
(Alphabetization Campaign)*
Linocut on orange paper
Paper: 40 × 27 cm; Image: 30.4 × 23.5 cm
[Gr.Inv.1990/0163.80]

CAT. 174-81 [no ill.]
García Bustos, Arturo
Folio 81: *El sinarquismo,* 1947
Ultra-Right Synarchism
Linocut on pink-colored paper
Paper: 27 × 40 cm; Image: 22.5 × 30.4 cm
[Gr.Inv.1990/0163.81]

CAT. 174-82 [no ill.]
Zalce, Alfredo
Folio 82: *La prensa y la revolución mexicana,* 1947
The Press and the Mexican Revolution
Linocut on greenish paper
Paper: 40 × 27 cm; Image: 29.8 × 21.5 cm
[Gr.Inv.1990/0163.82]

CAT. 174-83 [no ill.]
Beltrán, Alberto
Folio 83: *El nuevo ejército nacional,* 1947
The New National Army
Linocut
Paper: 27 × 40 cm; Image: 22.3 × 30.8 cm
[Gr.Inv.1990/0163.83]

CAT. 174-84 [no ill.]
García Bustos, Arturo
Folio 84: *La industrialisación del país,* 1947
Industrialization of the Country
Linocut on blueish paper
Paper: 40 × 27 cm; Image: 30.4 × 21.8 cm
[Gr.Inv.1990/0163.84]

CAT. 174-85 [no ill.]
Aguirre, Ignacio
Insert to the portfolio
Folio 85: *"Si por tierra en un tren militar"
(La Adelita),* 1947
"If by Land, on a Military Train" (La Adelita)
Linocut for the cover
Paper: 40 × 27 cm; Image: 6.6 × 8.5 cm
Reproduced in the insert of the portfolio:
*Estampas de la Revolución Mexicana.
85 Grabados del Taller de Gráfica Poular.*
Editado por La Estampa Mexicana,
México, D. F. 1947
[Gr.Inv.1990/0163.85]

Alfredo Zalce [P. 312] Ángel Zamarripa Landi [P. 312]

TGP / Portfolio 1956, CAT. 175

Grabados del Taller de Gráfica Popular.
23 grabados y litografías de cada uno de
los componentes del TGP, México 1956

CAT. 175-A [PP. 201, 238]
Cover
[Gr.Inv.1990/0277.1-23]

CAT. 175-1 [P. 238]
Jurado, Carlos
Folio 1: *Hombre / Man,* 1956
Linocut
Paper: 27.5 × 21.5 cm; Image: 20.5 × 17 cm
Inscr. b. r. on the plate: JURADO
[Gr.Inv.1990/0277.1]

CAT. 175-2 [P. 238]
Rabel (Rabinovich), Fanny
Folio 2: *El árbol muerto,* 1956
The Dead Tree
Lithograph
Paper: 27.5 × 21.5 cm; Image: 15.8 × 21.5 cm
Inscr. b. r.: Fanny Rabel
[Gr.Inv.1990/0277.2]

CAT. 175-3 [P. 238]
Catlett, Elizabeth
Folio 3: *Alfabetización,* 1956
Alphabetization
Lithograph
Paper: 27.5 × 21.5 cm; Image: 16.5 × 21.5 cm
[Gr.Inv.1990/0277.3]

CAT. 175-4 [P. 238]
García Bustos, Arturo
Folio 4: *Jinetes / Horsemen,* 1956
Lithograph
Paper: 27.5 × 21.5 cm; Image: 21.5 × 17 cm
Inscr. b. r.: García Bustos
[Gr.Inv.1990/0277.4]

CAT. 175-5 [P. 238]
Yampolsky, Mariana
Folio 5: *Madre de Juárez / Juárez' Mother,* 1956
Lithograph
Paper: 27.5 × 21.5 cm; Image: 21.5 × 17.1 cm
[Gr.Inv.1990/0277.5]

CAT. 175-6 [P. 238]
Gómez, Andrea
Folio 6: *Niña de la basura / Garbage Girl,* 1956
Linocut
Paper: 27.5 × 21.5 cm; Image: 21.5 × 8.5 cm
Inscr. b. c. on the plate: A.G.
[Gr.Inv.1990/0277.6]

CAT. 175-7 [P. 238]
Aguirre, Ignacio
Folio 7: *Tren revolucionario,* 1956
Revolutionary Train
Linocut
Paper: 21.5 × 27.5 cm; Image: 15.6 × 21.5 cm
Inscr. b. l. on the plate: I.A.; b. r. on the plate: T.G.P.
[Gr.Inv.1990/0277.7]

CAT. 175-8 [P. 238]
Anguiano, Raúl
Folio 8: *Ko,* 1951
Lithograph, ed. 30/30
Paper: 27.5 × 21.5 cm; Image: 21.5 × 17.5 cm
Inscr. b. l.: 30/30; b. r.: R. Anguiano 1951
[Gr.Inv.1990/0277.8]

CAT. 175-9 [P. 239]
Arenal Bastar, Luis
Folio 9: *Alfabetización,* 1956
Alphabetization
Linocut
Paper: 27.5 × 21.5 cm; Image: 17.2 × 12 cm
[Gr.Inv.1990/0277.9]

CAT. 175-10 [P. 239]
Beltrán, Alberto
Folio 10: *El camión / The Truck,* 1956
Linocut
Paper: 27.5 × 21.5 cm; Image: 16 × 11.8 cm
[Gr.Inv.1990/0277.10]

CAT. 175-11 [P. 239]
Bracho, Ángel
Folio 11: *El puente / The Bridge,* 1956
Linocut
Paper: 27.5 × 21.5 cm; Image: 14.3 × 21 cm
[Gr.Inv.1990/0277.11]

CAT. 175-12 [P. 239]
Calderón de la Barca, Celia
Folio 12: *Mujer de Mitla / Woman from Mitla,* 1956
Linocut
Paper: 27.5 × 21.5 cm; Image: 20.5 × 10.8 cm
[Gr.Inv.1990/0277.12]

CAT. 175-13 [PP. 40, 239]
Guerrero, Lorenzo
Folio 13: *Zapata. Plan de Ayala,* 1956
Linocut
Paper: 27.5 × 21.5 cm; Image: 21.5 × 7.5 cm
[Gr.Inv.1990/0277.13]

CAT. 175-14 [P. 239]
Huerta Múzquiz, Elena
Folio 14: *Cuescomates / Granaries,* 1956
Linocut
Paper: 27.5 × 21.5 cm; Image: 16.3 × 21.5 cm
[Gr.Inv.1990/0277.14]

CAT. 175-15 [P. 239]
Iñiguez, Xavier González
Folio 15: *Juárez,* 1956
Linocut
Paper: 27.5 × 21.5 cm; Image: 13.3 × 21.5 cm
Inscr. b. r. on the plate: Iñiguez Javier
[Gr.Inv.1990/0277.15]

CAT. 175-16 [P. 239]
Jiménez, Sarah
Folio 16: *Niñas / Girls,* 1956
Linocut
Paper: 27.5 × 21.5 cm; Image: 6 × 21.5 cm
[Gr.Inv.1990/0277.16]

CAT. 175-17 [P. 239]
Jiménez, Marcelino L.
Folio 17: *Mujeres mixtecas,* 1956
Women from Mixteca
Linocut
Paper: 27.5 × 21.5 cm; Image: 21.5 × 17.3 cm
[Gr.Inv.1990/0277.17]

CAT. 175-18 [P. 240]
Luna, Francisco
Folio 18: *Paisaje / Landscape,* 1956
Linocut
Paper: 27.5 × 21.5 cm; Image: 15.9 × 21.7 cm
[Gr.Inv.1990/0277.18]

CAT. 175-19 [P. 240]
Martín, Maria Luisa
Folio 19: *Mujer / Woman,* 1956
Linocut
Paper: 27.5 × 21.5 cm; Image: 21.5 × 16.3 cm
Inscr. b. l. on the plate: M. Martín / 1956
[Gr.Inv.1990/0277.19]

CAT. 175-20 [P. 240]
Méndez, Leopoldo
Folio 20: *A la plaza,* 1956
Toward the Square
Linocut
Paper: 27.5 × 21.5 cm; Image: 16.2 × 17.1 cm
[Gr.Inv.1990/0277.20]

CAT. 175-21 [P. 240]
Mexiac, Adolfo
Folio 21: *Campesinos del sur,* 1956
Peasants from the South
Linocut
Paper: 27.5 × 21.5 cm; Image: 21.3 × 16.5 cm
Inscr. b. l. on the plate: MEXIAC
[Gr.Inv.1990/0277.21]

CAT. 175-22 [P. 240]
Mora, Francisco
Folio 22: *Altamirano,* 1956
Linocut
Paper: 27.5 × 21.5 cm; Image: 21.5 × 16 cm
Inscr. b. l. on the plate: – MORA –
[Gr.Inv.1990/0277.22]

CAT. 175-23 [P. 240]
O'Higgins, Pablo
Folio 23: *El presidente municipal,* 1956
The Municipal President
Lithograph
Paper: 27.5 × 21.5 cm; Image: 21.5 × 16 cm
[Gr.Inv.1990/0277.23]

1] The information is from the following publications:
Haab 1957, pp. 103–126; Heller 1995; Berlin 1974,
pp. 154–164; Prignitz 1981, pp. 293–310;
Reutlingen 1998, pp. 129–146, and from individual
artist's monographs. Cf. Cited and Selected
literature, pp. 314–319.

Despite of careful research of the biographical information, it was not always possible to ascertain the exact places and dates of birth and death. In the cases of some artists, only little information was available. The individual artists' activities as mural painters, sculptors, and graphic artists are only mentioned in brief, as is their participation in exhibitions and their awards. The biographical entries focus on those parts of their lives most influencial for their graphic art.[1]

Aguirre, Ignacio [P. 243]

San Sebastián, Jalisco, Mexico
12/23/1900−7/11/1990
Mexico City, Mexico

From 1915 to 1917 Aguirre participated in the rebellion of Venustiano Carranzas's troops against Francisco "Pancho" Villa. He worked as a miner and in 1920 participated in the uprising on the side of General Álfaro Obregón. From 1921 to 1929 he worked in the Ministry of Communication and in the Secretariat of the President of the Republic in Mexico City. From 1929 he was an art lecturer at various schools and art academies. He took part in the Misiones Culturales and from 1934 was a member of LEAR. In 1937 he was a founding member of the TGP, his membership lasting until 1965. He held several solo exhibitions in New York in the 1940s. In 1952 he was a founding member of the FNAP. He traveled through Eastern Europe and China.

Amero, Emilio

Ixtlahuaca, Mexico
5/25/1901−4/12/1976
Norman, OK, USA

From 1911 to 1917 Amero studied at the Academia de San Carlos. Founding member of SOTPE. From 1923 to 1924 he collaborated with Jean Charlot. He learned mural painting under José Clemente Orozco, assistant to Diego Rivera. Occupation with lithographic techniques in Havana and New York. In 1930 he returned to Mexico City, where he founded a workshop for lithography at the Academia de San Carlos. From 1934 to 1938 he again resided in New York. In 1940 he was a lecturer at the University of Washington and director of the art department of Cornish College of the Arts, Seattle. From 1946 to 1968 he was a professor at the University of Oklahoma. Experiments in film and photography. He was a friend of Rufino Tamayo from childhood.

Anguiano, Raúl [P. 244]

Atoyac near Guadalajara, Jalisco, Mexico
2/26/1915−1/13/2006
Mexico City, Mexico

From 1930 to 1934 Anguiano studied painting at the Escuela Libre de Guadalajara. He founded the Jalisco Association of Young Painters and in 1934 moved to Mexico City. From 1935 to 1937 he was a lecturer for painting at La Esmeralda. In 1936 he became Secretary General of the Union of Art Educators. Member of the TGP from 1938 to 1960. In 1948 he was a founding member of the Sociedad para el Impulso de las Artes Plásticas and in 1949 participated in the expedition to Bonampak and to the forests of the Lacandon people. Anguiano was famous for his lithographs and murals and numerous national as well as international awards and exhibitions have honored his work. He traveled to Cuba and in the U.S.

Arenal Bastar, Luis [P. 247]

Teapa, Tabasco, Mexico
1908 or 1909−5/7/1985
Mexico City, Mexico

From 1924 to 1929 Arenal Bastar worked temporary jobs. He traveled and began several courses of study in the U.S. and Mexico. From 1932 to 1974 he worked with David Alfaro Siqueiros. In 1933 he was Secretary General of the League against War and Fascism in Mexico. He co-founded LEAR in 1934 and was its Secretary General until 1936. In 1936 he traveled to the American Artists' Congress in New York as a delegate. In 1937 he was a founding member of the TGP and in 1940 participated in the failed assassination of Leon Trotsky. Coordinator of the TGP in 1965. Traveled through Europe, North America, and South America.

Ávila, Abelardo [P. 247]

Jalpan de Serra, Querétaro, Mexico
12/17/1907–7/24/1967
Mexico City, Mexico

From 1921 to 1926 Ávila studied at the Escuela de
Bellas Artes in Querétaro. He moved to Mexico City
in 1926 and sudied painting at the Academia de
San Carlos. In 1934 he became a member of LEAR.
In 1947 he was a founding member of the Sociedad
Mexicana de Grabadores. From 1947 to 1967 he
lectured at La Esmeralda. In 1949 he co-founded
the Salón de la Plástica Mexicana.

Beltrán, Alberto [P. 251]

Mexico City, Mexico
3/22/1923–4/19/2002, ibidem

Beltrán conducted evening courses for com-
mercial graphic arts at the Academia de San Carlos.
From 1938 he worked in different graphic arts
studios. He studied at the Escuela de Arte Comercial
and worked as newspaper illustrator and poster
artist. Member of the TGP from 1944 to 1960.
He designed cartoons as a means to educate the
illiterate. From 1953 member of Salón de la Plástica
Mexicana. In 1956 he won INBA's Premio Nacional
for the graphic arts. He received further honors,
including first prize as best commercial graphic
artist (1958). From 1960 he was the director of the
Escuela Libre de Arte y Publicidad, and from
1965 to 1966 director of the art department at the
Universidad Veracruzana in Xalapa. In 1967 he was
a founding member of the Academia de las Artes
de México. General Director of the Investigaciones
de las Tradiciones Populares department of the
Ministry of Education. Beltrán was a commercial
artist for political propaganda and held numerous
solo exhibitions. He was married to the graphic
artist Andrea Gómez.

Berdecio, Roberto [P. 252]

Sucre, Bolivia
10/20/1910–1996

Berdecio went to school in Bolivia and Argentina.
He started painting as an autodidact in 1930
and lived in Mexico from 1934. Member of LEAR.
In 1936 he was a LEAR delegate to the American
Artists' Congress in New York, where he founded
the Siqueiros Experimental Workshop, together
with David Alfaro Siqueiros, Luis Arenal Bastar, and
Antonio Pujol Jiménez (1913–1995). He held
various exhibitions in the U.S. and in 1940 received
a Guggenheim fellowship. In 1941 he returned
to Mexico. Member of the TGP from 1948 to 1956.
He traveled through Peru, Bolivia, and Brazil.

Bracho, Ángel [P. 252]

Mexico City, Mexico
2/14/1911–2/1/2005, ibidem

From 1928 Bracho attended evening courses
at the Academia de San Carlos. From 1929 to 1933
he studied at UNAM. In 1934 he was a founding
member of LEAR. From 1936 to 1939 he participated
in the Misiones Culturales and was co-founder of
the TGP in 1937, also producing his first lithographs.
In 1948 he was a founding member of the Sociedad
para el Impulso de las Artes Plásticas. From 1952
to 1953 he was the director and from 1961 to 1963
president of the TGP. In 1960 he was awarded
the gold medal of the Biennale in Buenos Aires.
Known for his numerous murals.

Calderón de la Barca, Celia [P. 257]

Mexico City, Mexico
2/10/1921–10/9/1969, ibidem

From 1942 to 1944 Calderón de la Barca studied
at the Escuela Nacional de Artes Plásticas. In 1944
she received scholarship from UNAM. From 1947
she was an art lecturer. In 1947 she was a founding
member of the Sociedad Mexicana de Grabadores.
In 1950 she received scholarship from the British
Council for one year of study at the Slade Art School
in London. From 1952 to 1965 she was a member of
the TGP, in 1963 president. Member of the Salón
de la Plástica Mexicana. International exhibitions and
travels through Europa, the Soviet Union, and China.

Cantú Garza, Federico

Cadereyta Jiménez, Nuevo León, Mexico
3/3/1907–1/29/1989
Mexico City, Mexico

From 1922 to 1923 Cantú Garza studied at the Escuela de Pintura al Aire Libre in Coyoacán. From 1942 he was in contact with Diego Rivera and studied his mural paintings. From 1943 he lectured at La Esmeralda. In 1949 he became a professor at the University of California. Founding member of the Salón de la Plástica Mexicana.

Castro Pacheco, Fernando [P. 257]

Mérida, Yucatán, Mexico
1/26/1918–8/8/2013, ibidem

From 1930 to 1933 Castro Pacheco studied at the Escuela de Artes Plásticas in Mérida. He worked as a drawing instructor and muralist. He first turned to print graphics in 1939 and designed commercial art and woodcut posters. In 1943 he moved to Mexico City. From 1943 he worked as a poster artist and illustrator. Member of the TGP from 1944 to 1947, and member of the Sociedad para el Impulso de las Artes Plásticas from 1948. Director at La Esmeralda from 1961 to 1973. Castro Pacheco is known for his numerous murals. He traveled throughout Europe.

Catlett, Elizabeth [P. 258]

Washington, D.C., USA
4/15/1915–4/2/2012
Cuernavaca, Morelos, Mexico

Catlett studied art history at Howard University in Washington, D.C., until 1936 and at the State University in Iowa until 1940. She subsequently studied ceramics at the Art Institute of Chicago, lithography at the Art Students League in New York, and sculpture in New York. She taught art, ceramics, and sculpting at various schools in the US. In 1946 she moved to Mexico City and was a member of the TGP until 1965. From 1955 to 1966 she was head of the Colegio de la Escuela Nacional de Artes Plásticas and in 1963 Secretary General of the TGP. She held numerous exhibitions and received several awards in Mexico and the US. She married Francisco Mora in 1947.

Charlot, Jean [P. 261]

Paris, France
2/7/1898–3/20/1979
Honolulu, HI, USA

Charlot's mother was of French-Aztec origin. From 1914 to 1915 he studied at the École nationale supérieure des Beaux-Arts in Paris. During World War I, he served as an artillerist on horseback from 1917 and in 1921 traveled to Mexico. He joined a circle of Revolutionary artists. In 1925 he became the director of the art magazine *Mexican Folkways*. Studied under Fernando Leal and Diego Rivera. From 1926 to 1928 he worked as archeological assistant with research and digs in Chichén Itzá. From 1930 he was a lecturer at the Art Students League of New York and at Columbia University and in 1947 became the director of the Colorado Springs Fine Arts Center School. From 1949 he was a professor at the University of Hawaii in Honolulu. He turned to book illustration and mural painting. In 1968 he was awarded the honor of the National Art Committee in Washington, D.C. He held numerous exhibitions.

Chávez Morado, José [P. 265]

Silao, Guanajuato, Mexico
1/4/1909–12/1/2002, ibidem

From 1925 to 1931 Chávez Morado worked temporary jobs in the US. He studied painting at the Chouinard School of Art in Los Angeles, in 1931 he returned to Mexico City and studied at the Academia de San Carlos. In 1933 he became the director of the Department of Graphic Arts at the Ministry of Education. Member of LEAR from 1933 to 1938. He designed decorations and costumes for theater. Member of the TGP from 1938 to 1941. From 1945 to 1947 he taught at the Escuela de Artes del Libro. In 1948 he was a founding member of the Sociedad para el Impulso de las Artes Plásticas and in 1950 became director of the Department for Drawing Instruction at INBAL. He was a founding member and director of the Taller de Integración Plástica at INBA. In 1962 he co-founded and in 1966 became director of the Escuela de Diseño y Artesanías of INBA. From 1970 to 1980 he was director of the Museo Alhóndiga de Granaditas in Guanajuato. In 1974 he won the National Prize for Science and Art, and in 1985 was awarded an honorary doctorate from UNAM. He traveled throughout Europe.

Coronel Arroyo, Rafael

Zacatecas, Zacatecas, Mexico
*10/24/1932

From 1953 Coronel Arroyo studied at La Esmeralda. He was acquainted with the gallerist Inés Amor (Galería de Arte Mexicano, Mexico City). He was married Ruth Rivera Marín (1927–1969), daughter of Diego Rivera. Coronel Arroyo has lived in Cuernavaca since 1981. In 1965 he was awarded the Premio Córdoba al Mejor Pintor Joven Latinoamericano in São Paulo, and in 1974 was honored with the Bienal Internacional de Pintura Figurativa in Tokyo and Osaka, Japan.

Cortés Juárez, Erasto

Tepeaca, Puebla, Mexico
8/26/1900–12/8/1972
Mexico City, Mexico

From 1917 to 1922 Cortés Juárez studied at the Academia de San Carlos. From 1923 he taught art and was a university professor from 1946 to 1956. In 1929 he became a member of the group ¡30–30!. He became the director of the graphic arts class at La Esmeralda in 1946 and from 1947 was director of the graphic arts class at the Academia de San Carlos. From 1953 to 1963 he was a member of the TGP. As a teacher, Cortés Juárez had a defining influence on many young graphic artists.

Covarrubias, José Miguel [P. 265]

Mexico City, Mexico
11/22/1904–2/4/1957, ibidem

Covarrubias graduated from the Escuela Nacional Preparatoria in 1918. In 1924 he moved to New York, where he produced caricatures for several magazines. His works were published on the covers of *The New Yorker* and *Vanity Fair* magazines, among others. In 1932 he received a Guggenheim fellowship and moved to Mexico City in 1935, where he taught ethnology at the Escuela Nacional de Antropología e Historia at UNAM. He later became director of the Escuela de Danza at INBA.

Cuevas, José Luis

Mexico City, Mexico
*2/26/1934

From 1944 to 1946 Cuevas studied at La Esmeralda. A member of the Generación de la Ruptura, he received honors as a graphic artist at the V. Bienal de São Paulo in 1959 and the Premio Nacional de Ciencias y Artes en Bellas Artes in 1981. He was awarded the French Ordre des Arts et des Lettres in 1991 and the Premio Medallística Tomás Francisco Prieta by the Spanish king in 1997, among other honors. He wrote for the Mexican weekly *Excélsior.* In 1977 he participated in the *documenta VI,* Kassel. From 1976 to 1979 he lived in France. Cuevas received the Lorenzo il Magnifico prize at the VIII Florence Biennale in 2012.

Dosamantes, Francisco [P. 266]

Mexico City, Mexico
10/4/1911–7/18/1986, ibidem

Dosamantes studied at the Academia de San Carlos. From 1928 he was a member of the group ¡30–30!. From 1932 to 1937 and from 1941 to 1945 he participated in the Misiones Culturales. Member of LEAR from 1933 to 1938. In 1937 he was a founding member of the TGP, and member until 1947. In 1948 he co-founded the Sociedad para el Impulso de las Artes Plásticas and in 1952 FNAP. Renewed membership in the TGP from 1964 to 1967. Created book illustrations in an initiative against illiteracy.

Escobedo, Jesús [P. 269]

El Oro, Estado de México, Mexico
6/24/1918–10/13/1978

In 1921 Escobedo moved to Mexico City. From 1928 to 1934 he studied at the Escuela de Pintura al Aire Libre Santiago Rebull and in 1934 at the Academia de San Carlos and at the Escuela de Arte para Trabajadores. From 1935 to 1937 he was a member of LEAR and an assistant to the restorer of the Museo de Arte Popular. Member of the TGP from 1937. From 1945 to 1946 he held a Guggenheim fellowship in New York. In 1948 he became a founding member of the Sociedad para el Impulso de las Artes Plásticas. He was expelled from the TGP in 1956. Escobedo worked mainly as an illustrator.

Franco, Antonio

Guatemala City, Guatemala
11/16/1920–1994

From 1934 to 1936 Franco studied agriculture. From 1937 to 1939 he studied painting at the Academy of Guatemala. From 1940 to 1942 he worked on glass mosaics. Member of the artists' group Generación del 40 and the literary journal *Acento* in Guatemala. He lived in Mexico from 1943 to 1948 and trained with Frida Kahlo (1907–1954) and Alfredo Zalce, among others. From 1945 to 1946 he was an assistant to Diego Rivera. From 1946 to 1947 he taught mural painting in San Miguel Allende. Member of the TGP from 1947 to 1948 and assistant to José Clemente Orozco. He returned to Guatemala in 1949.

Gahona, Gabriel Vicente

see "Picheta"

García, Delfino [P. 269]

Zacualpan, Estado de México, Mexico
*1917

García studied together with Amador Lugo Guadarrama at the Escuela de Pintura al Aire Libre in Taxco directed by the Japanese artist Tamiji Kitagawa (1894–1989). From 1931 he was an assistant to Kitagawa.

García Bustos, Arturo

Mexico City, Mexico
*8/8/1926

In 1941 García Bustos studied at the Academia de San Carlos and at La Esmeralda, with Diego Rivera and Frida Kahlo (1907–1954), among others. Together with Arturo Estrada Hernández (*1925) and Guillermo Monroy he founded the group Artistas Jóvenes Recolucionarios. From 1945 to 1967 was a member of the TGP. In 1947 was awarded first prize for graphic arts and poster art in the UNAM competition. Received the gold medal at the Sixth Youth Festival in Warsaw in 1956. Traveled to Moscow and Cuba. Held numerous national and international awards and exhibitions.

García Robledo, Luis

Mexico City, Mexico
4/20/1925–9/26/1969, ibidem

In 1942 García Robledo studied with Carlos Alvarado Lang (1905–1961) at the Academia de San Carlos. From 1944 he was an illustrator for various publications and magazines. Member of the TGP from 1957 to 1958.

Gómez, Andrea [P. 273]

Irapuato, Guanajuato, Mexico
11/19/1926–11/?/2012
Temixco, Morelos, Mexico

Gómez was inspired to paint by her grandmother, the revolutionary Doña Juana B. Gutierrez de Mendoza (1875–1942). She worked as a commercial artist in an advertising studio. Member of the TGP from 1949 to 1960. Married to Alberto Beltrán, she learned graphic arts under the guidance of Leopoldo Méndez, Pablo O'Higgins, and Alberto Beltrán and specialized in book illustration.

Guerrero, Lorenzo

San Luis Potosí, San Luis Potosí, Mexico
*1930

From 1947 Guerrero studied at the Escuela de Artes del Libro in Mexico City. From 1949 he was member of the group ¡30–30! and from 1955 to 1958 a member of the TGP and FNAP. He was a lecturer at La Esmeralda.

Heller, Julio/Jules

New York, NY, USA
1919–2007

In 1939 Heller studied art at Arizona State University, and in 1940 he studied education at Columbia University. From 1941 to 1945 he served in the U.S. Army Air Force. From 1945 to 1948 he was a Ph.D. student at the University of Southern California. Guest artist at the TGP in 1947. He was a founding member of the Graphic Arts Workshop of Los Angeles.

Huerta Múzquiz, Elena

Saltillo, Coahuila, Mexico
7/15/1908–1997
Monterrey, Veracruz, Mexico

From 1921 Huerta Múzquiz studied at the Academy in Saltillo and from 1929 to 1933 at the Academia de San Carlos. In 1934 she was a founding member and until 1937 a member of LEAR; head of the theater section. Guest artist at the TGP in 1939 and member in 1948. She was director of the galleries José Guadalupe Posada and José Clemente Orozco in Mexico. She traveled in the Soviet Union, to China and Cuba and held numerous national and international exhibitions.

Iñiguez, Xavier González

Vista Hermosa, Michoacán, Mexico
4/7/1932–1979
Mexico City, Mexico

From 1942 Iñiguez studied architecture. He received several university scholarships. Member of the TGP from 1956 to 1962. He was the head of INBA in San Luis Potosí. From 1960 he was a lecturer at INBA's La Esmeralda and at UNAM's Academia de San Carlos.

Jiménez, Marcelino L.

Mexico City, Mexico
*1924

Jiménez studied at the Academia de San Carlos. From 1951 to 1959 he was an external member of the TGP. Collaboration with Alberto Beltrán, Andrea Gómez, and Adolfo Mexiac at the Instituto Nacional Indigenista Tzeltal-Tzotzil in San Cristobal de las Casas, Chiapas.

Jiménez, Sarah

Piedras Negras, Coahuila, Mexico
*2/3/1928

From 1950 to 1954 Jiménez studied at the Academia de San Carlos. From 1954 to 1967 she was a member of the TGP.

Jurado, Carlos

San Cristóbal de las Casas, Chiapas, Mexico
*11/3/1927

Jurado studied at La Esmeralda. From 1955 to 1960 he was an external member of the TGP in Oaxaca, and from 1974 director of the Facultad de Artes Plásticas der Universidad Veracruzana in Xalapa.

Leal, Fernando

Mexico City, Mexico
2/26/1900–10/7/1964, ibidem

Leal studied at the Academia de San Carlos. From 1922 he was the director of and lecturer at the Escuela al Aire Libre de Coyoacán. From 1927 he was the director of the Centro Popular de Pintura in Nonoalco. Founding member of the group ¡30–30! in 1928.

Lugo Guadarrama, Amador [P. 274]

Taxco, Guerrero, Mexico
4/12/1921–6/26/2002
Mexico City, Mexico

In the 1930s Lugo Guadarrama studied in Taxco
at the Escuela de Pintura al Aire Libre, directed
by the Japanese artist Tamiji Kitagawa (1894–1989).
In 1942 he moved to Mexico City. He studied at
the Escuela Nacional de Artes del Libro and from
1943 to 1945 at the Academia de San Carlos.
Founding member of the Sociedad Mexicana de
Grabadores in 1947 (together with José Julio
Rodríguez and Ángel Zamarripa Landi). He was
a founding member of the Sociedad para el Impulso
de las Artes Plásticas in 1948 and of the Salón
de la Plástica Mexicana in 1949.

Luna, Francisco

Mexico City, Mexico
*1931

From 1950 to 1951 Luna studied at La Esmeralda.
In 1953 he was assistant to David Alfaro Siqueiros.
Member of the TGP from 1952 to 1955. From 1954
to 1963 he was a lecturer at the UNESCO Educa-
tional Center and the Centro Regional de Educación
Fundamental para América Latina. In 1963 he
rejoined the TGP.

Manilla, Manuel

Mexico City, Mexico
1830–1895, ibidem

From 1850 to 1890 Manilla worked as a graphic
artist for Juan Lagarza. From 1882 to 1892 he was
a graphic artist for the publisher Antonio Vanegas
Arroyo (1850–1917). In 1888 he published his first
caricatures. Manilla's works were first rediscovered
by the French artist Jean Charlot in 1926.

Martín, María Luisa

Salamanca, Spain
1/1/1927–10/12/1982
Mexico City, Mexico

In 1939 Martín fled to Mexico. From 1944 she
studied at La Esmeralda. Guest artist at the TGP
from 1950 to 1953. She was an assistant to Diego
Rivera. Member of the TGP from 1955 to 1965.
In 1968 she became lecturer at the Facultad de
Arquitectura at UNAM. She traveled through
Eastern Europe and China.

Méndez, Leopoldo [P. 274]

Mexico City, Mexico
6/30/1902–2/8/1969, ibidem

From 1917 to 1920 Méndez studied at the Academia
de San Carlos and from 1920 to 1922 at the Primera
Escuela de Pintura al Aire Libre in Chimalistac.
From 1921 he was a member of the Grupo estriden-
tista. At this time he worked as a newspaper
illustrator, stage assistant, drawing instructor, mural
painter, and poster designer. From 1932 he was
the head of the department for drawing instruction
of the Ministry of Education. Founding member
of LEAR in 1934 and member until 1938. Illustrator
for the journal *Frente a Frente*. In 1937 he was a
founding member of the TGP and a member until
1960. In 1939 he received a Guggenheim fellowship
in New York. In 1946 Mendéz received the first
Premio al Libro mejor ilustrado de México. In the
same year he left the Partido Comunista. In 1952 he
and the TGP were awarded the Premio Internacional
de la Paz by the Consejo Mundial de la Paz; the
awards ceremony took place one year later in Vienna.
In 1955 he was a candidate for the Partido Popular
in the senatorial elections. In 1958 he co-founded
the publishing house Fondo Editorial de la Plástica
Mexicana, along with Mariana Yampolsky. In 1968
he was a founding member of the Academia de
las Artes. Méndez received various awards and held
numerous national and international exhibitions.
He traveled to the U.S. and Europe.

Mexiac, Adolfo

Cuto de la Esperanza, Michoacán, Mexico
*8/7/1927

From 1944 to 1946 Mexiac studied at the Escuela de Bellas Artes de Morelia in Michoacán. From 1947 to 1951 he studied at the Academia de San Carlos and later at La Esmeralda. Member of the TGP from 1950 to 1959. From 1953 to 1954 he lived in Chiapas; he produced illustrations for the Instituto Nacional Indigenista. In 1957 and 1958 he was awarded at the Salón de Gráfica. Mexiac was well known for his illustrations for union newspapers and textbooks.

Monroy, Guillermo [P. 279]

Tlalpujahua, Michoacán, Mexico
*1/7/1925

After an apprenticeship as foreman in a furniture factory, Monroy studied at La Esmeralda with Frida Kahlo (1907–1954). In 1947 he was assistant to José Clemente Orozco. From 1948 to 1951 he was a member of the TGP.

Montenegro, Roberto

Guadalajara, Jalisco, Mexico
2/19/1885–10/13/1968
Mexico City, Mexico

From 1904 to 1905 Montenegro studied in Guadalajara and from 1906 at the Academia de San Carlos. From 1906 to 1910 he resided in Europe enabled by a grant. After the Mexican Revolution he returned to Europe and in 1919 returned to Mexico. He was head of the Department for Sculptural Arts at the Secretaría de Educación Pública. From 1934 he was the director of the Museo de Artes Populares de Bellas Artes. In 1967 he was awarded the Premio Nacional de Artes. Founding member of the Academia de Artes in 1968.

Mora, Francisco [P. 279]

Uruapan, Michoacán, Mexico
5/7/1922–2/22/2002
Cuernavaca, Morelos, Mexico

From 1936 to 1939 Mora attended the agricultural school in Morelia. In 1939 he received a scholarship to study in Morelia. From 1941 to 1944 he studied at La Esmeralda. Member of the TGP from 1941 to 1965. In 1947 he married Elizabeth Catlett. From 1949 he worked as an art teacher. Mora traveled throughout Europe.

Ocampo, Isidoro [P. 280]

Veracruz, Veracruz, Mexico
6/20/1910–2/4/1983
Mexico City, Mexico

Ocampo trained as salesman. From 1928 he attended evening classes at the Academia de San Carlos and from 1929 to 1934 studied at Taller de Artes del Libro. He worked as book illustrator at the publishing house Cultura from 1932 to 1939. From 1936 he taught at various art schools in Mexico City. Member of LEAR. Founding member of the TGP in 1937 and member until 1948. Founding member of the Sociedad para el Impulso de las Artes Plásticas in 1949.

O'Higgins, Pablo [P. 283]

Salt Lake City, UT, USA
3/1/1904–7/16/1983
Mexico City, Mexico

From 1922 to 1923 O'Higgins studied at the San Diego Academy of Art. In 1924 he traveled to Mexico. From 1925 to 1927 he was assistant to Diego Rivera. From 1928 to 1929 he collaborated with Jean Charlot and Frances Toor (1890–1956) on the first monograph on José Guadalupe Posada. Participation in the Misiones Culturales. In 1932 he received a scholarship from the art academy in Moscow. Founding member of LEAR in 1933 and member until 1938. Founding member of the TGP in 1937 and member until 1960. O'Higgins was a lecturer at various schools in Los Angeles, San Francisco, and at La Esmeralda. In 1961 he was granted Mexican citizenship. He traveled to Cuba and Moscow and held numerous awards and national and international exhibitions.

Orozco, José Clemente

Ciudad Guzmán (Zapotlán el Grande),
Jalisco, Mexico
11/23/1883–9/7/1949
Mexico City, Mexico

In 1890 Orozco moved to Mexico City. He lived in
the same neighborhood as the printing press of
Vanegas Arroyo and as a child he encountered the
graphic arts of Posada and Manilla. From 1897
to 1904 he attended the Escuela Nacional de Agri-
cultura (for topographical drawing). From 1908
to 1914 he studied at the Academia de San Carlos.
In 1911 he participated in the students' strike at the
Academia de San Carlos. In 1922 he became a
co-founder of contemporary mural painting under
Venustiano Carranza. Member of SOTPE from 1923.
From 1927 to 1934 he lived in the U.S. In 1946 he
was awarded the Premio Nacional de Bellas Artes
de México. He was one of the main representatives
of *muralismo* and was one of *Los tres grandes*
(The Big Three) together with Rivera and Siqueiros.
He traveled throughout Europe.

Parraguirre, Maria Luisa

Mexico City, Mexico
*10/4/1947

From 1965 to 1972 Parraguirre studied at La
Esmeralda. She worked in the Taller del Molina
de Santo Domingo and lived in Paris in 1976.
She returned to Mexico in 1977. She was a lecturer
for graphic arts at La Esmeralda. Parraguirre
held diverse exhibitions, among others in
Switzerland in 1976.

"Picheta", Gahona, Gabriel Vicente

Mérida, Yucatán, Mexico
4/5/1828–3/1/1899, ibidem

In 1845 Gahona received a scholarship for Italy.
In 1874 he began publishing the magazine *Don
Bullebulle.* Caricatured life in Yucatán under his
pseudonym "Picheta". He was a patron of the arts
in Yucatán and founder of the first Academy for
Engraving Techniques. In 1881 he became mayor
during the term of Teodosio Canto (1825–1907).
His work was rediscovered when his family donated
one of the printing plates to the Museo Regional
de Antropología de Yucatán in 1938.

Posada, José Guadalupe [P. 284]

Aguascalientes, Aguascalientes, Mexico
2/2/1852–1/20/1913
Mexico City, Mexico

Posada worked in a ceramics workshop, as drawer
of religious images. In 1866 he was employed at
the workshop of José Trinidad Pedroza (1837–1920).
From 1871 he worked for the local magazine *El Jicote.*
In 1887 he moved to Mexico City and founded his
own graphics workshop. Posada held a permanent
position as illustrator for the publishing house
of Antonio Vanegas Arroyo (1850–1917) and also
provided illustrations for opposition pamphlets
against the Díaz government. He died in poverty,
and his works were first rediscovered by Jean
Charlot in the 1920s.

Quinteros, Adolfo

Chihuahua, Chihuahua, Mexico
6/1/1927–1994

In 1951 Quinteros received a scholarship, and from
1951 to 1955 he studied at the Academia de San
Carlos. Member of the TGP from 1956 to 1967. From
1960 to 1961 and in 1963 he was Secretary General
of the TGP. In 1957 he became a member of the
Salón de la Plástica Mexicana. He co-founded the
Jardín del Arte in Mexico City.

Rabel (Rabinovich), Fanny

Poland
8/27/1922–11/25/2008
Mexico City, Mexico

From 1929 Rabel lived in France and from 1938 in
Mexico. She attended evening school from 1939.
From 1940 she worked for David Alfaro Siqueiros.
From 1940 to 1945 she studied at La Esmeralda
and from 1945 to 1948 at the Escuela de Artes del
Libro. She was an assistant to Diego Rivera. In 1948
she was a founding member of the Sociedad para
el Impulso de las Artes Plásticas. Member of the
TGP from 1949 to 1961 and founding member of the
FNAP in 1953. She held numerous exhibitions.

Ramírez, Everardo

Coyoacán, Estado de México, Mexico
7/1/1906–1992

From 1922 Ramírez studied at the Escuela de
Pintura al Aire Libre in Coyoacán. In 1928 he
became an assistant to Alfredo Ramos Martínez
(1871–1946). Member of LEAR from 1933 to 1937.
In 1937 he co-founded the TGP and was a member
until 1947. From 1967 to 1968 he created copies
of works by José Guadalupe Posada under
commission from INBA.

Reyes Meza, José

Tampico, Tamaulipas, Mexico
11/23/1924–11/31/2011
Mexico City, Mexico

From 1938 to 1948 Reyes Meza studied at
the Academia de San Carlos and from 1942 at
the Escuela Nacional de Antropología e Historia.
In 1949 he became a founding member of
the Salón de la Plástica Mexicana. In the 1950s
he designed stage sets for several ballet
and theater productions.

Rincón Piña, Agapito [P. 284]

Mexico City, Mexico
9/20/1897–1973

From 1915 Rincón Piña studied at the Academia
de San Carlos. From 1931 to 1933 he was a lecturer
at UNAM. He worked as a watercolorist and
graphic designer.

Rivera, Diego

Guanajuato, Guanajuato, Mexico
12/8/1886–11/24/1957
San Angel, Mexico City, Mexico

In 1892 Rivera moved to Mexico City. In 1896
he studied at the Academia de San Carlos. He had
an influential encounter with José Guadalupe
Posada. He resided in Europe from 1907 to 1910 on
a foreign-exchange grant. From 1915 to 1920 he
lived in Paris. In 1922 Rivera created his first murals
and joined the Partido Comunista Mexicano (PCM).
In 1923 he became a member of SOTPE. He created
numerous frescoes between 1923 and 1928 at
the Secretaría de Educación Pública. In 1924 Rivera
became editor of the magazine *El Machete*. In 1929
he married Frida Kahlo (1907–1954). From 1929
he was director of the Academia de San Carlos.
From 1929 to 1935 he painted the main stairway of
the Palacio Nacional. From 1930 to 1934 he lived
in the U.S. Rivera is one of the main representatives
of *muralismo* and was one of *Los tres grandes*
(The Big Three) along with José Clemente Orozco
and David Alfaro Siqueiros. He frequently traveled
throughout Europe, the Soviet Union, and the
U.S. and held numerous awards, as well as national
and international exhibitions.

Rodríguez, José Julio [P. 289]

San Miguel de Allende, Guanajuato, Mexico
*12/20/1912

From 1930 Rodríguez studied at the Academia de
Bellas Artes in Querétaro. In 1936 he moved to
Mexico City and from 1939 studied at the Escuela
de Artes del Libro under the directorship of the
Slovakian artist Kolomán Sokol (1902–2003).
In 1945 he worked as an art lecturer in Guanajuato
and San Miguel de Allende. In 1946 he was a
lecturer at the Escuela de las Artes del Libro.
Founding member of the Sociedad Mexicana de
Grabadores in 1947 (together with Amador
Lugo Guadarrama and Ángel Zamarripa Landi).

Siqueiros, David Alfaro [P. 289]

Camargo, Chihuahua, Mexico
12/29/1896–1/6/1974
Cuernavaca, Morelos, Mexico

From 1911 Siqueiros studied at the Academia de
San Carlos. From 1914 to 1918 he served in the
army of the constitutionalists and in 1919 became
military attaché to Europe. In 1922 he returned
to Mexico. He received his first commissions for
murals and founded the journal *El Machete*. As
member of the Partido Comunista, he was active
politically rather than artistically. From 1923 to 1933
he was a professor at the Chouinard School of
Art in Los Angeles. In 1933 he was a central founder
of LEAR and a member until 1938. In 1937 he be-
came a member of the TGP. In 1937 he married
Angélica Arenal, sister of Luis Arenal Bastar. In 1940
he led a conspiracy to murder the Russian Leon
Trotsky (1879–1940) who was living in exile in
Mexico. In 1950 Siqueiros participated in the Bien-
nale di Venezia. He is one of the main represen-
tatives of *muralismo* and one of the *Los tres grandes*
(The Big Three) together with José Clemente
Orozco and Diego Rivera. He held numerous awards,
as well as national and international exhibitions.

Sosamontes, Ramón [P. 290]

Chilpancingo, Guerrero, Mexico
*8/31/1911

Sosamontes studied at the Academia de Bellas
Artes in Querétaro and from 1927 to 1932 at
the Academia de San Carlos. He participated in
the Misiones Culturales. External member
of the TGP. In 1956 he moved to Mexico City.
Permanent member of the TGP from 1960.

Tamayo, Rufino [P. 293]

Oaxaca de Juárez, Oaxaca, Mexico
8/26/1899–6/24/1991
Mexico City, Mexico

In 1911 Tamayo moved to Mexico City. From 1917 to
1920 he studied at the Academia de San Carlos.
In 1921 he became director of the Museo Nacional
de Antropología. He was a professor of painting
at the Escuela Nacional de Bellas Artes from 1928
to 1929 and from 1937 to 1957 at the Dalton School
in New York. In 1950 he participated in the Bien-
nale di Venezia. Creation of his first lithographs.
In 1953 he was honored at the Bienal de São Paulo
and in 1957 was awarded the national order of
the Légion d'honneur of the French government.
In 1959 he participated in the *documenta II,* Kassel.
In 1981 the Museo de Arte Contemporáneo Inter-
nacional Rufino Tamayo in Mexico City opened. He
became a member of the Royal Academy in London
in 1985 and received the gold medal for service
to the fine arts from the Spanish King Juan Carlos I.
In 1987 he was named Commandeur des Arts
et des Lettres of the French government. Tamayo
held numerous international exhibitions.

Tarragó, Leticia

Orizaba, Veracruz, Mexico
*1940

From 1954 Tarragó studied at La Esmeralda and
at Taller Libre de Grabado. In 1958 she was given
a foreign-exchange scholarship for Europe.
She received honors from the Instituto Nacional
de Bellas Artes and was a founder of the Taller
de Grabado de la Universidad de Oaxaca. In 1967
she was awarded the prize of the Graphic Arts
Salon. From 1968 to 1970 Tarragó worked at times
in Switzerland. From 1980 she was a lecturer at
the Instituto de Artes Plásticas de la Universidad
Veracruzana.

Toledo, Francisco

Juchitán de Zaragoza, Oaxaca, Mexico
*7/17/1940

From 1952 Toledo trained as graphic artist in the workshop of Arturo García Bustos at the Escuela de Bellas Artes of the Benito Juárez Autonomous University in Oaxaca. From 1957 he studied at the Escuela de Diseño y Artesanías del Instituto Nacional de Bellas Artes at INBA. From 1960 to 1965 he lived in Paris after which he returned to Juchitán. In 1975 he moved to Oaxaca. He founded the publishing house Ediciones Toledo in 1983 and the Instituto de Artes Gráficas de Oaxaca in 1988. In 1998 he received the Premio Nacional de Artes and in 2000 joined the Academia de Artes in Mexico City. In 2005 Toledo was awarded the Right Livelihood Award (Alternative Nobel Prize). He held numerous awards and exhibitions.

Villaseñor, Isabel [P. 293]

Guadalajara, Jalisco, Mexico
5/18/1909–3/13/1953
Mexico City, Mexico

From 1928 to 1930 Villaseñor studied sculpture at the Centro Popular de Pintura Santiago Rebull in Mexico City. From 1930 she was a lecturer at the Departamento de Artes Plásticas. She worked as an artist and writer.

Yampolsky, Mariana [P. 297]

Chicago, IL, USA
9/6/1925–5/3/2002
Mexico City, Mexico

Yampolsky studied humanities at the University of Chicago. In 1944 she moved to Mexico City. Member of the TGP from 1945 to 1960. From 1948 she studied photography and painting at the Academia de San Carlos. From 1955 to 1957 she was responsible for the exhibitions of the TGP. She founded, together with Leopoldo Méndez, the publishing house Fondo Editorial de la Plástica Mexicana in 1958. In 1966 she founded the training center for foreign languages. In 1972 she created illustrations for free school books. Yampolsky traveled throughout Europe and the U.S.

Zalce, Alfredo [P. 298]

Pátzcuaro, Michoacán, Mexico
1/12/1908–1/19/2003
Morelia, Michoacán, Mexico

From 1924 to 1927 Zalce studied at the Academia de San Carlos. In 1930 he participated in the Misiones Culturales. He founded the Escuela de Pintura al Aire Libre in Taxco and from 1931 studied lithography under Emilio Amero. From 1932 to 1939 he taught at elementary schools. Founding member of LEAR in 1934 and member until 1937. Founding member of the TGP in 1937 and member until 1947. In 1945 he conducted a study excursion through Yucatán. In 1949 he founded an art school in Uruapan upon invitation from General Cárdenas del Río. In 1950 he moved to Morelia. In 1952 Zalce became director of the Escuela de Bellas Artes de Morelia in Michoacán. He held numerous exhibitions.

Zamarripa Landi, Ángel [P. 298]

Morelia, Michoacán, Mexico
11/16/1912–7/6/1990
Mexico City, Mexico

From 1929 Zamarripa Landi studied at the Academia de San Carlos. In 1946 he studied lithography, etching, woodcut, and typography at the Escuela de las Artes del Libro. He was a founding member of the Sociedad Mexicana de Grabadores in 1947 (with Amador Lugo Guadarrama and José Julio Rodríguez) and editor of its organ, *Estampa.* He was a member of the group Xylon and of the Salón de la Plástica Mexicana.

Zúñiga, Francisco

Guadalupe, San José, Costa Rica
12/27/1912–8/9/1998
Tlalpan, Mexico City, Mexico

In 1927 Zúñiga studied at the Escuela de Bellas Artes de San José in Costa Rica. From 1928 to 1934 he worked in his family's sculpting business. In 1936 he moved to Mexico City and in 1938 studied sculpting, subsequently becoming a lecturer for sculpture at La Esmeralda. In 1943 he became a member of the sculpting workshop Taller Libre de Escultura. In 1987 he became a member of the Academia de Artes. Zúñiga received numerous national and international awards.

IMAGE CREDITS

CITED AND SELECTED LITERATURE

¡30–30! 1993
¡30–30! Contra la Academia de Pintura. 1928,
eds. Laura González Matute et al., Mexico City: Instituto
Nacional de Bellas Artes, 1993.

Althaus 2008
Karin Althaus, *Druckgrafik. Handbuch der künstleri-*
schen Drucktechniken, in cooperation with the Print
Collection of the ETH Zurich, with an essay by
Paul Tanner, Zurich: Scheidegger & Spiess, 2008.

Amor 1987
Una mujer en el arte mexicano. Memorias de Inés Amor,
eds. Jorge Alberto Manrique and Teresa del Conde,
Universidad nacional Autónoma de México, Mexico
City: Instituto de Investigaciones Estéticas, 1987.

Atl 1921, vol. 1
Dr. Atl [Gerardo Murillo], *Las artes populares en*
México. Texto, vol. 1, Librería México, Mexico City:
Cultura, 1921.

Atl 1921, vol. 2
Dr. Atl [Gerardo Murillo], *Las artes populares*
en México. Ilustraciones, vol. 2, Librería México,
Mexico City: Cultura, 1921.

Avila 2008
Theresa Avila, "Laborious Arts: El Taller de Gráfica
Popular & The Meaning of Labor in Las Estampas
de la Revolución Mexicana," in *Hemisphere. Visual*
Cultures of the Americas, vol. 1, spring 2008, pp. 62–82.

Avila 2013
Mary Theresa Avila, *Chronicles of Revolution and*
Nation: El Taller de Gráfica Popular's "Estampas de
la Revolución Mexicana" (1947), dissertation:
University of New Mexico, 2013.

Barajas 2009
Rafael Barajas Durán, *Posada. Mito y Mitote.*
La caricatura política de José Guadalupe Posada
y Manuel Alfonso Manilla, Mexico City: Fondo
de Cultura Económica, 2009.

Barajas 2013
Rafael Barajas Durán, *Historia de un país en*
caricatura. Caricatura mexicana de combate,
1821–1872, Mexico City: Fondo de Cultura
Económica, 2013.

Billeter 2012
Erika Billeter, "Francisco Toledo. Im Kosmos der
Tiere – Das Abenteuer der Fantasie," in *Mexicanidad –*
Frida Kahlo. Diego Rivera. Rufino Tamayo. Francisco
Toledo. Adolfo Riestra, exh. cat. Kunsthalle Würth,
Schwäbisch Hall/Künzelsau: Swiridoff Verlag,
2012, pp. 169–182.

Bonilla 2001
Helia Emma Bonilla Reyna, "El Calavera: la caricatura
en tiempos de guerra," in *Anales del instituto*
de Investigaciones Estéticas, no. 79, Mexico City,
2001, pp. 71–134.

Caplow 2007
Deborah Caplow, *Leopoldo Méndez. Revolutionary*
Art and the Mexican Print, Austin: University of
Texas Press, 2007.

Charlot 1963
Jean Charlot, *The Mexican Mural Renaissance.*
1920–1925, New Haven/London: Yale University
Press, 1963.

Cortés Juárez 1951
Erasto Cortés Juárez, *El grabado contemporáneo,*
vol. 12, de la Enciclopedia Mexicana de Arte, Mexico
City: Ediciones Mexicanas, 1951.

Costa 2009
Gina Costa, *Para la gente: Art Politics and Cultural*
Identity of the Taller de Gráfica Popular. Selected
Works from the Charles Hayes Collection of
Twentieth-Century Mexican Graphics, Notre
Dame: Snite Museum of Art, 2009.

Dyson 2009
Anthony Dyson, *Printmakers' Secrets,* London:
A & C Black Publishers Limited, 2009.

Einfeldt 2010
Kirsten Einfeldt, *Moderne Kunst in Mexiko:*
Raum, Material und nationale Identität, Berlin:
De Gruyter, 2010.

Fernández 1965
Justino Fernández, *Mexikanische Kunst,* London:
Spring Books, 1965.

Fernández 1969
Justino Fernández, *A Guide to Mexican Art. From*
Its Beginnings to the Present, Chicago/London:
University of Chicago Press, 1969.

Fernández 2006
Rosa María Fernández Esquivel, *Los impresos*
mexicanos del siglo XVI: Su presencia en el patrimonio
cultural del nuevo siglo, PhD thesis, Mexico City:
Universidad nacional autónoma de México, 2006.

Flores 2013
Tatiana Flores, *Mexico's Revolutionary Avant-Gardes.*
From Estridentismo to ¡30–30!, New Haven/London:
Yale University Press, 2013.

Friedrich 1979
Anton Friedrich, *José Guadalupe Posada,*
Diogenes Kunst Taschenbuch, vol. 7, Zurich:
Diogenes, 1979.

Gale 2010
Colin Gale, *Das Praxisbuch der künstlerischen*
Drucktechniken, Bern: Haupt, 2010.

González Ramírez 1955
Manuel González Ramírez, *La caricatura política,*
Fuentes para la historia de la revolución mexicana,
vol. 2, Mexico City: Fondo de Cultura Económica, 1955.

Greene Robertson 1991
Merle Greene Robertson, *The Sculpture of Palenque*,
Princeton N. J.: Princeton University Press, vol. 4:
*The Cross Group, the North Group, the Olvidado, and
other pieces*, 1991.

Guadarrama 2005
Guillermina U. Guadarrama, *El Frente Nacional
de Artes Plásticas (1952–1962)*, Mexico City: Estampa
Artes Gráficas, 2005.

Haab 1956
Armin Haab, *Mexiko*, Teufen: Niggli, 1956.

Haab 1957
Armin Haab, *Mexikanische Graphik*, Teufen:
Niggli, 1957.

Haab 1977
Armin Haab, "Über die Lust, Bücher zu machen,"
in *Zuger Neujahrsblatt 1977*, ed. Gemeinnützige
Gesellschaft des Kantons Zug, Zug: Kalt-Zehnder,
1977, pp. 31–81.

Haight 1946
Anne Lyon Haight, *Retrato de la America Latina –
hecho por sus artistas gráficos*, with an introduction
by Jean Charlot, New York: Hastings House
Publishers, 1946.

Heller 1995
Jules Heller and Nancy G. Heller, *North American
Women Artists of the Twentieth Century.
A Biographical Dictionary*, New York: Garland, 1995.

Herrera/Valero 2001
Alejandra Herrera Galván and Vida Valero, "El realismo
socialista y su repercusión en México," in *Tema y
variaciones de literatura: literatura mexicana, siglo
XX*, no. 16, 1st semester, Mexico City: 2001, pp. 47–66.

Indych-López 2009
Anna Indych-López, *Muralism Without Walls. Rivera,
Orozco and Siqueiros in the United States. 1927–1940*,
Pittsburgh: University of Pittsburgh Press, 2009.

Kenzler 2012
Marcus Kenzler, *Der Blick in die andere Welt. Einflüsse
Lateinamerikas auf die Bildende Kunst der DDR*,
ed. Matthias Bleyl, Theorie der Gegenwartskunst,
vol. 18, PhD thesis, Berlin: Lit. Verlag Dr. W. Hopf, 2012.

Kiessling 1974
Wolfgang Kiessling, *Alemania Libre in Mexiko*,
vol. 1: *Ein Beitrag zur Geschichte des antifaschis-
tischen Exils (1941–1946); vol. 2: Texte und Doku-
mente zur Geschichte des antifaschistischen Exils
(1941–1946)*, Berlin: Akademie-Verlag, 1974.

Kiessling 1980
Wolfgang Kiessling, *Exil in Lateinamerika. Kunst
und Literatur im antifaschistischen Exil 1933–1945*,
Leipzig: Verlag Philipp Reclam jun., 1980.

Klein 1975
Heijo Klein, *DuMont's kleines Sachwörterbuch
der Drucktechnik und grafischen Kunst. Von Abdruck
bis Zylinderpresse*, Cologne: Verlag M. DuMont
Schauberg, 1975.

Koschatzky 1980
Walter Koschatzky, *Die Kunst der Graphik. Technik,
Geschichte, Meisterwerke*, 5th edition, Munich:
dtv, 1980.

Krejča 1980
Aleš Krejča, *Die Techniken der graphischen Kunst:
Handbuch der Arbeitsvorgänge und der Geschichte
der Original-Druckgraphik*, 2nd edition, Hanau:
Dausien 1980.

Krumpel 2006
Heinz Krumpel, *Philosophie und Literatur in
Lateinamerika – 20. Jahrhundert – Ein Beitrag zu
Identität, Vergleich und Wechselwirkungen zwischen
lateinamerikanischem und europäischem Denken*,
ed. Stephan Haltmayer, Wiener Arbeiten zur Philo-
sophie, series B: Beiträge zur philosophischen
Forschung, vol. 13, PhD, Frankfurt a. M.: Peter Lang.
Europäischer Verlag der Wissenschaften, 2006.

López Casillas 2005
Mercurio López Casillas, José Guadalupe Posada.
Illustrator of Chapbooks, vol. 2 of the Library
of Mexican Illustrations, Mexico City: Editorial RM,
MMV [2005].

López Casillas 2005 Manilla
Mercurio López Casillas, *Monografía de 598
Estampas de Manuel Manilla. Grabador mexicano*,
with an introduction by Jean Charlot, Mexico City:
Editorial RM, 2005

Lozano/Coronel 2008
Luis-Martín Lozano and Juan Rafael Coronel,
Diego Rivera. Sämtliche Wandgemälde, Cologne:
Taschen, 2008.

Marley 2014
David F. Marley, *Mexico at War. From the Struggle
for Independence to the 21st-Century Drug Wars*,
Santa Barbara: ABC-Clio, 2014.

Meyer 1949
Hannes Meyer, *TGP México. El taller de gráfica popular.
Doce años de obra artística colectiva*, Mexico City:
La Estampa Mexicana, 1949.

Monsiváis 2002
Carlos Monsiváis, "Leopoldo Méndez: La Radicalización
de la Mirada," in *Leopoldo Méndez 1902–2002*, Mexico
City: Editorial RM, 2002.

Morse 1976
Peter Morse, *Jean Charlot's Prints. A Catalogue
raisonné*, Honolulu: University Press of Hawaii, 1976.

CITED AND SELECTED LITERATURE

Münzenberg 1928
Willi Münzenberg, *Das Werk des Malers Diego Rivera*,
Berlin: Neuer Deutscher Verlag, 1928 [n.p.]

Münzberg/Nungesser 1981
Olav Münzberg and Michael Nungesser, "Orozcos
mexikanische Wandbilder der dreissiger Jahre.
Soziale Kämpfe der Gegenwart und Vergangenheit,"
in *José Clemente Orozco. 1883-1949*, eds. Egbert
Baqué and Heinz Spreitz, Berlin: Leibniz-Gesellschaft
für Kulturellen Austausch, 1981, pp. 204-231.

Mujeres revolucionarias 1992
*Las mujeres en la Revolución Mexicana, 1884-1920.
Biografías de mujeres revolucionarias,* ed. Instituto
Nacional de Estudios Históricos de la Revolución
Mexicana, Secretaría de Gobernación and Instituto
de Investigaciones Legislativas de la H. Cámara de
Diputados, Mexico City: La Cámara, 1992.

Noack 2000
Karoline Noack, "Die 'Werkstatt der populären
Grafik' in Mexiko – die Bauhaus reist nach Amerika,"
in Sonja Neef (ed.), *An Bord der Bauhaus. Zur Heimat-
losigkeit der Moderne*, Bielefeld: transcript, 2009,
pp. 91-113.

Núñez Mata 1971
Efrén Núñez Mata, "Raúl Anguiano," in *Norte, Tercera
Epoca, Revista Hispano-Americano*, ed. Fredo Arias de
la Canal, no. 243, Mexico City, 1971, pp. 39-45.

O'Gorman 2004
Edmundo O'Gorman, *La invención de América.
Investigación acerca de la estructura histórica del
nuevo mundo y del sentido de su devenir*, Colección
Tierra Firme, Mexico City: Fondo de Cultura
Económica, [1958] 2004.

O'Gorman/Fernández 1955
Edmundo O'Gorman and Justino Fernández,
Documentos para la historia de la litografía en México,
Mexico City: Imprenta Universitaria, Instituto de
Investigaciones Estéticas, 1955.

Orozco 1999
José Clemente Orozco, *Autobiografía*, Mexico City:
Ediciones Era, [1945], 8th edition, 1999.

Orozco 2004
Clemente Orozco, *José Clemente Orozco. Graphic Work*,
Austin: University of Texas Press, 2004.

Pereda 2004
Juan Carlos Pereda, *Rufino Tamayo. Catalogue
raisonné. Gráfica = Prints. 1925-1991*, Mexico City:
Fundación Olga y Rufino Tamayo, Conculta-Inba,
Turner, 2004.

Pereda 2012
Juan Carlos Pereda, "Rufino Tamayo. Das Mexikanische
im Werk Rufino Tamayos," in *Mexicanidad – Frida
Kahlo. Diego Rivera. Rufino Tamayo. Francisco Toledo.
Adolfo Riestra*, exh. cat. Kunsthalle Würth, Schwäbisch
Hall/Künzelsau: Swiridoff Verlag, 2012, pp. 125-168.

Pohle 1986
Fritz Pohle, *Das mexikanische Exil. Ein Beitrag
zur Geschichte der politisch-kulturellen Emigration
aus Deutschland (1937-1946)*, Stuttgart: J. B.
Metzlersche Verlagsbuchhandlung, 1986.

Posada 1972
*Posada's Popular Mexican Prints. 273 Cuts by José
Guadalupe Posada*, eds. Roberto Berdecio and Stanley
Appelbaum, New York: Dover Publications, 1972.

Posada 2002
Posada Monografía: 406 Grabados, facsimile
of the 1st edition from 1991 in the Ediciones Toledo,
with an introduction by Diego Rivera, Mexico City:
Editorial RM, 2002.

Prager 2013
Christian Manfred Prager, *Übernatürliche Akteure
in der Klassischen Maya-Religion. Eine Untersuchung
zu intrakultureller Variation und Stabilität am
Beispiel des k'uh "Götter"-Konzepts in den religiösen
Vorstellungen und Überzeugungen Klassischer
Maya-Eliten (250-900 n.Chr.)*, vol. 2, PhD thesis,
Bonn, 2013.

Prignitz 1981
Helga Prignitz, *TGP. Ein Grafiker-Kollektiv in Mexiko
von 1937-1977*, Berlin: Richard Seitz & Co., 1981.

Prignitz 1990
Helga Prignitz, *Mexikanische Graphik. Katalog
der Sammlung Armin Haab*, 1990, unpublished
catalog text.

Reed 1979
Alma Reed, *José Clemente Orozco. Eine Monographie
nach Texten von Alma Reed und mit einem Beitrag
von Margarita Valladores de Orozco*, Dresden:
VEB Verlag der Kunst, 1979.

Reich 1967
Mexiko, ed. Hanns Reich, text: Hans Leuenberger,
photos: Thomas Cugini, Arpad Elfer, Armin Haab,
Hans W. Silvester et al., series: Terra-magica-
Bildband, Munich: Reich, 1967.

Reuter 1981
Jas Reuter, "Die Frau Symbol des Negativen?," in
José Clemente Orozco. 1883-1949, eds. Egbert Baqué
and Heinz Spreitz, Berlin: Leibniz-Gesellschaft
für Kulturellen Austausch, 1981, pp. 198-202.

Reyes Palma 1994
Francesco Reyes Palma, *Leopoldo Méndez. El Oficio
de Grabar*, ed. Galería Colección de Arte Mexicano,
Mexico City: Ediciones Era, 1994.

Röhrl 2013
Boris Röhrl, *Realismus in der Bildenden Kunst.
Europa und Nordamerika. 1830-2000*, Berlin: Gebr.
Mann Verlag, 2013.

Romero de Terreros y Vincent 1948
Manuel Romero de Terreros y Vincent, *Grabados y Grabadores en la Nueva España*, Mexico City: Ediciones Arte Mexicano, 1948.

Scheffel 1990
Michael Scheffel, *Magischer Realismus. Die Geschichte eines Begriffes und ein Versuch seiner Bestimmung*, Stauffenburg-Colloquium: vol. 16, PhD thesis Universität Göttingen (1988), Tübingen: Stauffenburg-Verlag, 1990.

Schele 1979
Linda Schele, "Genealogical Documentation on the Tri-figure Panels at Palenque," in *Tercera Mesa Redonda de Palenque*, eds. Merle Greene Robertson and Donnan Call Jeffers, vol. 4, Austin: University of Texas Press, 1979.

Schilling 1934
Pater Dr. Dorotheus Schilling, OFM, "Einführung der Druckkunst in Mexiko," in *Gutenberg-Jahrbuch*, ed. A. Ruppel, no. 9, Mainz: Gutenberg-Gesellschaft, 1934, pp. 166–182.

Schlirf 1974
Hans Schlirf, "Die ökonomische und politische Entwicklung der mexikanischen Revolution," in *Kunst der mexikanischen Revolution. Legende und Wirklichkeit*, ed. Neue Gesellschaft für bildende Kunst Berlin, exh. cat. Schloss Charlottenburg, Berlin: Neue Gesellschaft für bildende Kunst, 1974, pp. 63–72.

Schreiber 2008
Rebecca M. Schreiber, *Cold War Exiles in Mexico. U.S. Dissidents and the Culture of Critical Resistance*, Minneapolis: University of Minnesota Press, 2008.

Serdán 2010
Anonymous, "Carmen Serdán, antecesora de heroínas revolucionarias," in *La Crónica de Culiacán*, El Sol de Sinaloa, no. 293, November 17, 2010.

Siqueiros 1975
David Alfaro Siqueiros, *Der neue mexikanische Realismus. Reden und Schriften zur Kunst*, edited and with an introduction by Raquel Tibol, transl. Gerda Rincón, Christiane Barckhausen, and Fritz Rudolf Fries, Dresden: VEB Verlag der Kunst, 1975.

Siqueiros 1988
David Alfaro Siqueiros: man nannte mich den "Grossen Oberst": Erinnerungen [original title: *Me llamaban el Coronelazo. Memorias*, 1977], transl. Rose Gromulat, Berlin: Dietz Verlag, 1988.

Stein 1994
Philip Stein, *Siqueiros. His Life and Works*, New York: International Publishers, 1994.

Stibi 1948
Georg Stibi, "Soziale Graphik in Mexiko," in *Bildende Kunst*, vol. 2, no. 3, Berlin 1948, pp. 10–16.

Tibol 1970
Raquel Tibol, *Die Kunst Mexikos. Mexikanische Kunst des 19. und 20. Jahrhunderts*, vol. 3, Munich: Goldmann, 1970.

Tibol 1974
Raquel Tibol, "Die Kulturpolitik der Cárdenas-Regierung 1934–1940," in *Kunst der mexikanischen Revolution. Legende und Wirklichkeit*, ed. Neue Gesellschaft für bildende Kunst Berlin, exh. cat. Schloss Charlottenburg, Berlin: Neue Gesellschaft für bildende Kunst, 1974, pp. 91–96.

Toor 1947
Frances Toor, *A Treasury of Mexican Folkways: The Customs, Myths, Folklore, Traditions, Beliefs, Fiestas, Dances and Songs of the Mexican People*, drawings by Carlos Mérida, New York: Crown Publishers, 1947.

Tyler 1979
Ron Tyler, *Posada's Mexico*, in cooperation with the Amon Carter Museum of Western Art, Forth Worth, Texas/Washington: Library of Congress, 1979.

Velasco 1930
Rómulo Velasco Ceballos, *Aquiles Serdán. Episodios de la Revolución de 1910*, Cuaderno no. 1, Mexico City: Imp. Unda y García, 1930.

Wald 1997
Robert F. Wald, "The Politics of Art and History at Palenque: Interplay of Text and Iconography on the Tablet of the Slaves," in *Texas Notes on Precolumbian Art, Writing, and Culture*, no. 80, March 1997, pp. 1–18.

Westheim 1954
Paul Westheim, *El grabado en madera*, 1st edition in Spanish with an additional chapter on Mexico, Mexico City/Buenos Aires: Fondo de Cultura Económica, 1954.

Westheim 1966
Paul Westheim, *Die Kunst Alt-Mexikos*, 1st edition, 1950, Cologne: Verlag M. DuMont Schauberg, 1966.

Williams/Lewis 1993
Jerry M. Williams and Robert E. Lewis, *Early Images of the Americas. Transfer and Invention*, Tucson/London: The University of Arizona Press, 1993.

Wolfsturm/Burkhardt 1994
Hans-Jürgen Wolfsturm and Hermann Burkhardt, *Hochdruck*, Ravensburg: Ravensburger Buchverlag, 1994.

Wroth 1994
Lawrence C. Wroth, *The Colonial Printer*, 1st edition 1931, New York: Dover Publications, 1994.

Zimmering 2005
Raina Zimmering, *Der Revolutionsmythos in Mexiko*, Würzburg: Königshausen & Neumann, 2005.

CITED AND SELECTED LITERATURE

Exhibition catalogs

Berlin 1974
Kunst der mexikanischen Revolution. Legende und Wirklichkeit, ed. Neue Gesellschaft für bildende Kunst Berlin, exh. cat. Schloss Charlottenburg, Berlin: Neue Gesellschaft für bildende Kunst, 1974.

Berlin 1982
Wand. Bild. Mexico, ed. Nationalgalerie Berlin and the Berliner Festspiele GmbH "Horizonte '82 – Latein-amerika," in cooperation with the Instituto Nacional de Bellas Artes, exh. cat. Nationalgalerie Berlin, Staatliche Museen Preussischer Kulturbesitz, Berlin: Frölich & Kaufmann, 1982.

Berlin 2002
Taller de Gráfica Popular. Plakate und Flugblätter zu Arbeiterbewegung und Gewerkschaften in Mexiko 1937-1986, exh. cat. Collection of the Ibero-Amerika-nisches Institut, Preussischer Kulturbesitz, Berlin: Ibero-Amerikanisches Institut, Preussischer Kultur-besitz, 2002.

Buenos Aires 2001
Francisco Toledo, exh. cat. Centro Cultural Borges, Buenos Aires, 2001.

London 2009
Revolution on paper: Mexican prints 1910-1960, eds. Dawn Ades, Alison McClean, Mark McDonald, and Laura Campbell, exh. cat. The British Museum, London: The British Museum Press, 2009.

Mexico City 1960
450 años de lucha – homenaje al pueblo mexicano. 146 estampas de la lucha del pueblo de México, obra colectiva de los artistas del TGP en México, exh. cat., 1st edition, Mexico City: Talleres gráficos de la Nación, 1960.

Mexico City 1987
50 años TGP. Taller de Gráfica Popular. 1937-1987, exh. cat. Museo del Palacio de Bellas Artes, Museo Nacional de la Estampa, Galería José María Velasco, Mexico City, 1987.

Mexico City 2005
Miguel Covarrubias. Homenaje nacional. Cuatro Miradas – National homage. Four visions, ed. Miguel Covarrubias, exh. cat. Museo Soumaya, Museo Mural Diego Rivera, Museo Casa Estudio Diego Rivera y Frida Kahlo, Mexico City: Editorial RM, 2005.

Mexico City 2012
Rufino Tamayo. Trayectos – trajectories, ed. Juan Carlos Pereda, exh. cat. Instituto nacional de Bellas Artes, Mexico City, 2012.

New York 1940
Veinte siglos de arte mexicano. Twenty Centuries of Mexican Art, exh. cat. The Museum of Modern Art, New York in collaboration with the Mexican government, New York: The Museum of Modern Art, Instituto de Antropología e Historia de México, 1940.

Nuremberg 1971
Posada und die mexikanische Druckgraphik 1930 bis 1960, ed. Michael Mathias Prechtl, exh. cat. Albrecht Dürer Gesellschaft, Kunsthalle Nürnberg, Nuremberg, 1971.

Philadelphia 2006
Mexico and Modern Printmaking. A Revolution in the Graphic Arts, 1920 to 1950, ed. John Ittmann, exh. cat. Philadelphia Museum of Art and McNay Art Museum, San Antonio, New Haven/London: Yale University Press, 2006.

Reutlingen 1998
Ein Jahrhundert mexikanische Graphik. Aus dem Museo Nacional de la Estampa, Mexiko Stadt, ed. Städtisches Kunstmuseum Spendhaus Reutlingen, exh. cat. Städtisches Kunstmuseum Reutlingen and Städtische Galerie in der Stiftung Reutlingen, Reutlingen, 1998.

Schwäbisch Hall 2012
Mexicanidad – Frida Kahlo. Diego Rivera. Rufino Tamayo. Francisco Toledo. Adolfo Riestra, exh. cat. Kunsthalle Würth, Schwäbisch Hall/Künzelsau: Swiridoff Verlag, 2012.

Sevilla 2005
José Guadalupe Posada. El Grabador mexicano, exh. cat. Centro Andaluz de Arte Contemporáneo, Sevilla: Editorial RM, 2005.

Stanford 2002
José Guadalupe Posada and the Taller de Gráfica Popular: Mexican popular prints, exh. cat., Stanford: The Stanford University Libraries, 2002.

Vienna 1983
Rufino Tamayo. Graphik 1962-1982, exh. cat. Graphic Arts Collection of the Albertina, Vienna, 1983.

Vienna 1988
Imagen de Mexico. Der Beitrag Mexikos zur Kunst des 20. Jahrhunderts, ed. Erika Billeter, Vienna Festival in collaboration with the Cultural Office of the City of Vienna, exh. cat. Messepalast Wien, Bern: Benteli, 1988.

Zug 1989
Armin Haab. Photographien, in collaboration with the Schweizerische Stiftung für die Photographie, Kunsthaus Zürich, exh. cat. Kunsthaus Zug, Zug: Zuger Kunstgesellschaft 1989.

Zurich 1951
Mexikanische Druckgraphik. Die Werkstatt für graphische Volkskunst in Mexiko, El Taller de Gráfica Popular, Text: Hannes Meyer, exh. cat. Kunstgewerbe-museum der Stadt Zürich, Zurich, 1951.

Zurich 2012
Posada bis Alÿs. Mexikanische Kunst von 1900 bis heute, ed. Zürcher Kunstgesellschaft, Text: Milena Oehy, exh. cat. Kunsthaus Zürich, Zurich: Kunsthaus Zürich, 2012.